S0-AYQ-139

HAL SANDERSON
34 GILHAVEN ROAD
MANCHESTER, N.H. 03104

The Here's How
Book of
Photography
Volume II

EASTMAN KODAK COMPANY
ROCHESTER, NEW YORK 14650

© Eastman Kodak Company, 1977
Standard Book Number: 0-87985-200-3
Library of Congress Catalog Number: 73-184546

INTRODUCTION

The *Here's How* series began with a single book in 1964. We didn't plan to produce a series; it just turned out that way. Each successive book met with such an enthusiastic response that we have now produced ten of them, with a total of more than three million copies. Several of the books are still in print and are available from photo dealers and bookstores.

In *The Here's How Book of Photography, Volume II,* we've combined *The Seventh, Eighth, Ninth,* and *Tenth Here's How* books into one hardcover book that will make a helpful and attractive addition to your photographic library. This book contains a wealth of information on a variety of photographic subjects. The topics cover a wide range, including photographing wildflowers, color infrared photography, black-light photography, pet photography, nature photography, and many more. Each of the 25 articles was written by an expert who has achieved recognized success in the specialized area described.

While the articles are basically the same as those in the original *Here's How* books, they have been updated to provide the latest product and procedural information. So read on—whatever your photographic interest, you should profit from the well-illustrated informative articles in this book.

CONTENTS

The Here's How
Book of Photography
Volume II

John Brandow is a Supervising Photo Specialist in the Photo Information department at Kodak. His vast photographic background includes work in film testing and analytical sensitometry, as well as in salon photography. Hundreds of his photographs have been accepted in domestic and international photographic exhibitions. John is a well-known photographic judge and has taught many classes in photography. He has traveled extensively throughout the United States, presenting slide shows on many photographic subjects.

The Exotic World
of Color Infrared Photography

by John F. Brandow

It's a colorful world we live in. Color has become commonplace in magazines, television, movies, and photographs. The traditional colors of men's suits, women's stockings, automobiles, and home furnishings have given way to every hue of the spectrum. No longer is it necessary to wear a dark-colored suit or sheer flesh-colored stockings in order to be dressed correctly. In an increasingly color-oriented world, no color can be designated as the "correct" color anymore.

With modern color films and lenses it's not difficult to reproduce the normal colors of the scenes and objects you photograph. Looking for greater challenges, many color-conscious photographers try derivations, montages, and other unconventional approaches to color. Many techniques can add versatility to your color photography and give you some very impressive picture results. One of the more recent techniques is color infrared photography with KODAK EKTACHROME Infrared Film.*

*Equivalents can be used for the Kodak products mentioned throughout this book.

1

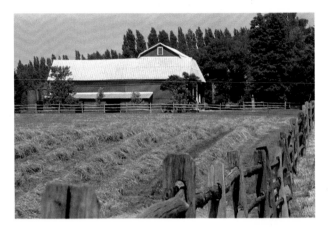

This typical farm scene was photographed on KODAK EKTACHROME Film.

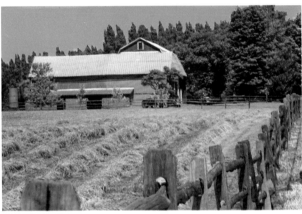

KODAK EKTACHROME Infrared Film has turned a rather ordinary picture into an unusual, strikingly colored tableau. Exposed through a No. 12 filter, 1/125 second at f/16.

The Film

KODAK EKTACHROME Infrared Film is available from photo dealers in 20-exposure 35-mm magazines. I've had a great deal of fun experimenting with it in a variety of picture-taking situations. It has a false-color response that provides different and interesting results. As you may know, the three image layers of a conventional color film are sensitized to blue, green, and red. The layers of this infrared color film record green, red, and infrared. The green-sensitive layer produces a yellow positive image in the processed slide, the red-sensitive layer produces a magenta image, and the infrared-sensitive layer produces a cyan image.

The effects you can get with this film are not only unusual but often unpredictable! For example, suppose you photographed a red barn in front of

2

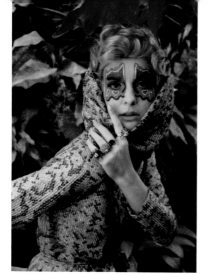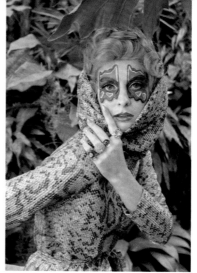

How's this for dramatic effect? The model used watercolors
for her striking eye makeup and wore a synthetic wig. The green skin tones
and red foliage add an air of fantasy to an already
exciting picture. Both pictures were made with daylight illumination.

some green trees and came up with a slide showing a pastel-green barn, red
trees, and a deep blue-green sky. Or how about a picture of a girl with a
greenish face and yellow lips? Sound interesting? These might be just the
kinds of show-stoppers you need to generate some excitement in the next
slide show you put on for your family and friends. And if well done, they
would surely catch the judges' eyes in a camera-club slide competition.

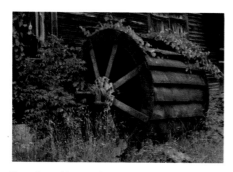

From the evidence of the growing vine and rust, you can see that this old mill wheel
hasn't turned for a long time. The colorful infrared version puts much more life
into the scene. Blue is added to the weathered wheel, and like all live green foliage
photographed on this film, the grass and vines appear magenta-red.

Filters

All three layers of a color-slide film are sensitive to blue light. In a conventional color film, a yellow filter layer just below the blue-sensitive layer prevents blue light from affecting the other two layers. Since EKTACHROME Infrared Film is not designed to record blue in any of its layers, you need a yellow filter over the camera lens so that no blue light can reach the film. The filter is necessary whether you take pictures with sunlight or artificial light. A No. 12 filter is recommended by our experts for a true "biological" color balance. However, I've found that the No. 15 filter works as well for my picture-taking purposes and seems to be stocked in more camera shops. The popular No. 8 filter transmits some blue light, so it isn't very suitable for color infrared photography.

Focusing

Most camera lenses won't focus infrared rays in the same plane as visible light rays, so some lenses have index marks on their focusing scales to correct for infrared focus. These index marks are fine for black-and-white infrared photography. But in a color infrared film, two of the three layers record visible light, with the sharpest image recorded in the green-sensitive layer. For this reason, the image will be sharper if you use the regular focusing-scale settings. If you have to use very large lens openings, try to focus on the front edge of the main subject.

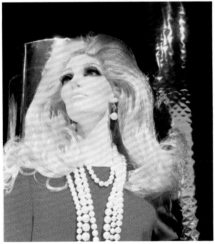

Here's another EKTACHROME Film (left) vs EKTACHROME Infrared Film comparison. The mannequin was in a department-store window under tungsten lighting. Who would have guessed that the black dress would become a brilliant red in a color infrared photograph?

4

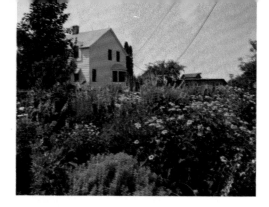

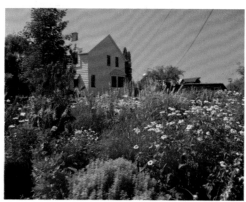

The wide variety of colors in this flower garden helps to demonstrate the response of EKTACHROME Infrared Film (left). Note the tendency of the white house to go blue despite the yellow filter that was used. This happens because a white subject is usually recorded as a very light (almost clear) yellow image in the green-sensitized layer. It allows magenta and cyan to predominate and combine to form blue.

Exposure

Because of the specialized sensitivity of EKTACHROME Infrared Film, its speed can't be indicated with an ordinary film-speed rating. But for a trial, using a No. 12 or a No. 15 filter on your camera, set your exposure meter at ASA 100 or start with a sunlight exposure of 1/125 second at $f/16$. Then make a series of exposures, increasing and decreasing the trial exposure by ½ stop and 1 stop. Keep a record of the exposures and compare results; then select the exposure you prefer. From this exposure, you can determine the film-speed setting to use with your exposure meter or camera.

If the exposure you selected is	Use film-speed setting
1 stop over	50
½ stop over	80
The trial exposure	100
½ stop under	160
1 stop under	200

For example, if the exposure you have selected is one stop less than the basic exposure you started with, you should double the film-speed setting; if it is one stop more, cut the speed setting in half. As you become familiar with this

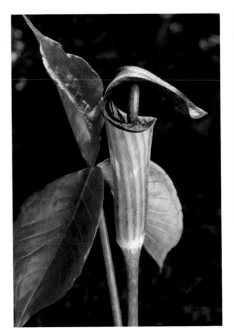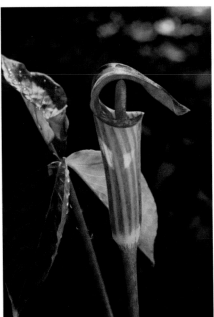

This jack-in-the-pulpit profile provides an excellent example of the color changes you can get when you photograph flowers with color infrared film (right). I find the color differences quite unpredictable but generally pleasing.

film response, you can further adjust your exposures to suit your taste and equipment until you've established your permanent personal speed rating for this film.

If you have a camera with an exposure meter that reads through the filter on the lens, set your meter for a film speed of 200 for your trial exposures.

For best color rendition indoors, electronic flash is recommended. You can use the guide numbers in the following table for making trial exposures with your electronic flash equipment. If your slides are too light, use a higher guide number; if they are too dark, use a lower guide number.

Output of Unit (BCPS)	350	1000	2000	4000	8000
Guide Number for Trial	45	80	110	160	220

Flashbulbs aren't recommended for true color balance with this film in scientific work. But don't let that stop you. Start with the guide numbers in the following table for your trial exposures, and as I said before, bracket your exposures.

Syn-chroni-zation	Shutter Speed	Cube		Shallow Cylindrical Reflector	Intermediate Reflector		Polished Bowl Reflector		Intermediate Reflector		Polished Bowl Reflector	
		Flash-cube	HI-POWER Flash-Cube	AG-1B	M 2 B	AG-1B	M 2 B	AG-1B	M3B 5B 25B	6B* 26B*	M3B 5B 25B	6B* 26B*
X	1/30	110	160	80	110	110	150	160	160	—	220	—
M	1/30	80	110	55	—	80	—	110	150	150	220	210
	1/60	80	110	55	—	80	—	110	140	110	200	160
	1/125	60	85	50	—	65	—	95	120	75	170	110
	1/250	50	70	40	—	55	—	80	100	50	130	80
	1/500	40	55	30	—	42	—	60	70	38	100	55

*Bulbs for focal-plane shutters; use with FP synchronization.

WARNING: Bulbs may shatter when flashed; therefore we suggest that you use a flashguard over your reflector. *Do not flash bulbs in an explosive atmosphere.*

You can also use 3400 K photolamps with this film. In addition to the No. 12 or No. 15 filter that is necessary with all light sources, use a KODAK Color Compensating Filter CC50C, and set your exposure meter at ASA 50 for your trial exposures.

Storing the Film

Infrared color film should be kept under refrigeration (13°C/55°F or lower) in the original sealed package before use. If you expect to store the film for a long period of time before you use it, put it into your freezer at −18° to −23°C/0° to −10°F. When you remove it from the freezer, allow the film sufficient time to warm to room temperature before opening the package. About an hour should be adequate.

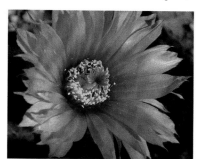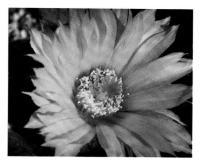

The structure of this cactus bloom is better revealed in the infrared picture on the right. Note the added detail in the ring of shadow just inside the petals. The color rendition, though, might well have puzzled Luther Burbank.

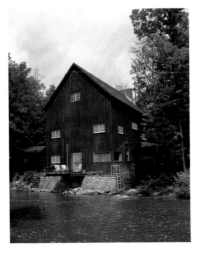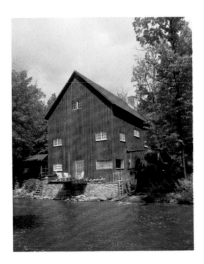

Old mills seem to be magnets for photographers, and they can be even more fascinating when photographed on infrared film. Notice the different shades of red in the trees. A healthy tree appears more red than a diseased one. Trees under stress gradually lose their infrared reflectance; their colors shift to magenta, purple, and green as the loss of reflectance progresses.

Processing

Have your EKTACHROME Infrared Film processed as soon as possible after you expose it. Return the exposed film to your dealer for processing by Kodak or another laboratory, or mail it directly with the appropriate prepaid processing mailer.

If you prefer to process the film yourself, use KODAK EKTACHROME Film Chemicals, Process E-4. No safelights can be used during processing—absolute inky-black, stygian darkness is a must!

If you send your film to a custom-processing laboratory or another commercial processor, be sure to indicate the type of film you are sending. It would be a good idea to attach a conspicuous note reminding the processor of the no-light requirement.

Want to Know More?

If you're interested in a much more technical discussion of infrared films and their uses, ask your photo dealer for a copy of *Applied Infrared Photography*, KODAK Publication No. M-28. This 8½ x 11-inch book presents 88 pages of facts and techniques for infrared photography.

Load up with EKTACHROME Infrared Film and shoot a variety of familiar scenes and subjects. I think you'll be impressed with some of the bizarre and beautiful results you see in your slides. Then, like me, you'll always want to keep a roll handy in the freezer.

Ed Austin is a Supervising Photo Specialist in the Kodak Consumer Markets Division. His group of correspondents answers consumer questions about moviemaking and Kodak amateur movie products. Ed's career with Kodak has taken him throughout the country—first as a sales representative and later to create and present workshops to train salespeople. Much of his photographic work reflects concern for the preservation of our natural environment, as shown by his nature photography and preparation and presentation of programs for our National Parks. Also, Ed is a member of his town conservation board.

Top-Quality Slide Projection

by Edwin A. Austin

Part of the fun of photography is sharing your pictures with others. For a color-slide enthusiast, this means projecting slides onto a screen to an admiring audience of relatives, friends, or perhaps the members of a social or civic organization. A carefully planned slide presentation can give you a well-deserved reputation as a top photographer and showman.

Your audience wants to see slides that are bright and sharp on the screen. No one enjoys straining his eyes to see the details in a dark or blurry image. Researchers have found that there is virtually no upper brightness limit for projected slide images. When offered a choice, most people prefer the brighter of any two images. (This doesn't apply to movies, because there is an objectionable flicker if the images are too bright.) Because the human eye can adapt to a great range of brightness, the members of your audience can appreciate the full beauty of a moderately bright slide if you don't give them a brighter picture with which to compare it.

There are a number of ways that you can control the brightness and general projection quality of your slides—perhaps more than you ever imagined. The factors that contribute to the projection quality of your slides can be classified under four main headings: Your Projector, Your Screen, The Room, and The Slides. By controlling these factors, you can give your slide shows a professional excellence that will add to the enjoyment of everyone who views them.

Your Projector

Your projector is only as good as the lens and lighting system. In choosing the focal length of the lens, you should consider the size of your slides, the size of the room in which you will usually show your slides, and the size of your screen. The table that follows can help you choose the lens that will fit your projection situation. It shows the size of the picture projected onto your screen at various projector-to-screen distances (in feet) for different combinations of lenses and slide sizes. Let's say you want to project some 126-size slides to fill a screen that is 40 inches wide in a room 22 feet long. The table indicates that you should use a 5-inch lens with your projector about 17 feet from the screen or a 4 to 6-inch zoom lens at 13.5 to 20 feet.

If you use various sizes of film within your family, for example, 110, 126, and 135, you'll find that a zoom lens lets you adjust the image sizes to fit the screen without having to move the projector or the screen. The zoom lens is also a good choice if you sometimes show your slides at different distances or with screens of different sizes.

You can project 110-size transparencies in a projector designed to accept 2 x 2-inch slides if the 110 transparencies are in 2 x 2-inch mounts (or in 30 x 30-mm mounts placed in 2 x 2 adapters). If the projector has a lens of fixed focal length, however, the area of the projected image from a 110 slide will be only one-fourth the size of that from a projected 35-mm slide. The easiest way to obtain the same approximate image size when projecting 2 x 2-inch slides and 110 slides in the same tray is to use a 4 to 6-inch zoom lens on your projector. For 35-mm or 126 slides, use the zoom lens at its longest setting (6 inches or 152 mm). With 110 slides, set the lens at its shortest setting (4 inches or 102 mm).

The optical system in a projector for 2 x 2-inch slides is designed to provide even illumination over a full 35-mm or 126 transparency. Because a 110 slide is only one-fourth as large in area as a 35-mm slide, three-fourths of the intensity of the bulb is lost when you project 110 slides in 2 x 2-inch mounts. Therefore, 110 slides will not appear nearly as bright as 35-mm and 126 slides. Your 110 slides will have their full brilliance when you show them in a projector with an optical system designed specifically for the small 110 format, such as a KODAK Pocket CAROUSEL Projector.

Your 2 x 2-inch slides in cardboard or thin plastic mounts will have more uniform sharpness on the screen if the projector lens has curved-field optics.

Distance in Feet from Slide to Screen (with Projector for 2 x 2 Slides)

Long Dimension of Projected Picture	126 Slides (26.5 x 26.5 mm)				
	3-inch Lens	4-inch Lens (102 mm)	5-inch Lens (127 mm)	7-inch Lens	Zoom Lens— 4 to 6-inch (102 to 152 mm)
40″	10	13.5	17	23.5	13.5 to 20
50″	12.5	16.5	21	29	16.5 to 25
60″	15	20	25	34.5	20 to 30
70″	17.5	23	29	40.5	23 to 34.5
84″	20.5	27.5	34.5	48	27.5 to 41.5
	135 Slides (22.9 x 34.2 mm)				
40″	8	10.5	13	18.5	10.5 to 16
50″	10	13	16.5	23	13 to 19.5
60″	11.5	15.5	19.5	27	15.5 to 23.5
70″	13.5	18	22.5	31.5	18 to 27
84″	16	21.5	27	37.5	21.5 to 32
	110 Slides (12 x 15.8 mm) in 2 x 2-inch Mounts*				
20″	8.5	11.5	14	20	11.5 to 17
30″	12.5	17	21	29.5	17 to 25
40″	16.5	22	27.5	38.5	22 to 33

*Image brightness is reduced considerably when 110 slides are projected in 2 x 2-inch mounts. While it is possible to obtain the image sizes indicated in this table, the image brightness may not be satisfactory— particularly at longer projection distances.

Distance in Feet from Slide to Screen (with 110-Slide Projector)

Long Dimension of Projected Picture	110 Slides (12 x 15.8 mm) in 30 x 30-mm Mounts	
	2½-inch Lens	2 to 3-inch Zoom Lens
20″	7	5.5 to 8.5
30″	10.5	8.5 to 12.5
40″	14	11 to 16.5
50″	17	13.5 to 20.5
60″	20.5	16.5 to 24.5
70″	24	19 to 28.5

This is because slides that aren't mounted in glass assume a curved (pillow-shaped) form rather than being perfectly flat. All KODAK CAROUSEL Projectors made to accommodate 2 x 2-inch slides are now equipped with curved-field f/2.8 KODAK Projection EKTANAR C Lenses. These projection lenses are also available as accessories in 102 mm (4-inch), 127 mm (5-inch),

and 102 to 152 mm (4 to 6-inch) zoom focal lengths, and can be used in any CAROUSEL Projector for 2 x 2-inch slides.

If your slides are glass-mounted, use a flat-field EKTANAR Lens for the sharpest images. These lenses continue to be available as accessories in focal lengths from 3 inches to 7 inches and in a 4 to 6-inch zoom model.

There are a number of ways to control the brightness of your projected slides. For example, you can use a projection lens with a larger lens opening, such as an $f/2.8$ lens instead of the more common $f/3.5$. However, most people can't really distinguish differences in brightness of the light unless it's increased or decreased by at least a factor of 2 (one f-number). So for a useful increase in the brightness of projected slides, you would usually have to use a combination of methods, such as a faster lens, a brighter projection lamp, and a higher line voltage.

Your choice of projection lamp and the voltage at which you operate it affect the brightness of your screen images. Some projectors are designed for use with only one type of projection lamp, some with more than one lamp. Check your projector instruction manual for the correct lamp.

Many KODAK CAROUSEL Projectors are designed for use with either DEK or CBA lamps. The CBA lamp has about 16 percent more light output than the DEK, its average life is twice as long, and it has no appreciable loss of brightness over its entire life. The DEK lamp loses approximately 70 percent of its brightness during its lifetime.

KODAK CAROUSEL Projectors with an H following the model number are equipped with an ELH projection lamp that has a rated life of 35 hours. For longer life (but less brightness) you can use an ENH lamp. There is no appreciable loss of brightness in either of these lamps during their lifetime.

If your projector has HIGH and LOW lamp settings, you can use the HIGH setting for brighter pictures, but you can extend the life of the projection lamp considerably by using the LOW setting. If you have a KODAK CAROUSEL Projector (2 x 2-inch) with the HIGH-LOW switch, the lamp life is usually about 3 or 4 times as long on LOW, and screen illumination is reduced to about 70 percent of what it would be with the switch set on HIGH.

If the line voltage to your projector is increased, the lamp brightness will increase and its life decrease. A boost from 120 volts to 125 volts will increase the brightness of CAROUSEL Projector lamps by approximately 15 percent but will reduce the life by about 40 percent.

You can control the line voltage to your projector with a voltage regulator. *However, be sure to check your projector instruction manual for the range of voltages over which the projector can be safely operated.* Most CAROUSEL Projectors are intended for use with a 110 to 125-volt, 60 Hz power outlet only. Voltages greater or less than those recommended can cause overheating and erratic operation, and can result in costly damage to the projector. To find a supplier of appropriate voltage regulators, look in the yellow pages of your telephone directory under Electrical Equipment and Supplies.

The table below summarizes the effects of HIGH-LOW switch settings (on projectors so equipped) and line-voltage variations on lamp brightness and lamp life in KODAK CAROUSEL Projectors (for 2 x 2-inch slides).

Brightness/Life Comparison of Projection Lamps

Switch Setting	Brightness (percent)	Life (hours)				
		110 Volts				
		DEK*	CBA*	ELH*	ENH*	ENG*
HIGH	75	75	150	90	—	—
LOW	55	300	600	155	—	—
HIGH	50	—	—	—	320	—
LOW	35	—	—	—	400	—
HIGH	100	—	—	—	—	45
LOW	70	—	—	—	—	85
		120 Volts				
HIGH	100	25	50	35	—	—
LOW	70	100	200	105	—	—
HIGH	65	—	—	—	175	—
LOW	50	—	—	—	330	—
HIGH	130	—	—	—	—	15
LOW	90	—	—	—	—	50
		125 Volts				
HIGH	115	15	30	20	—	—
LOW	80	60	120	75	—	—
HIGH	75	—	—	—	105	—
LOW	55	—	—	—	260	—
HIGH	150	—	—	—	—	5
LOW	105	—	—	—	—	35

*Always check your instruction manual to be sure that you use **only** projection lamps recommended for your projector.

Because projection lamps always seem to burn out at the most inopportune times (9 p.m. on a Sunday evening!), it's a good idea to keep a spare on hand. Don't let your audience down. Remember how *you* feel when a good TV show is interrupted by projection or transmission difficulties.

The most often overlooked culprit that can affect picture quality is dust and smudges in the optical system of the projector. Enough dust and fingerprint smudges can accumulate on the projector lens, condenser lenses, and heat-absorbing glass to reduce the light output by 50 percent! Consult your projec-

tor manual for the correct procedure for cleaning the optical elements. If your projector needs cleaning, do it while the optical system is cool—never after projecting, when the system is hot.

Your Screen

Your choice of screen material can affect the brightness and sharpness of the projected image, the area of the room where your audience should be seated, and the amount of stray light that can be tolerated in the room. Basically, there are four types of screens—matte, beaded, lenticular, and the KODAK EKTALITE Projection Screen, Model 3. Each one has its advantages and limitations. Choose the one that will give the best results in the room you plan to use for most of your slide shows.

Matte Screen

A matte screen—or flat white latex paint on any fairly smooth surface—reflects light evenly over a viewing area 45 degrees on either side of the lens axis (see diagram). It has the widest viewing angle of any screen surface, but viewers who sit more than 30 degrees from the lens axis may see a somewhat distorted image on the screen. A matte screen doesn't reflect as bright an

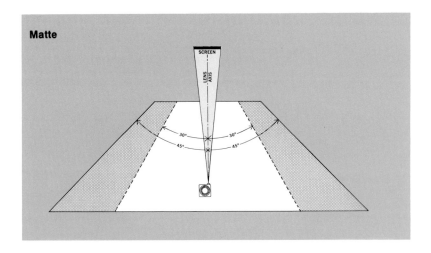

image as a beaded or lenticular screen, so it requires the darkest possible room. Any stray light is reflected evenly in all directions, degrading the picture brightness and contrast.

The image on a smooth, completely matte screen will be sharper and more even in brightness than on any other surface. This kind of screen can be rigid or flexible and is available in almost any size you need.

Beaded Screen

The clear glass beads that cover the surface of this type of screen reflect an image up to four times as bright as that on a matte screen—but in a narrow area 25 degrees on either side of the lens axis. Stray light is reflected back in the general direction of its origin, so a bit of stray light from outside the viewing area isn't usually a problem. However, any stray light originating from the viewing area can degrade the picture.

Because of the slight diffusion of light by the glass beads, the image is not quite as sharp as the image on a matte or lenticular surface. Like the matte screens, beaded screens are available in various forms and in many sizes.

Lenticular Screen

This type of screen has an embossed surface with a white or metallic finish. The image on a lenticular screen is about two to three times as bright as that on a matte screen in an area 30 degrees on either side of the lens axis. Part of any stray light from outside the viewing area will be reflected back outside the viewing area, but the rest of the light will be reflected into the viewing area, degrading the picture.

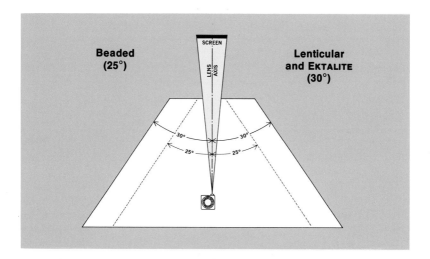

Image sharpness on a lenticular screen is better than on a beaded screen but not as good as on a matte screen. Lenticular screens are made of flexible material, that must be under tension when in use, or of rigid material. They are usually flat and are available in most standard sizes. While matte and beaded screens cost about the same, lenticular screens usually cost about 25 to 50 percent more. For projecting slides, the lenticular screen usually offers the best compromise between brightness and size of the viewing area.

The EKTALITE Screen is made of a thin sheet of specially treated and rolled aluminum foil permanently mounted in a slightly concave rigid frame. This screen will reflect the projected light in a fan-shaped area approximately 60 degrees horizontally and 30 degrees vertically. Stray or ambient light originating outside the viewing area is reflected back outside the viewing area and does not degrade the image. Excellent image contrast and color saturation, even in brightly lighted rooms, are characteristic of this screen. Image brightness can be as much as 16 times that of a matte screen.

Comparison of Screen Types

Type of Screen	Viewing Angle (degrees from lens axis)	Relative Image Brightness (compared to matte screen)	Order of Relative Image Sharpness
Matte	45	—	1
Beaded	25	Up to 4 times as bright	4
Lenticular	30	2 to 3 times as bright	3
EKTALITE	30	Up to 16 times as bright	2

Tips for Good Screen Results

A square screen is usually best for showing slides. It allows you to fill the screen from edge to edge horizontally or vertically with the longer dimension of rectangular slides and to fill the screen completely with square slides.

Use great care in handling the EKTALITE Screen or beaded screens. Keep them in a clean, safe storage area when you're not using them. All are difficult, and sometimes impossible, to clean if they become soiled. Most matte and lenticular screens are washable. Always follow the cleaning and storage instructions provided by the screen manufacturer.

To avoid distortion of the picture, try to place your projector on a level with the center of the screen, with the lens axis at exactly 90 degrees to the screen. If you merely tip the front of the projector upward, you'll get a distorted image.

For the sharpest possible image, avoid any motion of the picture on the screen by placing your projector on a rigid table or stand.

The Room

The room in which you will show your pictures is usually the least adjustable factor in influencing picture quality. The size and shape of the room are fixed, and controlling stray light may be quite difficult. That's why you'll want to choose carefully the best type of screen for your normal projection situation.

If you have a choice, select a room that is big enough for all your guests to sit comfortably and to have a good view of the screen. You might be able to

increase the usable viewing area by projecting diagonally from one corner to the opposite corner. Of course this will increase the projector-to-screen distance, so you'll get a bigger image, too.

For best viewing, the seats nearest the screen should not be closer than two times the shorter dimension of the projected image (designated H); the rear seats should not be farther than eight times the shorter dimension of the picture (8H). For example, if the shorter image dimension is 4 feet in length, the best viewing area will be from about 8 feet to 32 feet from the screen.

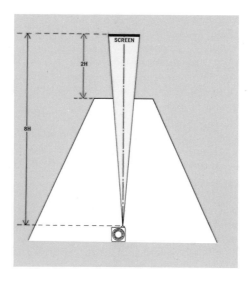

On screen surfaces other than that of the KODAK EKTALITE Projection Screen, stray light from outside the viewing area that falls on the screen can be reflected back into the viewing area and cause washed-out colors, reduced contrast, and loss of detail in the projected image. If you show your slides on such surfaces only at night, there should be no problem with stray light shining through the windows. For daytime viewing, however, you should black out the windows as much as possible. Most drapes and shades are inadequate, but large pieces of cardboard fitted inside the window frame can be effective.

The Slides

When it comes to picture quality, the slides are where it all begins. The best room, the finest projector, and the most efficient screen can't make a first-class image out of a poorly exposed, unsharp slide. Don't show a slide if you have to apologize for its poor quality or if it requires a lengthy explanation. You've probably heard it said that an important difference between a profes-

sional and an amateur photographer is that the professional shows only the best pictures. Likewise, your standing as a picture-taker will rise if you show only your best. People prefer a few really good pictures to a lot of mediocre ones.

You may occasionally find it necessary, because of their storytelling importance, to include slides that are slightly darker or lighter than normal. To lessen the strain on the eyes of your audience, it's a good idea to group your light slides together and your dark slides together when possible. This reduces the shock of jumping from one to the other.

Often a group of light slides can be improved by setting the projector lamp control to the LOW position if it has a HIGH-LOW switch. If only isolated light slides are involved, you might want to consider binding them with a piece of KODAK WRATTEN Neutral Density Filter No. 96, available in gelatin film squares. A .30 density reduces the brightness to 50 percent, while a .60 density reduces it to 25 percent. A 3-inch-square gelatin filter, available from photo dealers, would provide enough material for several 110, 126, or 135 slides.

If you want your viewers to appreciate the full beauty of your slides, go easy on their eyes. There's no need to begin your program with a glaring white screen that leaves them seeing spots in front of your first few slides. When you set up your projector, advance the first slide so that it is in the projector gate before you start the show. Then end your show with the last slide still projected on the screen. Turn on the room lights before you remove the last slide from the projector gate.

If you're using a KODAK CAROUSEL Projector and want to avoid screen glare during tray changes, place a piece of cardboard the same size and thickness as a slide mount into the projector gate before you start projecting. The cardboard will move into the "0" slot in the tray as soon as the tray rotates to slide number one. When you advance the tray after showing the last slide in a full tray, the cardboard will be lowered into the gate and will block off the light while the tray is being replaced. If your slide tray is not filled to its capacity, insert a duplicate piece of cardboard into the slot following the last slide. You can also use pieces of cardboard to separate different sections of your show.

Your color slides deserve the best, and so do your viewers. If you plan your presentation carefully, you can earn a great reward—the sincere praise of an enthusiastic audience.

Barbara Jean, a Sales Manager in Kodak's Business Systems Markets Division, has written and edited many Kodak books and pamphlets for amateur photographers. She is a two-star exhibitor in the Photographic Society of America, a Fellow of the Kodak Camera Club, and a judge and instructor of photography. She enjoys experimenting with photography in her darkroom and finding new ways of decorating her home with photographs. Barbara also wrote "Creative Close-Ups of Garden Flowers" in *The Fifth and Sixth Here's How* and "The Sabattier Effect," starting on page 190 of this book.

Give Your Home Personality with Photographs

by Barbara Jean

Decorating a room gives it personality. A room can be vibrant with color, warm, and casual, or it can be cool, quiet, and formal. The personality of a room depends on the colors and accessories you choose for it, and they should reflect *your* personality and interests. Whether you're an advanced photographer or a casual picture-taker, you can use your photographs to give your rooms personality—*your* personality.

At one time, my pictures didn't get much exposure—in our home, that is. I made enlargements, entered them in camera-club competitions and salons, and then stored the prints in the closet. I just hadn't thought about using my own pictures to decorate our home until a friend asked for one of my prints to decorate her wall! That's when I began to think of using my pictures to enhance the décor of our home. What a difference it's made! Now our home is really distinctively *ours*.

19

DECORATING WITH LARGE PICTURES

The first thing that may come to mind when you decide to decorate with large pictures (larger than 8 x 10 inches) is hanging the pictures on the wall.

Putting Pictures on the Wall

You'll discover many different and interesting ways to display pictures on a wall. Display one large picture, or combine several pictures into an interesting grouping. You can get many ideas for grouping pictures from the photographs of home interiors that you see in magazines.

Pictures usually look most pleasing if they're centered when hung over a piece of furniture such as a sofa or a chair. With a long piece of furniture such as a buffet, stereo, or sideboard, you may want to hang the picture off-center and balance it with a planter or a flower arrangement placed on the other end of the furniture. Most pictures look best when hung at eye level. (But not if you're 6'3"! Place them at the eye level of a person of average height.) There are special situations in which a print looks pleasing when hung slightly below eye level; however, single pictures hung above eye level give the impression that they're not part of the room.

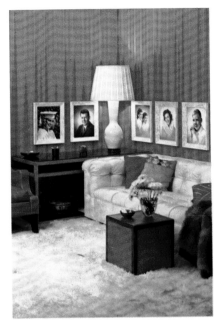 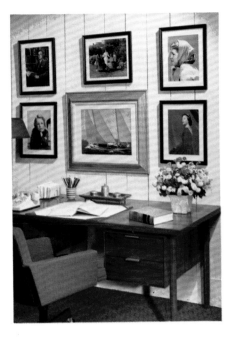

You can combine several pictures to accent an area of a room. Most pictures look best when hung at eye level or slightly lower than eye level.

Mounting

Mounting can enhance the visual effect of a picture. Some pictures look attractive when mounted on a white mat and put into a frame; other pictures look their best if they're flush-mounted and displayed without a frame. The best advice I can give is to choose a mount that suits your personal taste, keeps the emphasis on the picture, and blends with the finished display.

Mounting boards are available in a variety of colors at art-supply stores. (Avoid brightly colored mounts that may steal attention from your photographs.) There are several materials that can be used for affixing prints to mounting boards, such as mounting tissue and various adhesives. The mounting material you use should be determined by the type of paper used to make the print. For the latest information on mounting materials and methods based on the paper used for *your* prints, consult your photo dealer.

If you have your pictures framed, the mounting is usually included in the framing. Many ready-made frames come with mats, and you just slip the picture into place under the mat.

Flush-Mounting onto Thick Cardboard

For a simple, modern look, flush-mount your print on ¼-inch-thick cardboard. Cut the print a little larger than the mount, and then use a sharp knife, razor blade, or paper cutter to trim off the excess print after mounting. Finish the edges of the mount with a black felt marking pen.

Flush-mounting is simple and modern-looking.
It allows you to hang pictures without frames.

Finishing Mounts with Edgings

The ribbon or yard-goods department of any large department store has an almost unlimited selection of edgings that you can use to finish the edges of a mount. Mount your print onto a mounting board, and leave about ½ inch of the board exposed around the edge of the print. Glue the edging to the exposed edge of the board and put the board under a weight until the glue dries. Edging can become an instant frame in any color combination you desire.

Pictures on Place Mats

Place mats come in a great variety of shapes, colors, and textures, and some of them make excellent backgrounds for pictures. For example, you can attach an enlargement to a plastic place mat in a matter of seconds with double-faced tape. To finish the mount, cover the edges of the print with thin rickrack or ribbon edging in a matching color. I have several of these for my kitchen, and I change them to suit the season or my moods.

Mounting Prints onto Wood

Mounting prints onto wood is an unusual way to display them, as wood makes a sturdy, rich-looking mount. There's a great variety of wood finishes and shapes that are suitable for mounting pictures. For example, a picture

Fabric edging can become an instant frame in any color combination you desire.

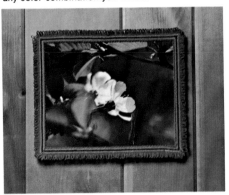

You can mount pictures on plastic place mats with double-faced tape.

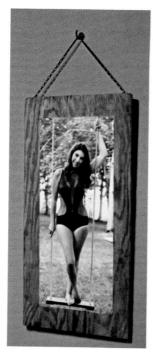

You can cover a bulletin board with colorful burlap and use pins or thumbtacks to attach the prints.

This print has been wet-mounted to a piece of driftwood; the length of chain is from a hardware store.

mounted on distressed wood fits in well with an Early American décor. I like to hunt for driftwood along the beach, and I've found several weather-beaten boards that have made good mounts.

If you prefer finished wood but don't want to do the finishing job yourself, look for an inexpensive cutting board in the housewares section of a department store. Cutting boards come in many shapes—from round to rectangular—and usually have an attractive wood grain.

If the wood you have selected has a smooth mounting surface, you can mount the print directly on the wood with a white glue, such as Elmer's Glue-All, which is readily available at hardware stores and drugstores. Use a damp sponge or a paint roller to apply an even coating of adhesive to the back of the print. With a dry roller or a soft cloth, press the print to the mount. Work from the center of the print toward the edges to remove any air bubbles.

Mounts for Changing Prints

Bulletin Boards

One of the easiest ways to display prints that you might want to change often is to put them on a large bulletin board. Bulletin boards come in many sizes and you can buy them already framed. If you prefer something original, try covering a piece of bulletin board with colorful burlap or yard goods which matches the draperies of your room. Use colorful pins or thumbtacks to attach the prints to this type of mount.

Pegboards

A pegboard can be a versatile mount for displaying pictures because the pictures are easy to change and you can hang other objects on the pegboard at the same time for an interesting display. You can hang the prints with small pegboard hooks around the edges of the mounts. You can also hang small shelves on a pegboard on which you can display plants or knickknacks, or any trophies you might have won for your pictures.

Cork

Insulating cork has become a popular decorating accessory, and it's often used in place of wood paneling. You can tack prints up anywhere on a cork wall and change the arrangement often without leaving a mark.

Building-supply stores sell this cork in 12-inch squares with or without adhesive backing, or in 18 x 36-inch sheets without adhesive. You can cut it with a serrated knife or a fine saw and attach it to the wall with double-sided tape or the adhesive usually used for putting down floor tile.

The "Frame-up"

Traditional Frames

Frames, like mounts, help separate a picture from its surroundings. Select a frame that adds impact to the picture, and avoid frames that draw so much attention to themselves that they detract from the beauty of the print. Frames come in many sizes, styles, and prices. A frame can be as simple as four aluminum strips that finish off the edges of your mount—similar to the frames used in some modern-art museums—or it can be as ornate as Victorian furniture, with many carved designs. Large department stores and some small specialty shops usually have a good selection of frames, and many of these stores offer a framing service (for a fee, of course).

If you're a do-it-yourself type, you might prefer to buy an unfinished frame and do your own finishing. You can also buy a framing kit or choose from a variety of wood framing materials available cut to length from hardware and lumber dealers. This allows you to frame a print in any square or rectangular format. One photographer that I know enjoys hunting for antique frames. He refinishes the frames himself, adds his color enlargements, and displays the products of two hobbies at the same time.

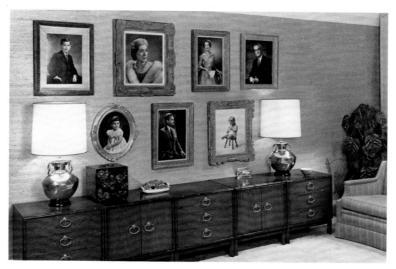

Frames come in many sizes and styles—from richly carved antique frames to sleek, modern aluminum ones.

Those who prefer the sleek lines of modern design may want to make shadow-box frames from 1-inch right-angle molding. Most lumber yards carry this molding, and it's quite inexpensive. Miter the corners of the frame and use heavy-duty staples on the back to hold the pieces together. Finish the wood and then glue your mount into the frame from the front. This type of frame is very light and really quite easy to make.

If you want to use glass in a frame, be sure to provide a slight separation between the picture and the glass. You can insert a mat or shim between the borders of the print and the glass to prevent the emulsion of the print from sticking to the glass under humid conditions.

Molding-Strip Frames

Photographers who enter salons usually have many pictures mounted on 16 x 20-inch mounting boards. A molding-strip frame provides a convenient way of displaying these prints and allows you to change the prints easily. This type of frame is made from two strips of flat molding, either wood or aluminum, with a groove along one edge. The grooves must be wide enough to hold a mounting board. Attach the strips to the wall either 16 or 20 inches apart—depending on whether you want to display more horizontal or vertical prints. You can slide your print into this frame from either end or bend the print slightly so that it will snap into the molding.

Glass-Sandwich Frames

With two sheets of glass and four mirror holders, you can create an almost invisible frame which will hold an unmounted or mounted print. The glass goes on each side of the picture (similar to mounting a slide in glass) and is held together and attached to the wall with mirror holders. A glass-sandwich frame is simple and relatively inexpensive to make, and you can change the print with very little effort. If you mount color prints in this manner, put several small pieces of felt between the glass and the borders of the color print. (You can hide the felt behind the mirror holders.) The felt will create a slight separation between the print and the glass and prevent them from sticking together under humid conditions.

Free-Standing Frames and Room Dividers

Another effective way to display a number of large prints that you would like to change often is with a free-standing frame which can also be used as a room divider. This frame is suspended between the floor and the ceiling much like a pole lamp. I really can't take credit for this frame idea; my father designed and

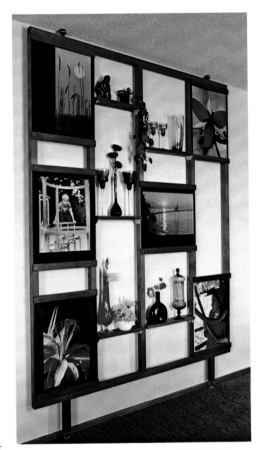

With two pieces of glass and some mirror holders, you can make an almost invisible glass-sandwich frame which will hold an unmounted or mounted print.

This frame is suspended between the floor and ceiling like a pole lamp. The prints slide into grooves in the molding and can be changed easily.

built my frame from a very rough sketch I showed him. Lucky girl to have had a handy dad! This frame has become the focal point of our living room, and our guests are always anxious to see what new prints I have on display.

The vertical poles and cross pieces on the top and bottom are square, 2 inches on each side. The flat pieces that hold the pictures are grooved on the rear edge so that I can slide the pictures into position. Because the frame is held between the floor and ceiling by pressure, you can easily convert it into a room divider by adding some additional strips of molding and displaying the prints back to back.

DECORATING WITH SMALL PICTURES

Because of their size, small pictures can be worked into your decorating scheme in many different and unusual ways. Let's consider any picture that measures 8 x 10 inches or less in this small-picture category.

Arranging Small Framed Pictures

Since most small pictures are processed by photofinishers, they come in standard sizes and it's easy to find frames for them. Desks, tabletops, buffets, and bookcases are ideal places to display small pictures in frames. When you have several small pictures to display, you can hang them on the wall above a piece of furniture such as a desk. Frames of the same size can be hung in a straight row just above the desk top. Or you may want to make a random arrangement with pictures of various sizes. If you want to experiment with several arrangements to find the one you like best, you can avoid making

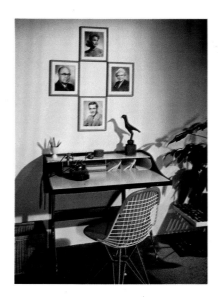

To save space on a desk, arrange several small framed pictures in a group on the wall above the desk.

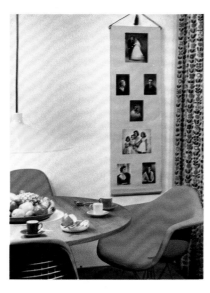

You can mount small prints onto a window shade to create a wall hanging.

Make a cube out of a milk carton and cover it with pictures for an unusual paperweight.

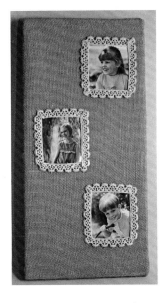

You can create a colorful mount for small prints with burlap and ribbon edging.

Unexpected items such as this hamburger press can be turned into attractive mounts for small pictures.

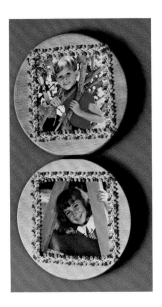

unnecessary nail holes in the wall by cutting pieces of paper the same size as your pictures. Masking tape will hold the paper shapes in place while you rearrange them to find the balance you want. Then you can hang the pictures in place of the paper cutouts.

To display a number of snapshot-size pictures, mount them on the same background and display them in one large frame. For example, you can cut out head-and-shoulder portraits from snapshots, use KODAK Rapid Mounting Cement to mount them on colored art paper or black velvet, and then frame the mount.

Displaying Small Pictures on Unusual Mounts

An unusual mount can help you group small prints together and can make them draw as much attention as larger pictures. For example, you can mount small prints on a colorful window shade to create a wall hanging. Or cover a piece of mounting board with burlap in one of the many colors available. You

can staple or cement the pictures to the burlap and use a ribbon edging in a contrasting color to finish off the edges of the prints.

For an unusual paperweight, make a cube from a milk carton and cover it with pictures. Put a rock in the cube to give it weight and attach the pictures with double-faced tape. Finish off the edges with yarn held in place with a few dabs of white glue. To help protect the prints from surface scratches and abrasions caused by handling, spray your paperweight with a clear spray, such as KRYLON Crystal Clear No. 1303 or Marshall's PRO-TEK-To Spray. Practice spraying onto an extra print. Hold the spray can about a foot from the surface and spray with an even, sweeping motion. Repeat the process if the first coat doesn't cover. If you apply too much spray at one time, the print surfaces will have an "orange-peel" appearance.

Many ordinary things can make unusual mounts for small prints, and most of them are both inexpensive and easy to assemble. For example, on a shopping trip to a local discount store, I discovered a wooden hamburger press that made an attractive mount for two small portraits. Just let your imagination take over and see what unusual mounts you can create.

Picture Plants

Pictures and plants make a good combination for home decoration. You can tape four snapshots to a plain square planter or cut down a milk carton and make your own planter in the same manner as described for the paperweight above. A picture planter makes a good centerpiece for a table, and it makes a good conversation piece, too.

You can grow a photo garden by planting pictures! Mount some snapshots on pieces of light cardboard and glue the mounted prints back-to-back with a flat stick (such as a Popsicle stick) between them. Plant the sticks in a planter along with some house plants and you'll have a photo garden.

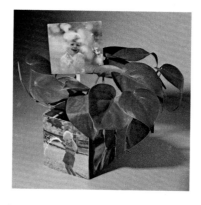

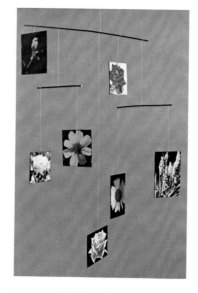

You can make a planter from a milk carton and four snapshots. Plant a picture in it to create a photo garden.

This mobile is strung together with pieces of coat hanger and clear fishing line.

29

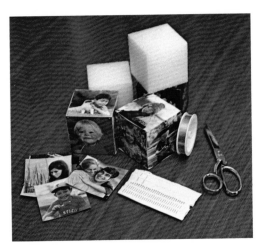

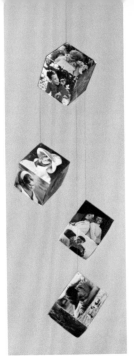

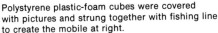
Polystyrene plastic-foam cubes were covered with pictures and strung together with fishing line to create the mobile at right.

Mobiles and Swinging Pictures

I'm sure you can tell by now that I like pictures everywhere in our home—even hanging from the ceiling. My latest creations have been mobiles. I enjoy taking close-ups of flowers, and they are ideal for a mobile because the image is large even though the prints are small. But almost any kind of picture can be used for a mobile, and you can combine different-sized pictures or cut the pictures into various shapes.

For my first mobile, I trimmed the flower prints to various sizes, mounted them back to back on light cardboard, and darkened the edges with a black felt marking pen. I used three pieces of a wire coat hanger to support the mobile, and suspended the pictures on clear fishing line. Because the line is clear, the wires and pictures seem to be floating in air.

The first mobile was so much fun that it launched many more ideas for mobiles and swinging pictures. Another mobile now in orbit is made from 3-inch cubes of polystyrene plastic foam (available in hobby stores) which are covered with pictures. The pictures are held in place with straight pins and the blocks are suspended by their corners with fishing line. I used a large needle to thread the line through the corners of the blocks.

For a mobile display of pictures in a vertical arrangement, mount prints on both sides of several pieces of mounting board. String these pictures together with clear fishing line and hang your creation from the ceiling. You'll find there's a different picture always swinging into view. If you're really ambitious, you could use swinging pictures as a room divider. Attach strips of molding to the floor and ceiling. Screw small hooks into the molding and string pictures on fishing line between the hooks.

From conventional frames to kooky mobiles, there's no end to the ways you can decorate your home with pictures. I hope some of my ideas have jogged your imagination and you'll put your pictures on display in your own home. Your friends will love seeing your work, and they'll respect you as a creative photographer and decorator!

These swinging pictures are strung together and hung from the ceiling with clear fishing line. Identical prints are mounted back to back on light mounting board.

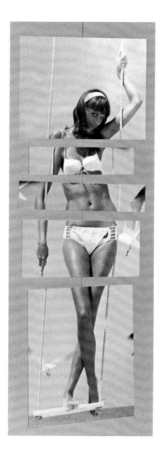
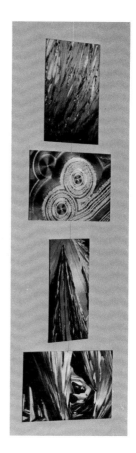

Bob Harris is a Program Specialist in Kodak's Photo Information department. He has been a professional photographer, and a lecturer, teacher, and author on the subject of photography. Bob graduated from the Rochester Institute of Technology with a Bachelor of Fine Arts degree in photographic illustration. He has been awarded the degree of Master of Photography by the Professional Photographers of America, and in 1967 was listed by PSA as the world's top color-slide exhibitor. Bob's article "Pushing KODAK High Speed EKTACHROME Film" appears in *The Third and Fourth Here's How*.

The Color of Motion

by Robert S. Harris, M. Photog.

Like an extra pinch of salt in the soup, an extra pinch of color may be what you need to add just the right flavor to some of your photographs. Sometimes a rather commonplace picture needs only an additional dash or splash of color to turn it into a prizewinner. An artist can take a paintbrush and dab colors onto a painting to an extent limited only by imagination. An imaginative photographer can also add colors that wouldn't normally be present in a color photograph. But instead of a paintbrush, a set of red, green, and blue filters can be used over the camera lens.

The "Watercolor" Effect

Several years ago, I began experimenting with techniques for adding dabs of color to my photographs. I learned that three exposures on the same film frame, made successively through a red, a green, and a blue filter, can add color to moving objects while all motionless objects are recorded normally.

Three separate exposures through red, green, and blue filters were made on one film frame to record the movement of the highlights on the water as different colors. The effect is stronger when the movement is closer to the camera.

Since this effect was quite pronounced in my early photographs of moving water, I began to refer to it as the "watercolor" effect. With this technique you can add a subtle hint of color to a nearly static scene or render an action-filled subject as a wild psychedelic abstraction.

If you placed your camera on a tripod and made a triple exposure of a *motionless* subject on a single frame of color film, you would get normal color rendition in the photograph. If the subject moved between exposures, multiple images would occur in the areas of movement, producing a ghostlike effect in the final result. Color rendition would still be normal. If you added a different colored filter (red, green, or blue) during each exposure, each image would appear in the color of the filter with which it was photographed, producing a multicolored effect. Since red, green, and blue combine to give normal color rendition, areas in which movement did not occur would appear normal in color.

Since the rocks did not move between exposures, they are recorded normally. The surf moved between the exposures and became colored.

I've used two methods of making the three filtered exposures. The first method is to make three separate exposures on the same film frame successively through a red, a green, and a blue filter. This triple-exposure method works well with subjects that can be confined to the area covered by a stationary camera during the time it takes to make the three exposures and change filters between exposures.

The second method allows you to photograph racing cars, runners, and other subjects that don't stay in front of the camera long enough for you to make the three separate exposures required for the first method. Using the "Harris Shutter," which I'll describe later, you open the camera'shutter just once and pass the three filters rapidly in front of the lens, making all three color exposures in a fraction of a second. This method can be used with cameras that don't allow multiple exposures on the same frame of film.

The Triple-Exposure Method

To use this technique, you will need the following items:

1. A camera that can take multiple exposures without advancing or even tugging the film. Many older 35-mm cameras are excellent for this purpose.

2. A very steady tripod. A rock-steady camera can record the three exposures of stationary subjects in perfect registration.

3. A color-negative film, such as KODACOLOR II Film, KODACOLOR 400 Film, or KODAK VERICOLOR Professional Film, Type S. It's best to use a color-negative film because it has more exposure latitude than a color-slide film, and the overall color balance can be controlled during the printing operation. However, slide films, such as KODACHROME 25 Film (Daylight) and KODAK EKTACHROME 64 Film are suitable for this technique if you aren't too concerned about the color balance. If you do want good color balance with a slide film, you may find it necessary to use a different exposure setting for each filter. Determining the correct exposures would require a series of trial-and-error exposure tests. Also, changing the lens opening or shutter speed between exposures would increase the chances of moving the camera. If you want slides, you can have them made from your color negatives. See your photo dealer.

4. A square No. 25 red filter, No. 61 green filter, and No. 38A blue filter. You may be able to buy these filters mounted in glass, but the gelatin film squares are less expensive and easier to find. KODAK WRATTEN Filters are available from photo dealers in 50-, 75-, and 100-mm gelatin squares.

5. A combination filter holder and lens hood is desirable, but such an item is seldom available in camera stores. To make a holder, first select the KODAK Gelatin Filter Frame Holder that fits your camera. The holder is available in Series 6, 8, and 9, accepting 50-, 75-, and 100-mm square filters,

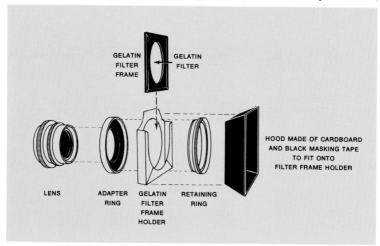

respectively. Your photo dealer can help you select the correct series to fit your camera. You'll also need an adapter ring that fits your camera, a retaining ring, and three KODAK Gelatin Filter Frames. (If you use glass-mounted filters, you don't need the filter frames.) To make a lens hood, you need some black cardboard and black masking tape. The diagram above shows how the hood should look.

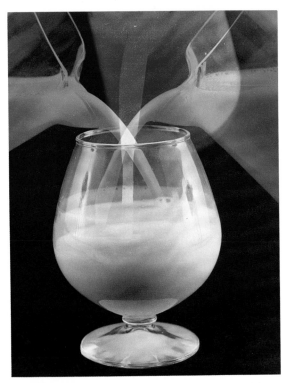

Milk was poured into the glass three times. Three electronic flash exposures were made with a red, then a green, and finally a blue filter over the lens. Notice the rings of color in the glass, showing the added layers of milk. At the point where the three colored streams of milk crossed just above the glass, it is white. This illustrates the additive mixing of red, green, and blue light to form white.

Be sure your camera is firmly mounted on the tripod and the tripod is rock-steady. To determine your exposure, take a meter reading of the scene and add one stop to the exposure that the meter indicates. Use this exposure for *each of your three exposures* through the filters. For example, the exposure for KODACOLOR II Film in bright sunlight should be 1/125 second at f/11. Adding one stop, you would use 1/125 second at f/8 for the exposure through each of the three filters.

You can make the three exposures (using the filters in any sequence) on the same film frame. Be careful not to move the camera or tripod while changing the filters between exposures. A very slight change in camera position will ruin the registration of the three images of stationary objects.

The Harris Shutter

Using the Harris Shutter, you can add extra beauty and excitement to photographs of sports and other action-filled events. You open the camera shutter just once and make all three color exposures in a fraction of a second. The resulting streaks and swirls of bright red, green, and blue shout "Action!" to the viewer.

Since the motion was both fast and close to the camera, the "watercolor" effect produced by the Harris Shutter is quite pronounced. The wild streaks of color shout "Action!" to the viewer.

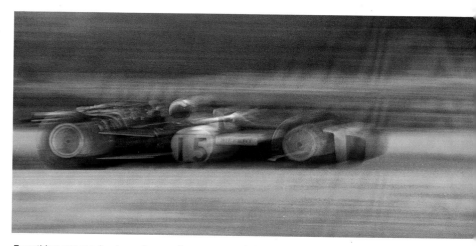

Everything was moving here: the car, the camera, and the Harris Shutter. The background became a sweep of colors that were not really there. The car is recognizable because the camera was panned with the subject.

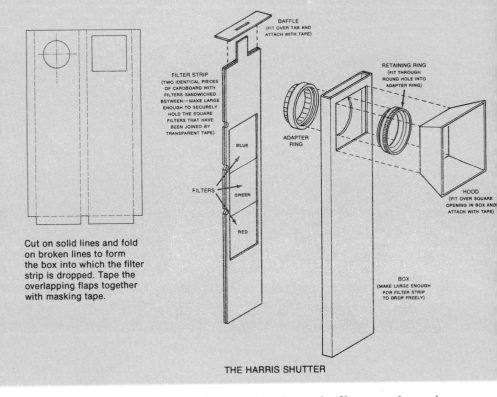

Cut on solid lines and fold on broken lines to form the box into which the filter strip is dropped. Tape the overlapping flaps together with masking tape.

BAFFLE
(FIT OVER TAB AND ATTACH WITH TAPE)

FILTER STRIP
(TWO IDENTICAL PIECES OF CARDBOARD WITH FILTERS SANDWICHED BETWEEN—MAKE LARGE ENOUGH TO SECURELY HOLD THE SQUARE FILTERS THAT HAVE BEEN JOINED BY TRANSPARENT TAPE)

BLUE

FILTERS

GREEN

RED

ADAPTER RING

RETAINING RING
(FIT THROUGH ROUND HOLE INTO ADAPTER RING)

HOOD
(FIT OVER SQUARE OPENING IN BOX AND ATTACH WITH TAPE)

BOX
(MAKE LARGE ENOUGH FOR FILTER STRIP TO DROP FREELY)

THE HARRIS SHUTTER

To make a Harris Shutter, you need the three color filters, an adapter ring to fit your lens, some black cardboard, and black masking tape. The diagrams above show you how to make the shutter assembly and attach it to your camera. No dimensions are given, as they will vary according to the size of the filters used. Be sure the filters are large enough to cover the diameter of the camera lens.

To make the exposure with the Harris Shutter, set your camera shutter on the T or B setting, hold the lower blank of the filter strip in front of the lens, and open the camera shutter. At the appropriate moment, drop the filter strip into the box. The three color exposures are made as the filters drop past the opened camera lens. The upper blank of this strip then stops the exposure by blocking the lens. Close the camera shutter, advance the film, and you are ready for a second exposure. Since different "shutters" will drop at different speeds, you may have to determine the best lens opening by trial and error. But I would suggest that you start with the lens opening that you would normally use with a shutter speed of 1/30 second. For example, with KODACOLOR II Film in bright sunlight you would start with $f/22$. Then bracket your exposures, trying one and two stops more exposure, and if possible, one and two stops less exposure.

38

The "watercolor" effect can be very subtle when the Harris Shutter is used on distant subjects.

This is the Harris Shutter attached to a camera. The author is about to drop the strip of filters past the lens to make a "watercolor" exposure.

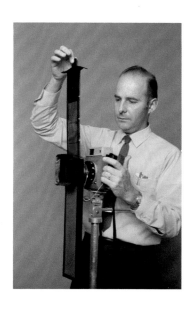

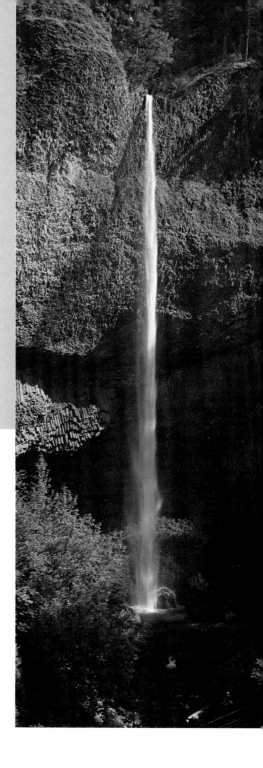

The cardboard frame surrounding the filters can be notched (see the diagram) so that you can make separate red, green, and blue exposures, as described earlier. A pencil or paper clip inserted in a notch will position the desired filter in front of the lens.

Showing Motion with Your Slide Projector

After you have taken a good assortment of "watercolor" pictures, you may want to make slides from some of your better efforts. A photo dealer can have slides made from your KODACOLOR negatives.

You can make some of your "watercolor" slides appear to move by moving the filter strip of your Harris Shutter up and down in front of the projector lens. In my slide talks on this subject, I use this trick to make a few of my slides "move" to the beat of accompanying music. It can be an impressive way to end your slide show.

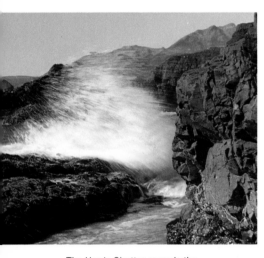

The Harris Shutter records the splashing of the surf as a violent kaleidoscope of color.

"Tulip Flame." The Harris Shutter captures the growth of the flame as a match head catches fire. Since the last exposure was through the red filter, the tips of the flame are red. (The order of the filters can be varied for special effects.)

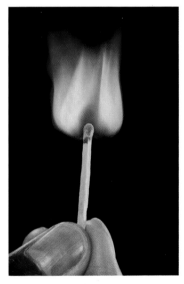

Bob McMurtrie, a Sales and Engineering Representative in the Motion Picture and Audiovisual Markets Division of Kodak, has taught college-level motion-picture, color-photography, audiovisual, and communications courses. He has worked in motion-picture production and has served as a consultant in the use of audiovisual aids. Bob has appeared on many programs at meetings of professional photographic and educational organizations and has served as chairman of the Audiovisual Institute for Effective Communications, co-sponsored by the National Audio-Visual Association and Indiana University.

Time-Lapse Movies—
The Time Compressor

by Robert E. McMurtrie

The emergence of a moth from a cocoon, a tulip opening its petals to the morning light, a beautiful sunset—chances are you've seen many photographs of events such as these. But suppose you want to show the event as it progresses from beginning to end. It might take several hours to photograph the entire sequence at normal speed with a motion-picture camera, and when you projected the film, the sequence of events would take the same length of time to view. By using time-lapse photography, you can compress those hours of almost imperceptible change into a fascinating short movie sequence that can be viewed in a few seconds or minutes.

When you make an ordinary motion picture, you take a sequence of still photographs in rapid succession, usually at 18 frames per second (fps) for silent films, and then project them at the same rate to recreate the motion. The

41

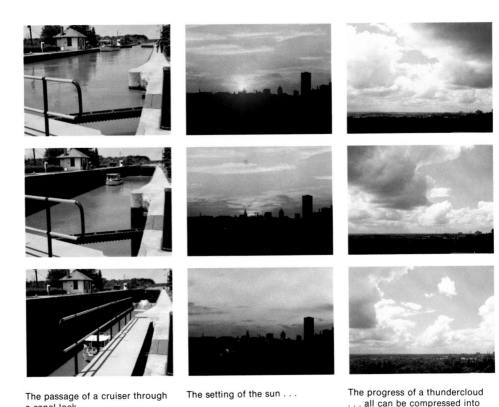

The passage of a cruiser through a canal lock . . .

The setting of the sun . . .

The progress of a thundercloud . . . all can be compressed into a few seconds on the movie screen.

motion on the screen will appear slower if you take *more* frames per second than normal, and then project the film at the normal rate. We've all seen slow-motion sequences of a football player reaching for that long pass or racehorses heading down the stretch.

In time-lapse photography, on the other hand, you take *fewer* frames per second than normal—perhaps only one frame per second, minute, or hour— then project the film at normal speed. If you exposed one frame every five minutes, for instance, an action that took 18 hours to occur would appear on the screen for just 12 seconds when projected at the normal 18 frames per second.

What Can Time-Lapse Movies Do for You?

Time-lapse sequences can be useful and fun. You can use them to add beauty, excitement, and humor to your regular movies. The next time you start on

vacation, begin your film with a time-lapse sequence of the family packing the car. After the car has been loaded, mount your camera and tripod in the back seat and continue to make time-lapse exposures through the windshield as you drive out of town. When your audience sees the speeded-up action on the screen, they'll be amused at your eagerness to start your vacation.

Everyday activities can be made more exciting, too. How about a sequence showing the confusion as the aunts, uncles, and cousins gather for a family reunion and devour the meal from start to finish, all in a few seconds? Or the kids from the neighborhood, playing in the backyard? All that energy compressed into a few seconds can make one of the liveliest movie sequences you'll ever see.

Vacation or travel films often contain at least one sunset, which is usually the climax of the film. Here is a natural spot for about 15 seconds of time-lapse movies. It would be best to start your sequence about an hour before sunset

and continue for an hour after, or until there is no light at all left in the sky. Photographed at one frame every 25 seconds, this will give you an interesting fade-out for your film.

How efficient are you at cutting the grass around your home? A silly question? To see how I went about the task, I set up my camera so that it was aimed out an upstairs window, set the timer for 2-second intervals, and mowed away. I used an electric power mower, and it turned out to be an interesting experiment. I found that by changing my normal cutting pattern, I would have less trouble keeping the power cord out of my way.

This same technique, when used in industry, is called memomotion. Memomotion is simply time-lapse sequences of people or equipment working. An engineer can quickly spot necessary changes to improve working procedures or equipment placement by studying memomotion sequences. One construction company in Hawaii regularly shoots time-lapse sequences of their day's work. Compressing a full day's work into a few minutes of screen time allows them to study the efficiency of their operations quickly and critically.

Industry, government, and science have long seen the advantages of using time-lapse photography as a tool to help them work more effectively. They have used time-lapse sequences to study automobile traffic congestion at an intersection, record a full day of weather, photograph a trip through the Panama Canal, and watch fruit as it ripens, all within a few seconds on the projection screen. Not only can time-lapse be fun to experiment with but it may prove to be a valuable tool in your job.

Equipment

A number of super 8 cameras have cable-release sockets and single-frame settings for time-lapse photography. Every time the cable-release plunger is pushed and released,* one frame is exposed. See your camera instruction manual on how to set your camera for single-frame operation.

If your super 8 camera doesn't have a single-frame setting, you can still make time-lapse sequences. First, use a *very firm* tripod so that the camera can't possibly move. Then lightly depress and release the exposure release as quickly as possible so that only one or two frames are exposed each time. A little practice will be necessary so that you don't shoot a burst of frames. There may be some fluctuation in the exposure because the shutter never gets up to normal operating speed, but sequences photographed in this manner can be quite acceptable.

Most of the super 8 cameras available today have built-in exposure meters that will automatically adjust the lens opening for any variation in lighting.

*When using a cable release with these cameras, don't hold the plunger down. The single frame is exposed as the plunger is RELEASED. Holding the plunger down only drains the batteries. Make your single-frame exposures with quick, firm strokes.

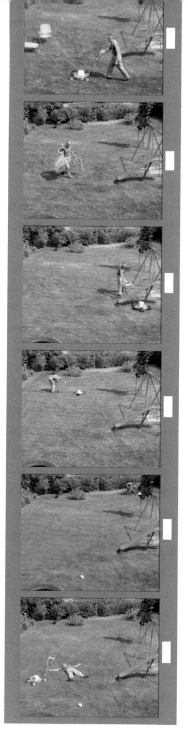

It took me 30 minutes to mow this area. The time-lapse movie, shot at one frame every 2 seconds, shows the whole operation in a frantic 50 seconds. The final scene, in which I zip to the foreground area and collapse, shows the audience just how I feel about the job.

The process from cocoon to full-blown cecropia moth took 45 minutes. Photographed at one frame every 3 seconds, the entire sequence lasts 50 seconds on the screen.

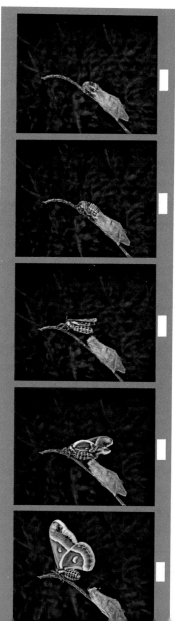

This means that even if you're shooting directly into a sunset, the camera will keep adjusting exposure until the sun goes down and there is no daylight at all, producing a natural fade-out. If your camera has manually adjustable lens openings, you will have to monitor it constantly when you shoot a sequence in which lighting conditions change.

With time-lapse, a tripod is *essential*. Once you've set up the subject you want to photograph and have positioned your camera, tighten everything down. Don't try to pan or tilt during a time-lapse sequence. Any slight movement of the camera or change in a zoom-lens position during shooting will have a jarring effect, with the entire scene jerking about when the action is viewed on the screen.

Use a stopwatch or a watch with a sweep-second hand to time the exposure intervals so that they are consistent. Irregularities in the exposure intervals may cause an annoying jump in the action on the screen. While you're shooting, keep your eye on your second hand, not on the subject.

Photographing plant development out of doors presents some problems; the wind is the most serious. Even a slight breeze can make flowers jump wildly around on the screen when your movie is projected. You may want to build a windscreen to keep any draft from moving the plant. You can make the screen from clear plastic sheeting stapled to wooden dowels. Push the dowels into the ground to support the screen. The clear plastic won't cast shadows, and if it's out of focus, it won't show in your picture.

In time-lapse photographs taken outdoors, shadows of trees and buildings can quickly move across your field of view as the sun moves across the sky. Scout your area and try to anticipate where the shadows will be during the time you'll be photographing the event. Then try to place your camera so that the shadows won't appear in the pictures.

You can shoot excellent time-lapse sequences manually, but you may not relish the idea of sitting around for hours just pushing a plunger every few seconds. Professional photographers use devices called intervalometers, which automatically control the interval between exposures. Some intervalometers have been designed to turn greenhouse lights off, turn photographic lamps on, trigger the camera, turn the photographic lamps off, and turn the greenhouse lights back on. A time-lapse setup such as this may last for months and the photographer may check on the operation of his equipment only once a day.

There are several equipment manufacturers who market small, relatively inexpensive, battery-powered timing units that can be used with many super 8- and 16-mm cameras. Timing intervals range from three frames per second to one frame every 50 minutes. For additional information, write to a firm that markets this specialized equipment, such as The Pacer Company, 1670 Woodmen Tower, Omaha, Nebraska 68102, or Sample Engineering Company, 33 Dellwood Court, Decatur, Illinois 62521.

The KODAK ANALYST Super 8 Camera is a single-frame camera that you can set to make exposures at intervals ranging from 1¼ seconds to 90 seconds. For additional information, write to Customer Relations, Graphic Data Markets, Eastman Kodak Company, 343 State Street, Rochester, New York 14650.

Determining Frame-Interval and Screen Times

Determining the best time interval between frames is a matter of judgment coupled with a little experimentation. I'm sorry I have no tricks in my bag that will help you come up with the right interval every time, because nearly every situation will be different. Generally, however, if the movement of people is your main interest, a 1- or 2-second interval is best. At longer intervals, the people seem to dart from one spot to another and all flow of action may be lost.

I have made time-lapse sequences showing the operation of a lock on the New York State Barge Canal. It takes about 30 minutes to raise or lower a boat in the lock. When I photographed that event at 1-second intervals, it showed people milling around as they watched, but the event itself wasn't too exciting. When I shot at 5-second intervals, the people appeared and disappeared too quickly in the frame, but the raising and lowering of the boats became dramatic. So you see that your frame interval will depend upon what you are photographing and what effect you want on the screen.

Sometimes you'll have a good idea of how long you would like an event to be shown on the screen. If you know how long it takes for the actual event to occur, the calculator inserted at the back of this book will help you quickly determine the frame interval you need. To assemble the calculator, follow the instructions printed at the top left of the sheet.

To use the dial, set your projection speed to the length of time you want the sequence to last on the screen (screen time). Then find the actual time it will take for the action to occur, and you will see the frame interval to use lined up with the actual time.

If you're mathematically inclined, you can use the following formula:

$$\frac{\text{Actual Time (seconds)}}{\text{Screen Time (seconds)} \times \text{Projected Frames Per Second}} = \text{Frame Interval (seconds)}$$

Let's take the opening of the tulips shown on pages 48-49 as an example. It took one hour (3600 seconds) for the flowers to open. To show the event on the screen in 40 seconds at a projection speed of 18 frames per second, it was necessary to make an exposure every 5 seconds $\left(\dfrac{3600}{40 \times 18} = \dfrac{3600}{720} = 5 \right)$.

The longer the frame interval, the shorter, and usually more dramatic, the effect on the screen. Some flowers, for example, will seem to explode on the screen when the frame intervals are relatively long.

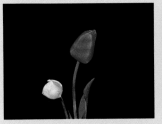 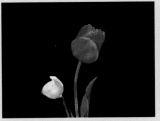 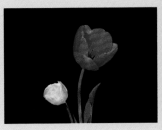

Although these tulips opened in the comparatively short time of one hour, no one would want to spend that much time watching them open on a movie screen. However, when you see it happen in just 40 seconds, it's an exciting event.

Making a Time-Lapse Sequence

Follow along with me now while I tell you how I made this time-lapse sequence of the opening of the tulips.

One cool evening my wife picked some tulips for the house, and as she was arranging them, she noticed they were beginning to open. Within a short time in the warm house, the tulips were fully open. Taking the cue, I arranged two fresh tulips in a vase, allowing space around the blossoms in case they moved around under the heat of the lamps I would be using. Then I attached a cable release to my camera and set it onto a sturdy tripod, arranged a couple of movie lights to show details of the blossoms, and propped up a piece of construction paper for a background.

Since the other blossoms had opened in less than an hour, I decided to expose one frame every 5 seconds. According to the formula on page 47, this would give me 40 seconds of screen time if the tulips opened in one hour. First I shot 18 or 20 single frames in rapid succession to provide about a second of screen time at the beginning of the sequence. This would give the viewer time to become oriented to what he was going to see. Then I began the time-lapse sequence. Using a watch with a sweep-second hand, I pressed the cable-release plunger every 5 seconds, being careful not to hold the plunger down. Within an hour under the warm lights, the tulips had fully opened. (It seemed a lot longer than an hour after I had pushed the plunger 720 times!) I ended the sequence with another rapid succession of single frames like the one I had shot at the beginning. The extra frames at the beginning and end of the sequence provided a smooth transition when I inserted the sequence into a finished film later on.

48

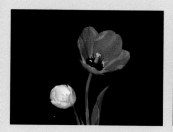 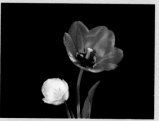

One of the fascinating aspects of time-lapse movies is the element of surprise. You can seldom be absolutely sure of what will happen when you photograph an event from start to finish, or how it will look on the screen. An uninvited fly popping in and out of the picture or a beautiful blossom that takes a dive right out of the picture just as it reaches the most dramatic part of its opening can be disconcerting to you but just plain funny to your friends. On the other hand, it's a proud moment when your audience sits enthralled by a beautiful sunset sequence you've made. Whatever the results, they're seldom dull. So be careful—you may become hooked on time-lapse movies for life!

More Information

An interesting book on time-lapse photography is *My Ivory Cellar—The Story of Time-Lapse Photography* by John Ott (Twentieth Century Press, Chicago, 1958). A more technical article, "Time-Lapse Cinematography," by Irwin A. Moon and F. Alton Everest, appears in the *Journal of the Society of Motion Picture and Television Engineers*, February, 1967.

O. J. Roth is a Program Specialist in the Kodak Photo Information department, where he produces and presents programs on photographic subjects. He spent many years with Kodak in mechanical engineering, designing and evaluating test photography on newly conceived mechanical equipment. O. J. has presented his creative slide shows to audiences throughout the United States. As a competitor in international competitions and exhibitions, he has won recognition with interpretations such as those illustrated in this article.

Focus on Moods

by O. J. Roth

Most of us like to make beautiful scenic photographs. To photograph a scene, we wait for a blue-sky day with big, white, puffy clouds—a day that will give us maximum color saturation and crisp definition in our pictures. These can be exciting pictures to make and I enjoy making them and looking at them.

The scenic photograph says to others "This is what I saw." But many of us occasionally have the desire to go a step further and make a photograph that says "This is how I felt." So let's talk about photography in terms of interpretation—the challenge to interpret photographically a scene that appeals to a certain emotion.

To excel in any style of photography, you need a good eye for composition plus the kind of sensitivity and perception that is so often possessed by the experienced, observant pictorial photographer. With practice, you can develop a sensitivity for moods and a delicate approach in your photography. Essentially, it requires that you take the time to examine your environ-

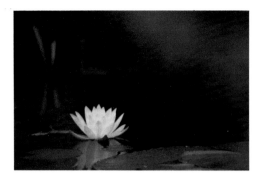

This water lily was exposed on a high-speed KODAK EKTACHROME Film balanced for daylight use. The telephoto lens, set at the maximum lens opening, was held only 3 or 4 inches from the foreground foliage, which registered as almost a green mist above the lily.

ment—to look for the basic beauty in a small weed, as well as in the majesty of a towering tree. Study the effects of light and weather conditions on a subject you're photographing; walk around it and examine it from every angle. With experience and the passage of time, you'll find that the emphasis in your photography is changing from the literal recording of scenic views to the artistic interpretation of form, texture, and mood.

There are many moods—exciting, happy, quiet moods. One of my favorite moods is the feeling of tranquility that comes over me during an early-morning walk in a quiet place. It's a delicate, ethereal mood, easily broken. I like to capture it in my pictures whenever I can.

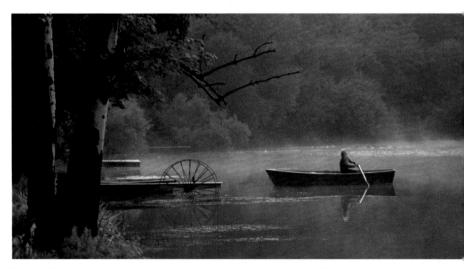

Captured before sunrise, this scene was made on a medium-speed KODAK EKTACHROME Film with a 135-mm lens wide open.

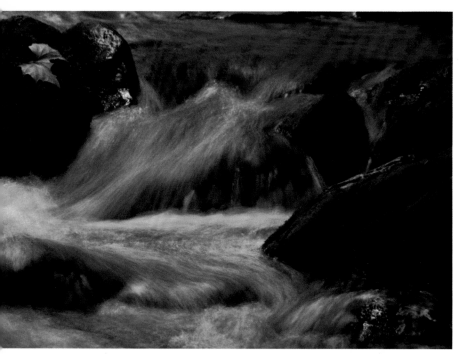

To obtain a feeling of motion in the water of this brook located deep in the woods, I used a very slow shutter speed. The exposure was made on a high-speed KODAK EKTACHROME Film balanced for daylight, with the camera on a tripod.

The Elements of Mood Photography

The elements of nature contribute greatly to the moods you can capture in your photographs. Sunlight and skylight, fog and mist, water, foliage—these are the stuff of which mood photographs are made.

I like early or late sunlight best for most mood and interpretive photography. The hours from sunrise until 10 a.m. and from 3 p.m. until sunset usually offer the best opportunities. Once the sun has risen to an angle 45 degrees or more above the horizon, the lighting becomes flatter than I like, many subjects seem to lose some of their brilliance, and shadows no longer offer much contrast.

Backlighting and sidelighting, especially when shining through a soft mist or filtering through leaves, can give your pictures a sparkling or translucent quality. Backlighting usually reduces the brightness of backgrounds, eliminating distracting details and putting emphasis on the main subject. On a

A small aspen grove at the shore of a mirror-smooth lake was the setting for this early-morning study in tranquility. The exposure was made through a 135-mm lens.

foggy or overcast day, the light has a diffused quality that adds a feeling of softness and serenity to a scene.

Fog and mist often create varying planes of density in the scene, adding a feeling of great depth to your pictures. Colors in the scene are more subtle, unwanted backgrounds are subdued, and unnecessary details are eliminated.

Water included as one of the elements in a scene can contribute a lot to the mood of your photograph. When the water is perfectly calm, reflecting objects as a mirror does, it contributes a feeling of seclusion and serenity to the scene. Gently moving, sparkling water has a feeling of softness and vivacity, while swiftly flowing water communicates a feeling of power and excitement.

Most photographers are aware of the value of foreground foliage as a frame to add depth to a scene, mask unwanted parts of the scene, and direct attention to the main subject. I like to use out-of-focus foreground foliage to

I chose a high-speed KODAK EKTACHROME Film to record the late-afternoon sunlight on the edge of a granite cliff while still retaining detail in the shadows. To register the foreground foliage softly, I used a long telephoto lens with a large lens opening and positioned the front of the lens about a foot from the foliage. The blue haze in the scene is enhanced as the result of the foreshortening of distance by the telephoto lens plus the lack of filtration.

This scene was photographed in late-afternoon light, using a very high shutter speed to stop the motion of the foreground leaves and windblown hair. The resultant large lens opening served to soften the foreground and heighten the feeling of seclusion.

communicate a feeling of seclusion, especially when it's in the shade so that it comes out black or a very dark green. This is particularly effective in soft-lighting situations for creating a quiet, solitary mood.

Camera Techniques

Outstanding mood photographs have been made with every kind of camera. Each photographer has a preference and way of handling a camera. In trying to capture a fleeting mood, the fewer camera-operating distractions you must contend with, the better. For the kind of mood photography that I prefer, a single-lens reflex camera offers a number of advantages over other types. Reflex viewing allows you to see precisely what the camera is seeing, and it eliminates the problem of correcting for parallax in close-up photography. If your camera has a fast lens and very high shutter speeds, you'll be able to use wide lens openings for shallow depth of field. In many situations, this will help you isolate your main subject by throwing everything else out of focus, a very useful technique in mood photography. A depth-of-field preview (which allows you to see in the viewfinder exactly what will be in focus) or a built-in depth-of-field scale is extremely useful when you want only a very small area to be in sharp focus.

I like to use a telephoto lens when possible, even for making close-up pictures of small objects, such as leaves and flowers. This allows me more

The very soft, out-of-focus foreground foliage and the still water serve to enhance the feeling of seclusion and serenity. Using the white stones and their reflections in the mirror-smooth lake as the center of interest, I made the exposure with a long telephoto lens on KODAK EKTACHROME Film.

room to move freely around my subject and to move back far enough to include out-of-focus foreground foliage when the situation calls for it. Also, I find the relatively shallow depth of field of a telephoto lens to be extremely useful when I want everything in the picture except the main subject to be out of focus.

Because subject and camera movement are magnified with telephoto lenses, it's usually recommended that you put your camera onto a tripod and use a cable release. However, I prefer to make handheld exposures. Using a tripod is safer in most situations, but interpretive mood photography depends very largely on delicate lighting situations that will often come and go while you're setting up a tripod. For instance, if a small spot of sun shining through the leaves falls on a fern leaf, you may have only a minute or so to find the best point of view, determine the exposure, and focus before the delicate lighting moves on. When making handheld exposures through a telephoto lens, I try to use shutter speeds of 1/250 second or faster to avoid loss of sharpness due to camera or subject movement. Such fast shutter speeds usually require correspondingly large lens openings, a situation that produces the shallow depth of field that is so often useful for creating a mood in my photographs.

The choice of film for this kind of photography is strictly up to the individual. There is no particular film, color or black-and-white, that can be considered best for capturing a mood. As we discussed earlier, many good mood

The sun rising over the mirror-smooth water resulted in a near-perfect reflection of the seaplane. To lend sharpness to the foreground foliage, I made an exposure of 1/125 second at f/11 on a high-speed KODAK EKTACHROME Film balanced for daylight.

photographs are made in fog or mist, in shaded areas, and early or late in the day. If you want to use fairly fast shutter speeds under such lighting conditions, and perhaps a polarizing screen, you'll need a fast film, such as a high-speed KODAK EKTACHROME Film intended for daylight use. If you need even more film speed, you can increase the speed of EKTACHROME 200 Film (Daylight) by 2 times—from ASA 200 to ASA 400—by taking advantage of a special processing service offered by Kodak.

Special processing is available for 135 and 120 film sizes only. To get this special processing, purchase a KODAK Special Processing Envelope, ESP-1, from your photo dealer. The price of the envelope is in addition to the regular cost of processing by Kodak. After you've exposed your film at the higher speed, put it into the ESP-1 Envelope. Then either return it to your photo dealer, who will send it to Kodak for processing, or put it into the appropriate KODAK Mailer (for Prepaid Processing) and send it directly to any Kodak Processing Laboratory in the United States.

If you prefer, you can push-process the film yourself. See "Pushing KODAK High Speed EKTACHROME Film" in *The Third and Fourth Here's How*.

A polarizing screen can be a very useful accessory in creating mood pictures. It can intensify the blue of a sky or reduce the sparkle of sunlight on water. Water sparkle often enhances the beauty of a scene, but there may be times when you want to create a quiet effect by removing the sparkle.

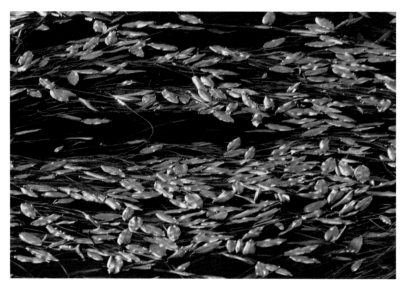

When I looked through the viewfinder, I was dazzled by the reflections of the low backlighting from the water and the floating leaves. A polarizing screen eliminated the glare and produced this effect of silver leaves floating on dark, quiet water.

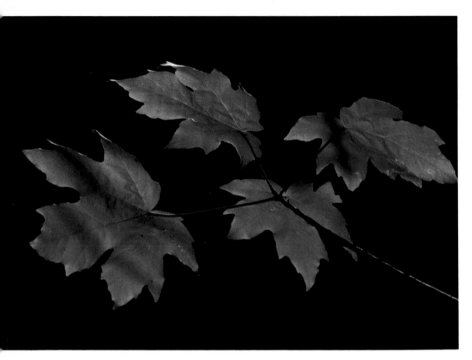

The color of these four leaves, backlighted against a deeply shaded background, was intensified with a polarizing screen.

When you're taking pictures of subjects with low-angle backlighting, you can use a polarizing screen to intensify the colors of some objects, such as the translucent emerald green of a leaf.

To be sure you'll get the effect you want, examine the scene carefully through the polarizing screen while you rotate it. Recently I was photograph- ing a waterfall at the bottom of which was a beautiful, intensely colored rainbow. Unthinkingly, I tried using a polarizing screen to enhance the emerald-green foliage near the bottom of the fall. But as I viewed the subject through the single-lens reflex camera and rotated the polarizing filter to intensify the green of the foliage, the rainbow disappeared. It had been "polarized out"!

The kinds of lighting situations that lend themselves well to the creation of moods in your photographs don't always lend themselves well to the use of an exposure meter. Exposure meters are at their best when they're being used to determine a normal exposure for a scene with average reflectance. But very often you'll find that a normal exposure doesn't convey the mood you want to express, and the lighting on the scene certainly doesn't produce average

reflectance. The procedure I've found best for determining exposure under such conditions is to make a reading of the scene with an exposure meter and then bracket my exposures. I take a picture at the exposure setting indicated by my meter, another at one stop larger, and a third at one stop smaller. If the light hasn't changed by then, I may try exposures at two stops over and under. Since capturing a mood in a photograph isn't an exact science, I've found that sometimes bracketing produces some unexpected "happy accidents" that are better than the results I had anticipated.

Practice, Practice

Interpretive photography is as personal as your toothbrush. Most of the specifics discussed in this article should be used only as guides or starting points from which to begin your quest for more and better pictures.

Involvement is a key factor. Learn all the possibilities and limitations of your equipment. Then take time to observe carefully the scene you're photographing and select the best camera angles. Study the lighting. Notice the color of the light, observe the angle at which it falls onto the subject, and study the depth and forms of the shadows it casts. Be willing to experiment—to try, try again. There was a great deal of truth in the answer given by a Broadway character to a tourist in New York City who asked, "How do I get to Carnegie Hall?" The answer: "Practice, man, practice!"

Faces are fertile fields for mood photographs, too. I like to photograph my subjects in a relaxed atmosphere indoors near a window, using daylight only. This extreme close-up isolates Joseph from his surroundings and emphasizes his eyes and mouth, which show his pensive mood.

Bob Clemens is a photographer for Kodak's Photographic Illustrations Division, where he has been a specialist in small-camera illustrative photography for many years. Beginning his photographic career as a studio assistant and darkroom technician for various commercial studios in Chicago, he went on to become staff photographer and editor of a camera column for an award-winning Midwest newspaper. His illustrated article "Hometown Newspaper Photography" appears in the *Encyclopedia of Photography*. Bob's camera work for Kodak, covering a wide range of subject matter, appears in the company's national advertising, publications, news releases, and audiovisual presentations.

WHAT YOU'VE ALWAYS WANTED TO KNOW ABOUT PHOTOGRAPHING GIRLS

by Bob Clemens

Has there ever been a better time than right now to photograph pretty girls? Cameras and films are better and easier to use than ever, and girls certainly have never looked or dressed better.

However ripe the time may be, trying to capture a flattering image of a lovely girl on film can be a frustrating experience for many would-be glamour photographers. Their pictures just don't seem to do justice to their charming and attractive subjects. Why not? Certainly not because of any lack of interest or enthusiasm on the part of the photographer—or the model.

I want to tell you how to get good pictures of any attractive girl, whether she's your loved one or a friend that you ran into at the beach—or both! And let me point out now that all the girls you see in these pictures—with one exception—are *amateur* models who pose for photographs only on an occasional basis. I make this point so that no one will say, "Sure, easy for him to show me lots of good pictures, since he uses professional models."

There are several things the article is *not* going to do. It is not going to get involved with any complex camera or darkroom techniques; it is not going to describe in detail any elaborate studio lighting setups; and it's not going to discuss the use of expensive and sophisticated cameras and accessories.

What this article *will* accomplish is to show you how you can use whatever camera you now own, plus a few other inexpensive photo accessories, to take interesting, pleasing photographs of any attractive nonprofessional model you may have available for a shooting session. So let's get started.

EQUIPMENT

You may have heard this line before, but it's true: You don't need a lot of complicated, expensive camera and lighting equipment to take good photographs. And this includes good photographs of girls. Any camera in good working order can be used with good results.

Easy-to-use cameras such as most KODAK INSTAMATIC® or TRIMLITE INSTAMATIC Cameras, with their wide-range automatic exposure controls, enable even the most casual snapshooter to get well-exposed pictures under just about any lighting conditions, from bright sunlight to dim interiors.

Here's a short list of equipment I feel is needed; all the pictures in this article were made with similar items:

A dependable camera. By this I mean a clean camera in good working condition with which you are *thoroughly familiar.*

A steady tripod. Many of your best pictures of girls will be made under low-level lighting conditions that won't permit you to handhold your camera because of the very slow shutter speeds (for example, ⅛ sec, ½ sec) required for correct exposure. A good tripod is a must.

A shaky, wobbly tripod means unsharp, blurred photographs. If you are not certain that your tripod is rock-steady, try hanging a brick or some other heavy object from it to reduce vibration.

A cable release. This inexpensive device goes hand-in-hand with your tripod. If your camera can be used with one, the cable release can help you to trip your shutter smoothly without moving your camera.

An accurate exposure meter. Unless your camera has a built-in metering

system, or is one of the simple non-adjustable types, you'll need a good meter to get consistently correct exposures under all lighting levels. Get to know your meter so that you can rely on it and trust it.

A large white card just out of the camera's view reflects window light into the shadow side of Lyn's face.

An efficient reflector. This valuable aid conveniently controls lighting contrast by bouncing light into shadow areas of your subject, particularly the eyes. Using a reflector is especially important when you're using sidelighting and backlighting, two very flattering types of lighting for your female models.

Reflectors come in all shapes and sizes; my favorite is a commercially made unit that resembles a small square umbrella with white fabric on one side and silver foil on the other. It measures about 33 inches on each side, and can be mounted on a portable light stand by means of an adjustable bracket.

You can make homemade reflectors by using a large sheet of white cardboard, a white bed sheet, or a sheet of lightweight plywood sprayed with white enamel or aluminum paint. Another very workable reflector is a home movie screen that has its own tripod stand.

Electronic flash was used to lighten the shadows in this poolside scene, photographed on KODAK EKTACHROME Film. Vivian's attractive figure is enhanced by the sideward pose of her body. The slightly bent leg and pointed foot give her leg a slim, shapely look.

A flash unit. Light from a flash unit can also be used to fill in shadows when working with backlighting or sidelight-

ing, indoors or out. Like a reflector, the flash fill reduces contrast, but it tends to be harsher in appearance. And, unless you've worked it out in advance, balancing the light from fill-in flash against the main light can be a little tricky. You can't make a visual check of its effect on the subject before you take the picture as you can when using a reflector. However, bounce flash is convenient to use in certain situations. Bounced from a wall, ceiling, or reflector indoors, it can help augment or boost the existing light and provide soft, pleasing lighting.

This is the professional model I told you about. She's Cybill Shepherd, a well-known New York professional model. If she looks familiar, it's probably because you've seen her face on the covers of magazines such as *Glamour,* in many television commercials, and in the movies. I liked the soft window light, which complements her cuddled-up pose. Light bouncing back from the white walls in the recessed window area provided shadow fill, making the use of my own reflector unnecessary.

Eleanor found the yellow flowers growing near our shooting location, so we used them as props. Natural props, such as flowers, give added visual interest to a picture of this kind without detracting from the girl. The bare foot added a natural touch to this setting. A soft-focus attachment lends a subtle, misty look to the picture.

A soft-focus or diffusion-type lens attachment. These attachments take the sharp edge off the focus, giving a misty, pleasingly soft look to the picture. This subtle quality is particularly welcome in close-ups of girls, in which the brutal sharpness of today's lenses can be quite unflattering (there just aren't many models with flawless skin and facial features!).

A soft-focus attachment can also enhance the air of feminine romanticism in a given scene where a more literal (perfectly sharp and crisp) rendering would not be appropriate or desirable.

These lens attachments are available from photo dealers.

Sally has an absolutely stunning face. I concentrated fully on it in this
picture by using a close-up lens on my telephoto lens and moving in very close.
A soft-focus attachment was also used.

A medium-focal-length telephoto lens.
If your camera will accept inter-
changeable lenses, this one will prove
extremely valuable. While it's possible
to make facial close-ups with a normal
lens, the nose and other features clos-
est to the lens can be distorted by ap-
pearing out of proportion to the rest
of the face. A telephoto lens of moder-
ate focal length (85-mm to 135-mm on
a 35-mm or 126 camera, 150-mm to
250-mm on a 2¼ x 2¼ camera) will
fill the frame with just the model's
head or even just her face without
producing unflattering distortion.

An innovative model can really help you obtain outstanding pictures like this one. Vivian had been sitting, feet on the floor, for several exposures. As I paused between exposures, she took the initiative and pivoted around into this pose. My reflector provided needed fill light. Note the pointed feet and the highlights on the model created by daylight coming from the back and sides of the porch.

Soft window light, plus soft-focus attachment, plus reflector fill, plus lovely model (Vivian) add up to this simple, appealing head-and-shoulders informal portrait. The camera was mounted on a tripod.

MY BASIC WORKING PHILOSOPHY

I take a pretty straightforward approach to photographing girls, avoiding the "cheese-cakey," stilted, over-contrived approach that for many years characterized a certain school of "glamour photography." I personally don't like overly meticulous studio lighting and unnatural posing used to the point of rendering the subject as a lifeless mannequin. Nor do I care for outdated props such as fur wraps, chandelier earrings, long white gloves, and a Grecian column for the model to lean against. And contemporary, candid techniques have no room for the "rule" that says the subject's eyes can never look directly at the camera.

My objective is to create an honest image of a girl looking lovely, showing poise and self-confidence in a pictorially interesting framework—and to see that she is obviously enjoying the entire experience.

Although some of my work for Kodak is done in the studio under carefully controlled conditions, I prefer to work outdoors or in an interesting interior setting when taking pictures just for the pleasure of it. I try to use the natural lighting present in the particular scene, augmenting its effect on the subject with my reflector.

My favorite types of lighting conditions are open or deep shade outside, and indirect sunlight coming through a window. It's most enjoyable to work in settings where I find flattering, interesting light combined with an attractive physical setting such as trees, water, architectural details, or furniture.

MAKEUP

The use of makeup can make the difference between a so-so picture of a girl and one that almost demands our attention—and admiration. And never has there been a wider selection of makeups, colors, or possible "looks" that can be produced. The entire subject could easily fill a book, but I'll try to cover the highlights here.

A cream or liquid base is first applied to the face, matched as nearly as possible with the model's natural skin color. To keep a smooth, natural look, do not powder over this base application.

A blusher is sparingly applied to the cheeks to shape and accent them, and to add a touch of color to the face.

Proper makeup can help your model look more pleasing in the final pictorial results.

Lips are outlined and lightly filled in with lipstick, using a lip brush. Avoid too thick an application; put on just a film of color. To add sheen to the lips, use lip glosser over the color.

Skin blemishes, lines, and dark areas under the eyes can be concealed or minimized with a lipstick-like cosmetic such as "Erace," by Max Factor. Use it over these areas before applying regular makeup. Most such products are available in a wide range of skin tones.

I've saved the eyes until last. They are the most important part of all. Start making up the eyes by outlining the upper lash line with an eyebrow pencil or with liquid eye liner. If you want a more dramatic effect, the bottom lash line can be outlined, too. The upper lash line should be extended slightly beyond the outside edge of each eye, and curved upward slightly. Underlining tends to decrease the "openness" of the eyes, so work carefully.

Eyelashes are emphasized by using mascara, applying it twice to build the desired effect. A third application is made on the outer lashes to give a wide-open impression. False eyelashes can be used instead, if preferred.

Eye shadow should be applied to the eyelid up to the crease, and then blended in with a brush or fingertip. A wide selection of colors is available; your choice will depend on the model's coloration, clothing, and the mood or feeling you wish to convey in the picture. White shadow can be used just under the eyebrows to highlight the eyes themselves.

Your model can practice these techniques at home to gain experience and judgment.

HELPFUL HINTS ON POSING AND CLOTHING

Let's face it—not every girl has a perfect face or figure! When I photograph girls, I try to pose them to bring out their best features and at the same time minimize any slight problem areas. There are many relatively easy ways of doing this. Some of the following suggestions may be helpful.

- For a slenderizing effect, use full-length stretched-out poses.
- A fuller, more rounded-out appearance can be given to the slender girl by having her pose seated or in a curled-up position.
- The female figure generally looks more shapely when turned at an angle of 45 degrees to the lens axis. Your model's feet should be gracefully pointed and one leg slightly bent at the knee.
- Shoes or boots with fairly high heels bring out the curves and flatter the legs.
- Sheer seamless hose give legs a smooth, finished look, especially with short skirts or shorts.
- If your model commonly wears panty hose, specify that she use a sheer-to-the-waist type so that the unsightly, darker reinforced area found in other styles won't show below short clothing.
- Great legs look even better when you pose your model in a swimsuit, leotards, or body shirt that is cut high at the thighs. The resulting "leggy" look is very flattering and lends itself to a wide range of poses. Any garment (especially a swimsuit) that is cut too squarely in the legs tends to make a model's legs look shorter and heavier.
- Use the old "stomach in, chest out" army routine and have your model draw in her stomach just before you're ready to take a picture. This is especially important when she is wearing a snug-fitting garment, bare-midriff clothing, or a bikini—also when she's in a sitting or reclining pose. Her waist will look slimmer, her stomach flatter, and her general appearance will be immensely improved.
- To help minimize a prominent nose, use a telephoto lens from a frontal position. In addition, avoid profile pictures.
- Corrective hair styling can solve the problem of a girl with a high or prominent forehead, particularly in close-up pictures. Bangs, or a style that brings the hair forward, can make a definite improvement. Sometimes a properly styled wig can be helpful.
- Keep a supply of straight pins, safety pins, and clothespins handy. They can be used to great advantage to remove gathers and wrinkles in loose-fitting clothing. Naturally, these "accessories" should be strategically placed so that they won't show in the pictures.
- Body makeup can be very helpful for touching up untanned areas of the body that show when various articles of clothing are worn by a model. It takes considerable skill and practice to be able to blend in the makeup so that it isn't noticeable, especially when the area to be covered is extensive.

YOU AND YOUR MODEL

Webster's dictionary defines the word "rapport" as a relationship "marked by harmony, conformity, accord, or affinity." Rapport is the key to a successful photographer/model collaboration; without it, all that goes before—attractive girl, great clothes, fine equipment, great setting—can be virtually wasted. Rapport is an elusive ingredient that must be present for a successful shooting session.

Rapport begins when both the photographer and the model *want* to produce good pictures, and are willing to cooperate and work hard to do so. Rapport develops and grows as the model and photographer gain mutual confidence in the other's intentions and abilities.

A warm sense of humor certainly helps set the emotional stage and seldom fails to relax a model. Photographers who are too somber or who are taking themselves or the shooting session too seriously cannot expect to get the best from a model.

By all means be specific and tell your model just what you want her to do for each picture (see "Helpful Hints on Posing and Clothing," page 68). Most girls have a latent ability to pose reasonably well, but they will need direction from you, particularly if you have not worked together before. The more the girl understands just how you are trying to portray her on film, the better the job she can do in front of the camera.

I enjoy the experience of taking pictures of a pretty girl. I like to make this enjoyment obvious to my model and make it infectious. The more she enjoys posing for me, the better the picture will be. If you approach your picture-taking in the same spirit, I believe that you, too, can take charming and rewarding photographs of girls.

How about trying it for yourself?

I purposely had Vivian pose in front of the brightly lighted bay-window area to let the background wash out. My reflector bounced light back into her face and body to provide better contrast and to put a sparkle in her eyes. See how she points those feet! Her costume is a one-piece body stocking.

Here, I feel, was a successful experiment in creating a mood of utter fantasy. A sheet of acetate was held just in front of my wide-angle lens. I smeared petroleum jelly on it in a circular pattern, but left an oval area in the center untouched. As it worked out, the pattern neatly matched the tree Vivian was in. The camera, a single-lens reflex, made it easy to compose the picture just as I saw it.

69

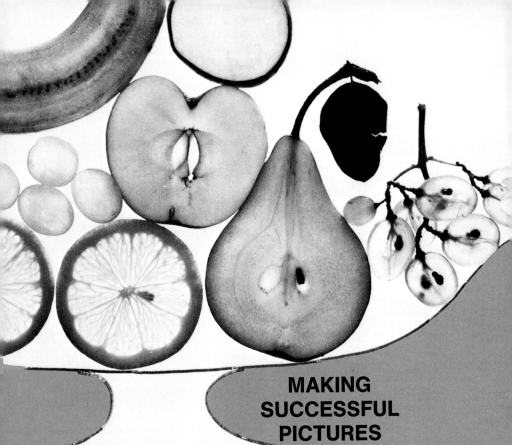

MAKING
SUCCESSFUL
PICTURES

by Peter J. Hunter,
ARPS, AFIAP, APRIA

Peter J. Hunter is the Coordinator of Information Services for Kodak (Australasia) Pty. Ltd., at Coburg, near Melbourne, Australia. His duties include public-relations activities, preparation of customer service literature, and supervision of the Kodak Lecture Service, which sends photographic programs to groups of camera enthusiasts all over Australia. Peter also teaches photography in night classes. His exhibition pictures have won prizes in many countries, and he's the only Australian who has won the George Eastman Memorial Medal in a Kodak International Salon of Photography.

What makes a successful photograph? To some photographers the criterion for successful pictures is how many medals they've won in photographic salons. To others, winning first prize in a high school camera club competition is the pinnacle of success. And many photographers measure the success of their pictures by the number of "oohs" and "ahs" they get in a family slide show.

In photography, so much of the success is really a matter of opinion—of a photographic jury, a competition judge, or your admiring friends. It would be too easy, I think, if judging a photo contest were as simple as recording the best time in a race.

Whatever standard of success you set for yourself, I recommend that you follow this piece of advice: If at first you don't succeed, try, try again. The originator of that remark must have had creative photographers in mind.

To be a successful photographer and salon exhibitor, however, you *really* must try—and try again. I do.

Basically, I have two approaches to my picture-taking. I call some of my prizewinning photos "found" pictures —and these, as you'll see, require quick reflexes and a lot of luck. I call the others my "made" pictures. These pictures I either made in my viewfinder or started there and didn't finish until I'd embellished them many hours later in my darkroom.

JUST MISSED . . . A classic type of "found" picture. Here's a "found" picture which, to the surprise of many photographers, is just as it happened—it's a straight print from the original negative. The picture was taken at a flying display marking the 50th anniversary of the Royal Australian Air Force. The most hair-raising stunt was the flight by six jets in tight formation with another plane passing within a few feet coming from the opposite direction—all passing at a combined speed of more than 1000 mph. I used KODAK TRI-X Pan Film and shot at 1/1000 second with a 400-mm lens on my camera.

"FOUND" PICTURES

Typical "found" pictures, such as a policeman holding up traffic as a mother duck and her family waddle across the road or the curved pattern of stampeding buffalo seen from the air, are exceedingly hard to find and capture on film.

But you need only one or two successes out of all those misses to make the quest worthwhile. Looking at the near collision of those jet fighters in my picture "Just Missed" still makes my heart skip a beat. Capturing an exciting picture, often in difficult circumstances, is more important than fine grain or superbly sharp images.

I really have to admit that not many of my pictures are the "found" type. I'm just not always in the right places at the right times, with my camera loaded with the right film, cocked, focused, and ready.

That's one reason that a good portion of my salon winners have actually been created right in my darkroom!

PICTURES "MADE" IN THE CAMERA

The nice thing about "made" pictures is that you can plan them days or even months in advance. This doesn't mean you'll necessarily plan right down to the finest details, but certainly you can form a broad conception.

For example, you can think up the outline of a situation when you're stuck in a traffic jam, as I did for "Driver's View on a Wet Night." This picture really was conceived in a traffic jam on a wet night in Australia—yes, we too have traffic jams! But the photograph was actually made several nights later.

Here are just a few of the preparations which went into the making of this picture:

1. The car was stationary but a suitable location was necessary to get the effect of heavy traffic, so I parked it alongside the curb during rush hour.

2. It wasn't raining, so I sprayed water onto the windshield with a plastic squeeze bottle.

3. I switched off the car ignition, rather than the wiper, to get the wiper blade at the best angle.

4. I removed the interior light cover to get more internal light.

5. I mounted the camera on a tripod and placed it so that the picture would be taken from the driver's position.

6. The self-timer on my camera gave me time to put both hands on the steering wheel before the exposure.

Even though I used TRI-X Pan Film, the exposure time was one second, so a tripod was necessary —and so was some breath-holding. Judging from the number of acceptances and medals it has won in competitions, I would say this was one of my most intriguing and successful pictures.

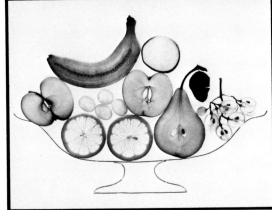

This photograph won many acceptances in exhibitions, but its greatest success came in the 32nd Kodak International Salon of Photography in Paris, where it received the A. E. Amor Award for the Best Print and then went on to win the George Eastman Memorial Medal for the Best Picture in the Salon.

My winning "Half a Bowl of Fruit" really came to fruition as a result of this earlier photograph that I made, "Lemon on Red Glass."

PICTURES "MADE" IN THE DARKROOM

A photographic darkroom can just about double your chances of getting some really great "made" pictures. Many pictures can be actually created in a darkroom. It's sometimes possible to do this from a picture which has some technical shortcoming that would normally make it fit only for the waste bin.

By applying high-contrast or other experimental techniques, it's often possible to transform a mediocre picture into an exciting image.

First, let me give you some general advice on making high-contrast copies; then I'll explain specifically how I created each of my "made" pictures that appear at the end of this article.

The high-contrast technique that I use depends on the use of KODALITH Ortho Film 2556, Type 3 (ESTAR Base). This high-contrast film is made for use in the printing industry and is usually available from graphic arts dealers.* Look in the yellow pages of your telephone directory for a dealer near you. I usually buy a box of 4 x 5-inch sheets. Then I cut a sheet into smaller pieces. A quarter of a sheet will comfortably cover a 35-mm frame. The film is developed in KODALITH Developer, available where you bought the film.

KODALITH Ortho Film is quite simple to use. If you already make black-and-white prints, the only extra equipment you'll need will be a safelight equipped with a KODAK Safelight Filter No. 1A (light red) or equivalent.

High-contrast images can be made by printing black-and-white negatives, color negatives, or color transparencies onto KODALITH Ortho Film. Get used to the idea that positive as well as negative images can be made on

Any time you have a few spare moments to think, even when you don't have your camera handy, put on your creative cap. It's this creative thinking that can produce a winner.

Probably my most successful "made" picture, which has won acceptances and awards in many exhibitions, is my "Half a Bowl of Fruit."

This photograph was inspired by a club assigned-subject competition; the subject was a "Picture made at home—not people." At first I was able to get several routine, technically-good-but-poor-in-creative-thinking pictures—the last of these being the slice of lemon on a red glass.

Then I thought, "What about placing several lemon slices on a piece of glass?" But that didn't make a worthwhile pattern. However, when I added other slices of fruit and outlined a dish with a felt-tipped pen, I had a real prizewinner.

Some of my best pictures didn't stop on the set, either. They required some extensive labor and creativity right in my darkroom.

*In Australia and other countries outside the U.S.A., this film may be obtained directly from Kodak.

film. You can use a contact-printing frame or an enlarger. It is important to use the contact method when you need same-size images, as described in the text accompanying some of the illustrations.

The techniques you use for making high-contrast images are the same as those you have used for making black-and-white prints. You don't even need to know the speed of the film; just make a test strip or use the KODAK Projection Print Scale in the usual way to determine the correct exposure time.* Develop the film according to the processing directions in the instruction sheet. You will need to work in a clean place, since any dust will be reproduced as pinholes on the high-contrast images. KODAK Opaque (sold by photo and graphic arts dealers) is useful for painting out these spots if they occur.

Make sure that you explore various high-contrast ideas, such as the techniques described here with the "made" pictures. It's tremendous fun. It can be creative, and your pictures will take on a new dimension.

In the future, when you look at any collection of pictures, whether they are in an exhibition, a magazine, or elsewhere, try to analyze whether each one is a "made" or a "found" picture. Both types can have tremendous impact, and that makes for highly successful photographs.

Straight Print

CARDIGAN STREET, CARLTON . . .
A "made" picture from a "found" subject.
The rather striking quality of this picture is due to the bas-relief effect. Sometimes a bas-relief can be so strong that it almost stands out from the paper it's printed on. Here's how this was done:

The original black-and-white negative was printed onto KODAK Commercial Film 6127. The printing could have been done with an enlarger, but in this case a simple contact-printing frame was used. After this step the original negative was not used again.

This high-contrast positive was again printed onto Commercial Film to produce a high-contrast negative. It was essential for this negative to be made by contact printing since it had to be the same size as the high-contrast positive.

The high-contrast negative and positive were then placed together with the two images in perfect registration. Then they were moved out of registration a fraction of an inch, taped in position, and printed with an enlarger to produce the bas-relief effect. The degree and direction of separation of the two images produce results with varying pictorial effects.

*For information on making test strips or on using the KODAK Projection Print Scale, read *Basic Developing, Printing, Enlarging in Black-and-White* (AJ-2), available from photo dealers.

High-Contrast Positive $+$ High-Contrast Negative

Bas-Relief Print

75

Original Negative

JACKHAMMER DERIVATIVE . . . "Made" by darkroom techniques. How everything vibrates when a compressed-air jackhammer is working—especially the operator! This is the feeling I wanted to convey in the picture.

A straight photo gave no idea of this vibration, so I set about making a derivative to convey the idea.

The original picture was made on KODAK TRI-X Pan Film, but the busy background spoiled it and had to be eliminated with opaque. Then a positive was made on KODALITH Ortho Film. This positive was printed again onto KODALITH Ortho Film. Once more, opaque was used to eliminate some of the unwanted background. It was this negative that was used to print the final picture.

After one straightforward exposure was made on Grade 2 KODABROMIDE Paper, carefully cut cardboard masks were laid on the paper so that only the worker could be multiple-exposed. The paper, held in a masking easel, was carefully relocated for each of the four successive exposures.

High-Contrast Positive

High-Contrast Negative (red areas show where opaque was applied).

Final Print

RED AND BLUE DERIVATIVE . . . "Made" by means of a slide duplicator. I often think that many photographers are frustrated artists. Burning inside them is unlimited creative energy, but when they can't draw or paint, they turn to photography as their creative medium.

Just as many artists have no desire to make completely "correct" representations in terms of color and tone, there's no need for every photographer to make a "correct" record of his subject. Many photographers, particularly color-slide makers, find an outlet for their creativity in making derivations. This particular technique is sometimes called posterization.

The derivation of the horse race started off as a normal color slide. It was printed, in a contact frame, onto a piece of KODALITH Ortho Film, which gave a high-contrast negative. This negative was printed, again by contact, onto KODALITH Ortho Film to give a high-contrast positive.

The two high-contrast copies were very carefully registered, one on top of the other, and taped to the aperture of a 1:1 slide copier fitted to a single-lens reflex camera. Tape was used to hold opposite edges of the two films to the copier so that each piece of tape became a hinge. This allowed each copy to be folded out of the way so that the other copy could be photographed separately.

I made the first of the two exposures with red-colored light illuminating the negative image. Then I swung the negative copy away, replaced the positive copy, and exposed it with blue-colored light.

Slide duplicators or copiers are available for most single-lens reflex cameras. And of course, you'll need a camera capable of taking double exposures. The instruction manual for the camera should tell you if it is possible, and if so, how to do it.

Original Slide

High-Contrast Negative

Red Filter

Blue Filter

High-Contrast Positive

Posterized Derivative

RED GUITAR . . . "Made" by colored flash light.
Many "made" pictures are really quite simple to make. I used multiple electronic flash to photograph the man playing the guitar—one flash at the camera, the other off to the left-hand side.

How did I get the red? By covering the side flash with red cellophane. The flash at the camera was unfiltered. Exposure was based on the distance from the main on-camera flash to the subject.*

Remember—in flash photography, two heads are often better than one.

This derivation of a girl was made in the same way as "Red and Blue Derivative," by double-exposing through red and blue filters. If you want to do something similar, I'd suggest you use a film such as KODAK EKTACHROME 50 Professional Film (Tungsten). It's a good idea to bracket your exposures and record them in your notebook.

*For more information on multiple-flash photography, read "Have Flash, Will Travel" in *The Third and Fourth Here's How* (AE-104). This book is available from photo dealers.

SYNTHETIC SUNSET . . . "Made" to get the effect of a 1000-mm lens.

Have you ever wished for a 1000-mm lens? Well so have I. But not everybody can afford one or would use it often enough to merit such a large expenditure. One reason I wanted one was to get a huge image of the sun in a sunset.

But I couldn't even borrow a 1000-mm lens for my sunset picture, so I produced the same effect without one! This picture was made entirely in the darkroom—hence the name "Synthetic Sunset." The final result is a "sandwich" of two pieces of film in one slide binder. Let's call the two films "sun" and "grass." Here's how they were made:

SUN: It won't take much imagination for you to picture the procedure when it's explained that the sun started off as a one-cent coin and some wrinkled cellophane in an enlarger. This combination was printed onto KODAK Contrast Process Ortho Film 4154 (ESTAR Thick Base), but almost any sheet film could have been used. The resulting black-and-white image on film was then copied onto KODACHROME Film using a single-lens reflex camera with a 1:1 slide copier. Orange cellophane colored the copying light to simulate the sunset. The picture was made slightly out of focus to soften the edge of the coin image and the wrinkles in the cellophane for a cloudlike appearance.

GRASS: A suitable piece of grass selected from the lawn (good photographers never have time to mow the lawn!) was placed in a milk bottle against a white background. This was photographed on KODAK PLUS-X Pan Film. From the resulting negative a positive was made on KODALITH Ortho Film. This produced an image of black grass on a clear surround.

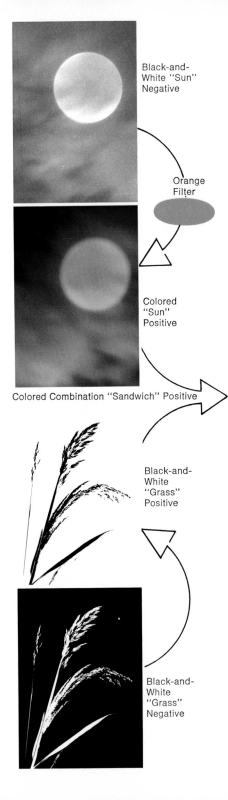

Black-and-White "Sun" Negative

Orange Filter

Colored "Sun" Positive

Colored Combination "Sandwich" Positive

Black-and-White "Grass" Positive

Black-and-White "Grass" Negative

82

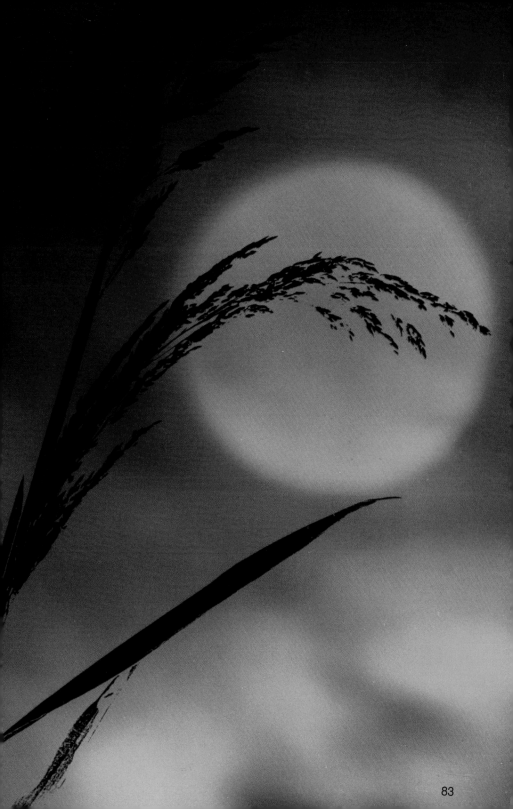

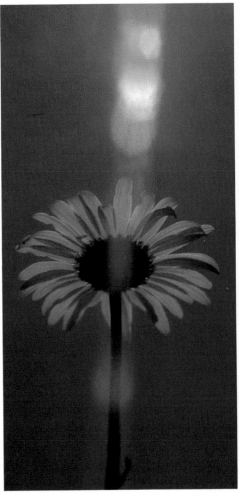

CREATIVE CAMERA TECHNIQUES

by Paul Kuzniar

Paul Kuzniar is a member of the Advertising Planning staff for Kodak's International Photographic Division, where he helps coordinate worldwide Kodak advertising and sales promotion. Paul is active as both a competitor and a teacher in photography. He has earned many acceptances and awards in local and international competitions. Also, Paul teaches photographic courses at the Kodak Camera Club and the Rochester Institute of Technology. His photographic experience also includes judging photo contests and presenting slide shows around the world.

Creative photography starts with *you* and *your* unique vision. It is *your* interpretation of a subject in a new and unusual way. It is a subjective style of photography drawing on *your* imagination and inspiration. Creative photography is personal, controversial, rewarding—and fun.

Through experience, you've already developed, or are developing, a photographic style—your special way of interpreting subjects on film. To enhance your photographic repertoire, I'd like to share with you some thought-provoking ideas on creative photographic techniques with your camera. These are not rules for creativity; they are ideas only—ideas to motivate and stimulate your own creativity.

SELECTIVE FOCUS

Selective focus can be simply defined as the technique of producing a selected area of sharp focus in an otherwise out-of-focus photograph. Some foreground material placed very close to the lens helps to concentrate attention on the selected area of focus. Selective focus imparts a feeling of intimacy and gives a dreamlike, impressionistic quality to your pictures.

The technique is easy. After choosing your subject, carefully determine the area that will be in sharp focus. Take a meter reading of your subject, and then calculate the exposure using a large lens opening, such as $f/4$, $f/2.8$, or $f/2$, to achieve shallow depth of field. A telephoto lens comes in handy for selective focus since it produces shallow depth of field. I like to use a lens in the 85-mm to 135-mm range.

Next, select some foreground object with which to frame your subject. The closer you can place the foreground to your camera lens, the more out of focus it will be. I always place

Creative photography suggests new ways of looking at familiar subjects, as shown by this selective-focus look at "Prometheus" in Rockefeller Center.

Add a veil of color to your pictures through selective focus.

Shallow depth of field creates a soft frame that isolates and emphasizes your subject.

85

Shoot through the foreground surrounding your subject for an intimate view of nature.

Chicory is a good foreground for selective focus; the lavender blooms appear to be painted on the picture.

Cut a slit in a facial tissue and place it over your lens. The result: instant selective focus.

the foreground within a couple of feet of the lens—closer, if possible. With a single-lens reflex camera, you'll see precisely the composition and framing you'll get in your picture.

The foreground is the exciting and challenging key to success in selective focus. A translucent foreground will transmit some light, enveloping your subject in a soft veil of color. Subtle, pastel colors in the foreground offer a soft frame for your subject and lend an aura of intimacy to your photographs.

Let your imagination go as you experiment with foregrounds. I generally look for some natural foreground, such as leaves, flowers, or tall grass, especially those that are backlighted.

I've also experimented with artificial foregrounds such as a nylon stocking, facial tissue, and textured glass. The results with such materials are often dramatic in contrast to the "soft" effect you get with natural materials. Experiment until you find the results that are most satisfying to *you*. Whatever your choice, selective focus will offer a means to personalize your pictures.

MOTION

Have you ever thought about introducing motion into the medium of still photography? I've enjoyed experimenting with two popular techniques: panning and zooming. In panning, you snap the picture as you follow a moving subject with your camera, just as you would when filming a movie. In zooming, you create motion in the camera by changing the focal length of a zoom lens during the exposure. Both techniques offer limitless possibilities (see "Action, Action, Everywhere," beginning on page 93, for more information on these two techniques).

The blurred action of this panned picture captures the exhilaration of flying through the air on a child's swing.

Panning

To blur the background in a panned picture, use a long exposure. I've had the greatest success with shutter speeds of 1/30 or 1/15 second when I use a normal lens. With a telephoto lens (85—135-mm), try 1/60 or 1/30 second. You may find that different shutter speeds work better for you. Too short an exposure may not blur the background enough, while a longer exposure may produce a complete blur.

With the exposure set, follow the subject's movement in your viewfinder as you release the shutter. If your timing and panning are right, you'll capture a degree of acceptable sharpness in your moving subject, creating a strong center of interest against the blurred background. The subject will be sharp because its motion and that of the camera coincided during the exposure.

On the other hand, when your timing is off, or your shutter speed is very slow, you may find only a blur of color in your pictures that conveys a sense of pure motion. Sometimes these impressionistic results carry stronger emotional impact than a sharper picture would.

Whichever result you find more pleasing, remember: Good panned pictures require practice. Camera handling during a long exposure is tricky under any circumstances. A steady hand comes from steady practice.

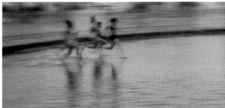

Although this picture is mostly a blur of color, can't you almost feel the water spraying the swimmers?

Use a slow shutter speed while following the action to achieve a blur of motion.

Zooming

Motion can also lie in the eye—or the camera—of the beholder. With a zoom lens, you can make a still subject come alive by zooming during the exposure. Zoom lenses have a range of focal lengths, such as 85 mm to 205 mm. Changing the focal length of the lens during the exposure creates an explosive blur of color leading from the center of the picture to the edges. The blur of color injects a sense of action into an otherwise still picture.

To give yourself enough time to change the focal length of the lens during the exposure, you'll need to use a slow shutter speed. The shutter speed will depend on the type of zoom lens you're using:

—With a zoom lens that *slides* in and out to change the focal length, use a shutter speed of 1/60, 1/30, or 1/15 second. A sliding zoom lens allows you to hand-hold your camera when you're using relatively fast shutter speeds.

—With a zoom lens that *twists* to change the focal length, you'll need a shutter speed of ⅛, ¼, or ½ second, since it takes longer to twist a lens than to slide it. I strongly recommend using a tripod and cable release when zooming with this type of lens because the twisting action can move or jerk the camera, creating an uneven zoom.

To take a zoom picture, focus and set your exposure; then press the shutter release and change the focal length of the lens during the actual exposure. You can try many variations on the zooming technique: Zoom in or zoom out; "freeze" your subject for just a fraction and *then* zoom; start zooming before the exposure and keep zooming throughout; try a stop-zoom-stop variation. Get into the habit of recording your tests so that you'll have an accurate means of checking your results.

With your zoom lens you can create an image that will be interpreted differently by each viewer.

Change the focal length of a zoom lens during a long exposure to generate motion.

Still subjects come to life through zooming.

A red filter used over the camera lens intensified this Bermuda sunset.

You'll find subjects for panned and zoomed pictures everywhere. Sporting events are a rich source of subjects that lend themselves to panning techniques—especially automobile and motorcycle races. People at work and play—any people in action—offer further possibilities. With a zoom lens, you can "activate" a variety of still subjects such as flowers, buildings, or even the cars in a traffic jam!

In fact, the list of "action" subjects is limited only by your imagination: So let your imagination go!

SPECIAL LENSES AND FILTERS

Take stock of your equipment and accessories, and try using them in new ways and on different subjects. Spice up your pictures with some of the special lenses and filters that are available today. Here are just a few ideas with which I've enjoyed experimenting.

Color Filters

All of us have used color filters at one time or another, especially in black-and-white photography. Why not try your yellow, orange, and red filters with color film? It's easy to do and produces surprising results.

Color filters fit right on your lens (directly or with an adapter) and generally require some exposure compensation, so check the instructions that come with your filters. Of course, most through-the-lens exposure meters compensate automatically for any exposure increase necessary for the filter. Check your camera manual for instructions on using filters with your metering system.

Color filters are especially handy on overcast days for adding color—any color—to "bald" skies. On clear days, they can change the mood of a picture. Use a red filter to enhance the

warmth of a setting sun; try a blue filter for "cool" seascapes. You can also use color filters in combination with another filter, such as a diffraction grating, or with a multiple-image lens.

Keep a selection of color filters in your gadget bag so that they can travel with you wherever you go. You never know when the need for a touch of color will arise.

Transmission Diffraction Grating

A transmission diffraction grating is a piece of clear glass or acetate plastic which has thousands of precisely spaced ridges etched on its surface. The ridges act as prisms, revealing the color spectrum of white light. When you look through the grating, you see the color spectrum as a thin streak emanating from a distinct source of light.

You can use a transmission diffraction grating over your lens to create unusual effects and to add color to your pictures. There is no exposure change with a diffraction grating; you just hold it in front of the camera lens while you take a picture. You can see different effects when you rotate the grating. When you see the effect you want, keep the grating in the same position as you place it over the camera lens. Try using the grating with a variety of light sources, such as the sun and streetlights; use two gratings together; or combine your diffraction grating with another filter, or even a close-up lens.

You can order inexpensive transmission diffraction gratings from suppliers of filters such as Edmund Scientific Company, Edscorp Building, Barrington, New Jersey 08007, and Spiratone, Inc., 130 West 31st Street, New York, New York 10001.

In experimenting I often combine two or more filters for unusual effects.

First I used the sun and a diffraction grating to produce this "sunstreak."

Then I added an orange filter for a striking background and a different mood.

One of the rewards of creative experimentation —I caught a "drop of light" on film by photographing the sun and a twig through a diffraction grating.

I used a close-up lens to photograph the daisy and added the streak of spectral light with the diffraction grating.

91

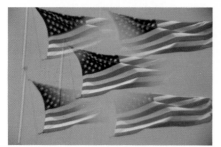

The multiple-image lens is easy to use. Pick your subject, select the composition by rotating the lens, and shoot the picture.

"Dream castles in the sky" with a multiple-image lens.

Multiple-Image Lens

A multiple-image lens is designed to produce multiple (generally three to five) overlapping images of the same subject. The multiple-image lens is attached directly to your camera lens just like a filter, and since it is transparent, it does not affect exposure. Just rotate the lens until your multiple subjects are arranged in a pleasing composition. With a single-lens reflex camera, you'll actually see the effect of the lens in your viewfinder.

The lens separates the image into the number of divisions in the lens itself. For instance, a lens with three sections produces three images of the same subject. I personally like the "mirage" effect that the lens simulates. A clean, uncluttered subject takes on a dreamlike quality; busy subjects become frantic. Try the multiple-image lens on lenses of different focal lengths for different effects. Dream up new pictures by using the multiple-image lens with color filters.

Enhance the symmetry of a simple subject with a multiple-image lens.

A fantasy created with the multiple-image lens and a red filter.

NOW IT'S UP TO YOU

Creativity is inherent in each of us. Consider the challenge, the fun, and the excitement of bringing your creative ability to the surface. Let the ideas presented here and throughout this book stimulate your imagination and creativity. Remember, you generate ideas and develop technique through practice; and through practice and experimentation, you'll expand your world of creative photography.

ACTION,
ACTION,
EVERYWHERE

by John Paul Murphy

John Paul Murphy is a Photographic Spe-
cialist in Kodak's Consumer Markets Divi-
sion. Versatile in many fields of photog-
raphy, John is a past president of the
Rochester International Salon of Photog-
raphy, an international salon judge, a pho-
tographic lecturer, a salon exhibitor, and
a former industrial and naval-aviation
photographer. He has earned many hon-
ors and awards for his photographic ac-
complishments. John holds a Bachelor of
Science degree in Photographic Science
and an Associate of Applied Science de-
gree in Photographic Illustration from the
Rochester Institute of Technology. His
article "Imaginative Color Printing" ap-
pears in *The Third and Fourth Here's How.*

The ultimate in rodeo action subjects—the rough, tough test of a man's endurance on a Brahma bull! Be sure to set your distance, aperture, and shutter speed ahead of time, and then shoot just before you think the action will pause or peak. It'll take practice, but it's worth it when you get results like this with a film such as KODACHROME 25 Film (Daylight). I used 1/500 second at f/2.8.

You'll find that action photography is like a kaleidoscope! Its thundering, tumbling subject matter unfolds form, color, and movement. As an action photographer, you must decide what you want to capture in your photographs, and record it instantly before it dissolves into new forms of action.

The action photographer is never still. He constantly moves, observes, and uses his photo equipment to capture the essence of the day and the event. Fun and excitement are where the action is, and both are remembered best in good pictures.

A nearby speeding boat crossing your line of vision at 20 knots can be "stopped" with an extremely fast shutter speed. KODAK EKTACHROME Film, 1/1000 second at f/4.

Anticipating the direction of the action is a major part of sports photography. Subjects moving toward or away from you are much easier to stop than those moving at a right angle to you and your camera. KODAK EKTACHROME Film, 1/250 second at f/4.

STOPPED, OR "FROZEN," ACTION

Briefly, let's review some of the many ways to "stop" action—to freeze that movement on film.

To stop really fast action, you'll need to use one of the faster shutter speeds on your camera, such as 1/1000, 1/500, or 1/250 second.

In addition to the use of fast shutter speeds, there are three other factors that affect your ability to stop action: (1) the angle of the subject's movement relative to the camera, (2) the distance between the camera and the subject, and (3) the speed at which the subject is moving. Let's examine these three factors.

Even with less complicated cameras that have shutter speeds such as 1/90 or 1/125 second, you'll usually be able to stop action that is moving directly away from or toward you. This kind of movement is much less apparent than action that's crossing at a right angle in front of your camera.

Also, the farther away a subject is from the camera, the slower its movement seems to be and the slower the shutter speed needed to stop the action. For example, visualize a 500-mph passenger jet that seems to creep across the sky at high altitudes.

You may be able to minimize the effect of the third factor, speed of the subject, by careful timing. Try shooting at just the instant when the action has slowed drastically or becomes momentarily suspended—for example, at the top of a jump or a dive. This is commonly called the "peak of action." Try to anticipate a stopping point or pause in the action, and press the shutter release just before the action stops (this allows for the slight delay until the camera shutter opens).

Try blur in some of your action pictures. Notice how blur conveys the impression of high speed, and how the subjects begin to change form radically. EKTACHROME Film, 1/15 second at f/22 with a polarizing screen.

Blur is the most desirable way (and sometimes the only way) to add the sensation of motion to your subject. A child's pinwheel looks static when it's still or when a fast shutter speed makes it look that way. A slow shutter speed exaggerates the movement. You can use a film such as KODACHROME 25 Film (Daylight). I shot this at 1/4 second at f/22 with a polarizing screen.

BLURRED ACTION, OR "THE LAZY SHUTTER"

You don't have to limit yourself to "freezing" or stopping motion. It's fun, but not the only way to photograph action. Blur in a photograph of a moving subject isn't always objectionable. There are times when a certain amount of blur actually improves the picture.

Ask yourself, "Does the eye really see every detail, anyway? Is an effectively 'stopped' subject sometimes too stationary or static to give the impression of movement?" A slow shutter speed (1/15, 1/4, or even 1/2 second) can enhance the pictorial effect of motion, create a feeling of move-

ment, or lend an atmosphere of fantasy to many subjects.

For an impressionistic style, use a very slow shutter speed and jiggle the camera on purpose. Experiment with this technique. Move the camera all around during or just before the end of the exposure. For another bizarre effect, pan along with the action as you use a very slow shutter speed, such as 1/15 second.

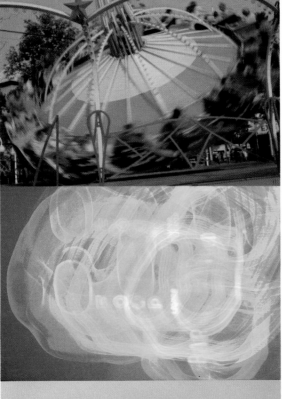

A whirl-around ride at an amusement park shows another application of this technique. Just leave the shutter open long enough for movement of the image to be recorded on the film. Use a film such as KODACHROME 64 Film (Daylight). I photographed this at 1/2 second at f/22.

To get this eerie nighttime shot of a lighted sign, I used an exposure of 1/2 second at f/8 first, and then closed down to f/16 for one more second with a high-speed KODAK EKTACHROME Film intended for use with tungsten illumination.

Panning at a slow shutter speed can blur not only the background but parts of the moving subject as well to create a bizarre impression of speed. You can use this technique for all racing subjects—people, dogs, horses, boats, or anything else that races. I got this unusual effect of the hurdler by using KODAK EKTACHROME Film at 1/15 second, f/22, with a polarizing screen.

Pivot, snap, and follow through. A rule of good composition is to leave some space in front of your subject. Try a film such as KODACHROME 25 Film (Daylight). This was exposed at 1/125 second at f/8.

A 200-mph Can-Am racing car can be photographed at extremely fast shutter speeds, yet you'll still get the blurred background for a tremendous feeling of speed. I panned this scene on EKTACHROME Film at 1/500 second, f/4.

PANNED ACTION, OR "SYMBOLIC MOVEMENT"

To show you how great panning can be, let's go to the races! High-speed car racing or motorcycle racing has tremendous potential for exciting panned-action shots.

You can represent the speed of these awesome machines in a highly dramatic or "symbolic" way by using shutter speeds such as 1/125 or 1/90 second and panning along with the subject. This technique can produce a blurred background and foreground, and yet keep the moving subject sharp.

If you haven't tried it yet, practice panning a few times with an empty camera to get the feel of it. You simply pivot at the waist, keeping the camera lined up on the passing subject as you trip the shutter, and continue following the subject (much like the follow-through of a golf swing).

When following a gull with your camera, keep your left eye open until the gull appears to move into the right range—in this case 25 feet. Then close your left eye and center the bird in the viewfinder with the right. You can capture the flight of a beautiful gull like this with a film such as KODACHROME 25 Film (Daylight). I exposed this picture at 1/500 second, f/4, with a polarizing screen.

Terns are quicker and more of a challenge—just expose for the sky and be sure to dress for the occasion, because these fellows are all sharpshooters! KODAK EKTACHROME Film, 1/1000 second at f/4 with a polarizing screen.

PANNING TO STOP ACTION

To stop action that is close to you—or that has been brought close with a telephoto lens—you'll need to use a very fast shutter speed (1/500 or 1/1000 second) *and* pan along with the subject. For instance, when I photograph birds in flight I use 1/500 or 1/1000 second and pan with them as I take the picture. Here, panning is an absolute must!

And so is prefocusing. I usually set the focus at 25 feet when I photograph gulls through a 200-mm lens. This gives me just enough room to capture their full wingspread in my viewfinder. By keeping my left eye on the gull as I follow it with my camera, I can estimate when it's about 25 feet away. Then I let my right eye take over, and press the shutter release when I've got the gull framed in my viewfinder. I follow through, even after taking the picture.

The big, lumbering herring gulls are quick enough for any photographer, but terns are much quicker and more challenging to photograph. They streak in at all angles. Because the smaller terns fly so much faster, I allow them a little more room in the viewfinder. Prefocusing my 200-mm lens at 25 feet and setting the shutter at 1/500 or 1/1000 second (with the proper lens opening to expose for the sky) produces the best results. Even with these guidelines, photographing terns is a hit-or-miss proposition, so I have to make a lot of pictures. After all, as someone once said, "One good tern deserves another."

Although I've used gulls and terns as examples here, the same techniques apply when photographing any close-up action, or action through a telephoto lens.

ZOOMED ACTION, OR "EXPLOSIVE MOTION"

Let's do something new to create action in a subject—even if the subject is stationary! I like to use what I call an "action zoom." I use a sliding zoom lens on my camera and zoom it as I expose at a slow shutter speed, such as 1/30 second. The effect is truly explosive! (For another discussion on this technique, see "Creative Camera Techniques," beginning on page 84.)

In terms of composition, zooming produces strong radial lines leading to (or from) a center of interest. A good example is this photograph of junked cars. Although they're an eyesore, they make excellent subjects for emphasizing the explosive effect you get with zoomed action.

For all my action zooms, I hand-hold my camera and use a sliding 43 to 86-mm zoom lens. I usually zoom in on my subject, but you can zoom away from a subject, too. I hold the camera tightly against my face to minimize camera movement.

To accentuate the center of interest, you can actually isolate it from its surroundings by zooming as I did in this picture of the Williamsburg carriage driver.

"EXPLODING" MULTIPLE IMAGES

If the radial-line pattern produced by zooming is interesting in a single image, imagine what it would be like in a multiple image! To get multiple images, just slip a three- or five-prism multiple-image lens over the zoom lens. When you zoom with a prism lens, you can get multiple explosive action!

You can find subjects everywhere that lend themselves to the zoomed-action technique. Try practicing these

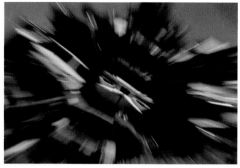

Doesn't this suggest a traffic accident to you? It may not solve any transportation problems, but it's certainly a good technique for putting motion into subjects at rest. KODAK EKTACHROME Film, 1/30 second at f/22.

This could have turned out to be a very ordinary photograph. But zooming the lens during a single 1/30-second exposure gave the subject an attractive, ethereal quality.

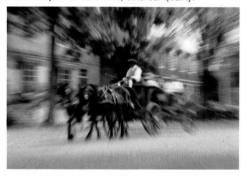

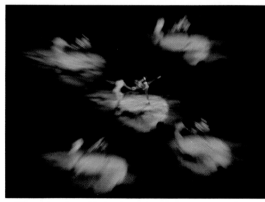

Zoomed action with the five-prism lens at the ice show frames the action within its own blurred multiple images. High-speed KODAK EKTACHROME Film balanced for tungsten illumination, 1/30 second at f/3.5.

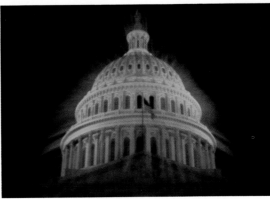

One car roaring by at 200 mph might be enough for most pictures. But this zoomed-action shot made with the five-prism lens suggests the almost endless action that's available to your camera. KODAK EKTACHROME Film, 1/30 second at f/22.

With the floodlights illuminating the Capitol Dome at night, I took this zoomed-action pictorial to convey the feeling of power that radiates from the center of American government. High-speed KODAK EKTACHROME Film for use in daylight, 1/30 second at f/3.5.

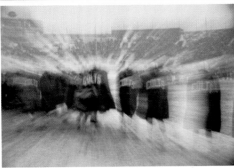

zooming techniques—with and without a prism lens—on stationary objects to get a feeling for it. You may be pleasantly surprised when you find that you have set the subject in motion in your finished pictures. Then try these techniques on moving subjects to enhance the feeling of panned action, or "symbolic movement." The action will seem to explode from your photographs.

Action photography like this is one great way to challenge the familiar and established ways of life, and to put newness, freshness, and originality into your photographs. But that's enough talk! It's time to start your search for action. When you find it, I hope to see you there.

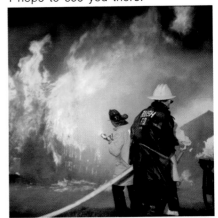

In action photography, the unexpected is what you attempt to capture. Look for the intangibles—the emotions, the feelings, and the moods that make photographs relate and move. KODAK EKTACHROME Film, 1/30 second at f/16.

This colorful, fiery background says "action" at a glance. You can almost feel the intense heat coloring your face! Following the hose team is a sure way to catch action—but stay out of their way! High-speed KODAK EKTACHROME Film balanced for daylight, 1/250 second at f/8.

100

BRILLIANT COLOR VIA THE BLACK-LIGHT ROUTE

by Dr. Albert L. Sieg, FPSA, FKCC

Dr. Albert L. Sieg is the Director of the Paper Service Division at Kodak Park, a manufacturing division of Eastman Kodak Company. He has worked extensively in the development of new and improved color and black-and-white photographic papers and was the company coordinator for the Kodak Instant Photography Program.

Dr. Sieg has won more than 75 medals in international salons and has been an active exhibitor and winner in photographic exhibitions with more than 1500 acceptances to his credit. He is a past president of the Kodak Camera Club, where he has been an instructor in the photo-education program. Dr. Sieg is also a popular lecturer on the PSA circuit and a frequent judge in photo salons.

Have you been searching for exotic ways to put new punch into your color slides, or for new areas to explore with your camera? If you're interested in the prospect of using ultraviolet (UV) rays to make exciting slides with neon-like or glowing colors, read on.

The average person has very little reason or opportunity to learn about ultraviolet rays except when an overdose of the shorter-wave variety from the sun causes a painful sunburn. Probably few of us consider the important function of ultraviolet radiation, either natural or artificial, in our daily living. Long-wave ultraviolet radiation, commonly known as black light, is used in the fields of medicine, industry, science, criminology, theatrical productions, and many, many more. And if you haven't already guessed, it's the long-wave type that can also be used in photography to produce pictures that glow with beautiful, brilliant color.

HOW IT WORKS

To understand how to use black light for photography, let's talk first about light—or radiant energy. Radiant energy that the human eye can see is called "white light" and is made up of the colors ranging from the violets to the reds. Radiation that is just below the wavelength the eye can see is called ultraviolet. It is composed of short, medium, and long wavelengths.

The long wavelength, or black light, is the most useful ultraviolet radiation for photography. It is also safe, causing no harm to the skin or eyes.

Every substance is composed of millions and millions of atoms. When invisible black-light rays hit certain of these atoms, the energy of the rays is absorbed and the atoms become excited; they move around trying to rid themselves of this extra energy. As they slow down, the extra energy is

released as visible light in various colors that we can see and photograph. This is called fluorescence. As soon as the black light is shut off, the substance stops glowing.

Substances that are particularly adept at exhibiting this phenomenon are said to be fluorescent and there are more than 3000 of these substances! Many of these are readily available today as inks, paints, crayons, papers, cloth, and plastics.

Since the kind of fluorescence you will be photographing is generally weaker than most normal room lighting, you should be in a darkened room so that the colors aren't overpowered by bright room lights.

In addition to a fluorescent subject, you'll need only a black-light source and a filter for your camera lens to start trying black-light photography.

The "Blacklight Blue" fluorescent tube. Make sure you get the dark blue "BLB" lamp—not the "BL," which is white.

LIGHT SOURCES

There are many sources of long-wave ultraviolet illumination, but the easiest to obtain and use are the black-light fluorescent tubes.

Several sizes are available from electrical-supply stores, hardware stores, and even department stores now that psychedelic lighting has become so popular. The 15-watt size easily fits in a desk lamp or a strip fixture, and two of these will supply ample light for photography. These tubes are made by all the major lamp

manufacturers and are identified by the code F15T8-BLB.

Whatever size of tube you buy, be sure you get one marked BLB (Black-light Blue). It is dark blue in color and has a built-in filter which virtually removes all visible light. Don't accept a BL Lamp—it gives off white light as well as black, and isn't useful for the purposes described here.

To control the light, you can fit aluminum-foil reflectors right on the tubes. These will shield the light from direct view of the camera lens, and will also be useful for shading and for introducing lighting control.

Many items around the house are good subjects for your pictures. Even these detergent boxes as well as their contents are striking under black light.

A second source of black light is the flashtube used in electronic flash units. The manufacturer places a filter in front of the flashtube (usually in the transparent cover) to remove much of the normal ultraviolet light; otherwise, your color pictures would be too blue. To achieve maximum UV output, remove this filter if possible. If you can't remove the filter, most flash units will still provide enough UV light to let you make good black-light pictures with a larger lens opening or by moving the flash closer to the subject. Whether or not you remove the built-in filter from the unit, use a KODAK WRATTEN Ultraviolet Filter No. 18A in front of the flashtube to make your unit a convenient, portable, action-stopping source of sufficient ultraviolet illumination for black-light applications.

The musical notes were cut from soapboxes and pasted onto a glass sheet. The toy horn was rescued from the kids' toy box. Always keep your eyes open for new black-light subjects!

MATERIALS

Fluorescent materials are just about everywhere. Many items around the house already fluoresce and are just waiting to be photographed.

Experiment with your exposures and record them so that you can determine your own guide numbers for your converted flash unit.

Eye protection is generally not necessary when you use long-wave ultraviolet light, because this radiation is considered harmless. But if you look directly at the lighted tubes, the eye fluids will fluoresce, causing some discomfort, so don't look at the tubes directly for any length of time.

A search through the kitchen, children's toy boxes, and closets with your black-light source on will light up countless fluorescent items. Kids' plastic building blocks, jump ropes, plastic items, clothing, boxes with bright-colored printing, detergents, and petroleum products are just a few.

If you want to photograph things that don't ordinarily fluoresce, you

Fluorescent crayons shown under black light.

A Space Spider toy photographed by black light without any camera filter. Poor color saturation and an overall bluish cast are the result.

Tempera or poster fluorescent paints. The blue background is a towel that had been laundered in a detergent containing a whitener.

Same scene photographed with a 2A filter.

can apply fluorescent paints, chalks, and crayons. Art-supply stores, arts and crafts shops, variety and discount stores, and hardware stores are all likely places to purchase items such as fluorescent spray paints, water and oil paints, crayons, chalks, coated papers, and brush pens.

Most of these items are also available on mail order from Edmund Scientific Company, Edscorp Building, Barrington, N.J. 08007.

FILTERS

The only other item you need for black-light photography is an ultraviolet filter to be used over the camera lens.

In general, all films are sensitive to ultraviolet radiation. In almost all of

A filter is required in front of the camera lens to block out ultraviolet rays. A No. 2A is best, but the No. 8 (K2) or No. 85 can be used.

your black-light photography, much reflected ultraviolet radiation will be entering the camera lens along with the visible light from the fluorescing subject. If this unwanted ultraviolet is not filtered out, your pictures will take on an overall blue cast and the colors will be washed out (on some occasions, however, this "mistake" can be used in a creative way to produce very pastel, bluish effects). The best filters for blocking unwanted ultraviolet light are the No. 2 series, such as 2A, 2B, 2C, and 2E. The 2A is the most readily available filter from camera stores.

In a pinch, you can use a No. 85 filter (the orange filter used to convert Type A films for use in daylight) or a No. 8 (K2) filter, the widely used yellow filter employed to darken skies in black-and-white photography. These last two filters, while useful, will absorb the blues in your pictures, and should be used only when you have nothing else available.

Pieces of fluorescent paper as recorded on KODAK EKTACHROME Film balanced for daylight. Daylight films accent the warm colors.

FILMS

Both daylight and artificial-light films can be used successfully for black-light pictures.

Daylight films—KODACHROME 25, KODACHROME 64, and KODAK EKTACHROME 200 Films—all give strong warm colors, accenting the reds and yellows. Because I like its moderate speed and its ability to give fully saturated colors, I use KODAK EKTACHROME 64 Film.

Artificial-light films such as KODAK EKTACHROME 50 Professional Film (Tungsten) accent the cooler colors, giving very good renditions of the greens and blues.

Depending on your personal taste, you can use either type of film; the choice is yours.

The same papers photographed on an artificial-light film. See how the blues and greens are intensified.

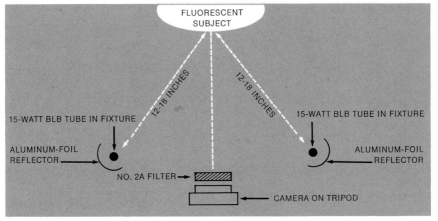

FLUORESCENT SUBJECT

12-18 INCHES

12-18 INCHES

15-WATT BLB TUBE IN FIXTURE

15-WATT BLB TUBE IN FIXTURE

ALUMINUM-FOIL REFLECTOR

ALUMINUM-FOIL REFLECTOR

NO. 2A FILTER →

CAMERA ON TRIPOD

EXPOSURE

To determine exposure for photographing fluorescing subjects, make a few simple test exposures. Individual situations will vary in much the same way as some situations you encounter in other types of picture-taking.

As a starting point, place two 15-watt BLB fluorescent tubes 12 to 18 inches from your subject, and set the lens opening at $f/16$ with KODAK EKTACHROME 64 Film. With this set-up, a 5-second exposure will usually produce acceptable results. Bracket your basic exposure by making exposures at $f/11$ and $f/22$.

A sensitive reflected-light exposure meter is helpful in determining correct exposure. Just set the meter for the normal film-speed rating for your film.

But you must be careful. That same villain, the reflected ultraviolet radiation that can affect your film so adversely without a filter over the camera lens, will also cause your meter to give incorrect readings. Therefore, you should make your meter reading through the same filter that you intend to use over the camera lens.

Frequently in black-light photography the backgrounds are very dark, so you should take close-up meter readings of only the subject areas

that are actually fluorescing. If your meter is built into the camera, you should move the camera in close to the subject to make the reading.

Even when you use an exposure meter, it's a good idea to bracket one stop over and one stop under the meter's recommended exposure, at least until you become familiar with the technique.

Most color films exhibit a reciprocity effect which decreases the effective film speed when the lens is open for 1 or 2 seconds or longer. Essentially, this means that you may have to give approximately twice the exposure indicated by the meter when this exposure exceeds a second. This is another good reason for bracketing your exposures. For specific information on the reciprocity characteristics of each Kodak color film, see the data sheets in *KODAK Films,* KODAK Publication No. AF-1, available from your photo dealer.

USES AND IDEAS

The uses of black light in creative photography are limited only by your imagination and willingness to try something new. Once you have mastered the basics, you can really let your ideas fly.

This geometrical pattern was made from a D-Stix set in Tinker Toy fashion, and was then painted with fluorescent paints.

While I was focusing, this interesting out-of-focus shape appeared in the viewfinder of my single-lens reflex camera. Let your imagination run wild.

Geometric Patterns

Geometric patterns are easily built with a toy called the Space Spider, available in most creative toy departments or from Edmund Scientific Co. (see page 104 for address and pictures). You can make many interesting designs with the fluorescent strings provided.

If geometric shapes intrigue you, photograph other toys such as D-Stix. Here you will have to add the fluorescent color by painting the sticks. Fluorescent spray paints come in a variety of colors and are easy to apply to these intricate forms. Once your setup is constructed, be sure to photograph it from many angles. Unusual angles frequently produce the best picture composition.

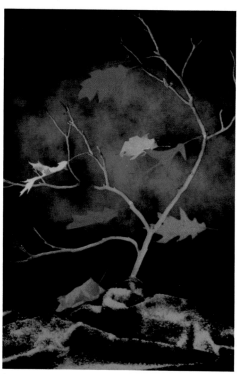

Fluorescent spray paints are very useful, and can be applied quickly and easily.

All the leaves were spray-painted; a brush was used to apply tempera fluorescent paint to the branch.

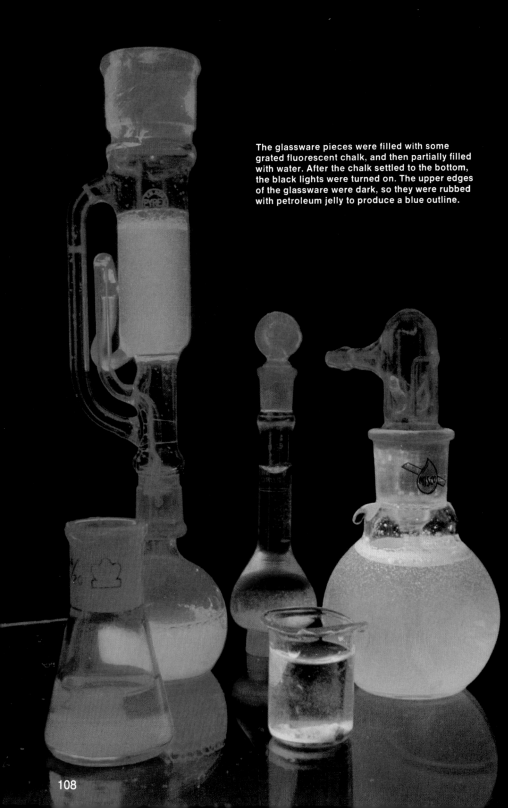

The glassware pieces were filled with some grated fluorescent chalk, and then partially filled with water. After the chalk settled to the bottom, the black lights were turned on. The upper edges of the glassware were dark, so they were rubbed with petroleum jelly to produce a blue outline.

Glassware

You can make some really exciting pictures of glassware filled with water to which some of the fluorescent watercolors have been added.

Another technique is to fill the bottom of the glass piece with grated fluorescent chalk and then partially fill it with water. After the chalk has had a chance to settle, a transparent color will be formed under the black light. This differs from the more opaque quality of color produced by watercolors.

To add highlights to the glassware, you can touch up the sides and rims of the containers with fluorescent paint of the same color as the water inside, or rub them with petroleum jelly to outline them in blue. This adds new interest and sparkle.

Tabletops

Traditional tabletop setups are fun, but try adding the punch of brilliant color by painting your props with fluorescent paints. You can enliven almost any tabletop setup by using this painting technique and black light.

Applying Fluorescent Paint

When painting materials such as glass, plastics, metal, and wood, you can usually get better adherence of the fluorescent paints and better color saturation if you first use a base coat of flat white latex paint.

Also, if you want to mix colors, do it under black light so that you can get the color you really want. You would probably be disappointed with the results if you mixed the paints in regular light and then saw them under black light.

All types of tabletop subjects can be painted and photographed. This spaced-out fantasy was made from plastic models.

These demons are halloween masks arranged in glass wool that was spray-painted with red fluorescent paint. BOO!

Even intricate objects can be painted. This clock was taken apart, each gear was sprayed a different color, and everything was put back together.

109

Action black-light photography is possible if you convert electronic flash to a black-light source by using a KODAK WRATTEN Ultraviolet Filter No. 18A over the unit. Black light at 1/1000 second stopped this dancer.

Ultraviolet-filtered electronic flash stopped this girl in midair. All clothes were made from fluorescent materials.

People and Action—with Strobe

One of the newest and most exciting areas of black-light photography is photographing motion by using an electronic flash converted to a black-light source with a KODAK WRATTEN Ultraviolet Filter No. 18A (see page 103). With this portable high-speed black-light source, you can open a new, vivid world of color and motion!

One of the most exciting and colorful applications of high-speed black-light photography is photographing go-go dancers in fluorescent costumes at discothèques.

Or closer to home, you can take pictures of your family suitably made up. Many cosmetics themselves fluoresce, and rubbing petroleum jelly into the skin will cause it to fluoresce an eerie blue. Many bright-colored clothes also fluoresce. This new field is a virtually unlimited one for your imagination to explore!

Special Effects

It's possible to extend black-light photography even further by combining it with other techniques. You might try bubble pictures lighted by black light. Place your subject in an aquarium or other clear transparent container, cover the subject with water, and then add club soda (approximately 1 part of club soda to 40 parts of water). In about an hour, an unusual effect will be obtained from the bubbles that form on the surface of the subject. Or you might go way out and use KODAK EKTACHROME Infrared Film and a No. 15 filter. For an interesting article on using EKTACHROME Infrared Film, see "The Exotic World of Color Infrared Photography," starting on page 1.

Reflected black light either alone or combined with ordinary visible light can be useful to illuminate shiny objects such as metal and glassware. You might even try the black-light flash method on such subjects as tropical fish for unusual nature pictures. For surrealistic effects, combine water and oil paints with powders and crayons. This mixture can be painted, poured, or smeared onto black construction paper and photographed both wet and dry.

As you can see, the possibilities are great, and there's lots of room for experimentation. Use your ingenuity to extend your photographic horizons.

The subject was placed under water in a fishbowl; then club soda was added to the water. After an hour or so these bubbles formed, giving a new twist to the black-light effect.

Black lights were used to illuminate large pieces of fluorescent paper hung around a room. The resulting reflected light produced this pleasing still life.

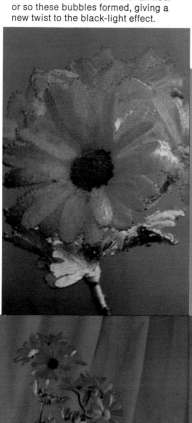

A pleasing still life photographed under black light with KODAK EKTACHROME Film.

The same scene and light source, but KODAK EKTACHROME Infrared Film was used with a No. 15 filter over the camera lens.

"We travel together, passengers on a little spaceship, dependent on its vulnerable resources of air and soil; all committed for our safety to its security and peace: preserved from annihilation only by the care, the work, and, I will say, the love we give our fragile craft." —*Adlai Stevenson*

CLEAN THE SCENE WITH PICTURES

by John Stampfli

You and your camera can make significant contributions to your community. As a photo hobbyist, you can become personally involved in constructive environmental-action projects. Your pictures can provide an accurate and dramatic message that will create the public awareness and concern needed to promote conservation, beautification, and pollution-abatement programs.

The Boys' Club of Greeley, Colorado, made a slide program documenting defaced traffic signs and underpasses. They showed their slides in schools and to the public, explaining the high cost of vandalism to state and county taxpayers. The result has been a *decrease* in the frequency of vandalism!

The Consumer Council of Monroe County (New York) made a promotional movie and a photographic poster to help collect more than 100 tons of glass that provided $2000 for local consumer-education programs.

The Environmental Defense Fund, East Setauket, New York, uses photographs as testimonial evidence in the courtroom against polluters.

KDB Teens for a Greater Detroit takes pictures of garbage and litter to encourage local merchants to obey existing city ordinances.

Chances are your community already has several environmental organizations actively pursuing a variety of improvement projects. These groups can use your pictures to document their work, solicit funds, recruit volunteer help, educate the public, and produce positive results. Your photographic talent is desperately needed!

John Stampfli, an Advertising Planner in Kodak's Consumer Markets Division, plans the advertising objectives, budgets, and media for a variety of products, including movie equipment, processing services, and darkroom equipment. Formerly a Publications Editor, John wrote and took pictures for Kodak books and pamphlets for amateur photographers, specializing in youth photography and community-service photography.

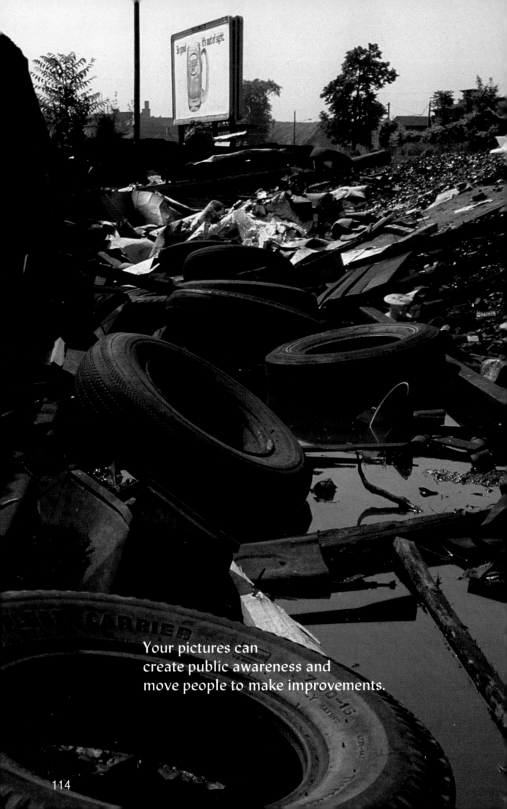

Your pictures can
create public awareness and
move people to make improvements.

Your first step is to become acquainted with the vital environmental issues in your community. These may involve solid-waste disposal facilities; water-treatment plants; recycling of glass, paper, and used metals; and the preservation of open spaces and natural areas. You can keep informed through the news media, your public library, and newsletters published by local environmental groups. *Take the time to study the facts carefully.* It's also a good idea to be aware of what's being done in other cities and towns. Reading newspapers, magazines, and newsletters will give you an overview of the national issues and an insight into what you can do.

This vacant lot is wasted space and an eyesore, and is dangerous to children.

BE CONSTRUCTIVE

While you are doing your research, think about the kinds of pictures you can take to help produce positive results. You'll have to be able to suggest *constructive* ways to improve existing conditions. Merely pointing your finger at a bad situation may not produce results.

Let's take an example. Suppose your city or town owns a vacant lot that is spattered with broken glass and other debris. This can be both a danger to children and a waste of valuable land, especially if it's located in an area of dense population. Showing pictures of the bad effects may not be a strong enough message to move people to make changes.

You can greatly enhance your chances of success by showing that

We can convert the lot into an attractive and valuable playground like this one.

this dangerous vacant lot can be converted into a useful, healthy playground or mini-park for the children in the area. Here are examples of the kinds of pictures you can use to illustrate the existing situation and the proposed playground. Naturally, you should include information on how much it will cost to create and maintain such a playground.

This black-and-white photograph of a pond does not record the situation effectively.

Notice how much better color film shows the plant life.

EQUIPMENT

Camera

You can use any simple, automatic, or adjustable camera to make good environmental pictures. However, an adjustable or automatic camera with a variety of shutter speeds and lens openings will allow you to take pictures under almost any conditions.

Film

Color pictures will *generally* be much more effective than black-and-white. This is especially true if you are documenting examples of air and water pollution or wildlife for conservation purposes. If you need a fast color film for night pictures, for obtaining greater depth of field, or for stopping action with fast shutter speeds, see "Lighting," page 123.

Accessory Lenses

If you have accessory lenses, here's how to use them to good advantage.

Telephoto lenses. Many times you won't be able to get as close to your subject as you would like to for a dramatic picture. In such a situation, a telephoto lens may be helpful, especially when you're photographing examples of air pollution.

Many groups concerned with visual pollution are currently striving to change local zoning laws regulating the dimensions and placement of advertising signs and billboards. Pictures provide an effective way of showing the current situation. However, a strong telephoto lens may actually *distort* the facts by making signs appear

117

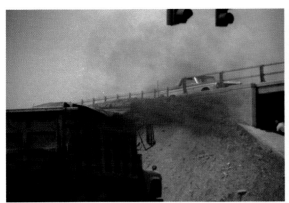

This is the perspective you would see if you walked down the side-walk. This picture was made with a 50-mm lens.

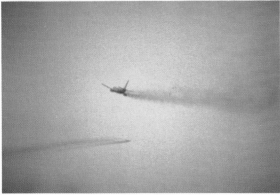

These two pictures were made with a 200-mm lens on a 35-mm camera. You can use pictures like these in a presentation about air *or* noise pollution.

This is the same scene photographed with a 200-mm lens, and from a *slightly* different camera position. Notice how the signs appear to be closer together and the entire scene seems more cramped than it actually is. This picture distorts the actual situation.

to be closer together than they actually are. Compare these two pictures made with the same 35-mm camera and from approximately the same location. They are printed full-frame and both are enlarged to the same percentage.

Because photographs have such a strong emotional impact, you have a special responsibility to be sure that all of your pictures show situations as they actually exist. You should not distort the facts in any manner with your pictures.

Wide-angle lenses. A wide-angle lens is helpful when you want to establish the location for your audience. Many times you won't be able to stand far enough away from your subject with a normal lens to include as much of it as you would like to show.

Close-up lenses. Close-up lenses can be used effectively for photographing pollution-abatement, conservation, and beautification projects. They help you take dramatic close-up pictures of flowers, wildlife, plant life, and debris. Your photo dealer can help you fit your camera with the right close-up lens. To take close-up pictures, follow the instructions that come with your close-up lens.

A wide-angle lens (28-mm on a 35-mm camera) helps the photographer show the location of this vacant lot by including a street sign and surrounding buildings and houses.

You can use close-up pictures like this one to promote beautification projects. Another example of an effective close-up picture is the one showing glass and debris in the playground photo story on page 116.

I used a wide-angle lens (28-mm) to establish the location and identity of the smokestack, and then changed to a telephoto lens (200-mm) to illustrate the problem more dramatically. Both of these pictures were taken from the same location with a 35-mm camera.

PICTURE STORIES

A picture story is simply a sequence of two or more photographs that together tell a story. A sequence of pictures will often be much more effective than a single picture for your projects. Be sure to document your *entire* project by taking "before," "during," and "after" pictures.

It's also a good idea to take extra pictures so that you'll have them on hand if the need arises. For example, you may want to send some original slides to local government officials or a newspaper, or enter them in a photo contest, and also keep similar originals for a slide presentation you have created.

"Before" and "after" pictures are an excellent way to show the benefits of your activities and to sell a proposed project. If you can graphically show good results along with the conditions you want to change or have already changed, you'll make quite an impression on your audience.

Sometimes you may want to use a sequence of "before" and "after" pictures, as we did for the story about the playground on page 116. You can use a sequence of pictures to convince the proper people of the many benefits that a pedestrian mall provides for shoppers, tourists, and local businesses.

If you think your city might benefit from a pedestrian mall, take "before" pictures of an existing street (with traffic) in your city. Then you'll need some "after" pictures. You may want to visit a city that now has such a mall (for example, Minneapolis, Boston, or Fresno). Or you may want to encourage your city to convert a local street to a pedestrian mall on a *trial basis* for a week (Toronto has done this).

Take pictures to document the results. Then use these "after" pictures to promote a permanent mall. Here's a photo story of the beautiful Nicollet Mall in Minneapolis. It's a good idea to photograph signs and use them as title pictures in your photo stories.

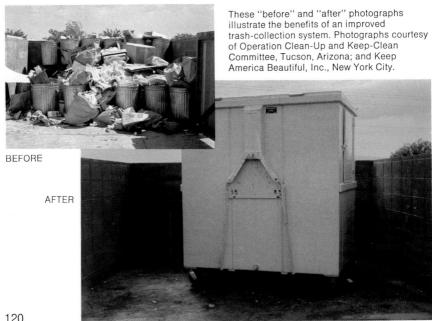

These "before" and "after" photographs illustrate the benefits of an improved trash-collection system. Photographs courtesy of Operation Clean-Up and Keep-Clean Committee, Tucson, Arizona; and Keep America Beautiful, Inc., New York City.

BEFORE

AFTER

120

LIGHTING

Because our environment is a 24-hour concern, you may want to take pictures at dawn, dusk, and night in addition to during the day. In many cases, flash won't cover the area you want to photograph, so you'll need a fast film and a camera with an $f/2.8$ or faster lens to take existing-light pictures at night.

By taking advantage of a special processing service offered by Kodak for high-speed KODAK EKTACHROME Films, you can increase the film speed of EKTACHROME 200 Film (Daylight) by 2 times—to ASA 400—and the speed of EKTACHROME 160 Film (Tungsten) by 2 times to ASA 320. This special processing is available for film in 135 and 120 sizes only.

To get special processing, buy a KODAK Special Processing Envelope, ESP-1, from your photo dealer. The cost of the ESP-1 Envelope is in addition to the charge for regular processing by Kodak. After you've exposed the film at the increased speed, put it in the ESP-1 Envelope and take it to your dealer for special processing by Kodak, or mail it directly to a U. S. Kodak Processing Laboratory in the appropriate KODAK Mailer. The addresses of these laboratories are printed on the mailer.

You can take nighttime pictures like this one of the Nicollet Mall with KODAK EKTACHROME 200 Film (Daylight) pushed to ASA 400. The same subject photographed at night on Tungsten film may appear more natural to some people.

Backlighting

When photographing examples of air pollution, you'll find it helpful to use backlighting. With frontlighting, the smoke doesn't appear as dark as it really is. You'll also get better results if the sky is blue rather than overcast.

The smoke in this picture does not appear as dense or dirty as it actually is. Frontlighting was used to make this picture—the sun was behind the photographer, shining on the sides of the smokestacks facing the photographer.

Notice how much more revealing this picture is! Here are the same smokestacks, photographed only minutes later. The photographer moved to the opposite side of the smokestacks so that backlighting would clearly show the density of the smoke.

You can present a slide show or movie, or prepare a print display like this one for your city or town hall, schools, public libraries, museums, church halls, shopping malls, banks, and local ecology fairs and workshops. This display at the Brighton (New York) Town Hall documents the work of the Brighton High School Anti-Pollution Club. Photograph by Stan Feingold.

SHOWING YOUR PICTURES

You'll have to expose many people to your environmental pictures if you want to produce results. You can do this by means of a slide or movie presentation, a photo report book, or a print display.

Show your pictures to your family, friends, neighbors, teachers, local environmental organizations, and government officials. You may want to send a photograph with a letter to the "letters to the editor" section of your local newspaper. Many communities now sponsor "dirty picture" contests. Be sure to submit your best pictures.

ACTION TIPS

1. Convince yourself of your personal responsibility to do your part in constructing a healthy environment in your community.

2. Get the facts! Do sufficient research (reading and discussion) to acquaint yourself with the environmental issues and organizations in your community.

3. Select **one** environmental-action project to pursue.

4. Plan your picture story.

5. Take plenty of pictures initially so that you can show only your best ones; then you'll have extra pictures when the need arises.

6. Be complete—document every step of your project with pictures.

7. Keep your camera loaded and ready for action! Opportunities for good pictures will arise unexpectedly.

8. Be patient and allow plenty of time to complete your photo story. You may have to search hard for just the right picture.

9. Only a qualified person using special equipment can determine whether air or water is polluted. If your pictures lead you to suspect that you have discovered air or water pollution, contact your County Health Department. They can tell you who is qualified to make a scientific analysis.

10. Keep elected and appointed political officials of your local, state, and federal governments (as well as news media) informed about your project. Make sure they see your pictures!

11. Show your pictures as often as possible to as many people as possible.

12. Teach others how they can take and make use of pictures to produce positive results.

A canoe or boat may help you in photographing shoreline areas that can't be reached by land.

Sometimes your best viewpoint will be from
the air. This picture shows how a pond and
trees can enhance a college campus.
Ironically, it also illustrates the vast amount
of land required for parking space. It might
also point out the need for planting trees
and shrubs to help beautify parking lots.

Ordinary citizens in the streets merit special attention. Bright saris may be common and everyday in India, but to you they may be a whole new experience. Your moderate telephoto lens will keep you at a respectful distance. Please ask your subjects' permission.

NOTES ON TRAVEL PHOTOGRAPHY

by George Butt, APSA

Involvement—total involvement—is the phrase that best expresses my feelings about travel photography. Eliminate the distance between you and your new surroundings in every way if you want to make prizewinning travel pictures and slide shows that will send your friends to the nearest travel agent. You should plan, travel, and live your trip—baptized in the flavor of the lands you're traversing.

You'll be the producer, director, and photographer for your travelogue. The producer sets the objectives: Will you see the sights and take only record-keeping snapshots, or will you spend a little extra time to bring home all the wonders in photos? I prefer to do the latter. Snapshots of the world's famous landmarks are as common as French fries. Researching your destination will give you better pictures that radiate local atmosphere.

The director assumes the responsibility for setting up picture-taking situations in the most interesting locations. The locale must be researched to find the little details that mean so much in telling a story.

The photographer, of course, is the person who comes home with the pictures. Responsible for equipment and all aspects of camera handling, the director's function is the most basic. You'll be all of these people, so challenge yourself to make an outstanding picture story of every place you will explore.

George Butt is the Coordinator of Program Services in the Photo Information department at Kodak, where he supervises the production and presentation of programs on a variety of photographic subjects throughout the world. With more than 25 years of experience as an international photographic judge, teacher, lecturer, professional photographer, and cinematographer, George brings a wealth of practical experience to his audiences. His inspirational photographic presentations have been enjoyed throughout the United States and Canada, and readers of *The Fifth and Sixth Here's How* will remember George's article "The Art of Seeing."

ORGANIZATION

Whether I'm producing a feature-length multimedia travel presentation for audiences around the country or

(continued on page 133)

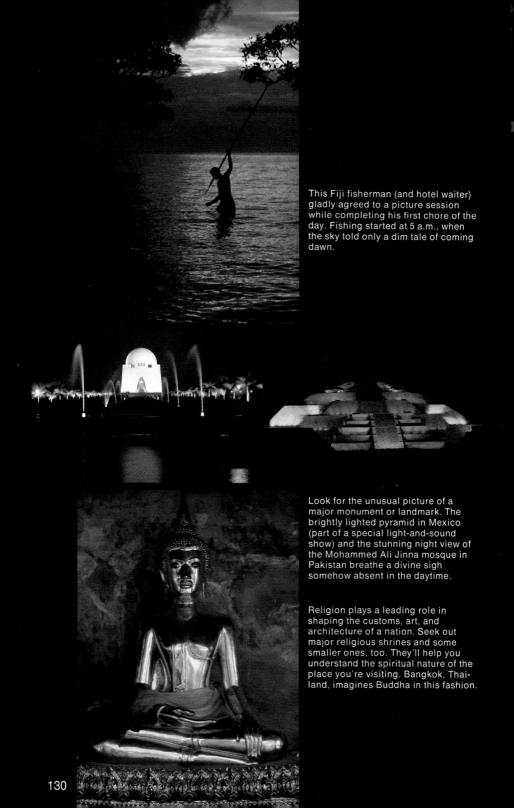

This Fiji fisherman (and hotel waiter) gladly agreed to a picture session while completing his first chore of the day. Fishing started at 5 a.m., when the sky told only a dim tale of coming dawn.

Look for the unusual picture of a major monument or landmark. The brightly lighted pyramid in Mexico (part of a special light-and-sound show) and the stunning night view of the Mohammed Ali Jinna mosque in Pakistan breathe a divine sigh somehow absent in the daytime.

Religion plays a leading role in shaping the customs, art, and architecture of a nation. Seek out major religious shrines and some smaller ones, too. They'll help you understand the spiritual nature of the place you're visiting. Bangkok, Thailand, imagines Buddha in this fashion.

Topography, housing, climatic conditions, color, and natural wonders attract my attention during pre-trip research. It was no accident that the peculiar houses of Afghanistan, the terraced hillsides of Nepal, and the glowing flower fields of Kashmir caught our lenses. The mountains didn't come as much of a surprise, either.

Your research should give you an idea of important national holidays and other times of celebration. You'll see bright costumes, indigenous dances, and other activities. Above: Mexican pole-dancers recreate an ancient ceremony for tourists in Acapulco. The feathered headdress of this Mexican Indian appears only on special occasions. A Kandy dancer in Ceylon offers homage and thanks to the gods who tolerate her existence. The Royal Fiji Military Forces Band greets each ship that docks in Suva. Color and action like this will keep your camera busy for hours.

simply taking a weekend pleasure trip, I spend adequate time researching the areas I plan to visit.

Questions such as where to go, what to do, how to get there, and what to see usually mean a few trips to the library and my travel agent, some browsing time in the local news store, and letters to tourist bureaus representing the places I plan to see.

Although everyone's preferences vary widely, I'd like to make a case for traveling by car. In a car you're entirely the master of your own destiny. If you see a magnificent landscape, you can stop to capture it on film. If you want to enjoy a roadside picnic with the particular fruits of the land, that's easy, too. Of course, it's a bit difficult to drive from here to Europe, but it's very easy to rent a car once you arrive there.

Since I often make these car journeys, I find that I have to budget my time pretty carefully to emphasize the important places that I especially want to see. The great body of my research helps me to know roughly what I most want to see and where to find it, and assists me in allowing enough time to get there and enjoy it. Here are some of the subjects I try to check out for picture possibilities when I'm gathering information about a place: major landmarks, industry, history, religion, culture, products, agriculture, topography, weather, foods, types of transportation, animal life, and forms of popular entertainment. I also try to note holidays and feast days, when there will be colorful costumes, dances, and other activities.

One of my favorite sources of travel tips and general information deserves special mention. Almost every nation you'll ever want to see operates a government bureau devoted exclusively to tourism, one of the world's leading industries. In many places it may be the only income-producing industry except for a small curio-export flow. Governments of all tourist-supported places want to make your journey pleasant, so long before you embark, write to your local representative of the place you plan to visit. If there is no local representative, get in touch with that country's office in New York City. The information they'll give you will be up to date, and they'll be glad to answer specific questions.

Some places have even instituted a program designed to make individual visitors feel at home. Jamaica offers a "Meet the People" program where Jamaicans host individual travelers with interests similar to their own. In many cases the guests are invited to stay in private homes and participate in local activities. Can you think of a better way to become a part of the place you're visiting? Several photo organizations also offer assistance to traveling members.

I organize my trip around the sights I really want to see, and the ones that I think would be the most photogenic. I don't have to say that the most interesting places, people, and things are the remarkable ones—the ones that are distinct from the rest of the world in some way. For instance, I see nothing unusual about the fact that Americans ski in the winter, but it's an odd twist that while Americans are skiing, Australians on the other side of the world are surfing and enjoying the sun. So I allot my time, buy tickets, and make reservations accordingly.

EQUIPMENT

Although each journey might demand something a bit different in the way of camera equipment, I set certain broad, general guidelines for myself, and try to keep everything as simple as possible. If I'm going on strictly nonphotographic business, and I don't want

Fishing is a major
industry in much of the
world. You'll find that
some peoples have an
approach different from
that of their cousins.
Netting is popular in
one region of Ceylon,
whereas other villages
prefer the solitude of
using a pole.

to be burdened with gear that won't get much use, I take a KODAK TRIMLITE INSTAMATIC® Camera. I keep it with me and make great pictures of unusual sights at a moment's notice. It can be carried inconspicuously in a pocket, a purse, or a briefcase.

When I'm traveling for pleasure, or taking still pictures for Kodak wide-screen programs, I ordinarily pack two compatible camera bodies and three or four lenses. The extra body is good backup in case of a breakdown. It also gives me the option of keeping two different lenses mounted, and two types of film available. I like a medium zoom lens in the 40—80-mm range, a telephoto zoom about 80—200 mm, and a wide-angle lens in the 24—28-mm neighborhood. I occasionally indulge myself by carrying a fast lens in the 105—135-mm range that's handy for making good people pictures under almost any lighting conditions.

You could call me a general picture-taker with no particular areas of specialization. I don't require the extra-long lenses necessary for wild-animal photography, and I would rarely need a tripod. The same goes for a flash unit. A fast lens ($f/2$ or faster) and high-speed KODAK EKTACHROME 200 Film with special processing for increased film speed give me the pictures I want in low-light situations.

Perhaps the best advice I ever heard about traveling with photo equipment was, "Have your camera checked over by a competent repair technician before your trip so that you'll know it's working properly." If your camera is new, make sure you spend a little time getting used to it. Take some pictures before you go so that you know what kind of results to expect. *And read the instruction manual*—it will help guard against many easy-to-avoid problems.

Before I leave the United States, I always register all photo gear made outside the U.S. with the customs office to prove that I bought each piece of equipment here. This simple procedure allows me to reenter the U.S. without having to pay duty.

FILM IS IMPORTANT, TOO

If you standardize your film supply, you'll get used to the same exposure settings for normal conditions (a good automatic check system on your meter), and you won't get confused about the speed of the film you have in the camera. For my good-weather outdoor picture-taking, I like a medium-speed transparency film, such as KODACHROME 64 Film or KODAK EKTACHROME 64 Film. I try to take about twice as much film as I think I'll need. For special occasions at night or indoors, I take a small supply of high-speed KODAK EKTACHROME Film (Daylight) and (Tungsten). If you want to lighten your load as you go along, you can send your exposed film back in prepaid mailers. You won't have to carry it; it'll be safe from the hazards of travel, and it'll probably be waiting for you at home, ready to view when you get there.

TRAVELING

I begin my involvement and romance with my location before the rising of the sun. I always feel a little guilty about staying in bed, because an inner voice tells me to get as much out of my travel time as possible. This often means dawn pictures, and in the tropics the liquid-red rising sun is one of the most dramatic sights to capture, especially when you magnify it with a telephoto lens.

More important, nearly any city is at its brightest and liveliest in the early morning. The real events that keep the

That shimmering dawn horizon, hinting at a world
both fascinating and mysterious, is rarely seen in the
northeastern United States. Maybe I overdo it,
but I can't resist dawn pictures like this.

The marketplace is often a center of blurring activity. You'll always find photogenic color, strange foods, exotic products, and many, many people. Left, top to bottom: Vegetable market in Karachi, Pakistan; handicraft stall in Papeete, Tahiti; and kite market in Bangkok, Thailand. The airborne kite at the bottom hatched in the kite market. Freed from its perch it soared like a bird. Right: Market in Amecameca, Mexico. The market can tell you much about the entire economy and tastes of the area you're visiting.

city alive are happening in the market-place, on the docks, and in the streets. Bartering, wheedling, colors, noise, products you've never seen before, strange and exotic food, fascinating faces, and odd animals will give you a good feeling for what is going on in a region. You'll often discover crafts and curio-making that you didn't know existed. Sometimes you can make contacts in the market that will later help you get a picture story of the production of some fascinating craft item. Flavors, smells, colors, light, and noises are all concentrated in the early-morning workings of a city, and that's when to tune in to the emotional wavelength of a particular place.

Talk to the people you see, ask plenty of questions as they're working or playing, and you may pop up with a fantastic subject for a picture sequence. You're really after photo stories, not unrelated snapshots ("That last one was Athens, and, oh yes, this is Barcelona"). As the pulse of a community's native life, the market is a grand place to pursue potential photo stories and learn more about native activities and their roles in the workings of that country. You can usually count on picking up tips on the important crafts of the locale (although the natives think of them as necessary livelihoods, not mere "crafts"). You'll also get a pretty good idea of local industry and agriculture. Is fishing important, and is it performed any differently from that in the other fishing lands of the world? Are any unusual crops grown—grapes, dates, coconuts, tea, mangoes — and do these crops require special farming techniques? The market is where you get the ideas. Then it's up to you to make necessary arrangements for the pictures of unique activities that would most interest your friends or any other audience.

I always find this sort of bargaining quite pleasant. Let's say that you've found a woman who makes splendid pottery pieces. In fact, her wares are the region's best and most typical and she has attracted widespread attention. Naturally you want to photograph her at work, and spend some time photographing the other terrific creations she has in her shop or dwelling. If you see this person in the market, your best bet is to talk to her in sign language or whatever tongue you share, and explain just exactly what you have in mind. Unless religion or suspicion interfere, your prospective subject should cheerfully agree to be photographed.

When you've been fortunate enough to find a willing subject for a photo story, one who will keep on working (and maybe explain the steps while you shoot), you'll find that the two of you will share a fairly close relationship for a short time. It's important that you reciprocate the favor. Most people nice enough to share their work with you would be insulted if you offered them money, but you can certainly offer to buy the piece that they have been working on and that you've been photographing, even if it's only partly made. I've classed my many half-carved figures and rough-polished pottery among my most prized possessions from a trip. One of my co-workers, Bob Harris, guessed that he had the only half-carved elephant in the world after he returned from our last trip to Ceylon. That's one way to repay a favor.

Another popular way to say "thanks" is to promise to send enlargements—all well and good if you follow through. Many photographers offer prints of their pictures to reluctant models. We've done quite a bit of this ourselves, and it's fine if we don't get lazy and forget about the

Legendary Mexican craftsmaster Rosa fashions one of her world-famous black vessels in Oaxaca. We asked her for pictures and she kindly obliged. In return, we bought several of her pieces, including the one she was making.

whole thing once we return home. Naturally, *we* don't get hurt by forgetting, but pity the next photographer who follows in our footsteps. Can you imagine what kind of reception he or she will get? Sometimes we'll devote a couple of days back home to preparing pictures for people who helped us on our journeys.

No matter what you take, grab shots or a prolonged study in photographs, be sure to extend the courtesy of asking permission to take the pictures. Many tourists we've seen just stick a camera in someone's face, shoot, and then run like crazy. It's not fair to the subject—who's just been treated as an object of local interest, not as a person—and it certainly isn't fair to the next person who tries to take a picture. It's plain good manners to let people know you're in the area taking pictures. This usually works out well, because after a few minutes, when the embarrassment wears off and business gets back to normal, you'll become an accepted part of the scene. You'll see great expressions, free from self-consciousness, and you can come and go as you please, at any distance.

When you're asking permission, try to use the local language if you can. This mark of respect is always welcomed. If you're stumped by the words, try charades. Point to your camera, and to your subject, and then SMILE. We've found that smiles will get you further than all the gasoline in the world. If you travel long enough, though, you may find yourself using this technique at home, where it's likely to make people wonder.

I must admit that sometimes native people won't respond to your desires or requests. It's not that they don't want to—it's just that they're not accustomed to your ideas. If it's not part

Silversmiths of this man's caliber are rare, even in Taxco, Mexico. We contacted the shop where he worked, and they cooperated beautifully. A little extra effort can get you pictures that will take your audience out of the ordinary textbook and travel-magazine world.

The town of Oaxaca, Mexico, with what is reputed to be one of the purest strains of Indian descendants, gave us many picture stories. The women under the tree in the center picture are weaving the belts you see in the other two frames.

I feel that photo stories are important in making a coherent visual statement. A single shot of a subject is often like an unfinished sentence.

In Iran we made a long
sequence on the fabulous art
of rug-weaving, which
demands a woman with the
fine eye, patience, and care
to follow through on
such an exacting task.

Native crafts depict in
miniature the lifeblood,
happiness, sadness, color,
and sophistication of a
culture, as you can see by
this Pakistani's glowing urn.

South Seas copra
production starts with
picking coconuts. The
nuts are opened and left
to dry in the sun. The
fermented meat later
provides margarine,
suntan oil, and soap.

143

Don't overlook native foods in your quest for local flavor. Record the preparation and consumption of a typical feast for the uninitiated back home.

In this down-to-earth series, Toby, our aborigine guide through the swamps of northwest Australia, invited us to his simple but effective midday feast during a special expedition to photograph alligators. We planned to spend the day traveling the waterways of this remote region but overlooked the need for a meal. Toby's answer was to catch a fish (a barramundi, by the way) in the native fashion, kindle a fire, cook the fish in broad leaves, and serve a succulent, though primitive, meal. Naturally, our cameras never cooled off during the whole event.

of their routine, you may never get your idea across. In one place, the phrase "coffee now" was greeted with smiles and much head-nodding *before breakfast,* and we relaxed, confident that the steaming brew was on its way. Unfortunately, the custom was coffee *after breakfast,* and that's when we got it. This sort of thing, however, happens rarely if you stay in one of the giant international hotels, because the staff is used to serving American needs.

You may want to sample the typical local accommodations. Small hotels offer the true flavor of the area and have reasonable prices. Respected as a seasoned traveler, you'll get the pick of native foods and more obliging service. Try staying in guest homes when you're in foreign cities, and in rural areas try to get lodging in a plantation home. This way you'll feel closer to what's really going on there. You can't help but take better pictures if you involve yourself in the community. You must understand your surroundings before you can photograph them honestly. A more graphic demonstration of this philosophy appears in the accompanying panel (Toby and the fish). As you can see, the preparation of unusual native foods can give you an exciting sequence that will startle your most jaded audience ("You mean you ate it, too?").

TECHNIQUES
Burden
I should introduce this section by saying that the various bits of wisdom that follow were all learned the hard way. Is there any other way to learn? They may help you—they've certainly made my life a lot easier.

Nearly my first waking command to myself every day is not to bog myself down with photo equipment that I'm not going to use. Perhaps I planned this day's itinerary the evening before and I've decided what I need to make pictures. If I take too much equipment, the activity will leave me behind. I need to be free to help—I once aided some fishermen getting their boat into the water. I may find myself working, playing, chasing the action—doing whatever is called for. Many foreign people caricature the American tourist as a display stand for photo gadgetry. I like either to carry a small, inconspicuous bag for film and my two extra lenses, or to wear a many-pocketed fisherman's vest, which allows me almost complete freedom. If you choose to climb a tree, you don't want your gear hanging all over you!

Exposure and Lighting
There's nothing tricky about the exposure for most travel photography. I've memorized the information on the film instruction sheet for normal conditions on a sunny day. When the sun goes away or when I get into shadowed areas, I rely strongly on my in-camera meter. If there is a group of us working on the same location, we try to keep each other posted about exposure so that one person doesn't accidentally go haywire. It's good to check the meters in your two camera bodies every now and then to see if they match. If they don't, compare both with the settings printed on film instruction sheets. If you don't have an extra camera body with a meter, consider a separate meter.

If I can timorously mention morning pictures once again, you'll find that early light is extremely flattering to buildings, landscapes, and seascapes. It's soft but dramatic. The shadows are long but less dense than later in the day. Since the industrial day has not yet begun, you'll find that dust, haze, and smog haven't discolored city skies. This is especially important

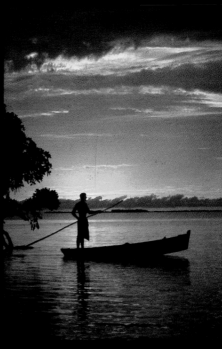

Pictures taken at different times of day can liven up your travel presentation. Sunrise or sunset will flood any scene with rich, warm color, streaking dramatic shadows across ruins, buildings, and textured landscapes.

when many countries have serious pollution problems in their cities. Morning is also the best time to take aerial photos, because the air is clear. Keep this in mind when you're booking reservations, or when you're lucky enough to be reserving a charter flight.

Filters

Natural-looking pictures please me most, so I rarely use filters. Since most of the pictures I shoot are used in travel slide shows, it's important that the color saturation, density, and hue of individual slides don't contrast markedly with those of other slides. Constantly changing skies, water, faces, and foliage will confuse any audience.

Security

I try to observe normal precautions to protect my equipment. I keep it within easy reach. In an airline bag, my cameras and lenses are quite inconspicuous and not tempting to a thief.

The idea of film fogged by x-rays is quite unnerving. Generally, when you travel by airplane within the U.S.A., *unexposed* film can be x-ray inspected up to five times without apparent damage—especially if it is reoriented between flights. If more inspections are anticipated, place the film in carry-on luggage and request visual inspection by airport security officials. Allow extra time for this procedure when checking in. *Outside the U.S.A. and when embarking on foreign airlines at a U.S. international airport, visual inspection of carry-on luggage is recommended.* Mark any checked luggage containing *unexposed* film with "DO NOT X-RAY" signs.

Keep It Clean

One good way to avoid possible camera breakdown is to do a little preventive maintenance every night. I make sure that the lenses I used during the day are free from dust, sand, and salt spray if I've been near the ocean. I watch the shutter open and close at several speeds to see that it's operating normally. Finally, I blow out any foreign particles that might have sneaked into the camera bodies by using an air syringe.

Action

Action, ideally, requires a movie camera, but we're not talking movies. My three action techniques are simple, and I use them all so that one doesn't become repetitious in a travel show. Panning, or moving your camera with your subject, will give you a partly sharp subject and a blurred background. Very fast shutter speeds (above 1/250 second) will freeze the motion so that all elements of the scene are sharp. A slow shutter speed will let everything blur a bit, capturing movement over a wider slice of time.

Aside from pure camera technique, there are two other ways to consider action photography. One is to take the position of the spectator. The other —and few people ever think of this— is to take the position of the participant and be part of the action. A mixture of the two provides perspective for a show.

In the sequence on parasailing (traveling by parachute) in Acapulco, you'll notice that some of the pictures were taken on the ground, and some were taken in the air by the parasailor. To gain a proper feeling for an action situation, your audience ought to be offered the chance to sit in the driver's seat. Let them *become involved!*

Getting into the arena is easier than you'd think in many foreign places. Sports clubs, both amateur and professional, are often cooperative in getting you pictures. In Australia (or anywhere), a cricket game is far

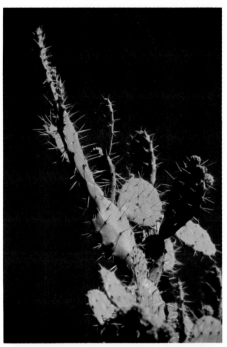

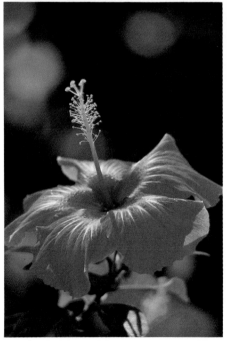

Many travelers ignore the smallest wonders of their travels. I make it an exercise to *see* the small things around me. Cactus, thistle, or flowers can add a real feeling to your show. Vary your scale—landscapes, people, flowers, buildings. Don't keep your eyes or your camera focused at the same distance all the time.

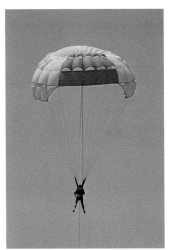

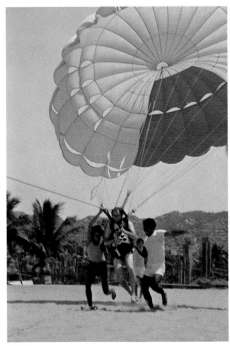

Action sequences ought to involve your audience when at all possible. Here, one of my intrepid co-workers flew a parasail and took pictures from the air while the rest of us recorded the stunt from the ground. Our audiences have applauded the bird's-eye view enthusiastically.

Tradition rules the play of a cricket match. To get the close-ups of the wicket, the batter's stance, and the catching mitts, we asked to attend a practice session, when we wouldn't be in the way. The long shot was made during an actual game.

too traditional an affair to allow a photographer in the middle of the premises. But you can ask to attend a practice session, where you'll be able to make important storytelling pictures, close-ups, dramatic angle shots, and photos that will help you explain how the game is played.

While trying to take pictures of a polo match in Calcutta, we got the players and horses to cooperate during warm-up, enabling us to shoot spectacular "you-are-there" pictures. These pictures blended later with the spectator pictures taken during the game to make a real story. Naturally, we found ways to use the warm-up pictures that avoided the obvious question, "Were those really taken during the game?" I don't like that question, so I try to be a bit coy. Notice the close-up of the player's head. Who can tell that those eyes weren't looking toward a real goal?

It's easy to get cooperation from

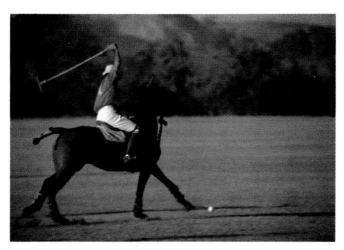

The experience we gained from the Australian cricket match inspired us to try the same technique on an Indian polo match. All the close-ups and even the medium shots were taken during the pregame warm-up period. Our game-time pictures show a more general view.

sports clubs, even if they're professional. They can always use good public-relations pictures, and you're going to be in a position to supply them, free. Share your pictures—everybody benefits!

SUMMARY

If I have a major message here, it's this: Everyone takes pictures of the well-known scenics and landmarks; few people get involved to the point of bringing back the essence of the places they've visited. When I make a slide presentation, I want the audience to learn what it must be like to live in the places they're seeing. Immerse yourself in the communities you visit. Learn their schedules, stay in their hotels, eat their food, watch and help them work and play, and learn and respect their culture. You'll get better pictures, and as we all know, better pictures make better travel shows.

PRODUCING SUCCESSFUL SLIDE SHOWS

by Keith Boas

Presenting a slide show effectively can go a long way toward guaranteeing its success. Your program subject may have all the makings for strong audience appeal, but chances are it will not be communicated successfully unless you present the package well. The polish that results from good program organization, program pacing, and careful picture selection will be at least fifty percent responsible for the success of your show.

The points that follow are cornerstones of successful visual communication, that is, the flow of thoughts, ideas, opinions, and general information from you to your audience through a pictorial medium. Let's take a look at a few tips for showing your pictures effectively and in such a way that you'll distinguish yourself as a master of your craft.

Photographer, editor, and writer, Keith Boas holds a Bachelor of Fine Arts degree in Photography from the Rochester Institute of Technology. Before joining Kodak in 1962, Keith was a commercial photographer in the New York State Adirondack Mountains. Hundreds of his photographs depicting the area have appeared in magazines, on postcards, and in advertising brochures. He has also won recognition as both a salon exhibitor and a salon judge.

Currently, Keith writes and edits KODAK Photo Books for Consumer Markets Publications at Kodak. Having served in a variety of interesting capacities, he has traveled throughout the United States researching material for his publications, making television appearances, and lecturing on photography. His picture-taking assignments have taken him to such exotic locations as New Zealand, Bora Bora, Tahiti, Fiji, Holland, and the Carribbean.

PLANNING

There are probably as many different approaches to creating a slide program as there are places and subjects to photograph. But in each case, good organization is essential for professional-looking results. Before the first click of the shutter, research your subject. You'll want to begin your project fully prepared with everything you'll need to get good pictures and good picture variety. Visit your local library; send for specific literature; ask questions.

In general, know your topic thoroughly. During the research phase, make notes and work them into a written treatment (an outline of your program). Visualize and then describe

Making multi-image slides is one way
to increase the impact of your slide presentation.
See pages 161-166 for more details.

on paper how you want the finished program to flow. The more thorough your planning is at this point, the more easily the pictures will blend later.

The plan of your slide show should always be at the back of your mind during all picture-taking sessions. As you make photographs, you will no doubt form new ideas or decide to expand old ones, so keep your treatment somewhat flexible. If you use a 3 x 5-inch index card for each of the pictures you plan, for instance, you can easily add new cards and rearrange them into the most effective story order.

PHOTOGRAPHY: QUALITY AND QUANTITY

Once you've established what you want to say and in what order you want to say it, begin your picture-taking.

Make sure you take enough pictures to tell your story fully. If your theme is vacation camping and you want to open your show with a pictorial view of your campsite, make several exposures that will yield at least one or two scenic masterpieces. Tramp the perimeter of your setting and try different framing possibilities by aiming your camera through or between nearby trees, rocks, shrubs, vines, and flowers. Look for strong foreground interest such as a winding path, a dock, the curve of a shoreline, or a crackling fire. Consider the time of day. How would the scene look at sunrise, at sunset? (You can always return to the sack after you've taken your sunrise pictures.)

You'll probably want to include people in your slide program, so take plenty of pictures, varying your subject distance and camera angle. This will give you a wide selection to choose from when you edit your results. Close-ups of interesting faces can provide valuable material for a change of pace in your finished show. Pictures like these are called "cutaways" by photographers and editors in the moviemaking business.

In addition to taking plenty of pictures to tell your story, strive for quality in every single frame. A good slide program should be clever, entertaining, storytelling, and somewhat educational—it should also represent your very best picture-taking efforts. There's no excuse for showing your audience any picture that has poor exposure, lacks sharpness, or is badly composed. Take some time in planning each picture, double-check your camera settings, and arrange your subjects carefully in the viewfinder. Aim at making every picture a top-quality photograph, and you'll wind up with a slide program that shines overall with the gloss of professionalism.

EDIT OBJECTIVELY

One of the most exciting parts of photography is viewing your pictures after they've been processed and picking those you want to share with an audience. This editing process can also be the most challenging step in constructing a slide show, simply because the pictures are your own. Your personal feelings about the subject matter can easily overshadow your perception of small technical errors in your photography. To produce the best program from the slides you have at hand, you need to edit objectively. Put your own emotional responses to a picture aside, and consider the objective reactions of your audience. The old "you had to be there to really appreciate this picture" excuse doesn't succeed in a slide presentation. You have to take your audience to the original scene in pictures—not by insinuation.

Let's say you're assembling a show

on home flower gardens. You have a slide of a potted geranium sitting in a wheelbarrow; the lighting is poor, the angle could have been better, and the background detracts from the geranium. But you remember with affection the warmth of the overall setting on that day and recall with pleasure the conversation you had with the gardener (not even shown). You might favor a slide like this and wish to place it in your program because of what you remember—feelings not reflected in the actual picture. But since your audience wasn't there, they will simply see it as a poor picture of a geranium.

Select only those pictures that will assist you in communicating your message without the need for a lot of narrative. The slides you select should be readily understandable to your audience, closely follow your story outline, and require no apologies for any technical weakness.

You'll improve and speed up your editing if you can see several slides at one time. Then it's easy to compare exposure, expression, composition, and color. People who work regularly with slides usually have large, specially built illuminators capable of holding an entire program at one time. Large and small illuminators are available commercially, or if you prefer, you can build one yourself. (See *Audiovisual Planning Equipment,* KODAK Publication No. S-11.*)

When I'm editing at home, I lay a storm window across two chairs. Then I tape a large sheet of white translucent paper on the underside of the glass to diffuse the light. On the floor between the chairs, I set a table lamp without the shade or a floodlight

*Request a free copy of *Audiovisual Planning Equipment* by sending a self-addressed business envelope with the publication name and code number printed on the back to Eastman Kodak Company, Dept. 412-L, Rochester, New York 14650.

Good planning helps to make any slide show better. Before taking any pictures, I try to organize all my ideas with planning cards. Then I have a framework to follow.

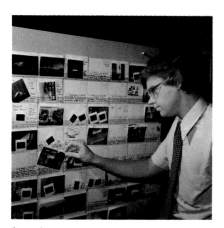

As work on the show proceeds, I amplify my simple planning cards with prints from some of the pictures I've taken. Now the organization begins to shape up visually. If you've been traveling, this is an ideal way to organize some of your travel pictures.

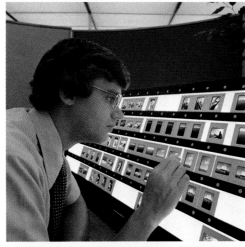

Careful editing of your slides can reward you with wide-awake audiences. This large commercial illuminator aids me when I'm dealing with many slides at once.

At home, I place a storm window across two chairs, tape white translucent paper to the bottom of the glass, and position a desk lamp underneath to make a convenient and inexpensive illuminator.

reflector that holds a 100-watt bulb. I keep the bulb several inches below the paper and glass to give me relatively even illumination over the entire work surface and to guard against scorching the paper. The top side of the glass provides a smooth, lint-free surface for editing.

If your presentation is to be instructional, consider adding pictures of charts or diagrams. Title slides can give a polished touch to the flow of any picture story. By viewing an entire slide sequence (or a group of sequences) at one time on an illuminator, you'll see where titles are needed.

You can also pace your story effectively by varying the times that individual slides appear on the screen. If there is no narration, you may want to project your pictures at a comfortably fast rate—changing slides every 4 or 5 seconds, perhaps. Under few circumstances is it wise to show a slide for longer than 15 seconds. Keep in mind what you want to say and how you want to say it as you arrange your slides. Perhaps a picture of a specific subject will require a lot of narration. Instead of projecting just one slide throughout your narration, you may want to use several slides that show the same subject but at varying angles or distances. You can project a long shot, a medium shot, and a close-up, all of the same subject, while explaining a single point. Your audience will unknowingly appreciate the variation.

YOUR DELIVERY

Occasionally I'm asked "How long should my slide program be?" Well, the length is far less important than the content, the quality, and the pace. If I had to watch a slide talk in which a monotone described the principal ingredients of concrete while the mixing process was being shown at a projection rate of two slides per minute,

I'd say that the maximum program length should be about 1 minute—or preferably less! On the other hand, I've viewed fast-paced, entertaining programs on a variety of subjects running 45 minutes that hold audience interest all the way.

If your presentation communicates the right message to your audience and still manages to leave them wanting more, you can consider your effort successful.

EXTRA FRILLS

While I'm grouping my slides into storytelling order, I give some thought to how I can lift my presentation out of the ordinary run of slide programs. This is always a good time to consider fresh ideas that can place your show a distinct cut above the competition.

Perhaps the biggest recent step forward in slide showmanship has been the increased popularity of the dissolve technique for projecting slides. Basically, a dissolve unit such as the KODAK EC-K Solid State Dissolve Control is a device that allows the image on the screen from one projector to "melt" or dissolve into the image from another projector. This unit controls the operation of two slide projectors, such as KODAK CAROUSEL Projectors, that have remote slide advance. When the projectionist signals a slide change, the unit dims the light in one projector while bringing up the light in the other. The effect is a smooth visual transition with no black screen between slides.

Good choice of subject matter and picture design add greatly to the success of a dissolve. Simple compositions and clean-cut pictures often melt into each other better than busy, involved illustrations. Pictures with similar compositional outlines also follow each other well. Most pictures that
(continued on page 161)

A dissolve might look like this on your screen. The overall view of the locomotive in the first frame gradually gets dimmer as the locomotive's emblem in the second frame becomes brighter, eventually replacing the first frame entirely. Your screen never gets totally dark but maintains a nearly even image brightness. For this reason it's a good idea to dissolve slides that are fairly close to one another in density.

Two projectors and a dissolve unit will smooth your transitions and make your story flow more easily. These four slides taken in Holland make a good dissolve sequence because all the centers of interest are the same shape and color. The red hat makes an effective way to shift the focus of our story from a cheese market in Alkmaar, Holland, to a tulip garden.

Slightly more sophisticated in nature, these slides dissolved effectively because of subtle similarities. The shape of the mast and rigging and the color of the sky in the first frame match the sky and building shape in the second frame. The black outline in the second frame is a natural blend with the outline of the sign in the third frame. The swirling lines of the sign blend easily into the flashlight abstraction of the fourth picture. Although you would probably never have cause to match such unlike subjects, you can see that successful dissolve sequences depend on picture design, color, and balance of light and dark areas.

include a circular design—a porthole, tire, wheel, salad bowl, coiled hose, or face—will usually dissolve well into one another. Match sequential slides according to density. The dissolve transition will not be as flowing if a very dark slide melts into a light one.

Your dissolve show will be smoother if you group your slides so that the format is consistent. Rather than running a vertical slide between a pair of horizontals, put horizontals together in one sequence and verticals together in another. I realize that obeying these editing guidelines is not always easy because you have to follow your story line with the visuals available. But within these limits, try to control design and subject relationships from one slide to the next to preserve that fluid continuity so necessary for a smooth dissolve program.

Although it's disappointing to get an otherwise magnificent picture with the horizon tilted, it's simple to correct the problem by cropping and remounting as you see here.

CROPPING

You probably have many more good slides than you realize. Don't throw away a slide just because it might be a bit off center, or it shows too much sky, too much foreground, or a tilted horizon. You can generally correct little deficiencies like these by changing to a slide mount with a smaller opening. Ask your local photo dealer for specially shaped and sized masks for your slides.

MULTI-IMAGE SLIDES

A special slide-making technique I like and apply quite often is one that calls for multi-image masks. Such masks make it possible to project more than one image on the screen at one time with only one projector. Multi-image slides can highlight the show by breaking up a monotonous single-picture pace. And if you're using a dissolve control, you can create some nice effects as images fade in and fade out on different parts of the screen.

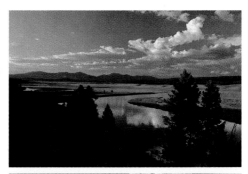

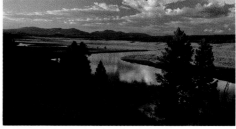

It's so easy to include too much sky, too much foreground, or a dead-center horizon. Careful cropping will cure these ills, too. This slide showed enough sky to detract from the S-curve composition of the river, trees, and mountains. The simple solution was to cut out some of the blue.

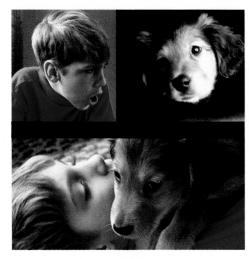

Multi-imaging can help you
set a mood with just one
slide—or even tell a short
story, as with this boy
and his dog.

Multi-imaging can lend
emphasis and impact to a
single subject in a
single slide.

You can show side-by-side
comparisons—day and night
in this case—within the
same frame.

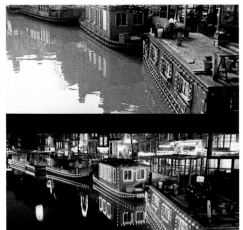

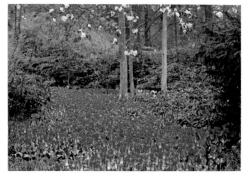

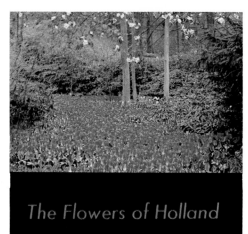

The Flowers of Holland

You can make your story more concise by combining pictures and titles.

Long shots and close-ups in the same sequence can be combined for maximum effect.

Whether you're using a single projector or a two-projector dissolve technique, multi-image projection can help you create a mood, increase subject impact, tell your story quickly, and show a side-by-side comparison.

Kodak does not distribute nonstandard masks for multi-imaging, but they are supplied by several other companies, including these:

Graphic Merchandising, Inc.
175 Varick Street
New York, New York 10014

Pemmco
P.O. Box 772
Haddonfield, New Jersey 08033

Louis Heindl and Son, Inc.
Photographic Products Division
200 Saint Paul Street
Rochester, New York 14604

To construct a multi-image slide, gather the following items:

Opaque paper or precut masks
(2 x 2-inch)
KODAK Slide Cover Glass 2 x 2-inch
(thin)
KODAK Metal Binders
Thin transparent tape (¼-inch)
Chart-Pak tape (black, ⅟₁₆-inch)
Scissors

Choose slides with images that can be cropped to fit the smaller sizes and different shapes of the mask openings. With steady hands and clean, dry fingers, open the cardboard mounts with scissors and remove the transparencies. Trim the transparencies to fit the desired mask openings and tape them into position with thin transparent tape. It's not usually necessary to tape more than one edge of the film to the mask, because the cover glass will ultimately hold the composite in position. Cover the intersections of the film edges with narrow opaque tape or narrow strips of opaque paper. Or use a ready-made mask with multiple openings.

You must cut up your transparencies to make multi-image slides. You then fit them into specially produced masks or masks that you have made from opaque paper and Chart-Pak tape. You bind the result into a sandwich with KODAK Slide Cover Glass 2 x 2-inch (thin) and KODAK Metal Binders.

Make sure that all glass surfaces are completely free from dust and fingerprints. Place the composite of images between two pieces of slide cover glass, and slip the entire sandwich into a KODAK Metal Binder, top first. Placed upside down for projection, the open end of the binder will appear on top. Make sure that your projector will accept glass-mounted slides.

If you're about to put some of your pictures into multi-image formats, consider these aesthetic guidelines. Overall composition, a central theme, and simplicity must work together to create effective multi-image slides. Each image you choose must relate to the others in some manner and should complement—not compete with—the others. Avoid slides with lots of detail and busy composition. Combine slides which harmonize in color and match closely in density.

(continued on page 168)

Make your multi-image slides with simple subjects that approximate each other in design and idea. Notice how the horizontal flow of the flower beds is continued in both sides of the oval slide, and there's a surprising similarity between the live man and the statue in the round frame. A note here: The round shape works well in this case because both faces are oval. The last picture in the series shows exactly what *not* to do. The images are disjointed, confusing, busy, and disturbing to the viewer.

There's something a bit disturbing about the first slide. All the implied action is leaving the picture. One person looks out of the picture on one side, and the other person looks out to the opposite side. Facing your subjects into the picture is much better, and the difference is rewarding. Now the two images work together.

Here's another situation that would have been impossible to capture in one image, and the meaning would have been lost in two consecutive slides. By multi-imaging, we can include the nature photographer and a close-up of the frog he's photographing.

Strictly speaking, montaging is a form of multi-imaging. After all, it's combining two or more transparencies to make one slide. The first two pictures depict the original finale in a skiing slide show. It looked dull and didn't measure up to the rest of the show. I used THE END slide just the way you see it, and found a similar but overexposed skier. I sandwiched the second skier with the title, which ended the program with a bit more zip.

The same skiing show gave me an opportunity to use a bird picture that I'd had for a while. The similarity in pose between skier and gull was remarkable, and lent an airy feeling of gracefulness to a rather ordinary scene. Montaging can help create a mood by combining disparate and unusual elements in the same frame.

The slides that fill the entire 12 x 36-foot screen may come from a 2¼ x 2¾- or 2¼ x 3¼-inch color negative. A photo expert crops the negative to the correct dimensions, and then the three transparencies that appear side-by-side on the big screen are made from the negative.

MULTIMEDIA EXTRAVAGANZAS

Within the last few years, slide presentations have expanded to exciting new horizons. Burlington Mills produced a complex mixed-media show in New York featuring projection of 5,500 slides with 69 KODAK EKTAGRAPHIC Slide Projectors programmed to display 1500 images a minute. And at Expo '67, a plateau was reached when the Czechoslovakian Pavilion employed a battery of 224 CAROUSEL Projectors to bombard viewers with 12,000 slides every 10 minutes.

We at Kodak have been using the CAROUSEL Projector as a principal component in the big, colorful multimedia travel-and-photography promotion shows that tour the United States each year. Presented by means of 6 CAROUSEL Projectors and a KODAK PAGEANT Arc Projector (16 mm), our wide-screen road shows are 90-minute family-oriented extravaganzas that fill a 12 x 36-foot screen with beauty and action. The subjects are diverse and appeal to the American love of travel and adventure. The purpose is to provide spectacular entertainment and promote photography to large audiences.

Each show, presented by two Kodak photo specialists, works this way: The CAROUSEL Projectors are set up in three pairs to project slides onto the 12 x 36-foot screen—one pair of projectors for each third of the screen. When one projector in each pair is projecting a slide, the other is changing slides. A dissolve control then turns the light off in one projector and on in the other, making a smooth transition from one slide to the next. A KODAK PAGEANT Arc Projector is mounted on a swivel to project short movie sequences onto any part of the huge screen.

The special pictures that fill the complete screen may come from single 120-size KODACOLOR or KODAK VERICOLOR Negatives. Each negative is printed onto a piece of KODAK EKTACOLOR Slide Film 5028, which the show designers cut and fit into three separate 2 x 2-inch slide mounts. One of these slides (less than ⅓ of the original negative) is projected onto each third of the screen to produce a wide-screen picture.

To help change slide trays in darkened auditoriums, we mark each CAROUSEL Projector with a narrow piece of white tape on the outer lip of the tray well at the rear center. To correspond with these markers, we place

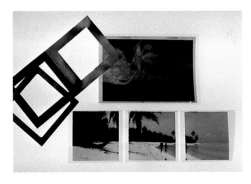

The feature-length Kodak travel programs presented to large audiences across the country employ much of the same equipment sold by your photo dealer. Six KODAK CAROUSEL Projectors dissolve images on three sections of the big screen—two projectors for each section. Interspersed among the slides are movie clips shown with a KODAK PAGEANT Arc Projector. Two photo experts present each program— one operating the equipment and the other narrating the story.

a similar piece of white tape on each slide tray at slide position No. 21 (using 80-slide-capacity trays). It then becomes a simple matter to zero a tray on the projector by aligning the tape mark on the tray with the tape mark on the projector.

When there's a movie running on one part of the screen, dissolving slides appear on the other two parts of the screen. They are carefully edited to complement the movie clips, and are often mounted in the multi-image masks we discussed earlier.

The narrator presents the story live on stage, accompanied by a stereo sound track. To produce the sound tape, we purchase and record music from commercial sound libraries and add sound effects and interviews recorded at the locations where the show was filmed.

By the time our screens, sound equipment, projectors, 24 KODAK CAROUSEL Slide Trays, cords, tape, flashlights, and portable spotlight are packed into our truck, we have more than a ton of programming equipment —a package somewhat larger than you might plan to use, but designed with the same goal—entertaining an audience.

Whether you operate one projector in your home recreation room or 224 in a World's Fair exhibit, remember that the only important objective in making a slide presentation is communicating your message. And you'll achieve more successful visual communication by perfecting your technique. What is good technique? Well, paraphrasing the words of a philosopher, good technique is *no* technique. No *obvious* technique, that is. When your audience stomps, claps, whistles, shouts for an encore, and yells "great show," without a single reference to any of your skillful methods, *that's* good technique.

PET PHOTOGRAPHY
by Walter Chandoha

Like nearly everything else, spectacular animal photography has to commence somewhere. A war, a love affair, a great career—each had its small beginnings. Success in different areas of photography is no exception. Everyone needs a starting point for photographing flowers, children, landscapes, abstractions, or whatever area of specialization he chooses.

You have to find a departure point in animal photography, too. I'd suggest that you focus your attention first on studying the animal you want as a subject. A dog, a cat, a chipmunk—even a box turtle—follows a daily routine that you can learn and put to work for producing better photographs. Being observant of animals' habits and customs is the first step in making good animal photographs. Example: A homemaker's magazine was doing an article on exercise. Somewhere in the article it was mentioned that cats stay in condition by stretching. To illustrate this, the art director wanted me to provide a photograph of a cat stretching—front legs close to the ground and paws extending forward, with the hind end elevated.

When the art director asked me if such a shot could be made, I confidently said "yes," because I was acquainted with the habits of my cats. One of them, Minguina, would do this stretching routine every day. After waking up from a nap, she would get out of her basket, take about two steps, stop, yawn, stretch forward first with her left front paw, then with her right paw, extending as far as she could. With her front stretching finished, she'd do her middle stretch, humping her back like a Halloween cat.

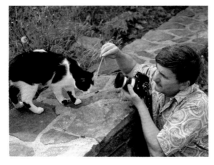

One of the world's best-known portrayers of the animal kingdom, Walter Chandoha has had his pictures of cats, dogs, and other animals presented in media as diverse as TV commercials, magazine covers, package illustrations, posters, calendars, greeting cards, and billboards. In his home/studio in Annandale, New Jersey, Chandoha constantly strives to improve his understanding of animals and to discover new ways to gain their cooperation in making successful photographs.

He is the author of more than twenty books that display his photographs and his feelings about his well-loved subjects. His satisfied clients for advertising photographs include Eastman Kodak Company, Ralston Purina, Quaker Oats, Star-Kist, Hallmark, American Greetings, General Foods, and many, many others.

This article was drawn from Chandoha's exciting book *How to Photograph Cats, Dogs, and Other Animals,* KODAK Publication No. AC-38, Crown Publishers, New York, New York, 1973, 154 pp, $7.50. For additional examples of his cat photography, see his latest book, *The Literary Cat,* J. B. Lippincott Co., Philadelphia, 1977, 192 pp, $10.00. Ask your photo dealer or bookstore for these absorbing books that give further information and insight into developing a magic touch when photographing the world of animals.

170

To illustrate a magazine article on exercise, an art director asked me if I could make a picture of a cat stretching. Knowing the habits of my cats, I was confident that I could deliver the picture.

I knew that I could make the required shot. All I had to do was to bring Minguina's basket into the studio, feed her, let her take her usual nap, and be ready and waiting for her when she woke up. When she woke up, she hopped out of the basket, stretched, and I was shooting pictures.

Watch what your pet does in the morning, in the heat of the day, in the cool of the night. Is it more alert or playful at any one time of the day? How does it behave when it's hungry, and also when it's well fed? Does it like to be petted or scratched? How does it react when another of its kind comes on the scene? Does it favor one person more than another? What makes it lazy, and what makes it active?

Compare your pet's activities with those of your neighbors' animals of the same species. If there is a difference, try to determine the reason. Initially, it might help you not to rely on memory alone. Put your observations down on paper. It helps to know what to expect from an animal before you take any pictures.

EQUIPMENT

Since animal photographs are best when taken at the eye level of the subject, you'll be shooting from ground level much of the time. If you use a prism reflex (a typical 35-mm single-lens reflex) or a rangefinder camera for ground-level shooting, you'll find yourself crawling around on your belly like a snake—not the most comfortable position for taking pictures. With the mirror reflex cameras (typically a 2¼-inch TLR or SLR), however, even if you shoot at floor level, all you have to do to use the viewfinder is bend over and look down into it. By resting the camera on the floor or on your knee, you get the benefit of added stability.

Many of your small-animal pictures will require that you move in closer than 2 or 3 feet from your subject to get a large, sharp image on your film. To do this, you'll need a device that enables you to move in close and at the same time retain sharpness. The most economical and common method is to use a close-up attachment fitted over the camera lens, which en-

The most effective photographs—of animals *or* people—are those in which the subject has direct eye contact with the viewer. It helps to photograph animals from their own level. Move in close to crop out any distractions. Sometimes this will require a close-up lens. If you use a close-up lens, you might consider placing it on a telephoto lens that will allow you to maintain a comfortable distance between you and your subject.

Small kittens—and puppies, too —tend to be very active. Isolating them on a table or chair will usually keep them in camera range.

This type of photograph obviously requires the help of at least one assistant whose job is to keep the animals in place; your job is to be alert. When all the models are right, you shoot—and shoot fast. You may not get a second chance.

ables you to get a sharp image from a distance of as little as 8 or 10 inches.

You can also get close with extension rings or tubes which are placed between the camera body and the lens. The more distance between lens and camera, the bigger the image. Since light must travel a greater distance from the lens to the film when you use extension tubes, you must increase exposure slightly. The amount of increase depends on the length of the tube.

A tripod gives rock-steady support to your camera, which is very handy for your initial animal pictures. A good way to test the stability of a tripod is to extend the legs to the maximum, place both your hands on the top, press down, and try to rotate the tripod. If you get a pronounced wobble or side-to-side sway, the tripod is not stable enough to eliminate all camera movement.

The tripod will be used primarily with a posing table, the next piece of equipment recommended for animal photography. The posing table need not be elaborate—an old kitchen table, a bureau, a couple of boards set on some sawhorses; I've even used a high stool. Its purpose is to limit pet movement. You'll find that kittens or puppies are pretty active, and if you don't limit their range, you'll be spending more time in retrieving them than in making pictures of them. Most young animals placed on a posing table will roam the limited surface, and that will be it. They may want to jump off, but you can easily confine them to the tabletop.

An assistant sounds like an ambitious acquisition, but you'll really need one to make good animal pictures. Your assistant can be anyone who likes animals as much as you do— your spouse, a friend, or one of your children. The assistant's primary task

will be to keep the animals in camera range, whether they're up on a posing table or down at ground level. With your assistant restraining the animals, you'll be free to concentrate on their poses and expressions—most of the time. Until the animals are settled, however, you'll probably have to pitch in and do your bit to help keep them in place. Hence you'll need both the tripod and a long shutter release. Later, as you gain experience in shooting animals, you might dispense with your tripod in the studio. Outdoors the use of a tripod can be limiting, so leave it home.

FILMS

I've tried to standardize my film choices for animal photography. I do most of my outdoor and available-light shooting in black-and-white with KODAK TRI-X Pan Film, rated at ASA 400. When I shoot indoors with speedlights, TRI-X Film is too fast, so I use KODAK PANATOMIC-X Film. For 35-mm color, my favorite is KODACHROME 25 Film (Daylight), which I use in my studio and outdoors. KODAK EKTACHROME 64 Film is good for shooting 2¼ square or 4 x 5 both outdoors and in the studio. When I require color negatives, I use KODAK VERICOLOR Professional Film, Type S. For low-level existing light or high-speed action, I'll switch to KODAK EKTACHROME 200 Film either at the normal speed or push-processed to double the normal speed.

OUTDOOR ANIMAL PHOTOGRAPHY

I prefer to take outdoor pictures in the shade or on a hazy, overcast day. Under these conditions, the light has a pleasing softness and there is less chance for exposure error. Whenever I can, I try to avoid shooting in bright sun at midday. If I have the time, I'll

wait for the light that I prefer. If I *must* take pictures in bright sun, I like to do it early or late in the day, when the sun is low in the sky. The low angle of the sun gives the subject more interesting shadows and modeling.

I like to have my subjects back-lighted by the sun; this gives a nice, even tone in the shadow areas, plus a sparkling brilliance where the sun rim-lights the subject. If you use this lighting technique, make sure you give the shadow area sufficient exposure to get good detail. A quick-guess exposure for backlighted subjects: Give 2 stops more exposure than required for the basic bright-sun exposure.

Outdoors, pay special attention to your background and foreground. When you encounter a lot of "garbage" in the background, think like a professional photographer. While shooting on location or anywhere for that matter, I do a thing called "cleaning up the viewfinder." Here's what you do: Look through the viewfinder at your subject, and allow your eye to roam over the entire area in front of, alongside, above, and behind your subject. Do this immediately upon lifting the camera to your eye. If you find no distracting elements, fine! Most of the time, however, you'll find insignificant things that are just enough to mar what would otherwise be a good picture. Maybe a tree in the background seems to be growing out of your horse's head. Move your position a few feet to the left or right to transplant the offending tree and get a better picture. At a dog show, you may have an appealing poodle sharply focused in the viewfinder, but you notice the leg of a chair on one side just behind the dog and a crumpled coffee cup by its paw. Put the cup away, move the chair (or your position), and you've got a clean, uncluttered background.

On the other hand, perhaps your cat is stalking through a jungle of grass, and as you're about to press the shutter release you notice that a stray blade of grass is in front of its eyes. Do you reach out to remove the blade of grass to "clean up the view-finder" and thereby miss a good shot? No, you shoot it as is—and shoot fast. You may have a distraction in the picture, but if you hesitate, you may lose that great picture forever. Perhaps you'll be lucky and your subject will allow you to make additional pictures. Then you'll have time to focus accurately, verify exposure, and better compose your picture.

INDOORS WITH YOUR PET

Although an indoor studio situation may seem unnatural for pet photography, you'll find immediately that you have much more control of what's going on. First, you can control the lighting. Second, you can control the background. And third, you won't have any surprise visits or distractions from other animals. It's often easier to control your pet's behavior in a familiar place than it is in an unexplored spot where all the smells, sights, and sounds are new. And if you live in the North, you'll appreciate the comfort of your cozy basement on a January afternoon when an ice-dagger wind is bending the saplings double.

Although many films today, both black-and-white and color, are fast enough to let you make pictures indoors during the day without any extra light, certain posing situations definitely require some sort of extra artificial illumination. This "provided light," as I prefer to call artificial light, is of two types: photolamps and flash. Photolamps generate a great amount of heat, which makes them undesirable for animal pictures. Animals react in two ways: They get hot and start

I prefer not to photograph animals in bright overhead sunlight. Instead, I wait for days when the sunlight is diffused by haze, or times when the sun is not so high in the sky. This way, dark shadows don't obscure important detail, and contrast doesn't spoil the picture.

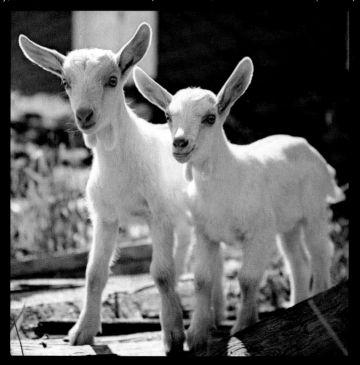

Backlighting tends to snap your subject out of its surroundings with a rim of light around the edges.

High-speed strobe lights make action pictures such as this one easy to take. All you do is focus on the spot where you expect the action to take place, and then shoot at the right time.

Indoors, you can choose your backgrounds carefully to emphasize your subjects. There is no background here that will distract the viewer.

to pant, or they're so comfortable under the lights that they soon get drowsy and fall asleep. So unless you want a lot of sleepy pet pictures, use flash.

Flash comes in two varieties: expendable sources such as flashcubes, magicubes, flipflash, and flashbulbs; and the repeating type called strobe, speedlight, or electronic flash. If you plan to take animal pictures indoors just once in a while, flashbulbs, flipflash, or cubes will suffice. But if you intend to photograph animals seriously, you should invest in a good speedlight outfit.

I prefer the type of speedlight used by press and wedding photographers. The 510-volt battery needed to power these units sells for about $20, recycles the unit quickly in a couple of seconds, and is good for about 1,000 flashes. It deteriorates with age—its useful shelf life is 8 months or so. You'll have to take a lot of pictures to justify the cost of the strobe unit and battery, so start with flashbulbs or an inexpensive strobe unit; then if you increase your shooting, get the higher-priced unit. When you're not using your flash unit, store the battery in your refrigerator to prolong its life.

LIGHTING POSITIONS AND BACKGROUNDS INDOORS

Since my primary concern in this article is helping you to gain the cooperation of your pet and describing the special tools and techniques that have helped me the most, I won't dwell on light placement or types of backgrounds. Generally, a standard portrait setup will give you pleasing, well-balanced illumination. Animal photographers use many different backgrounds, including rolls of paper, fabric, or almost anything you can think of. If you want to explore this subject further, see Jack Englert's article on

pet photography, "Photography of Cats and Dogs," in *The Fifth and Sixth Here's How.*

PATIENCE

Patience is usually termed a virtue, but as an animal photographer you'll find it an absolute necessity. Dealing with unpredictable subjects requires an unlimited store of patience. It's important to remember that pets don't volunteer to model. They cannot be coerced to do it; they cannot be pleaded with, and promises of fame and riches fall on deaf ears.

Your patience must be sensibly directed. You can have the perseverance of a saint—of all the saints—but it will do you no good if you're trying to get your hungry cat to balance a mouse on the tip of its nose. If an animal won't or can't do something, no amount of waiting will help you get a picture. However, if you've seen an animal strike a certain pose before or perform a particular antic, you can get your picture—eventually.

A magazine once did a story on the resurgence of the British economy, and the editors wanted the cover to show an English bulldog wearing a bowler with a small Union Jack sticking out of the hatband. They asked me if I could make such a shot, and upon my assuring them I could, I got the assignment.

To photograph a dog wearing a hat is no great problem. A dog would rather not wear a hat but, if you persist, will go along with the gag. So from past experience and knowledge of my subject, I knew it was a shot I could do.

A friend who is a talented writer and photographer supplied the model, a friendly but fierce-looking bulldog named Ginger. I tried the derby on Ginger a couple of times, only to have her shake it off disdainfully. Again and again she shook it off. I

A dog prefers not to wear a hat but will do it if you have the patience to keep trying. Knowing what an animal will do is important. All the patience in the world, however, will not get you a picture if the animal is incapable of doing what you want it to do.

tried; she shook. Then she noticed the flag, and every time she shook the hat off she'd take a nip at the flag. As the shooting session dragged on, the hat began to stay on her head a few seconds longer each time. After a couple of hours and maybe a half dozen exposures, Ginger got the idea and finally kept the hat on her head for a long time—at least 30 seconds—which was adequate to make all the necessary exposures. The job was simply a matter of knowing what the animal would do, setting up the situation, and hanging in until we got cooperation.

MOTIVATION

Animals are motivated by hunger, sex, and curiosity, and you can use all these forces to get their cooperation for your picture-taking efforts. These instincts are responsible for keeping animals fueled up, reproducing, and safe from predators—all actions fundamental for survival.

While observing your pet before you started taking pictures, I hope you noticed that sounds play an important role in the lives of animals. Cats and dogs (and most other animals) are keenly aware of the sounds about them—much more so than human beings are.

Observe your dog in the middle of a quiet, cold, snowy winter evening. It's so still you can hear a pin drop, but your dog, who was peacefully dozing on the hearth, is suddenly wide awake. The ears twitch ever so slightly. Then to get better reception of whatever was heard, your dog will lift its head and maybe turn it one way or another. It's listening to something, but you can't hear a thing.

Since animals are so responsive to sounds, these should be your primary devices to evoke a response. And not surprisingly, the noises pets respond to best are those that have animal overtones—a meow, bark, moan, growl, chirp, sigh, cough, bleat, caw, whinny, gobble, grunt, moo.

One of my favorites when I'm working with both cats and dogs is a sort of high-pitched whimper much like that a young puppy would make. Although it is what we would consider a "dog" sound, cats respond to it just as strongly as dogs do. It is an especially good sound for dogs when you're looking for one of those quizzical, head-cocked-to-one-side poses that are so appealing.

Usually the vocal sounds made by you or your assistant will get some kind of favorable response from the animals. But if your subjects just sit there ignoring you, don't despair—try other sounds. Squeak-toys made of rubber or plastic are very effective. For years our children seldom had the pleasure of prolonged playing with these squeak-toys. The youngsters would no sooner get a new one than we'd appropriate it for use in the studio. Playful dogs puncture the rubber and the toys lose their squeak—hence, the constant need for a new supply.

Another sound-maker that photographers usually have handy is an empty small metal can. You can get a variety of symphonies by half-filling several cans with objects of different densities. Put some pennies in one, a handful of rice in another, several marbles in another, and you'll have a whole array of sound-makers. Shake these cans at camera position, or if you want your subject to look off into the distance, toss a couple of them over your shoulder; as they bounce off a wall behind you, your subject will probably look toward the sound.

Another nonvocal sound that is good for cats and kittens is the quiet, subtle sound created by rubbing your thumb across the tip of your other fingers. Try it now as you read this—

put your fingers up to your ears and rub. My theory is that a cat believes this sound is made by a mouse. But whatever it thinks doesn't matter. You just want your cat to be alert.

A splendid reason for using a twin-lens reflex camera is the sharp rattling sound you can make by banging your fingers on the focusing hood. Many of my photographs of animals with good, alert expressions were obtained with the aid of the "reflex rattle."

All the sounds mentioned above have been successful on some occasions; yet on other occasions they were complete failures. Try them, and if they work, use them again. If they don't work, make up some of your own—improvise. When your pet finally recognizes that a particular sound is not important, you must switch to a new one. Keep in mind, however, that whatever sound you use, try to keep it subtle. Sharp, sudden explosive sounds may scare your subject.

One sound at a time from one person at a time is a rule in our studio.

Picture this: a magnificent canine on the set—I'm behind the camera, my assistant is on my right, one of the dog's owners is on the left with his wife sitting in a director's chair on the far right. The dog is not cooperating. I try some sounds; my assistant tries some sounds at my suggestion, and we begin to get cooperation. Then the owner on the left makes a sound, and the dog turns in that direction. What confusion! After everybody quiets down, we get back to shooting pictures properly.

Use a cat's romantic disposition to your picture-taking advantage if you know how to sound like a sexy cat. Feline courting is not the most subtle in the animal world. Caterwauling is what it's called. Since these moaning meows are made by both the male and the female, either sex will sit up and take notice when you duplicate the sound of a cat in love. Introducing

Using Pavlov's theory of classical conditioning made it easy to get this shot of a leaping cat. It had been taught to associate the sound of a clicker with food.

a member of the opposite sex off the set can be an effective attention-getter, too. To a lesser degree, dogs will also fall for the sexy-mate-on-the-sidelines gimmick.

Capitalizing on the hunger drive of animals is also useful at times. (When I say this, I don't suggest starving an animal in order to get it to cooperate.) Dogs and cats will snap up a tasty morsel even if they've just had a meal. Our cats will always respond when bribed with shrimp or cheese. Dogs usually go for a liver snack, cheese crackers, hot dogs, or sardines (they're a little sloppy); potato chips are also big with dogs, as are salted nuts. Cats are crazy about liverwurst. The snack should be something your model likes but does not get very frequently.

Let's say you want to photograph a cat in midair as it leaps from one point to another. Here's how you do it:

Place the cat at point A, and give it a tiny bit of a favorite snack—maybe it's Cheddar cheese. Then place a piece of the cheese at point B, and indicate to the cat that the cheese is there. Let it eat. Put the cat back at point A and put another piece of cheese at point B, but this time move B farther away from A. The cat will easily leap from A to B to obtain the snack. Keep repeating the process until points A and B are sufficiently separated so that the cat must take a healthy leap to get the snack.

To carry this experiment still further, introduce the element of sound. Next time you're in a 5 & 10-cent store, buy a clicker—one of those thumb-size gadgets made from a piece of metal and a steel spring that makes a clicking sound. Now when your cat bites into the piece of cheese at point A, click the clicker, and click the clicker again when the cat bites the cheese at

An unusual noise will alert your subjects.

point B. Repeat the cheese/clicker routine several times, and before too long you'll find that the cat will go from point A to point B when it hears the clicker alone. What happened? Each time it bit into the favorite snack it heard a click. It soon learned that the click and the snack were closely related.

Let's get back to cat pictures. You want to get a sensational midair shot of a cat leaping. After you've trained your cat, the shot is a cinch. Place it at point A, place point B about four feet away, and focus your camera at some midpoint. You're all set. Your assistant makes a click at point B. The cat thinks of cheese, makes a spectacular leap, and you get a sensational picture. Just to keep your cat happy, you ought to reward it with a double portion of cheese for being so cooperative.

Suppose you want to get a picture of a dog licking its chops. The problem is that not all dogs lick their chops. Who knows—maybe, like people, some dogs have better table manners than others. To encourage cooperation, first feed your model a good-size portion of its regular dog food to take the edge off its appetite. It may now lick those chops and you'll get your shot. If not, rub some bacon grease on either side of its mouth. It will like the fat so much that it will lick like crazy and the fat will be good for it. Many professional breeders regularly include bacon fat in their dogs' diets to make their coats slick and shiny. Cat-lovers will be pleased to know that feline subjects, too, are impressed by the bacon-fat routine.

In getting animals to cooperate, you have two things going for you: the curiosity of animals shown by their response to sounds of all kinds, and their constant preoccupation with food and eagerness to gulp down any tasty morsel that they regard as gourmet fare. Remember, though, that puppies and kittens tire very easily and require frequent naps. If they begin to tire, we quit shooting, let them take a nap, and resume when they're ready.

FAST REACTIONS

To get a higher percentage of good pictures, you must have a quick trigger finger. You can develop your timing to a point where you have the fastest photo-finger in town. Often you must shoot fast to get some peak action, such as the dog leaping over the sawhorses. The only way to make a picture such as this is to catch the dog at the peak of the leap.

When your eye sees the dog through the viewfinder, it sends a message to your brain, which in turn commands your trigger finger to release the shutter. If your reaction time is fast, you'll get your shot; if not, you'll miss. A fast human reaction time (from perception to action) is 1/30 second. What you want to do is develop your reaction so that you shoot when the action is just right—not too soon, not too late.

Here's a way to develop your timing. Let's assume you're driving over to a local store to buy some supplies. You're on a road that has numerous traffic lights. Although your hands are on the steering wheel, pretend you're holding a camera instead, with your shutter finger poised on the release button. You stop the car for a red light. Now pretend that the instant the light turns green, you're supposed to shoot some peak action. You know it's going to turn, and the instant it does— "shoot."

To keep your timing sharp, make these practice sessions a habit. When I'm out walking on a country road and a rabbit scoots out in front of me, I

(continued on page 188)

It's easy to get a dog to lick its chops. Feed it until it's full, and after it's finished
eating, it will lick the residue from its mouth. A little bacon fat rubbed
on its chops will serve as an added inducement for licking.

You need fast reactions to capture an appealing moment such as this.
Try practicing to shoot at just the right second.

Action pictures require a feel for the right instant, too. Have the dog do the stunt several times until you have the timing down cold. Then try to get the picture at the very peak of the action.

This type of action picture required panning to blur the background and a slow shutter speed to blur the dog's moving limbs. The effect is one of fast motion.

No second chance on a picture like this! We were taking conventional magazine-cover photos with this weimaraner when he spotted one of our cats. The wide-eyed expression was the result. When we tried a retake, nothing happened —the surprise was gone. Be ready to capture the unexpected pose to make a unique picture.

press my thumb against my index finger to simulate releasing a shutter. A pheasant makes a startled ascent, and I try to get a "picture" of it. If I'm walking in the city, I try to see pictures and pretend I'm shooting them. When I see a bus approaching a curb, I try to get a "picture" of a passenger about to step off—with one foot just hitting the pavement and the other still on the step. You get the idea. Only by continuously practicing this imaginary shooting will you be able to sharpen your timing—and keep it sharp!

ANTICIPATION

This picture of the five kittens required more than fast shooting and a quick trigger finger—anticipating the action was important, too. The kittens were especially playful, and at first I thought I might get some interesting pictures of them. Then frankly, because of the erratic and lightning-fast way they were playing, I wondered if I'd get any pictures at all. Finally, as they began to tire, their actions were not so quick. Then I saw what seemed to be working up to a good picture when the kitten in the middle got up on its hind legs. What goes up must come down, and since that kitten was in a playful mood, I anticipated that it would pounce onto one of the siblings as it descended. So just as it started to pounce, I shot—and as the message was going from my brain to my finger, I noticed the other two cats smiling! By anticipating that something was about to happen, I shot when I saw the situation beginning. Had I waited until the peak of the action to make an exposure, it would have been too late. The best action would have passed.

In animal photography you won't find too many sensational peak-of-action situations. Your subjects run, jump down, jump up, and jump over—and that's it. But there's much more to photograph than sensational action. An upraised paw, a grimace, a big meow, an unusual body position— you should anticipate these little actions. The subtle movements that you capture on film often separate great pictures from commonplace ones. Practice—in watching, in getting cooperation, in anticipating and capturing the right moment—will give you truly notable results.

Successful pet photography, in a nutshell, combines the ability to study a pet's behavior, familiarity with dependable equipment, patience, ingenuity in eliciting cooperation, and lightning-fast reflexes. Not that I claim all of these at once—often one asset seems to override the others. You'll find that practicing these skills is exciting, challenging, and enjoyable. Look at me—I liked it so much that I made it a profession.

Getting five kittens just to sit and pose is a feat in itself. And to get them all simultaneously engaged in some sort of subtle action requires more than a quick trigger finger. By anticipating the action, I was able to turn this photograph for Kodak into a great picture.

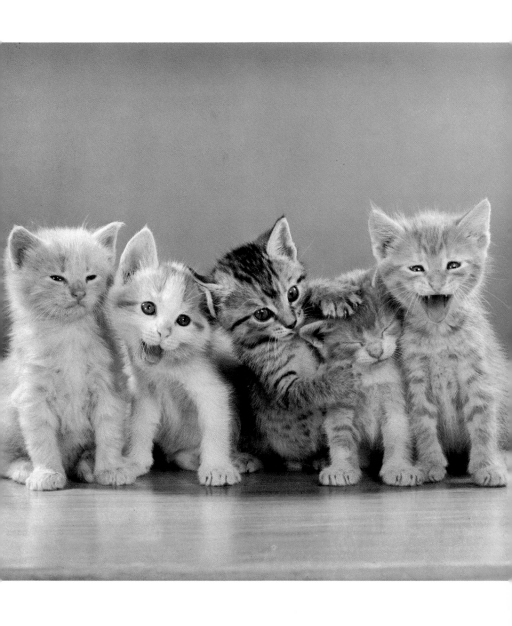

THE SABATTIER EFFECT IN BLACK-AND-WHITE AND COLOR

by Barbara Jean

Barbara Jean, a Sales Manager in the Business Systems Markets Division at Kodak in New York City, at one time wrote and edited Kodak books and pamphlets for amateur photographers. She is a two-star exhibitor in the Photographic Society of America, a Fellow of the Kodak Camera Club, and a judge and instructor in photography. She enjoys experimenting in her darkroom and in her home, where she finds new, decorative functions for her pictures. Barbara and her husband, Paul Kuzniar, form Kodak's only husband-and-wife team who create and present "how-to" slide shows for amateur photographers around the country. You'll enjoy these other *Here's How* articles by Barbara: "Creative Close-Ups of Garden Flowers," in *The Fifth and Sixth Here's How,* and "Give Your Home Personality with Photographs," presented earlier in this book. Paul is the author of the article "Creative Camera Techniques," which starts on page 84.

The Sabattier Effect is one of the most exciting photographic techniques I've ever tried. By reexposing the film during development, you can produce both a negative and a positive image on one piece of film. Not only can you make new pictures from existing negatives and slides but you can also salvage photos that are slightly underexposed or overexposed. You can bring out details hidden in shadow areas on a continuous-tone black-and-white film with the Sabattier Effect, and with a high-contrast film, you can create a photograph that looks like a line drawing or a tone-line.

Apply the Sabattier Effect to color film and—WOW, what colors! The bolder-than-life psychedelic hues are extremely dramatic. One advantage of the technique I use (pages 199—207) is that you create color slides directly from other color slides without an internegative step. You can also produce color slides from black-and-white and color negatives by making a high-contrast intermediate film.

With the Sabattier Effect, new picture possibilities are almost endless. But sometimes the results may surprise you! Consider this article as a guide to help you get started, and then make adjustments as you gain experience with the processes. Since this is an experimental technique, I prefer to print my original image onto another sheet of film and use that film for my experimentation. That way, if I accidentally ruin the film, I still have the unharmed original negative to make more copies.

Technique described on pages 199-207. Original exposure and reexposure: 30 seconds at f/3.5 to white light.

The original slide was a close-up of a reflection in water taken with a telephoto lens. The technique is explained on pages 199-207. Original exposure and reexposure: 30 seconds at f/3.5 with white light.

This article will explain how to subject darkroom-exposed films to the Sabattier Effect. Briefly, here's what happens. The film is exposed normally, partially developed, then reexposed and fully developed. During reexposure, the partially developed image acts as a negative through which the rest of the light-sensitive silver in the film is exposed. This produces some image reversal, and the result is part positive and part negative.

You can also produce the Sabattier

Effect on photographic paper and on film you expose in the camera. But I still prefer applying the technique to darkroom-exposed film. It's often difficult to duplicate results on a print. However, once I've created a negative, I can make many prints from it. It's also easier to work with films exposed in the darkroom because you can use a safelight with certain black-and-white films. This way you can see what you're doing and watch the image develop.

The Sabattier Effect on KODAK Commercial Film 6127. Exposure was 7 seconds at $f/22$ with a reexposure of 5 seconds at $f/8$. The original image was a color slide.

The color slide used to print the picture above was also used as the original image for this slide. Original exposure was 1 minute at $f/8$ through a 40C (cyan) filter, and the reexposure was 30 seconds at $f/8$ through a 40Y (yellow) filter.

SOLARIZATION VERSUS THE MACKIE LINE

The Sabattier Effect is often confused with solarization because both techniques produce a negative and a positive image on the same film. Since the results look almost identical, many people mistakenly refer to photographs made with the Sabattier Effect as solarized prints or slides. Solarization is obtained only by extreme overexposure and is very difficult to produce with modern films. Most photographs you see today showing both a positive and a negative image are made by means of the Sabattier Effect, which is easily identified by a narrow line or rim of low density, called a Mackie Line, between adjacent highlight and shadow areas. A concentration of bromide ions in the emulsion greatly retards development at the boundary separating completely developed areas from areas that are just developing.

available from photographic dealers who deal in supplies and equipment for the professional photographer.

First I printed a color slide on KODALITH Film; then I contact-printed that film onto another sheet of KODALITH Film, reexposing this second sheet during development to produce the Sabattier Effect. As a result of balancing reexposure with the original exposure, only the Mackie Line outlining the image is left. This print was made directly from the second KODALITH Film.

GENERAL INSTRUCTIONS ON PRODUCING THE SABATTIER EFFECT

You don't need a lot of equipment to start making pictures by the Sabattier process. Basic requirements are a perfectly dark room, safelights with the appropriate filters, processing trays, a printing frame to make contact prints, and a light source. Many practitioners of this art prefer to use an enlarger as their light source, because it is easily controlled and you can easily record all the exposure variables. Others prefer to unmask the safelight over their sink and make that the light source, keeping all the sloppy processing trays in the sink where they belong.

NOTE: All the films, chemicals, and filters mentioned in this article are

This is also a print from a KODALITH Film reexposed during development to produce a Mackie Line. The original reexposed KODALITH Film was so dense that I contact-printed it onto another sheet of KODALITH Film, making the negative which produced this print.

The Process

Note that these are general instructions to give you an idea of the process. You'll find specific recommendations for each film and process later.

First, place your negatives or slides in contact with the black-and-white or color film which will receive the Sabattier Effect. The emulsion of the unexposed film should contact the negative or slide and face the light source. Expose the film and then begin development. As a rule of thumb, reexpose the film after it is about one-third developed. Stop agitating about ten seconds before reexposure and allow the film to settle to the bottom of the developer tray. After reexposing, complete the normal development for your first exposure, agitating continuously except with KODALITH Films.

Fresh developer and stop-bath solutions will give you the best results with the Sabattier Effect. With practice, you'll learn what effect you want and you'll be able to pull black-and-white film from the developer at the right time to achieve that effect. Naturally, fresh stop bath is a must for putting a quick halt to development and preserving the image you saw while the film was in the developer.

When color film is in the developer, you'll be working in total darkness and you won't be able to see the image. Once you turn on the lights, don't despair if the film doesn't look as you expected it to. The color and density may change dramatically during the rest of the process.

Exposure

As I mentioned before, you don't really need an enlarger for this technique, but I use my enlarger with color films to make controlling the exposure a little simpler. With black-and-white, I also like to enlarge original negatives or slides onto 4 by 5-inch film, which is much easier to retouch than 135-size film. However, if you don't have an enlarger, or if you want to produce several films at one time, you can contact-print your original negatives and slides onto a piece of sheet film. You'll easily fit six 135 negatives or slides onto one piece of 4 by 5-inch sheet film. Then expose these films to the light from your enlarger or any other light source.

To reexpose black-and-white films, I use the safelight over the sink. With the safelight filter removed, it is an excellent white-light source, and its location lets you keep all the solutions in the sink—away from your dry area.

Although your enlarger will give you more control over reexposure time, you have to combat solution spills by placing a large, empty tray on your enlarger baseboard and then putting the smaller developer tray into the large tray. Color films almost always require the control provided by the enlarger for both original exposure and reexposure. The enlarger lets you repeat your results more consistently, and you'll be better equipped to handle color filters.

You can repeat your results without difficulty if you keep track of both the exposure and the reexposure times. The original exposure time will vary depending on the density of your negative or slide, so make a test strip to determine this exposure. Reexposure, once you've discovered the right time, will remain constant if the distance between the light and the film (and the lens opening, if you use an enlarger) remains the same. You have to experiment to determine the correct reexposure time for your particular set of variables. Try a reexposure series of 15-second increments over a two-minute period with your enlarger set at $f/8$.

Controlling the Amount of Reversal

Three variables affect the amount of reversal or the amount of negative image visible: (1) intensity and duration of reexposure, (2) extent of development after reexposure, and (3) the point during development at which the reexposure takes place. If the reversal effects are too strong to suit you, shorten the reexposure time or develop the film longer before giving the reexposure. If you want more reversal, increase the reexposure time or reexpose earlier in development.

BLACK-AND-WHITE FILMS

You can process some films made for copying continuous-tone originals under the light of a safelight. Not only can you see what you're doing, but, more important, you can watch the image develop and pull the film out of the developer when you see the results you want. This is the one time when it's perfectly all right to submit to that urge to juggle your developing times. The development times given here are only guides. With experience, you'll be able to judge development visually and get perfect results by pulling the film out of the developer and plunging it into a fresh stop bath at just the right moment.

KODAK Commercial Film 6127 (Continuous Tone)

This continuous-tone film gives good results with the Sabattier Effect. It's easiest to start with a color slide, which will produce a negative image on the film. The Sabattier Effect will bring out detail in the shadow areas, so select a slide that has interesting shadow detail.

If you use a negative as the original image, you'll need to contact-print your first sheet of film onto another sheet of film to convert the image to a negative. Or you might get some interesting results by trying the Sabattier Effect on the film positive. Try it—if you don't like the results, you can always take the process one step further and make a negative.

With proper exposure, a full image will appear on the film after 30 seconds of development. Don't panic when the film turns almost black a few seconds after reexposure, and resist the temptation to pull the first film from the developer before the full development time; the film will clear and become much lighter after fixing. Once you become familiar with the sight of a well-exposed film in the developer, you can judge development by eye and pull the film at the right moment.

THE SABATTIER EFFECT WITH *KODAK* COMMERCIAL FILM 6127

Use a KODAK Safelight Filter No. 1 (red), or equivalent.

1. Make a test strip to determine the best exposure; develop the film in a developer such as KODAK Developer DK-50, full strength, for 2 minutes with continuous agitation.

2. Print your original image onto a sheet of film. Use the best exposure time from the test strip.

3. Set your timer for 2 minutes—the total development time—and start timing and developing.

4. Slip the film into the developer, emulsion side up, and develop with continuous agitation for 20 seconds; then allow the film to settle to the bottom of the tray for 10 seconds with no agitation.

5. Reexpose the film to white light while it's in the developer. (A safelight without a filter or the light from your enlarger works fine.)

The Sabattier Effect on KODAK Commercial Film 6127. The film was
printed from a color slide with an exposure of 5 seconds at $f/22$.
After 40 seconds in KODAK Developer DK-50 (full strength),
the film was reexposed for 3 seconds at $f/16$.

6. Begin agitating again after reexposure, and complete the total development time of 2 minutes.

7. Stop, fix, wash, and dry the film according to the instructions on the film instruction sheet.

KODALITH Ortho Film 2556, Type 3 (ESTAR Base)

The Sabattier Effect produces dramatic results with this high-contrast film because the Mackie Line (see page 193) around the image becomes quite pronounced. A short reexposure time creates a very high contrast image, which also includes some gray tones in the reexposed areas.

Process the film for a total of 2¾ minutes in a developer such as KODALITH Developer. Wait until the last minute to mix the two stock solutions together, and use only a small amount of the blend, because this active developer oxidizes very quickly. The developer will exhaust itself in a few hours when mixed, so storage is out of the question. Eight ounces of solution in a 5 by 7-inch tray will develop three sheets of 4 by 5-inch KODALITH Film. To keep your results consistent, discard the used developer after three sheets, and mix a fresh batch. You can exceed the three-sheet limit if you increase the processing time. Since you can watch the film develop, leave it in the developer until you see the results you want.

Agitate the film continuously in the developer before, *but not after,* reexposure. If you agitate KODALITH Film after reexposure, the reexposed areas will appear mottled or streaked. This phenomenon is called bromide drag, and is caused by a heavy concentration of bromide produced during development of the high-density areas of the film. By not agitating, you prevent bromide drag and obtain a more vivid Mackie Line.

By extending your reexposure or development time (so that the reexposed image is as dense as the original), you'll produce a black film with the subject outlined by a clear Mackie Line. If you're after such an outline of the subject, start with a high-contrast original—an image printed onto KODALITH Ortho Film. Print this film onto another sheet of KODALITH Film and reexpose the second film during development. Opaque out any extraneous detail that detracts from your main subject.

These dense negatives require long printing times, which you can avoid by contact-printing the Sabattier Effect film onto another sheet of KODALITH Film. When you print this second film onto paper, you'll get a black print with the subject outlined in white. To produce a white background with the subject outlined in black, contact-print the second KODALITH Film onto a third sheet of KODALITH Film, and then print that film onto paper.

THE SABATTIER EFFECT WITH *KODALITH* ORTHO FILM 2556

Use a KODAK Safelight Filter No. 1A (light red), or equivalent.

1. Make a test strip to determine the best exposure; process in a developer such as KODALITH Developer (equal parts of Solution A and Solution B) at 68°F (20°C) with continuous agitation for 2¾ minutes.

2. Print the original image onto a sheet of KODALITH Ortho Film, using the printing time you determined from the test strip.

3. Set your timer for 2¾ minutes—the total development time—and start timing and developing.

4. Slip the film into the developer, emulsion side up, and develop with continuous agitation for 50 sec-

onds; then allow the film to settle to the bottom of the tray for 10 seconds with no agitation.

5. Reexpose the film to white light while it's in the developer. (A safelight without a filter or the light from your enlarger works fine.)

6. Allow the development to continue without agitation for the total development time of 2¾ minutes, or pull the film from the developer when you see the effect you want.

7. Stop, fix, wash, and dry the film according to the instructions on the film instruction sheet.

I'm always looking for ways to create several different photographs from one original image, and the Sabattier Effect offers many opportunities. For example, a color slide similar to this can be made by copying a KODALITH Film onto a color-slide film, such as KODAK EKTACHROME 64 Film, through a green filter. The original image (a black-and-white negative) and the KODALITH Film printed from it can be given the Sabattier Effect. In addition, you could use the same KODALITH Film to make a black-and-white or color print.

COLOR SLIDES

Producing the Sabattier Effect on transparency film will give you slides that explode with wildly vibrant color. Now you can make dull or underexposed slides unusual and eye-catching. You can even turn black-and-white negatives into striking color slides! Many thanks to Don Evins, a PSA friend, who first introduced me to this technique several years ago. Since then, I've spent many enjoyable hours using it to create new pictures.

Printing directly from continuous-tone black-and-white and color negatives does not produce good results with this technique. If you want to produce the Sabattier Effect in color from a black-and-white or color negative, contact-print the original negative onto a sheet of KODALITH Film. Then use the KODALITH Film as your original. You don't have to be concerned about negative or positive images—both give splendid results.

The Process

You'll need KODAK EKTACOLOR Print Film 4109 (ESTAR Thick Base) and KODAK Color Film Processing Chemicals, Process C-22, for your Sabattier Effect color slides. KODAK EKTACOLOR Print Film is a sheet film that is available in 4 by 5-inch and 8 by 10-inch sizes, among others. It's easy to handle, and you can gang-print at least six 35-mm images on each sheet of 4 by 5-inch film—or 36 images on an 8 by 10-inch sheet. The

The original image for this slide was an underexposed color slide.
Original exposure: one minute at $f/8$ through a 40C (cyan) filter.
Reexposure: 30 seconds at $f/8$ through a 40Y (yellow) filter.

The original image for this slide was an overexposed color slide.
Original exposure: two minutes at $f/8$ through a No. 47B (blue) filter.
Reexposure: 30 seconds at $f/8$ through a 40Y (yellow) filter.

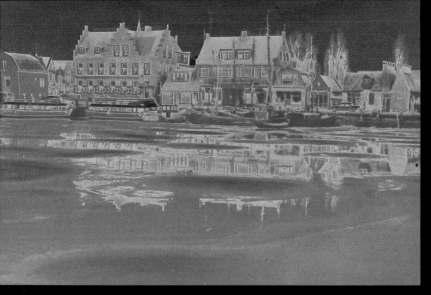

The original color slide was a monochrome scene with a dull-gray sky—not a very exciting picture until given the Sabattier Effect. Original exposure: 30 seconds at f/3.5 with white light. Reexposure: 15 seconds at f/3.5 with white light.

I contact-printed a black-and-white negative onto KODALITH Film; then this Sabattier slide was printed from that KODALITH Film. Original exposure: two minutes at f/8 through a 47B (blue) filter. Reexposure: 30 seconds at f/8 through a 40Y (yellow) filter.

C-22 Chemicals for processing are available in 1-gallon kits.

Although the temperature of the chemicals is not critical in this process, a higher temperature produces more grain in the slide. Fill 5 by 7-inch trays with 8 ounces of each chemical and 8 by 10-inch trays with 16 ounces. Discard the *developer* after processing three sheets of film, and the other chemicals after processing six sheets of film.

If you compare this process with the one recommended by the chemical instruction sheet, you'll see that the rinses between the chemicals have been eliminated. This keeps the process as short as possible and won't harm the film if you discard the chemicals as I've suggested. Agitate the film continuously (except just before and during reexposure) by tipping up one side of the tray and then the adjacent side.

In a printing frame, fit as many 35-mm slides or KODALITH Films as possible for the film size you're using. In the dark, place a sheet of KODAK EKTACOLOR Print Film 4109 (ESTAR Thick Base) in the printing frame with the emulsion side toward the originals and the glass of the frame. Expose the film to the light from your enlarger, with or without a colored filter over the enlarger lens. It's very important to keep track of the exposure time and the filter number so that you can duplicate your results.

Develop the film for 5 minutes and reexpose it to the light from the enlarger with or without a filter over the lens. Again, record the exposure time and the filter used. Finish the process and then view the film on an illuminator. Remember to judge the density of this film just as you would that of a print—if it's too dark, it needs less exposure; if it's too light, it needs more exposure.

This was made from a color slide that was gold in the center with shades of brown around the outside. Original exposure and reexposure: 30 seconds at f/3.5 with white light.

You'll save yourself a lot of time by making a test strip on your first film. Make it in the usual way, allowing about 2 minutes for maximum exposure during the original exposure. Then during reexposure, expose half the film for 30 seconds and the other half for 1 minute. Adjust the enlarger so that it's just high enough to cover the 4 by 5-inch or 8 by 10-inch area, and set the lens opening at f/4.5, f/5.6, or f/8. This type of test strip should enable you to produce well-exposed slides on your second film. Write down the filter combination and exposure you use for each film so that you can duplicate your results. One easy way to code the different pieces of film is to cut off one or more of the corners.

I like to use 8 by 10-inch KODAK EKTACOLOR Print Film because it allows me to contact-print 36 slides at one time. I tape the 35-mm slides or negatives to my printing frame for easier handling in the dark.

During reexposure, you should be able to see a black-and-white image on the film. If there's no image visible, your original exposure was too short. This step is done in total darkness (except for the light during reexposure), so we simulated this picture in white light to show you how the film should look during this step.

You can turn the white lights on during the stop bath and watch the images changing during the rest of the process. The film looks black and white and won't show much color until it's in the bleach.

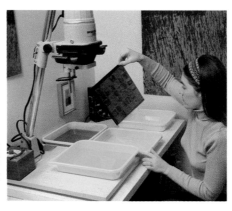

Once in the bleach, the color begins to show, and you'll get an idea of how your final slides will look.

After a minute or two in the fixer, the background color will show up and the film will look very similar to the finished slide.

And here's the finished Sabattier Effect film next to the original slides used to make the film. The EKTACOLOR Print Film was exposed and reexposed with white light.

Here are some of the color combinations you can create from a black-and-white original by using filters with the Sabattier Effect. It's possible to create an infinite number of combinations. I've just picked the ones I like the best.

This KODALITH Film negative was made by contact-printing a color slide, and was used to expose all the color slides in this series.

OE: one minute at f/8 through a 40Y (yellow) filter. RE: 30 seconds at f/8 with white light.

OE (original exposure): one minute at f/8 through a No. 61 (green) filter. RE (reexposure): 30 seconds at f/8 through a No. 61 (green) filter.

OE: one minute at f/8 through a 40Y (yellow) filter. RE: 30 seconds at f/8 through a No. 61 (green) filter.

OE: one minute at f/8 through a No. 61 (green) filter. RE: 30 seconds at f/8 with white light.

OE: one minute at f/8 through a No. 47B (blue) filter. RE: 30 seconds at f/8 with white light.

OE: one minute at f/8 through a No. 61 (green) filter. RE: 30 seconds at f/8 through a No. 29 (red) filter.

OE: one minute at f/8 through a No. 47B (blue) filter. RE: 30 seconds at f/8 through a No. 61 (green) filter.

OE: one minute at f/8 through a No. 29 (red) filter. RE: 30 seconds at f/8 through a No. 61 (green) filter.

OE: one minute at f/8 through a No. 47B (blue) filter. RE: 30 seconds at f/8 through a No. 29 (red) filter.

Filters for Different Colors

Using white light for both the original exposure and the reexposure will create brilliant colors. If you want different colors, you can experiment with colored filters over the light source during the exposure and reexposure steps. You'll want to test a great variety of combinations of different filters for both exposures or white light for one exposure and a filtered light for the other.

I've tried the filters listed below, and they all produce good results with black-and-white originals. The color in the right-hand column is the color you'll get when you use the filter on the left for both the original exposure and the reexposure. When you're printing from color slides, colors in the slide act as filters, and the color in the film during the reexposure acts as a filter, so the results might not always be exactly the color you expect.

I prefer the colors I've obtained by exposing and reexposing with white light, and the colors produced by making the original exposure through a 40Y (yellow) filter and reexposing through a 40C (cyan) filter. Shop around and see which color combinations you like best—you'll find they're all dramatic.

Filter No.	Color of Filter	Color Produced
40Y	yellow	blue
40M	magenta	green
40C	cyan	red
29	red	cyan
61	green	magenta
47B	blue	yellow

THE SABATTIER EFFECT WITH *KODAK EKTACOLOR* PRINT FILM 4109 (*ESTAR* THICK BASE)

Use continuous agitation throughout the process.

In total darkness:

1. Expose the film by the light of an enlarger with or without a filter.
2. Develop the film after the original exposure for 4½ minutes with continuous agitation. (Total development time is 7 minutes.)
3. Move the tray under the enlarger, turn the film emulsion side up, and allow it to settle to the bottom of the tray without agitation. Allow 30 seconds for this step.
4. Make the reexposure with or without a filter over the enlarger lens.
5. After reexposure, move the tray back to the sink and continue development with continuous agitation to a total development time of 7 minutes.
6. Stop bath—5 minutes. After the film has been in the stop bath for 2 minutes, you may turn on the room lights.

In room light:

7. Hardener—3 minutes.
8. Bleach—8 minutes.
9. Fix—8 minutes.
10. Wash—8 minutes in running water; then rinse the film in a solution such as KODAK PHOTO-FLO Solution, and hang it up to dry.

The original was a montage of two color slides. The sun on one slide and the birds on the other gave an overall color of golden yellow with black birds as subjects. Original exposure: one minute at *f*/4.5 through a 40Y (yellow) filter. Reexposure: 30 seconds at *f*/4.5 through a 40C (cyan) filter.

BETTER PICTURES OF PEOPLE

by Neil Montanus,
M. Photog., Fellow-ASP

Let's refresh the old-fashioned snapshot by introducing an air of informality to make our people pictures more natural *and* more flattering. With the improved camera equipment and wide range of films available, you'll find this fun and an exciting challenge.

You won't need much to start with —just a liking for the company of other people and a thorough familiarity with your camera. The most flattering pictures of people are often those in which subjects are relaxed and informal. That's because you're used to seeing them this way. You'll want your subjects to feel at ease and to be interested in what you're doing. This requires a bit of psychology and a bit of subtle pose control.

EQUIPMENT

My tools for people pictures are fairly simple—I don't want to be burdened when I start to shoot. Generally, I prefer a lens of slightly longer than normal focal length with a wide aperture —in the f/2 to f/2.8 range. If you own a 35-mm camera, you'll probably like a lens in the 85-mm to 105-mm range. If you're a lover of the 2¼ x 2¼-inch format, you're going to be looking for a lens in the range of 105 mm to 200 mm. Here are some excellent reasons for using a moderate telephoto lens:

1. You'll obtain a more pleasing perspective of your subject—particularly when you move in close.
2. You can emphasize your subject by throwing the background into soft focus.
3. You can maintain a comfortable

Neil Montanus is a photographer for the Photographic Illustrations Division at Kodak. He has traveled throughout the world creating advertising photographs for the company. He has been awarded the degree of Master of Photography and a Fellowship in the American Society of Photographers by the Professional Photographers of America. Neil has exhibited a number of photo shows and is a well-known judge of photographic salons. He has a degree in photography from Rochester Institute of Technology. Neil's articles "Underwater Photography" and "Photographing the Dance" appear in *The Fifth and Sixth Here's How.*

(continued on page 213)

A typical snapshot of the "old school." Notice the harsh frontlighting, stiff frontal pose, distracting background, and distortion from a normal lens held at a slightly low angle.

Ah, yes—the new vogue. Keeping faces out of direct sunlight eases the expressions and smoothes the complexions. An informal pose looks more believable and pleasing. Flowers and bright clothing add color to the scene, while the high angle and use of a mild telephoto lens keep the background unobtrusive.

In this comparison of normal- and telephoto-lens renderings, see how the telephoto lens (left) keeps the girl's face and body in what appears to be the proper relationship and blurs the background. The normal lens creates an apparently false perspective that makes the girl's head seem too big for her body (a generally unpleasing aspect) and allows the background to remain sharp and distracting. The whole effect of using a moderately long lens is usually better.

Since all you care about is the subject, why not let the rest of the picture melt into a diffuse haze? Close focusing with your medium telephoto lens will put the emphasis on your subjects, sharply distinguishing them from their out-of-focus backdrop.

Ideally your lens should be fast enough to let you take pictures under shaded conditions (left) or in poor weather (below). In the picture on the left, we had to get off the beach and under this shelter because the glare was so great that Lanie couldn't help squinting. The shelter allowed her to open her attractive eyes and relax her face. Michelle (below) looked especially appealing in her colorful rain gear on this cold, drizzly day. You can even see the raindrops on the car.

A child's world is a blur of excitement and action. If you want to make pictures of kids as they really are, you'll abandon your tripod and join the fun with a telephoto lens that's fast enough to let you hand hold the camera.

working distance from your subject. A normal or wide-angle lens can make your subject uneasy because you and the camera are too close. This is especially important with children—if you can back away a bit, kids are less likely to be self-conscious.

The speed of the lens is important, too. If you're taking a backlighted portrait with a moderate-speed film, such as KODAK EKTACHROME 64 or KODACOLOR II Film, you will want a wide aperture to let you use a high shutter speed (high enough to eliminate camera movement with that telephoto lens) and to blur any obtrusive backgrounds. A fast lens helps on cloudy days and in the shade, too.

With a fast lens you can also choose a shutter speed high enough to let you abandon your tripod when you're photographing children. Kids are so quick-moving and unpredictable out of doors that you'll have to hand hold your camera most of the time.

APPROACHING YOUR SUBJECT

When we said at the beginning of this article that we were going to improve on the old-time snapshot, we mentioned that we would be relaxed and natural about the whole thing. So how do you approach a model, even a member of your family? The friendly way!

You've established that you like people. You should always be friendly, warm, and enthusiastic. Try to develop a special rapport with your subject. After your model has agreed to share some picture-taking with you, you should do a little preliminary planning to lift your efforts out of the snapshot class. Begin by discussing your model's hobbies and interests, and decide what type of clothing and setting will be most flattering and con-

Notice how softly the light brightens the face in this picture. Any more illumination would have created shadows too dark to hold any detail. The out-of-focus flowers in the foreground contribute nice touches of color.

venient. Discuss your location, bearing in mind that a private and quiet place is best. A spot with people watching and many distractions is likely to inhibit your subject.

Let's say, for example, that your model is a pretty girl and that you've decided to take your pictures in a garden on an overcast day. From the time you arrive on the scene, you must constantly communicate with your subject. Keep her interested—small talk is usually best for bringing out a nice, relaxed look. It's helpful to give a model specific instructions as to posture, direction of attention, and expression. Also, keep your framing tight. Come in as close as possible to crop out any unnecessary and distracting elements in your pictures.

Limited depth of field has a remarkable way of isolating the important subject.
The sharply detailed shrubbery competes aggressively for attention
with my subject in the top picture, while everything blends in a quiet harmony
in the bottom picture, where only the girl is sharp.

Part of your approach should de-emphasize the importance of an individual picture. Professionals know that film is the least expensive part of any job, so they take lots of pictures. After you've taken several pictures of each situation, your model becomes accustomed to the sound of the shutter and begins to relax in front of the camera. Your chances for super-successful people pictures are better if you record all changes of pose and expression.

Working with Children

Your approach to children should be pretty much the same as we've already described. Outdoors you can forget your tripod, because the normal, active, healthy child probably won't stay in one spot long enough to make it worth your effort.

Portray children as they are in reality, not as adults would like to see them. The more natural your pictures of kids are, the more "oohs" and "aahs" you'll get from audiences and friends. It sounds easy, but children are very aware of their environment, and when this includes a person who keeps aiming a camera at them, they can soon become self-conscious. Your long lens comes in handy here.

Children definitely require a warming-up period. Get to know the child you're photographing, and suggest fun things to do while you're taking pictures. It helps, too, to have another person around to play games or to do things that will help the child forget your presence. In general, let children be themselves, but be prepared to spend time talking and kidding them into interesting photographic situations. Then move back and photograph them when they've become absorbed in their own activities.

Probably the big three don'ts in child photography are as follows:

Don't intrude upon the small sphere occupied by your child subjects. You'll get a bonus of completely candid activity and expression. These kids, monitored with my telephoto lens, are totally oblivious to my presence.

1. Don't have the child face into direct sunlight. It produces a sun squint and makes the normally gentle, soft face of a child look harsh and unappealing.
2. Don't pose your subject too far from the camera. You'll get a small image, which might be difficult to enlarge.
3. Don't carelessly choose a background that takes attention away from the child. Remember that kids are smaller than adults, and that everything else in pictures (houses, fences, cars, and trees) will seem twice as big when surrounding your small subject.

Just look at the difference between these two pictures. Typical of many family snaps
taken from an adult's looking-down camera angle, the one on the left shows
an unattractive patch of grass and a mixed-up background. On the right, we have the same
subjects, same clothing, same outdoor setting, with this difference—
we moved in close with that faithful telephoto lens on the little girl's level.
Nothing else is visible. Do you really want to see those baggy white jeans? What's more
important—her face or the fence? Full-figure renditions usually aren't necessary.

Set up situations for children that will take their minds off you and your camera. Another person, Mom or Dad for instance, can help. In this case, Mother dragged out the rain slickers and the umbrella on a hot summer day while Dad sprinkled the scene with a garden hose. The umbrella also helped to diffuse the bright sunlight and flatter the subjects' faces with soft, low-contrast illumination.

Kids are so much smaller than adults that getting rid of the background can often be rather difficult. A normal camera angle is a big help because it brings you down to their low level. You see the scene as they would see it. You should move in *very* close and fill the frame; this way the background is much less noticeable.

A snapshot with such a cluttered setting is mediocre.

Photographing Groups

In some respects, two people together are easier to photograph than a single individual. With a father-and-son twosome, for example, the father has direct physical control over the child and can use props to keep the child interested. Photographing larger groups of people is a tremendous challenge to your ingenuity and, quite often, your patience.

If you're looking for a fine-quality, somewhat formal grouping, I suggest leaving the job to a professional portrait photographer. If a more relaxed, informal happening is what you'd like to portray, then take time to plan the location and the placement of figures carefully. Try to get people interested in each other or in some activity. It's important that their attention be directed toward some common point of interest.

Here are some guidelines for the placement of figures within the picture frame:

1. Place your subjects' heads so that no two line up vertically. This emphasizes the dynamic nature of a unified group.
2. By the same token, don't line up any heads horizontally. Heads in a vertical or horizontal line tend to keep the composition static—not at all what you want.

Before I get everyone to pose, I make a rough sketch showing where to place different members of the group. I draw triangles connecting all the members. Each triangle vertex is a head that is in a different vertical and horizontal plane from any other head. I like to use pieces of furniture of varying sizes to seat my group.

One way to occupy a child's active mind is to provide direct physical involvement with a parent. A toy completes this picture by Norm Kerr.

Keep 'em busy. An adult assistant can be very helpful.

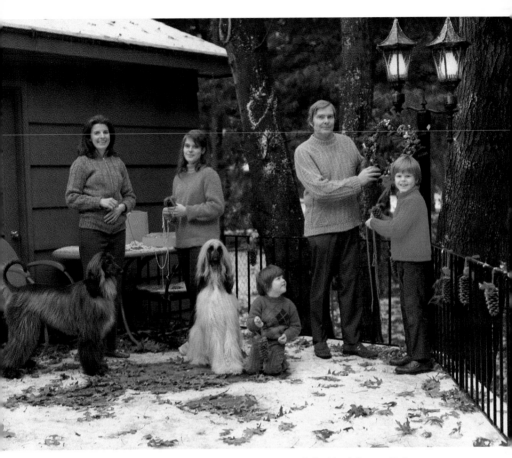

The informal Christmas card portrait above was made by friend George Butt.
George followed this important rule: Organize any group so that no head is in a
vertical or horizontal line with any other. Try to arrange your subjects in triangular groupings.

Creating a formal portrait usually requires the services of an experienced professional photographer, who knows just what type of setting, lighting, and grouping to employ. This magnificent portrait was made by such a professional, Bob Phillips.

OUTDOOR PICTURE-TAKING

Remember in the snapshooter's code where it says to pose your subject in direct sunlight and stand facing your subject with the sun coming over your shoulder? We're going to debunk all that and take a fresh look at outdoor techniques.

Lighting

I'll wager that 90 percent of my outdoor informal portraits are taken with the sun backlighting the subject or with no direct sun at all—the kind of lighting you'd find on a cloudy-bright or even cloudy-dull day. My main reason is that most subjects can't look toward the sun without squinting, which isn't the ideal expression, you'll agree. Also, shadows created by direct sunlight are difficult to fill.

Bright sunlight produces contrasty lighting. The lighting ratio between the bright highlights and the shadow areas in a scene may be much greater than your film can reproduce. Unless you reduce the contrast of the subject, highlight detail, or shadow detail, or both, will have to be sacrificed.

I often use soft fill-in light on a backlighted subject. A white towel, a sheet, or a white umbrella makes a great surface from which to bounce light. Sometimes I've been able to plan my pictures so that I could take advantage of light reflected from a white house or a sidewalk or even a stone surface. A very bright aluminized reflector or a sheet of aluminum foil is just too bright. It'll make your subject squint almost as much as the sun will.

One of the common ways of reducing lighting contrast in pictures of nearby subjects is to use fill-in flash. This is especially useful for taking pictures of people. Have your subject turn away from the sun for a natural and relaxed expression without squinting.

Then use flash to lighten any shadows that exist.

For fill-in flash with color films, use blue flashbulbs, flashcubes, or electronic flash, because the light they produce is about the same color as daylight. All of the subject must be illuminated by light of the same color quality to obtain proper color rendition in the finished picture.

You can use the fill-in flash tables on page 223 with *any* film because the tables are based on the ratio of flash to sunlight, not on film speed. A small electronic flash unit—having a guide number of 40 or 50 with a film rated at ASA 25—can be used as a fill-in light. The most common mistake people make with flash is overdoing it. Usually you'll want a lighting ratio of 2:1 or 3:1 so that the main illumination of the scene will be about two or three times as strong as the flash fill you will supply.

Here's how to use the tables:

1. See your camera instruction manual for the flash synchronization (M or X) and shutter speed recommended for flash picture-taking with your camera.

2. Use the corresponding lens opening that would give you normal exposure for a frontlighted subject in sunlight—for example, f/22 at 1/30 second for a film with a speed of ASA 64.

3. If you're using a flashbulb, find your bulb and reflector combination in the table. With electronic flash, you'll need to know the BCPS output of your unit and use the electronic-flash table.

4. Read to the right in the table and locate the distance range for the shutter speed you're using. You'll get full fill (2:1 lighting ratio) with your subject at the near distance,

The kind, even light on a cloudy day can give an all-over glow to a human face. Lines and blemishes seem to disappear, eyes open wide, and smiles appear without emphasizing the little wrinkles at the corners of the eyes. Overall contrast is diminished to give a gentler appearance.

In bright sunlight, I just move the sun around to the other side of the subject (the back) and get this sort of pleasing effect. Again, low-contrast ambient light aided by reflections from a white sidewalk covers this pleasant countenance and brightens a pretty smile.

average fill (3:1 lighting ratio) at the middle distance, and slight fill (6:1 lighting ratio) at the far distance.

5. Position your subject's back to the sun at the distance that will give you the amount of fill you want, and then take the picture.

If you want to get closer to your subject than the near distances in the tables, you can cut down on the amount of light from the flash by covering it with one layer of white handkerchief. Then you can divide the subject distances in the tables by 2.

SUBJECT DISTANCES FOR FILL-IN FLASH WITH BLUE FLASHBULBS
(Distance in Feet) (Bright Sunlight)

Type of Reflector	Blue Flashbulb	Shutter Speed						
		X Synchronization		M Synchronization				
		1/25 or 1/30	1/50 or 1/60	1/25 or 1/30	1/50 or 1/60	1/100 or 1/125	1/200 or 1/250	1/400 or 1/500
	Flashcube Magicube	3½-5-8	2½-3½-6	2½-3½-6	3½-5-8	4-5½-9	3½-5-8	4-5½-9
	HI–POWER FlashCube	5-7-11	3½-5-8	3½-5-8	5-7-11	6-8-13	5-7-12	6-8-13
	AG-1B	1½-2-3	1½-2-3½	1-1½-2½	1½-2-3½	2-3-4½	2-3-4½	2-3-4½
	M2B	3-4-7	3½-5-8	*	*	*	*	*
	AG-1B	3-4-7	3-4-7	2-3-5	3-4-7	4-5½-9	4-5½-9	4-5½-9
	M3B	4½-6-10	3½-5-8	4½-6-10	5½-8-12	6-8-14	6-8-14	6-8-14
	5B, 25B	4½-6-10	2½-3½-6	4½-6-10	5½-8-12	6-8-14	6-8-14	6-8-14
	M2B	4-5½-9	5½-8-12	*	*	*	*	*
	AG-1B	4½-6-10	5-7-11	3-4-7	4½-6-10	5½-8-13	5½-8-13	5½-8-13
	M3B	6-8-14	5-7-11	6-8-14	8-11-18	9-13-20	9-13-20	9-13-20
	5B, 25B	6-8-14	3½-5-8	6-8-14	8-11-18	9-13-20	9-13-20	9-13-20
	6B, 26B	FP Synchronization		6-8-14	6-8-14	6-8-14	6-8-14	6-8-14

*Not recommended.

SUBJECT DISTANCES FOR FILL-IN FLASH WITH ELECTRONIC FLASH
(Distance in Feet) (Bright Sunlight)

Output of Unit BCPS	Shutter Speed with X Synchronization*				
	1/25-1/30	1/50-1/60	1/100-1/125	1/200-1/250	1/400-1/500
350	1½-2-3½	2-3-4½	3-4-7	3½-5-8	4½-6-10
500	2-3-4	2½-3½-5½	3½-5-8	4-5½-9	5½-8-13
700	2-3-4½	2½-3½-6	4-5½-9	4½-6-10	6½-9-15
1000	2½-3½-5½	3½-5-8	5-7-11	6-8-13	8-11-18
1400	3-4-7	4-5½-9	6-8-13	7-10-15	9-13-20
2000	3½-5-8	5-7-11	7-10-15	8-11-18	11-15-25
2800	4-5½-10	6-8-13	8-11-18	10-14-20	13-18-30
4000	5-7-11	7-10-15	10-14-20	12-17-25	15-21-35
5600	6-8-13	8-11-18	12-17-25	15-21-30	18-25-40
8000	7-10-15	10-14-20	15-21-30	17-24-40	20-28-50

*With a focal-plane shutter, use the shutter speed that your camera manual recommends for electronic flash.

The top picture shows too much flash fill. It looks faked and very washed-out. The bottom picture had no flash fill—see how dark and shadowed our friend's face is? The middle picture has just enough fill to brighten her face in correct proportion to the surrounding scene.

It's a good idea to leave the flash on the camera when the sun is bright. The idea here is to avoid creating any secondary shadows and only to lighten the original shadows. On cloudy or overcast days, you can use your flash off the camera to create a higher highlight-to-shadow ratio. This ratio refers to the difference in brightness between the areas of your subject that are in the light and those that are in the shade.

The professional portrait photographer creates soft lighting in the studio to minimize heavy shadows and facial lines and to make pictures that people will like. You can get the same flattering effect outdoors in the soft, diffuse light of a cloudy day or in the shade.

Arranging this picture gave me fits of frustration for about 3 minutes.
Everything was right, except that the room behind the chess player was filled with busy-looking
furniture. The obvious answer was to employ a high angle and crop out the distractions.

The normal eye-level angle of the camera gave a realistic, natural look to this attractive scene.

Use of a low camera angle here eliminated a confusing horizon line, leaving only the out-of-focus trees as a suitable backdrop.

Backgrounds

I've noticed a high casualty rate among informal portraits. Many otherwise good pictures didn't quite make it because the photographer ignored the background. The camera saw everything in the scene and gave it all equal time. Here are some techniques that have helped me make better portraits.

Choose your camera position carefully. Make sure that there are no distracting elements competing for attention with your subject. When you find the best vantage point, consider different camera angles. Would a high angle or a low angle be more dramatic —or would a normal angle be more natural? With children, it's frequently a good idea to get down to their level; this seems to lend a more intimate mood to the photograph, and the kids react favorably to your geographically equal status.

Here again, you're going to appreciate your long lens. It will let you exercise better control over the focus of your background. Since you want only the main subject sharp, I suggest using an aperture no smaller than $f/4$ or $f/5.6$. Let all the rest go soft and you'll really emphasize your center of interest. An out-of-focus background tends to look soft and blurry, with no discernible details. Remember to keep the background elements as compatible as possible so that one patch of blurred color doesn't contrast violently with another patch.

Foregrounds

Again following the example of our friendly professional photographer, note that attention to foreground pays off in much more impressive pictures. The studio professional often uses a vignette in front of the lens to soften the foreground and produce a path that directs the eye smoothly to the

Bad weather can often contribute to great pictures. Even if they're not great, they'll at least be unusual, says Norm Kerr, the man behind this shot.

center of interest. We can use the same technique outdoors. A pretty bush, flowers, tree branches—nearly anything will become a soft-edge frame for the person you're photographing. As with backgrounds, make sure that your aperture is large enough to throw the foreground out of focus.

When the raindrops pelt your windows or when the sun starts its voyage to the equator, don't pack away your camera. People are more photographically appealing off-season, when the weather dampens timid spirits. In fact, bad weather offers you an opportunity to make outstanding informal portraits that are quite out of the ordinary. The lighting is excellent for flattering a face—snowflakes, raindrops, and cold-weather clothing can add a flavor of adventure and realism.

Framing with blurry, out-of-focus foreground objects—flowers, trees, rocks, or whatever—can isolate and concentrate attention on your subject.

INDOOR PICTURE-TAKING

We're free! Liberated by advances in cameras and films in recent years, we can take pictures under almost any conditions imaginable. Since nighttime and inclement weather often keep us inside, we find that we can make some of our best informal portraits indoors.

Natural Light

The great portrait painters of the past —Rembrandt and his colleagues— painted their subjects under light that came from windows and skylights. Today, our professional studios emulate this successful formula by having a similar soft glow of indirect light brighten their subjects.

To capture this ultra-flattering illumination, you need only your fast ($f/2.8$ or faster) medium telephoto lens, a tripod, and a white reflector. Pose your subject near a door, window, or skylight *out of direct sunlight.* Use the white reflector to bounce a bit of shadow-filling light into the dark areas, and start shooting. I believe indirect daylight indoors is the most natural-looking and believable light source.

Artificial Light

As we all know, the sun shines for a limited time every day. If you're photographing a baby and mother naturally lighted indoors and the sun goes down, you've got a difficult situation. Here's what I did in a situation of this type. I put my fully charged electronic flash unit (when I'm planning pictures anywhere, I make sure it's got plenty of juice) on an extension cord and bounced flash off the same white reflector I had been using to bounce daylight a few moments before. This lighting, as you can see, appeared very similar to the daylight coming through the window. In the

Co-worker Don Maggio took this natural picture by posing his elderly friend near a window, out of direct sunlight. The "Rembrandt" lighting (amplified by a white reflector on the shadow side) gave a mellow ratio of highlight to shadow on her face, allowing her warmth and friendliness to come through. This type of indoor lighting is extremely tolerant of lines and other characteristics of human skin that we try so hard to hide.

When I started this series, there was plenty of light from the outside, but after a short while the sun went down. The picture on the left was made with sunlight near a window. The one on the right was made with electronic flash bounced off a reflector to simulate sunlight.

Rembrandt, Jr., who forgot his brushes, was lighted by flash bounced from a small umbrella. The even illumination is reminiscent of daylight on a cloudy day.

Umbrellas come in a wide variety of shapes, sizes, and fabric coverings.

This photographer decided that his portrait would benefit if he set up two umbrellas to light his subject. The small umbrella on the right is the main light, which casts the stronger, more directional beam at the front of the subject. The wide, shallow umbrella fills in the shadows on the far side. And voilà—here's the stunning result!

picture of the small boy finger-painting, I made artificial daylight by bouncing my flash from a small (3-foot-square) white umbrella reflector.

Photographic umbrellas can be handy assistants in achieving more control over your lighting. They offer a number of advantages:

1. The color quality of your illumination will remain constant.

2. Umbrellas are misers with your light. The metallic type reflects more than 80 percent of the original flash.

3. You can easily vary the amount of subject coverage and lighting intensity by opening or closing the umbrella.

4. An umbrella is lightweight and usually folds into a neat and portable package.

5. You can use this reflector indoors or out.

You can find umbrellas that are either square or round, and they come in different sizes ranging from 18 inches to 6 feet in diameter. If an umbrella is wide and shallow, it will bounce back a broad beam of soft light. If the shape is deep and narrow, it will concentrate brighter light on a smaller area of your subject.

The reflecting surfaces can be as bright as silver and as soft as a white nylon material. Colored fabrics have just arrived on the scene. A gold material will reflect warm light, a blue fabric will cool things off a bit, and black makes a good "gobo" (go-between) or barricade between the light source and the lens. A gobo is often used to prevent unpleasant flare in portraiture.

I like to equate the type of light reflected by a metal-foil or silver umbrella with sunlight filtered through clouds on a slightly overcast day. It's flatteringly soft for people pictures but doesn't produce the excessively mushy softness you sometimes get with bounce lighting.

Naturally, if you're fortunate enough to have space for a small studio, you can create almost any lighting situation imaginable. Half the fun is experimenting with your portraiture to see which lighting combinations (and there are an infinite number) produce the best results. A four-light setup is an easy way to start. Use photolamps of a color temperature compatible with the film you're using. See the chart on page 244 for the correct film/bulb/filter matches.

Again I feel that the most natural and likable pictures of people are made with indirect lighting. In the diagram you can see that all frontal lighting is bounced—the main light off a white umbrella, and the fill light off a large white reflector. Not only will your model's features benefit from the kinder illumination but you'll find that his or her disposition will be improved, too. These lights can get pretty hot when aimed directly. This is just one idea of how to start with a studio setup; you can find more ideas in *Professional Portrait Techniques,* KODAK Publication No. 0-4, $2.50.

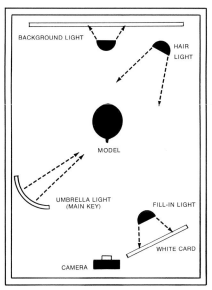

BACKGROUND LIGHT

HAIR LIGHT

MODEL

UMBRELLA LIGHT
(MAIN KEY)

FILL-IN LIGHT

WHITE CARD

CAMERA

SUMMARY

In reviewing some of the important elements that contribute to a relaxed, informal portrayal of your subject, here are a few pointers to keep in mind:

1. Be thoroughly familiar with your camera equipment.
2. Remember the pictorial advantages of working in soft, diffused light.
3. Approach your subject in a warm, friendly, and enthusiastic manner.
4. Choose your locations carefully, mindful of backgrounds and foregrounds, opportunities for different angles and camera positions, and the existence of any distracting or inhibiting elements, such as an abundance of passersby.
5. Concentrate on getting good expressions. In the last analysis, expression means the difference between success and mediocrity.

The experimenters in the crowd will probably enjoy tinkering with a four-light setup in their studios to obtain results like this. Start by following the diagram above left, and then suit yourself. If you're using photolamps, be careful not to wilt your subject. I recommend electronic flash to preserve your subject's good disposition.

Even, low-key illumination treats your picture subjects more kindly.

Expression says it all!

Choose your location carefully—background, foreground, and even the ground itself are all important to a successful picture.

Bill Pinch (left) attends to the x-ray identification and orientation of crystals and the preparation of samples for crystal research in the Physics Division of the Kodak Research Laboratories. Acknowledged as a many-faceted mineralogical expert, Bill is a Fellow of the Mineralogical Society of America and a member of the Mineralogical Association of Canada and the Mineral Museums Advisory Council. He is also Chairman of the Nomenclature Committee for the American Federation of Mineralogical Societies. He operates his private mineralogical museum by appointment only and specializes in the study of new and rare species of minerals. Pinchite, a mercury oxychloride, has been accepted as a valid species by the International Mineralogical Association.

Tom Hurtgen (right) is a Technical Editor in the Radiography Markets Division at Kodak. He received a Bachelor of Fine Arts degree in Photographic Illustration from the Rochester Institute of Technology before joining Kodak in 1970, and his picture-taking activities cover a wide range. Work in fluorescent and infrared photography prompted Tom's interest in minerals, and he has lectured to mineral and lapidary societies on the finer points of taking specimen pictures.

PHOTOGRAPHY OF MINERALS

by *William W. Pinch and Thomas P. Hurtgen*

WHY?

You'll discover an exciting and enticing new world in mineral photography. The challenge of successfully capturing the essence of a beautiful specimen intrigues collectors and photographers alike. Some people make mineral pictures as gifts for friends or as unique home decorations. Others find such pictures useful for describing a specimen to a friend many miles away or as easily mailable examples of specimens for exchange. In case of theft, a photo inventory is the only way to identify your missing specimens. Should your mood prompt you to write an article for a textbook or a journal, you'll surely want to include some good color illustrations.

Whatever reason prompted you to read this article, you're bound to enjoy making better pictures of mineral specimens. Picture success in this case combines such ingredients as lighting techniques, camera positioning, background selection, and appropriate equipment. Let's explore some ideas and practices that can help you produce excellent results.

While the large, spectacular, and more valuable specimens usually reside in museums, smaller and less expensive minerals will offer photo opportunities just as stimulating as those provided by their larger brethren. The magnificent calcite specimen on page 238 cost only $5.00. We'll discuss approaches for museum specimens later, but let's start with and concentrate on the small, inexpensive type that most of us can own or borrow.

Holding a specimen in your hand is often the start of a good picture.

This superb elbaite specimen, a member of the tourmaline group, has been backlighted to reveal the internal colors. (Pala, California; Joel Arem; 6″ high; courtesy of the Smithsonian Institution Collection)

Striking in its delicate symmetry, the full beauty of this calcite specimen is enhanced
by careful lighting, specimen positioning, and choice of background.
(Calcite; Nasik, India; 3½″ high)

Pick up your favorite specimen and look at it. As you rotate it and view it from different angles and with different lighting, you'll instinctively select the most flattering position and lighting angle. Probably this same viewpoint, specimen position, and lighting angle will also make the best photograph. Once you have your camera in the best viewing position, you've got a starting point for successful mineral photography. After we discuss a few pertinent facts about cameras, films, backgrounds, and lighting, you'll be all set to go.

Finding the most flattering photographic position is largely a matter of instinct. The dramatic sunburst effect of this specimen was emphasized by positioning and overhead lighting. (Laumontite; Bishop, California; Joel Arem; size, 8 x 10"; courtesy of the Smithsonian Institution Collection)

CAMERAS

Practically any camera can be used to photograph mineral specimens; however, a camera capable of close-up focusing is best because it enables you to capture more nuances of color and design—the elements that make mineral photography so exciting. The KODAK INSTATECH X Close-Up Camera* produces excellent results, being ideally suited for those with little or no photographic experience. Lens attachments will give you three possible field sizes—one approximately 2 inches square (optional), one about 3¼ inches square, and another approximately 9½ inches square. We made the calcite picture (right) with a KODAK INSTATECH X Close-Up Camera.

You can take close-up pictures of specimens with simple cameras such as KODAK INSTAMATIC® Cameras and many of the earlier KODAK BROWNIE Cameras. A little craftsmanship, a close-up lens or two, and you're set. There are no close-up lens attachments available for KODAK

With the KODAK INSTATECH X Close-Up Camera you can take excellent close-up pictures with a minimum of expense and bother. (Calcite; Frizington, Cumberland, England; 2½" across)

*For more information on the KODAK INSTATECH X Close-Up Camera, ask your photo dealer or write to Lester A. Dine, Inc., 2080 Jericho Turnpike, New Hyde Park, New York 11041.

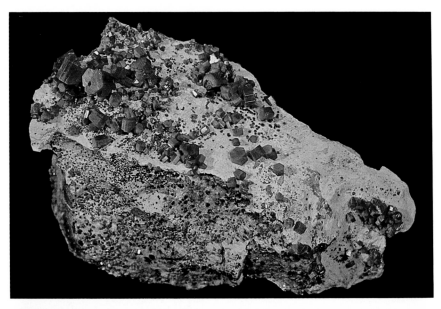

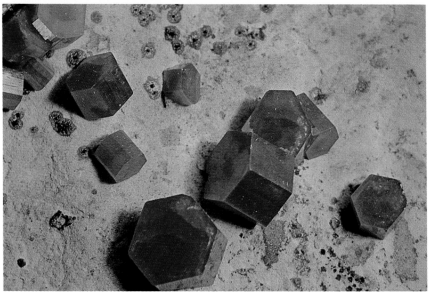

Several different aspects of a specimen may appeal to you. We moved in close on the specimen at the top to produce the extreme close-up (bottom) of the crystals. (Vanadinite; Morocco; size of whole specimen, 8″ across)

TRIMLITE INSTAMATIC Cameras, but the TRIMLITE INSTAMATIC 48 Camera will focus to about three feet. For more details on close-up photography with a simple camera, see your photo dealer, or write to Eastman Kodak Company, Photo Information, Department 841, Rochester, New York 14650, and request the KODAK Customer Service Pamphlet *Close-Up Pictures with KODAK INSTAMATIC® Cameras and 35 mm Cameras* (AB-20). For prompt delivery, please send a self-addressed, unstamped business-size envelope with the publication title and number written on the back.

The most versatile and popular camera for photographing mineral specimens is a single-lens reflex (SLR). Close-up lenses, lens extenders, bellows extension units, and special macrolenses allow you to determine easily the best composition and focus for hand-size specimens. Your photo dealer can demonstrate a camera with any of these attachments.

The simplest and least expensive attachment is the close-up lens, available in powers of +1, +2, and +3. You simply put these lenses in front of your normal or telephoto lens and decrease the minimum focusing distance of that lens. The Close-Up Lens Data table shows the field sizes that you will get by using these lenses singly or in combination. (Incidentally, cleaning these additional lens surfaces is just as important for overall picture sharpness as cleaning your camera lens.) Using a close-up lens requires no exposure compensation.

Lens extenders and bellows extension units fit between the camera body and your camera lens. By increasing the distance between the lens and the film you can focus more closely on a smaller field. The instruction booklet for many lens extenders and bellows units gives a field size

CLOSE-UP LENS DATA

Close-Up Lens and Focus Setting (in feet)	Lens-to-Subject Distance (in inches)	Approximate Field Size (in inches) for a 50-mm Lens on a 35-mm Camera	
+1	Inf	39	18 x 26¾
	15	32¼	14¾ x 22
	6	25½	11¾ x 17¼
	3½	20⅜	9⅜ x 13¾
+2	Inf	19½	9 x 13½
	15	17¾	8⅛ x 12
	6	15½	7⅛ x 10½
	3½	13⅜	6⅛ x 9⅛
+3	Inf	13⅛	6 x 8⅞
	15	12¼	5⅝ x 8⅜
	6	11⅛	5⅛ x 7½
	3½	10	4⅝ x 6¾
+3 plus +1	Inf	9⅞	4½ x 6⅝
	15	9⅜	4¼ x 6⅜
	6	8⅝	4 x 5⅞
	3½	8	3⅝ x 5⅜
+3 plus +2	Inf	7⅞	3⅝ x 5⅜
	15	7½	3½ x 5⅛
	6	7⅛	3¼ x 4⅞
	3½	6⅝	3 x 4½
+3 plus +3	Inf	6⅝	3 x 4½
	15	6⅜	2⅞ x 4¼
	6	6	2¾ x 4⅛
	3½	5⅝	2⅝ x 3⅞

Ultraclose photography requires special equipment such as the close-up lens illustrated above.

and magnification ratio for different lens-to-film distances. Both of these methods require additional exposure, because light has to travel farther to reach the film. Your camera instruction manual or the instruction sheet that comes with the attachment you select will give you an accurate guide to correct exposure with the additional distance involved.

Undoubtedly, the most flexible close-up system is the macrolens, which will focus from infinity to within a few inches of the subject. Framing and focusing on a subject over this wide range are continuous, and in most cases you don't need to make an exposure compensation at very close subject distances. Unlike lenses for general picture-taking, which are designed to give you maximum sharpness at infinity, macrolenses are designed to give you maximum sharpness at very close subject distances. Really, no matter what camera you own or want to buy, you can usually adapt it for close-up pictures of mineral specimens. (If you're going to use a 35-mm rangefinder camera, write to Eastman Kodak Company at the address on page 241 for the KODAK Publication *Close-Up Pictures with KODAK INSTAMATIC® Cameras and 35 mm Cameras* [AB-20].) Most 35-mm SLR manufacturers offer a macrolens, and there are extension tubes, bellows units, and close-up lenses to fit nearly any SLR camera available.

FILMS

The wide range and beauty of the colors in mineral specimens demand color film. Your choice depends on what type of light source you use—flash, photolamps, or sunlight—and on what type of pictures you want—prints or slides.

If the specimens will be illuminated by daylight or electronic flash, KODACOLOR II or KODACOLOR 400 Film is a good choice for prints. Should you prefer slides, a daylight film such as KODACHROME 25, KODACHROME 64, KODAK EKTACHROME 64, KODAK EKTACHROME 200, or KODAK Photomicrography Color Film 2483 will suit your needs.

Indoors with tungsten light sources, you can get good slides if you use KODAK EKTACHROME 50 Professional Film or KODAK EKTACHROME 160 Film. For color prints, KODACOLOR II or KODACOLOR 400 Film will work fine with the appropriate color-balancing filters. See the KODAK Color Film table on page 244 for the correct combination of light source, film, and filter (if necessary).

As a general rule in close-up photography, the contrast and resolving power of slower slide films are assets in achieving good picture quality. Such films include KODACHROME 25, KODACHROME 64, and KODAK EKTACHROME 64, EKTACHROME 50 Professional, and Photomicrography Color Film 2483. Also you may find that a slide with correct color balance will help your photofinisher to make color prints later that more closely reproduce the colors of your specimen.

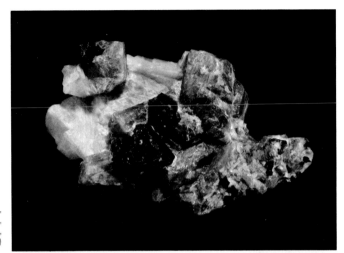

(Calcite, Willemite, Franklinite; Franklin, New Jersey; size, 3" across)

Although the black-and-white picture shows excellent detail in this specimen, the color picture in the middle adds extra dimension. Another side of this specimen is revealed by short-wave ultraviolet light. For more information on photographing fluorescent minerals, see "Photographing Fluorescent Minerals" in *The Here's How Book of Photography* (AE-100), $10.95, and *Ultraviolet and Fluorescence Photography* (M-27), $2.25. These Kodak books are available from your photo dealer.

KODAK COLOR FILMS FOR STILL CAMERAS

KODAK Film	Type of Picture	For Use with	Film Speed (ASA) and Filter		
			Daylight	Photolamps 3400 K	Tungsten 3200 K
KODACOLOR II	Color Prints	Daylight, Blue Flash, or Electronic Flash	100	32 No. 80B	25 No. 80A
KODACOLOR 400*	Color Prints		400	125 No. 80B	100 No. 80A
KODACHROME 25 (Daylight)	Color Slides	Daylight, Blue Flash, or Electronic Flash	25	8 No. 80B	6 No. 80A
EKTACHROME 50 Professional (Tungsten)	Color Slides	Tungsten 3200 K	40 No. 85B	40 No. 81A	50
KODACHROME 64 (Daylight)	Color Slides	Daylight, Blue Flash, or Electronic Flash	64	20 No. 80B	16 No. 80A
EKTACHROME 64 (Daylight)	Color Slides				
EKTACHROME 160 (Tungsten)	Color Slides	Tungsten 3200 K or Existing Tungsten Light	100 No. 85B	125 No. 81A	160
			200† No. 85B	250† No. 81A	320†
EKTACHROME 200* (Daylight)	Color Slides	Daylight, Blue Flash, or Electronic Flash	200	64 No. 80B	50 No. 80A
			400†	125† No. 80B	100† No. 80A
Photomicrography 2483	Color Slides	Daylight	16 CC20G		5 CC40Y+ CC40C+ CC30C

*Not recommended for simple (nonadjustable) cameras.

†With KODAK EKTACHROME 200 and 160 Film, 135 size, and ESP-1 Processing.

BACKGROUNDS

A perfect background displays your specimen to the best advantage; a poor background distracts the viewer's attention. You want to surround your specimen with just the right texture and color. The texture should be slightly different from, but still compatible with, that of the mineral specimen. Vast differences between background and mineral textures give the viewer an uncomfortable feeling.

Choosing a color for the background is somewhat more exacting. The background color ought to complement the color of the mineral. Although individual tastes seem to vary a bit, most people agree on general principles. (If all people agreed exactly on color, all backgrounds would be the same.) Your background color might be complementary, coordinating, or neutral (black, gray, or white). In the photograph of selenite the blue background adds a refreshing coolness to the clear crystals. Although it's possible to use backgrounds with violently clashing colors, we'd advise against it. You may prefer the autunite specimen, page 246, on the red background—we'd choose something else. As a rule, you're safer with subdued pastels for dark specimens and very dark backgrounds for light-colored specimens. Of course, rules are breakable. Intense colors wisely used can really flatter a specimen such as gold. You'll find a variety of background colors in a large packet of construction paper, or you can choose single sheets in an art-supply store. Color-Aid and Day-Glo papers photograph very well and are available in a wide selection of colors.

Texture, or the lack of it, is intended to make the specimen stand out alone. A textured background that takes attention away from your specimen is definitely wrong. Usually materials

A dark, quiet background provides a necessary backdrop for the subtle loveliness of this colorless group of crystals. (Gypsum var. Selenite; Cave of the Swords, Chihuahua, Mexico; Kay Jensen; size, 10" high)

The garish color contrast, plus a combination of different textures, makes this an unfortunate choice of background material. (Autunite; Mt. Spokane, Washington; size, 3″ across)

The almost monochromatic rendition of this unusual specimen emphasizes intricacy of form and delicacy of structure. A viewer's eye is riveted to the specimen, never pausing on the gray background. (Silver; Kongsberg, Norway; size, 2½″ high)

The complementary but not jarring background strengthens rather than weakens the magenta of the specimen. (Rhodochrosite; Restauradoria, Argentina; size, 3″ across)

Many white specimens will appear strikingly three-dimensional
against a black background. (Calcite; Cave of the Bells,
Arizona; size, 2½" across; courtesy
of the Smithsonian Institution Collection)

Often it's rewarding to photograph the same specimen
with different backgrounds. We liked both of these.
(Stilbite; Poona, India; size, 3" across)

Crystallized gold seems enriched by the faded blue background. Enhancing the specimen is the only purpose of a background. (Gold; Placer County, California; Joel Arem; size, 1" high; courtesy of the Smithsonian Institution Collection)

White translucent plastic can become a versatile background element. In this case a sheet of pale-blue paper behind the plastic added a touch of color to the background. (Silver and copper; Keweenaw Peninsula, Michigan; size, 2¼")

with a bold pattern or heavy weave (such as the unbrushed red velvet in the autunite picture on page 246) won't serve your purpose well. Many fabrics, however, make excellent backgrounds. About two-thirds of a yard of cloth is sufficient for hand-size specimens. Velvets come in many colors and can become spectacular backgrounds. (A hint for velvet-lovers: Dust and lint love your velvet as much as you do; keep a roll of double-faced cellophane tape around to clean your backgrounds. Little dust particles can look enormous in your pictures.) Several of your fabric backgrounds can be stored wrinkle-free on a roller.

White translucent plastic ⅟₁₆ inch thick can be used in a number of clever ways. Alone it's the perfect neutral background. Colored paper behind the plastic paints it with just a touch of color. Such plastic also comes in black and in bright colors, and you'll often find scrap pieces big enough to serve as backgrounds for your hand-size specimens.

Since nature produces minerals, don't overlook the possibility of adapting natural backgrounds. Sand, for instance, makes a nice setting. Try to keep such natural settings relatively uncluttered, because out-of-focus details weaken the visual "grabbing power" of your specimen.

POSITIONING

Positioning a specimen for photography is easy when you hold it in your hand and move it around until you find its most pleasing aspect. Usually this is the same view that will compose well in your camera's viewfinder. Place your specimen on the background. Occasionally it won't maintain the exact position you want. A bit of modeling clay will keep it propped the right way. Steady your camera on a tripod, and you're ready to frame,

focus, and But we're still in the dark—let's shed some light on the subject!

LIGHTING

Suitable lighting reveals the crystal form and surface texture of a good mineral specimen. Actually, the lighting principles we'll discuss here are the same as those applied in any type of controlled photography. The only difference (if you want tungsten illumination) is that the lamps must be small enough to render shape and texture without overwhelming your subject. We've found that microscope illuminators provide a great deal of control.

There are three basic elements in an effective plan for lighting mineral specimens. The first element is the main light, which should model the shape of the specimen and reveal its texture. The second element is the fill-in light, which must brighten dense shadows so that the film can record detail over the whole specimen. The final element is accent illumination, which will separate the subject from its background or brighten special areas to heighten visual impact.

Your lighting should depict the subject as naturally as possible. Light should appear to strike the subject from one direction—usually from an angle slightly higher than your camera and off to one side. Your best lighting setups will usually give the impression of sunlight.

Remember that the formula for good lighting is simple. Move the main light into many different positions until key details are easily visible from the camera viewpoint. Apply fill-in illumination when there are shadows on important areas of your specimen. Again, move this second source of light around until it gives an effect exactly

(continued on page 254)

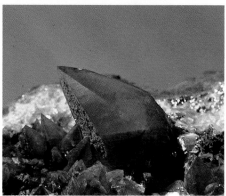

Finding the right camera position will bring out the most important portions of a specimen. We thought that the calcite crystals merited attention, so a new position for the specimen, slightly closer, set off our center of interest against the background. The specimen wouldn't easily hold our chosen position, so we propped it up with a bit of modeling clay. (Calcite; Chihuahua, Mexico; size of large crystal, 3¼" long)

While the picture on the top is an adequate rendition of a fine specimen, we were able to improve our efforts by adding a white reflector to the single main light. Of course, we'd crop out the piece of white cardboard another time, but we left it here to show how it brings up details in the bottom of the specimen. (Apatite in Calcite; Otter Lake, Quebec; size of crystal, 4½″ long)

Adding a second light source, perhaps the reflection from a white card, helps to shape the specimen (bottom), separating important details from the background. In comparison, the picture on the top is lifeless. (Microcline var. Amazonite; Florissant, Colorado; size, 5½" across)

Both of these specimens were photographed with two electronic flash units
opposed at a 45-degree angle to the subject. Although more difficult
than other lighting techniques, flash can still provide good results.
(Top: Anhydrite; Simplon Tunnel, Valais, Switzerland; Rock
Currier; size, 4″ across. Bottom: Legrandite; Ojuela Mine, Mapimi,
Durango, Mexico; Rock Currier; size, 3″ across)

A reflective specimen will photograph poorly in direct sunlight (top)
unless surrounded by a tent-like diffuser (bottom). (Hematite var.
"Kidney Ore"; Ulverstone, England; size, 6″ across)

to your liking. The fill-in illumination should be much less intense than the main light. You just want it to preserve detail in the shadows. Light bounced from mirrors or matte reflectors (white cards or paper) makes a good source of fill light. Too much light often adds confusing multiple shadows to the scene. A subdued accent light low and in back of the specimen may help to define the shape of your specimen and emphasize its brilliance. See the "before-and-after" application of these elements in the accompanying pictures.

"Pipe-lighting" is a lighting technique that infuses any translucent specimen with a rich, fiery glow. Flooding the interior of the crystal with a small beam of intense light seems to breathe life into the mineral's center. Usually the effect is accomplished with the beam of a microscope illuminator placed out of view and behind the specimen. A crystal with many reflecting faces will accept light "differently" from different angles, so you may want to experiment with different illuminator locations. Try two lights for even more of a glow.

Sunlight is an excellent source of illumination that is well suited to many specimens and many color films. Apply the rules for backgrounds, positioning, and lighting just as you would indoors. A position near the edge of some open shade will shed partly diffuse, partly directional light on your subject. Direct sunlight (usually best in early afternoon) can be quite successful. The pictures of the microcline specimen on page 251 were taken outdoors in direct sunlight.

Mineral photography requires careful attention to the detail you see in your viewfinder. You'll want to be aware of what effect your lighting has on your specimen. Although it's possible to use flash illumination, you'll be somewhat handicapped by not being able to see the effect of the flash before you take the picture. It will be difficult to predict what image your film will record. One way to visualize the lighting effects of flash is to aim a tungsten lamp at your specimen from the flash position. You can also use special studio electronic flash units with built-in tungsten modeling lights. You should see any disturbing reflections and unwanted shadows.

Since you'll want to record as many tones of your subject as possible, it's important to consider lighting contrast —the ratio of brightness of the main light to that of the fill-in illumination. A specimen with a very low lighting ratio will appear flat and lifeless in a picture; a mineral with an extremely high lighting ratio will snap right out of the picture—unfortunately it will lack shadow and highlight detail. When the main light is three times as bright as the fill light (a 3:1 ratio), you will have a happy compromise between these two extremes. This ratio usually allows excellent recording of both highlight and shadow detail, and preserves enough contrast to give the picture some life.

In bright sunlight a specimen with shiny faces or very smooth surfaces will be a maze of dazzling reflections. Your photograph will look the same way, so you should concentrate your attention on what you want your shiny specimen to reflect. When photographing gold, for instance, surround the subject with gold or yellow reflectors and permit it to reflect a gold color.

One successful method often used to photograph very shiny subjects is to enclose them in a tent or white cylinder made of paper, plastic sheeting, or cloth. Tent-lighting minimizes specular reflections and happily avoids the dark shadows caused by a

darkened room. The tent should let soft, diffuse light pass freely through its walls to illuminate the specimen. You can also tone down reflections on shiny nonmetallic specimens by attaching a polarizing filter to your camera lens. A diffuser, such as a piece of translucent white plastic, can soften harsh beams of sunlight enough so that both highlights and shadow detail can be recorded easily.

EXPOSURE

Your camera's built-in reflected-light exposure meter, or any reflected-light meter for that matter, may misinterpret different backgrounds and specimen values. A specimen placed on a black background will fool your meter into giving you more exposure than you need. A white background will register less exposure than you need. Exposure meters read middle gray tones as perfect exposure and try to reduce blacks and whites to gray. For more accurate meter readings, place an 18-percent gray card in the same position as your specimen, with the same light falling on it, and make a reflected-light meter reading from the card. An incident-light meter will give truer readings without the need for a gray card. Even with a meter, it may be wise at first to bracket your exposure by taking several pictures. Keep a record of your camera settings so that you'll be able to duplicate your best results. This will check the accuracy of your meter and give you experience with both dark- and light-toned subjects on backgrounds of different tone values. If you do not have an 18-percent gray card to use with your reflected-light meter, check your camera or meter instruction manual for information on exposure compensation with extreme lighting and subject-value conditions.

Brilliant pipe-lighting provided by microscope illuminators at both ends shows the internal color of this fine crystal. This method simulates the natural effect of transmitted sunlight. Pipe-lighting allows you to use a dark background while still displaying the specimen's internal color. (Topaz; Villa Rica, Brazil; Joel Arem; size, 2″ long; courtesy of the Smithsonian Institution Collection)

The dark, unobtrusive background allowed sunlight to explore
the subtlety of this specimen's pale blue color. (Barite;
Frizington, Cumberland, England; size, 5″ across)

As there are several approaches to meeting every challenge, so there are
several ways to photograph some minerals. In the center you see a good
standard view of a specimen, looking as it does in nature. At the bottom,
a similar specimen is photographed with a single intense light
(a microscope illuminator) from the top back. It should be viewed as a
work of art, not as a natural representation. This type of ''pipe-lighting''
bounces great amounts of light around inside the crystal, causing it to
glow with intensity. (Both: Cinnabar; Kwei Chow, Hunan Province, China;
center—William Pinch; size, ⅜″ across crystal; bottom—Joel Arem; size ½″
across crystal; courtesy of the Smithsonian Institution Collection)

It's important to keep as much of the specimen in focus as possible. At very close
distances, you'll have to increase your shallow depth of field by using
small lens openings and slow shutter speeds. Be sure to select a camera position
that keeps most important details in a plane parallel to your film plane.
(Silver; Kongsberg, Norway; size, 3″ high)

Depth of field is not as crucial with flat specimens
(flats) such as this. A typical flat is merely a slab sawed
from a larger specimen. Be sure to avoid reflections from
highly polished surfaces such as this. (Quartz var. Agate;
Minas Gerais, Brazil; Kay Jensen; 6" across)

Some specimens invite the use of a scale or measure to
indicate size. This dull-metal scale is 1 inch long overall
and 1 centimeter long at the right of the mark. Notice how
the scale shows up well on both light and dark backgrounds
without detracting attention from the specimen. The black
background, incidentally, eliminates the confusing shadows
that are cast onto the white background. (Pyromorphite;
Mercur Mine, Ems, Germany; Rock Currier; 3" high)

DEPTH OF FIELD

Mineral specimens are emphatically three-dimensional and should appear that way in pictures. A part of the specimen (especially the foreground) that's out of focus in this type of photograph is *very* distracting. Choose the smallest lens opening you can—many macrolenses go as small as $f/22$ or $f/32$. Clever positioning of important details within the same plane of focus will help you keep the whole specimen acceptably sharp.

SCALE

Some specimens and picture situations call for the inclusion of a scale. This object should easily identify the specimen size. A conventional ruler can be distracting. A small piece of calibrated metal as shown on page 258 works well. A dime or some other familiar coin serves the same purpose. Out in the field, merely place a tool of known size, such as a rock hammer, next to your subject.

PHOTOGRAPHY IN MUSEUMS AND AT MINERAL SHOWS

A mineral collector can hardly resist the temptation to photograph the fabulous specimens in museums and at mineral shows. In either situation you will want to contact authorities for permission to photograph the displays. Be sure to ask about using flash. You may also want to ask about photographing some of the specimens that are equally spectacular but not often displayed.

Some simple techniques and safeguards should help your museum and mineral-show pictures. It's all too easy to record a reflection of yourself or your flash in the display case. As illustrated on this page, you can eliminate these reflections by positioning flash and camera at an angle to the display glass. If you have a flash ex-

tension, merely position the flash a couple of feet away from your camera at an angle to the exhibit and aim your camera straight on.

If you're taking pictures by existing light, you may want to try a polarizing filter to play down other reflections. Also make sure that the film you're

This pair of pictures taken with a KODAK Pocket INSTAMATIC Camera illustrates the importance of choosing your flash angle carefully when you photograph glass museum showcases. By just aiming at a slight angle to the glass, you'll eliminate most reflections.

using is compatible with the display lighting. When the light comes from skylights or windows, use any daylight-balanced color film. If the lighting is primarily fluorescent, load your camera with daylight film and attach a special FLD filter (available from your photo dealer). Tungsten or

Flash reflections can spoil your pictures of showcases at mineral shows, too. By moving in much closer (a good idea anyway) with your flash at an angle, you'll avoid annoying reflections. (Courtesy of the David P. Wilber Collection, Cincinnati Gem and Mineral Show, Cincinnati, Ohio, 1973)

You can often tell a better story by taking one overall showcase picture and then moving in close to several mineral specimens. (Courtesy of the Keith Procter Collection, AFMS Show, Charlotte, North Carolina, 1973)

Pipe-lighting from the top right kindles red flame in this remarkable specimen.
(Proustite; Niederschelma, Saxony, Germany; Joel Arem; size, 1¼" high;
courtesy of the Smithsonian Institution Collection)

incandescent light sources require a film specially balanced for artificial light, or a daylight film with special filters (see page 244). An incorrect match of film and lighting will give you off-color results, and when you're trying to capture the subtle beauty of a specimen, poor color balance can do it an injustice. Good quality in existing-light pictures dictates the use of a tripod and cable release. Not only will you avoid camera movement but also you'll be able to use slow shutter speeds and small lens openings for greater depth of field.

Remember that you can apply close-up lenses, bellows units, and extension tubes to telephoto lenses. The working distance of a telephoto lens will allow you to take close-up pictures from beyond the protective glass of a display case. If you're shooting up close with a macrolens, your on-camera flash will be too bright. Some electronic flash manufacturers provide special density filters to cut down the intensity of the flash. One or two layers of white handkerchief accomplish the same goal. It's a good idea to experiment a bit at close-up distances.

Often at a mineral show, the best times for photography occur before the opening and at the closing, when specimen display cases are being constructed or disassembled. Wait until the glass cover is gone, or get there before it's mounted, and take pictures with no fear of reflections.

WHY NOT?

Try something new. Many of the most tantalizing and subtle colors in nature appear in these small mineral masterpieces—as well as some of the most incredible designs. It's not difficult to capture them on film, and you can make mineral pictures all year long, regardless of the elements raging

outside your door. The thrill of magnifying your best specimens on a projection screen or in enlargements is a unique experience.

Unless otherwise indicated, all specimen pictures in this article are by the authors, courtesy of the William W. Pinch Collection, Rochester, New York.

BOOKS ABOUT MINERALS AND GEMS

Color Under Ground: the Mineral Picture Book, White, John S., Jr. New York, Charles Scribner's Sons, 1971; $6.95.*

Dana's Manual of Mineralogy, Hurlburt, C. S. New York, John Wiley & Sons, Inc., 18th ed. 1971; $19.95.

Field Guide to Rocks and Minerals, Pough, Frederick H. Boston, Houghton Mifflin Co., 1953; $8.95.

Getting Acquainted with Minerals, English, George L., Jensen, D. E. New York, McGraw-Hill, Inc., rev. ed. 1958; $8.95.*

Minerals and Man, Hurlburt, Cornelius Jr. New York, Random House, Inc., 1968; $17.95.

Rocks and Minerals, Arem, Joel. New York, Bantam Science, 1973; $1.95.

The Gem Kingdom, Desautels, Paul E. New York, Random House, Inc., 1971; $17.95.

The Mineral Kingdom, Desautels, Paul E. New York, Grosset & Dunlap, Inc., 1968; $7.95.

PERIODICALS:

Lapidary Journal: Box 80937, San Diego, California 92138; Monthly, $6.95.

The Mineralogical Record: (Friends of Mineralogy) Box 783, Bowie, Maryland 20715; Bi-monthly, $10.00.

*Not in print. Check with your library.

NATURAL ZOO PHOTOGRAPHY

by *Paul D. Yarrows,*
FPSA, FRPS, Hon. FPSSA

Zebras, giraffes, mandrills, exotic birds—I've photographed them all, and not one picture required a major journey. The artificial wonderlands created by zoo authorities have provided the opportunities for some of my favorite nature pictures. You, too, have the chance to capture many, many fantastic creatures on film in a single location without searching the world over. It's inexpensive at the zoo; you don't need much vacation time; the animals are a bit more confined, and they'll tolerate the presence of human beings. In addition, many progressive zoos are building homes for their inhabitants that simulate their natural environs.

Of course, there are two types of zoo pictures. The more common type is the fun picture—of people, kids, animals, and happenings. The other kind demands that you separate an animal from its surroundings. You want natural-looking pictures that don't show the "hand of man." It's the second type of picture that we're concerned with here. I've greatly enjoyed my zoo photography and would like to share it with you.

Paul D. Yarrows is a Program Specialist in Kodak's Consumer Markets Division. His imaginative photographic lectures have been enjoyed throughout the United States and Canada. Paul's article "Moons in the Refrigerator" appeared in *Here's How.*

A HINT FOR MORE SUCCESSFUL ZOO DAYS

Animals at the zoo get tired of seeing people. They retire to the backs of their enclosures at the end of a busy week or in the middle of a bustling Saturday. You'll want to avoid the crowds. Ideally you should make your safari on a rainy weekday morning during the school year. Chances are you won't see another soul. You'll appreciate some peace and quiet that'll

Today, most zoos provide their tenants with surroundings that duplicate their native habitats.
It's easy and fun to take nature pictures that don't show the "hand of man."
I found this cooperative giraffe in the Oklahoma Zoo, unencumbered by fences
or other photographic hindrances.

allow you to set up and shoot at your leisure. If you go in the early morning, your subjects will be more alert and not yet bored by those curious monkey facsimiles on the other side of the fence.

Renting a baby stroller for the day may save you a lot of unnecessary effort in lugging around your equipment.

EQUIPMENT

I try to take what I'm sure I'm going to use and not much more. We photographers can learn something from the backpackers, who are experts at the art of lightness. If you're not going to use it, don't take it. Even so, after all these words of wisdom, I usually rent a baby stroller to transport my stuff. The sight causes a few stares and some gibes, but at dusk my back still feels great. My basic equipment consists of a single-lens reflex camera, a fully charged electronic flash unit, a 300-mm $f/5.6$ telephoto lens, a tripod, a cable release, and a long uncoiled sync cord. I usually add lens-cleaning tissue to clean fingerprints and noseprints off the display glass. Of course I carry some other equipment, too, but these are the essentials.

YARROWS' SUCCESSFUL TECHNIQUES FOR PHOTO HUNTING

Every animal has a distinct personality. Watch the one you want to photograph. It may be lazy; it may be active. It may be interested in people; it may be bored to tears. Every animal rests in a particular place in its little home. You can focus on that spot for pictures of the animal in repose. Most animals also have a distinct exercise pattern. Each time they'll play or pace in the same area and in the same manner. Watch the routine, find the part of the act that you like best, focus on the spot where it happens, wait, and shoot. Prefocusing is a must in photographing active animals. You'll find it's nearly impossible to focus on a restless cat, for instance. The key word is patience. Concentrate on one animal at a time, even if it takes an hour or two. One really good picture is worth more than a roll of hurried shots.

Some animals don't move much—and when they do, they're not too swift. Reptiles and amphibians slither into this category. Lizards, alligators, and snakes are easy to keep in focus and are easily illuminated by flash. They provide a good way for you to ease into zoo photography.

Most animals are alert and active right before the feeding hour. This is the best time to get pictures of them with their eyes open wide and ears ready for meal sounds. Feeding offers some great possibilities for realistic pictures, too. Immediately after dinner, the great animal population considers a siesta. First they clean up, then they find a comfortable place to lie down (almost always the same), and then they yawn, stretch, and zonk out. You get the same performance in reverse when they wake up. Each

In a zoo where the animals are separated from crowds by a ditch or moat, you'll have many good picture opportunities with a strong telephoto lens and a tripod. It may be handy, if permitted by the zoo, to have a friend get the animal's attention with some bits of food. Be sure to check the rules. Your widest aperture will throw the background out of focus, and the magnification of your telephoto lens should fill the frame with the animal.

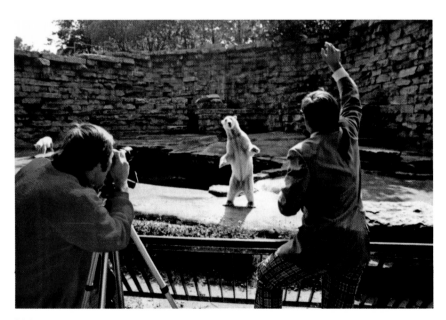

phase will give you grand pictures, plus a great deal of insight into how life should be lived.

If an animal chooses to ignore you when you've got your exposure all set, the focus sharp, and finger steady, try a whistle, cluck, hiss, gurgle, growl—anything to get its attention. This will often work wonders with unsuspecting animals.

My last bit of advice in this section is to take adequate notes on your different picture-taking situations. This way you can compare your results with your expectations and make your next trip to the zoo an even greater success.

UNDER SUN AND SKY

Some zoos want to preserve a natural-appearing habitat for their outdoor animals. Many of these animals are separated from the crowd by only a moat and a low fence (to keep the spectators out, not the animals in). Try to take the best advantage of these exhibits and pick an angle that shows only the animal against a natural background and foreground. Don't hesitate to use a wide lens opening that throws the background into a diffuse haze.

Here are some pointers for coping with outdoor enclosures. Try to put the front of your lens right next to the fence (if it's safe), with the wires out of sight around the edges. Use the biggest lens opening you have for minimum depth of field, and focus very carefully on the most important part of your subject. You're going to have some problems if the animal is near a fence or if you have to stand back from the fence. Look for openings in fences and cages. Some angles are definitely better than others.

Suppose you solve the problem of the foreground fence and manage to

The rim lighting on this deer reminds me a bit of day's end in a tropical climate. All I did was to catch my subject in a backlighted position and underexpose.

Your patience will be rewarded with a superb picture. Animals, like people, look better in some positions than in others and it's worth your time to wait until your subject assumes a good pose.

Fences obstruct your path to good pictures.
As you can see from this series, animals
near the back fence, side fence, or front
fence will not look natural. When you can put
your lens right next to the fence and find
your subject in the middle of the compound,
you can get a good close-up portrait
with a telephoto lens.

get close to your subject at an angle that shows a good background. At that angle, is the sun casting objectionable shadows on the subject? Well, you can't have everything. If you can, by all means lighten the scene with some fill-in flash. If the sun is low in the sky, as in the morning or in the evening, you may be able to get some exciting silhouettes.

Morning is an excellent time to be outdoors at the zoo, because the light is bright but not harsh. Sometimes you may be lucky enough to find mist or fog still covering some of the grounds.

INSIDE MAN-MADE CAVERNS

Indoors, as outdoors, look for displays where the animals live in natural surroundings, or where the color of the background is natural for the subject matter.

Most zoos illuminate indoor facilities with skylights, so you can usually count on shooting with a daylight-balanced film. There's always the exception, of course, so be prepared with either tungsten film or an electronic flash unit.

When you're taking pictures by existing light through glass cages, watch out for insidious little reflections that'll creep into your scene when you least expect them. Move about at an angle to the glass until reflections that can spoil your pictures are minimized or eliminated; then make your exposure. Or place a polarizing filter over the lens to beat your reflection problems.

Some subjects and lighting situations are naturally dark and need to be perked up with extra light. That's why you brought your flash unit. But when a bright blast of light is bounced back into the lens of your camera, it accomplishes nothing except to ruin what might have been a nice picture.

(continued on page 277)

Birdhouses and other similar enclosures are often lighted by skylights. The soft, diffuse lighting on the scarlet ibis against the heavy green background definitely gives one a feeling of deep jungle quiet and color. The vertical out-of-focus background complements this extremely vertical stork. Again, the soft lighting helps to set a natural mood.

Big cats are always impressive. These indoor
enclosures were lighted by windows or skylights
of some kind. To make sure that the background—
an unimpressive tile wall—disappeared, I
underexposed a bit, catching just the highlights
of the feline heads. This treatment can emphasize
the power and wild spirit of a big cat.

Indoors, you may want to use flash. Behind glass, the lighting is often dim, but with an electronic flash unit you can control your lighting, and subject movement is of little consequence.

The two lizard pictures on page 274 were taken through glass. I used electronic flash to light up the scene and to add a little snap. It's pretty difficult to tell that these pictures weren't taken in the lizards' natural home. The top picture on this page shows what happened when I backed away from the glass with my flash on the camera—I got a huge glare.

The bottom two pictures demonstrate two ways to avoid the glare. Hold your flash at an angle to the glass and at a distance from your camera. If you tire of this, get a friend to hold the flash. In addition, holding the camera and/or flash extremely close to the glass can be a help. (The two bottom pictures in themselves are excellent examples of how effective shooting at an angle can be.)

These two views of a brightly colored mandrill illustrate the benefits of flash with a relatively close subject, and of patience in waiting for the right moment.

There are lots of ways to combat flash reflections in glass, and they're all simple. If you put your camera right against the glass, you can safely mount your flash unit off camera in any position. If you put the flash against the glass, all will be well. If both camera and flash are away from the glass, be sure the flash is far enough from the camera so that its reflection will not appear in the camera's field of view. With flash on your camera, you can avoid reflections by standing at an angle to the glass.

Poor human, since you have only two hands and your feet are virtually useless for holding things (no wonder monkeys mock us), you'll probably have some difficulty achieving enough separation between flash and camera. Fortunately, if you hold your camera close to the glass, you needn't make too wide a separation between camera and flash unit. If you can't get close to the glass, you'll need that long cord. I prefer straight cords because the spring tension of a coiled cord can pull the contacts apart. If you're smart, you'll take along an assistant to hold the flash wherever you want it. The moral support and conversation are also something that your gadget bag can't supply.

WHERE THE PEOPLE ARE HELD CAPTIVE

I highly recommend some of the new attractions that recreate portions of the African veldt and some parts of the jungle. From bus or car you have the opportunity to view exotic wildlife much as it appears in its homeland, not to mention the chance for some great pictures.

MORE THAN TEETH AND WHISKERS

Zoos aren't all animals and serious photography. I've spent some of my most pleasant hours observing the visitors, especially the kids. They come to have fun, and you'd be surprised at all the different forms fun takes. Some kids pay attention to the animals and are shocked, amused, mesmerized, horrified, amazed. Some kids can't even comprehend these other forms of life, so they just play in their usual way. Hot dogs and cotton candy, bears accepting marshmallows from tots—the whole spectacle is worth capturing. You may even get a prizewinner out of a candid shot.

Well, I don't know what you're waiting for. If the lure of the plains intrigues you, you can spend hours looking into those mysterious, vastly foreign eyes of the lions. A thoughtful, ponderous elephant can make you feel tiny and insignificant. The grace of a gazelle and the dainty gestures of a baby giraffe can transport you thousands of miles to another type of world, eons old, unchanged, primitive, and eminently sensible. Let's go to the zoo!

You'll be able to move right in on the gentle animals
of the children's zoo. Electronic flash brought out just a hint
of catchlight in the fuzzy koala's eye.

Some exhibits now allow animals to roam free at will, acting out a more natural part of their existence. You'll be able to get more natural pictures, too, such as this tree-borne lion and the close-up of the ostrich. Be careful and follow the rules—wild animals are always unpredictable and often dangerous.

If you're fortunate enough to know someone with a private zoo, you'll find unique picture opportunities. You'll get to know the animals well—their habits, expressions, and positions. The owl, bobcat, and raccoon all resided in the backyard of a friend of mine. They were cooperative and we were patient.

Using a telephoto lens from a nearby blind, I was able to get a tightly cropped portrait of this great horned owl. Note that what appears to be a blinking eye is actually the nictitating membrane which gives protection to the eye.

Richard D. Robinson is Supervisor of the Photographic Markets Information Bureau, Kodak Canada Ltd., in Customer Services. His diversified career in photography includes several years as a staff photographer for the Ontario government and later as a technical sales representative for Radiography Markets Division at Kodak Canada. Specializing in birds of prey, Dick has been photographing winged creatures of the wild since 1941. His outstanding pictures have earned him the Fellowship of the Royal Photographic Society. His work has appeared in several books, the most recent being *Birds of North America,* published by Doubleday and Co., Inc., New York. Dick and his family make their home in the Toronto, Canada, area.

PHOTOGRAPHING WILD BIRDS

by Richard D. Robinson, FRPS

Bird photography is a great way to combine an interest in photography with a love of the outdoors. It's a hobby that can be practiced in varying degrees, depending on your enthusiasm and available time. Pictures of approachable winter birds such as cardinals and chickadees can be made easily at a window feeder or in a back garden on a Sunday afternoon. As you become more proficient with bird photography, you may wish to spend your entire vacation far from home, making a photographic record of the life and habits of some unusual bird.

YOUR GARDEN—A GOOD PLACE TO START

Experienced bird photographers are usually very informed naturalists, fully aware of their quarry's haunts, habits, and personality. They know where and when to search for a particular species. They also understand the nature or makeup of a particular kind of bird and take into consideration the limitations of their approach, equipment, and procedure. Most others will acquire this knowledge along the way. If the idea of bird photography as a hobby is new to you, you will be able to have fun and get good results right from the start by photographing the

This close-up picture of newly hatched coots was taken with a
handheld camera and flash.

To photograph this chestnut-sided warbler with her young, I
used a remote-control wire attached to the camera.

more common and tame species, starting with the birds that you'll find in your garden.

A bird is a fleeting subject which is normally difficult to capture on film. It helps if you can predict where it may come and stay—long enough for you to focus, compose, and take the picture. Watch the habits of a bird and determine a spot where it will appear regularly and often. Birds will often frequent a feeding station in the garden during the winter months, and in summer you might find a birdbath popular. Some birds regularly use a perch which can provide you with a known spot on which you can focus your camera, ahead of time.

Sometimes, you can use appropriate food to entice birds into camera range. I have photographed ducks by scattering grain on a patch of shoreline, while pieces of chopped spaghetti placed on the beach stopped shorebirds in front of my blind long enough for me to get several good pictures.

Often, you don't have to look far to discover a nest. This Eastern phoebe made her home in a concrete culvert under a highway.

FINDING THE NEST

By far the most photographically profitable place to photograph a bird is at its nest—where its maternal instinct greatly helps to overcome its fear of the camera. During the nesting period of a few weeks, the bird will have an overwhelming desire to carry out various activities at this spot, activities that include nest building, incubating, and feeding the young. This instinctive drive greatly increases the chances of obtaining a series of excellent photos.

During the breeding season, you can usually find nests without much difficulty if you are prepared to take whatever species happens to turn up. The simplest way to discover an active nest is to tramp through a secluded area and investigate the obvious

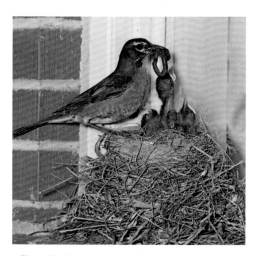

The robin is a common garden bird found in most areas and may occasionally build its nest in a location that's neighborly, such as on a nearby window ledge.

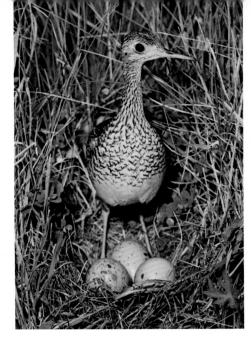

Upland plover. You'll have your best chances to obtain excellent photographs of birds during the nesting season. Their natural instinct to protect the eggs often overcomes their fear of the photographer.

clues. If a thrush or warbler flushes out of a bush, examine the site closely, particularly if the bird lands nearby and appears agitated. Pound upon trees with holes or cavities—you'll be surprised how often a woodpecker or crested flycatcher will look out.

Most songbirds become noisy and agitated at the appearance of an intruder near their nest; but if you sit down and quietly wait, they will soon resume their normal activities, eventually revealing their nest to you and your waiting camera. If you see a species that particularly interests you, take cover in a shaded or unobtrusive spot and watch the bird through your binoculars. In the nesting season, the bird with eggs to incubate or young to feed is waiting for you to leave. However, if you are still and persistent, you will eventually see the bird sneak to its nest. In the spring the rule "where there is a bird there usually is a nest" has paid off for me many times, although sometimes it has taken hours of sitting and searching. When you encounter an agitated bird, you are almost sure to find a nest nearby.

There are many ways of finding nests of certain species. For example, if you wish to locate the nest of a ground-nesting bird such as a bobolink or meadowlark, take a long rope to a suitable field and, with the help of a friend, drag the length of rope over the grass, investigating the spot from which each bird rises. Flushing a bird near the rope usually means you will find its nest nearby. Or if you wish to photograph a hawk or an owl at its nest, you should stroll through forested country in the early spring, examining all large nests in the treetops with your binoculars for signs of down or feathers clinging to the edges of the nest.

Government topographical maps are of great assistance in finding nests by indicating the locations of various types of habitat. The secluded little marsh that is perfect for rails, gallinules, etc, is often not visible from the road. Bird books and field guides are also invaluable for indicating in what habitat you should search for a particular species.

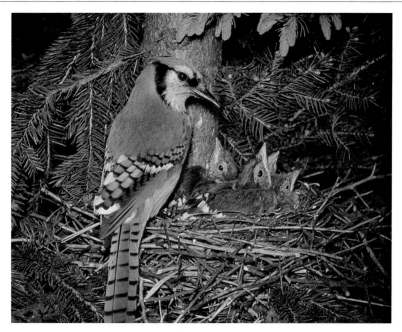

Blue jay and young

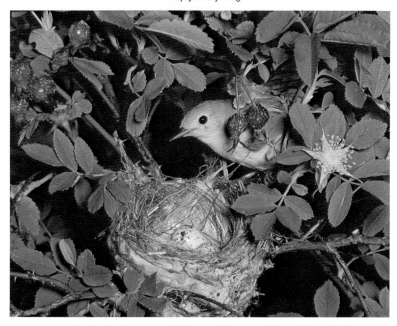

Yellow warbler

During the nesting season you can count on the female to stay close to her eggs or young. The nest, therefore, becomes *the* spot where the bird will appear regularly and often.

Canada geese—taken with a 135-mm telephoto lens.

PHOTO EQUIPMENT
Cameras

Today's bird photographer is indeed fortunate to have superb equipment available—rapid-winding cameras, fast and long lenses, and fast, fine-grain color film. All these things make every picture-taking project easier and more enjoyable. Bird pictures can be made with any type of camera, but single-lens reflex (SLR) models with interchangeable lenses are by far the best because of their convenience and versatility. With their ground-glass focusing, you can observe and focus the image of a flighty subject right up to the instant of exposure. Such a camera is desirable for nesting pictures as well as flight pictures, both in and out of a blind.

Lenses

SLR 35-mm cameras have a wide range of lens accessories that are useful to the bird photographer. The newer and popular variable-focus (macrozoom) lenses are most convenient when working from a blind. You can take long shots including a little of the habitat and, with the same lens, zoom in for an extreme close-up, perhaps even a head-and-shoulders portrait of the bird.

To make good pictures of birds you need a telephoto lens. When using a 35-mm camera from a blind or by remote control to photograph a bird at its nest, I generally prefer a 150-mm lens. This focal length provides me with a 3X image magnification and yet

Trumpeter swan

To take these two pictures,
I set up my camera (with 360-mm
lens) on a tripod within full
sight of the birds. The more
than 7X magnification of
the long lens helped me get
good close-ups of these birds,
even though they were some
distance from shore.

Avocet

Instead of using a tripod, you
can steady your camera by
resting the lens on a bean bag.

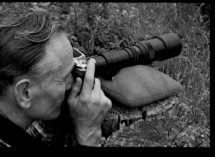

When using a long-focus lens
on a tripod, I tie a heavy weight
around the center post to
reduce vibrations.

gives me an easy-to-handle lens with a relatively large f-stop capability.

Because a bird photograph should be very sharp, don't use a lens of a focal length longer than necessary. Definition will often decrease and the chance of camera shake, which results in loss of definition, increases with longer-focal-length lenses. But if you lack the time or inclination to build a blind, you'll find the longer lenses (300-mm to 1000-mm) very useful for recording many types of birds by merely shooting from a tripod in full sight of the bird. With long lenses you can photograph waterfowl and shorebirds some distance out from shore and other casually encountered species with a minimum of effort. You'll need a sturdy tripod and a weight suspended from its head to reduce vibrations. Use a cable release with all long lenses to eliminate possible camera motion from tripping the shutter release with your hand.

If you intend to take pictures from an automobile, steady your long lens by resting it on a bean bag draped over the edge of an open window. Or you may prefer to get out of the car and rest the camera on a couple of bean bags on the hood or roof. Always use a shutter speed as fast as possible to minimize camera motion. High-speed films, such as KODAK EKTACHROME 200 Film (Daylight), are ideal because they allow you to use a fast shutter speed under most lighting conditions.

Teleconverters

As an inexpensive alternative to buying a longer-focal-length lens, consider purchasing a telephoto converter (generally called a teleconverter or tele-extender), which changes your normal or telephoto camera lens to a lens of higher power. A teleconverter is a supplementary optical accessory which you attach between the camera body and the camera lens. Once in place, it will, in effect, increase the focal length of the lens—the amount of increase depending on

Jaeger in flight. When hand-holding a long lens to pan with the movement of the bird, use the fastest shutter speed possible to minimize camera and subject motion.

Being unsure that this Cooper's hawk would tolerate a blind in an adjacent tree, I fastened the camera (using a bracket) to a limb nearby and ran a remote-control wire back to the blind, which was on the ground about 75 feet away.

the magnifying power of the tele-converter.

One possible disadvantage in using some teleconverters is a slight loss of image sharpness, particularly at the edges of the picture. Teleconverters also reduce the amount of light which reaches the film. A 2X teleconverter, for example, requires 2 additional stops in exposure compensation. Let's suppose you have a 100-mm f/2.8 lens. A 2X teleconverter will convert it to a 200-mm focal length with a maximum effective aperture of f/5.6.

Close-Ups by Remote Control

The sharpest bird photos and the ones with the best poses usually are taken at the nest with normal or slight-ly telephoto lenses, involving the use of a blind, which I'll describe later. Use a close-up lens attachment, bel-lows, or extension rings for subjects closer than the minimum focus dis-tance marked on the lens barrel. This is often necessary when taking pic-tures by remote control with the cam-era on a tripod only a couple of feet from the nest.

This wood thrush's nest was 10 feet up in a tree. I positioned the camera nearby and made the exposure by remote control from a blind 30 feet away.

Cable releases and pneumatic-tubing releases 30 or more feet long that screw into the cable-release socket of the camera are available from many photo stores. However, I prefer an electrical system to operate a solenoid which trips the shutter. I have found this type of release to be more reliable, and it will capture the most fleeting pose. It can be made easily, using 50 to 100 feet of 3-conductor wire. The handle on the operator's end holds two push buttons: one to turn the electronic flash unit on and off and the other to trip the shutter solenoid. Current loss in the long release wire can be overcome by putting two or three flashlight batteries into a small box in the circuit at the camera end. This box also contains a relay which closes the solenoid-flashgun circuit when the button is pushed. A person

with electrical experience can build this type of release; however, solenoids for cameras have gone out of vogue and may be hard to find.

A newer type of remote release now being used by some serious nature photographers who have motor-driven cameras is a wireless device. The unit uses 9-volt transistor batteries to power a transmitter and receiver. While more expensive and capable of operating only motor-driven equipment, these wireless triggering devices do have the added feature of a greater range—about 200 yards on the average.

Several manufacturers of 35-mm cameras now supply electrically operated film-advance mechanisms for their cameras. These are of great value to bird photographers because they can be operated readily by remote

control, allowing users to shoot a full roll of film on a nesting bird before needing to reapproach the camera. Film-advance noise can be reduced by wrapping the outfit in insulation such as sponge-rubber padding.

Flash Considerations

Obviously, flash of some kind is required for birds, such as barn swallows, that nest inside buildings. Similarly, you'll need flash for photographing owls feeding young at night. (Flash does not frighten the birds during the day any more than the click of the shutter does, and at night it appears to disturb them only momentarily.) The phoebe shown on page 285 had its nest under a bridge, where flash was essential. In addition many species nest in deep shade, a location again requiring flash.

Electronic flash has a real advantage of having a short flash duration, which minimizes the chance of picking up camera and subject movement in your pictures. This virtually always stops even small, fluttering birds in any activity, as long as ambient light which could produce a blurred "ghost" image is not strong enough to register during the remainder of the exposure.

Even when working under reasonably bright daylight, it's often both possible and effective to use flash. With flash you can use a smaller lens opening, which will increase the depth of field, so you do not have to be as selective about where the bird must land in your picture area. Natural light is uncertain in both brightness and direction, but flash is consistent and dependable. Exposure adjustments to the lens when sunlight fails are impossible when you are hidden in your blind—joined to your camera many feet away by only a release wire.

Flash made it possible for me to capture this night picture of a barn owl. I propped up an old window frame for a perch to get the bird to land at a level higher than the window-sill. This gave me a picture having better framing and a more effective angle of view.

You'll need some form of flash illumination to photograph birds that feed their young at night.

293

Let the bird become familiar with your photo equipment before attempting close-ups by remote control. Build a dummy camera and gradually move it closer to the nest over a period of several hours or a few days.

PATIENCE BRINGS REWARDS

Whether you find a nest through good fortune by stumbling upon it or through long, hard searching, it's a good idea to delay actual photo operations until incubation of the eggs is nearing completion or even until the nest holds young birds. At this time the adult bird's protective instincts will be peaked, overcoming its fear of the camera. It will make a speedy return to the nest to avoid the danger of chilled eggs or of hungry young unattended.

The well-being of your feathered subjects should be a major consideration. You should not attempt photography when the eggs are fresh—even tame birds will desert. You'll discover that waiting for this peak period is usually to your advantage, since many nests require physical changes before they can be photographed.

For example, nests in trees are often an inconvenient distance from the only other tree suitable for holding the camera or blind. This problem can often be remedied by using a board to brace the trees farther apart, or a rope to pull their tops closer together. Likewise, if a nest in a small tree is too high for your tripod, you can bind long poles onto the tripod legs for additional height. Or maybe you'll want to set up a suitable perch near the nest. In the photo of the screech owl on page 295, I added the perch after discovering that without it the bird flew straight into the hole, allowing no chance for a picture. You may want to remove other unsuitable perches, as long as their removal will not expose the nest to predators or endanger the well-being of the young.

Your biggest task during this wait-

Don't rush your picture. If the bird appears to be nervous, let her warm up the eggs
for a few minutes first. I let this red-eyed vireo sit on her eggs about 20 minutes
before making the picture. The camera and flash (on a tripod) were set off by remote control.

I added the limb in this picture so that the screech owl would use it as a
landing perch instead of flying directly into the hole.

This peregrine falcon, photographed more than 25 years ago, is a
member of a species now on the endangered list. Rare pictures such as this one
serve as biological records of birds that have become scarce.

ing period is to gradually accustom the bird to a dummy camera or blind within a suitable camera range. Start this familiarization by setting up a dummy camera on a tripod about 30 feet away from the nest. If possible, do this a day or two in advance of the actual attempt at picture-taking. After a period of the bird's becoming used to the "camera," move it forward several feet. The interval between moves depends on the bird's reaction, the available time for visiting the site, and when you wish to begin picture-taking. The time between moves may be half an hour or a few days. In any case, the dummy camera should be sitting near the nest, fully accepted by the bird, when you want to begin. (In the case of a bird that obviously has little fear of the photographer, the camera on the tripod may be set up right away in the ideal spot—usually one which gives a nest image that fills about a third of the picture width.)

When it's time to switch the dummy for the real camera, lightly camouflage it with a few sprigs of suitable greenery to reduce the glare off any pieces of chrome (dark tape can also be useful for this). The general camouflage also reduces the chance of investigation by a curious predator or another person passing by. Next lay the remote-control wire along the ground to your blind or hiding place some 50 to 100 feet distant.

Setting Up a Blind

I've covered the standard technique for bird photography best used by photographers who have a minimum of time for their hobby. It is often successfully used with nests containing young. However, this procedure has disadvantages. First the bird is frightened from the nest each time the photographer goes forward to advance the film for another exposure, assum-

ing regular camera equipment is being used. Only one picture is obtained after each vigil, and the photographer is too far away to see the bird to advantage for the best pose.

A different technique resulting in more and better pictures is to have the tripod and camera in a blind located near the nest. You can use this technique with birds that prove to be rather fearless. The lens protrudes from a slit in the blind, allowing you to obtain better poses, take a series of pictures, and make film changes without once disturbing the bird.

It usually takes time and caution to get the blind near the nest. First overcome the bird's fear gradually by setting up the blind some distance away from the nest, possibly 100 feet at first. Then once or twice daily, move the structure forward several feet as was done with the camera in the standard procedure, so that when you're ready to commence photography, the blind will be only a few feet from the nest. Obviously, you cannot use this system of moving the blind closer with tree nesters such as hawks and owls; however, you can obtain the same result by gradually building your blind in a nearby tree. During two or three visits, build a rough framework and seat of branches or boards. Another couple of visits will see the burlap covering and foliage camouflage completed. The bird will have accepted these gradual changes by the time you're ready to photograph.

Where a bird proves to be very fearless and cooperative in the standard procedure, you can move the blind forward quickly to give you the benefit of more pictures in a given time period. When you find that you must be extremely cautious, though, try starting out with the blind at half-height to minimize its effect on the bird—then increase its height as you

move it forward. Picture-taking from within a blind is probably the most successful way to take bird pictures because you can get large images of the bird(s) and see choice poses to best advantage. This technique also eliminates the need for remote-control equipment.

When working near the nest, whether it be during the preparatory stages or during the actual photography, plan all your steps before you flush the bird from the nest, so that the length of time it is off is kept to a minimum. Once the bird has been flushed, work fast because the chance of it deserting is in direct relation to the length of time the nest is unattended. Some birds appear more anxious to return to the nest as the time increases—up to a point—then they may suddenly disappear for good.

After setting up or moving a dummy camera or blind, quickly retreat as far as possible, but where you can still see the nest, and watch with binoculars to make sure that the bird returns to it and resumes incubating, or feeding the young. If the bird does not accept the situation and resume normal activity in a reasonable time (depending on the temperature), you should quickly back off your equipment or remove it, and leave the area—the eggs and young birds come first!

I needed no blind to take this close-up picture of an American bittern. Her eggs were ready to hatch, putting her maternal instinct at its peak. Instead of leaving the nest, she assumed a "frozen" pose in an attempt to blend in with the surrounding foliage.

Blind Facts

The blind is an important piece of equipment, although it can vary drastically depending on many factors. My basic blind consists of a cloth cover hung over a frame made from aluminum tubing. The frame breaks down into a portable package which takes up very little storage space in the trunk of my car. Check with your local hardware or building-supply store for suitable aluminum tubing or angle material. Choose a cloth covering that is completely opaque so that the bird does not see your moving outline against the sky. Pick a good camouflage color, such as a medium-toned brownish green, to blend into the surroundings. Next sew some pockets into the bottom edge. They'll be useful for holding rocks at locations where it is not possible to anchor the cloth by other means.

The blind must be large enough so that you can move a little without bumping the sides. Sew a two-way zipper into the front where you will stick the camera lens through and observe the return of the bird. A long zipper in the back of the blind will provide an entrance and exit. As an alternative to the zipper for the camera hole, make the blind with a hole about 10 inches square in the front. This makes positioning of the tripod, camera, flash unit, and film-advance mechanism less critical. When all is finally ready, use a separate piece of cloth to cover the remaining spaces around the equipment, and hold it in place with safety pins. Cut peepholes about an inch or two in size on all sides of the blind so that you can watch the bird's return. Whatever your choice for material, cover the blind with appropriate foliage such as reeds or brush to make it appear more natural to the surroundings.

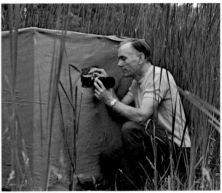

The blind pictured here consists of a cloth cover hung over a frame made from metal tubing. To keep the blind in place in case of wind I push each leg of the frame several inches into the ground.

After cutting a hole in the material for a window, position your tripod so that the camera will peek through the opening.

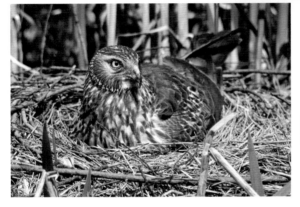

A marsh hawk—photographed from my cloth-covered blind with a telephoto lens.

After you've roughly composed the picture in the viewfinder, you may have to tie back or even remove a leaf or branch near the nest to see the bird properly. Carry out your pruning with great discretion as you may be reducing the natural cover that the bird must have for its nest to survive predators after you've gone. If you must cut off a branch, the cut should be at an angle that cannot be seen in the picture. If this is not possible, darken it with a dab of mud, shoe polish, or a felt-tipped marker to reduce the distraction. To protect the nest from predators later, it's better to temporarily tie back a branch with dark thread than to remove it. The bird photographer's golden rule insists that no picture is worth endangering the safety of the eggs or young birds—that he or she will not expose either to the elements for more than short periods, nor allow the blind or camera to keep the adult from feeding its young or incubating its eggs.

Special Blinds

Normally bird photographers have to squint through either the camera viewfinder or a peephole to see the subject. But in photographing a gyrfalcon's nest in northern Canada, my partner and I used a plywood-blind setup with large pieces of one-way

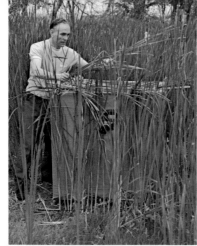

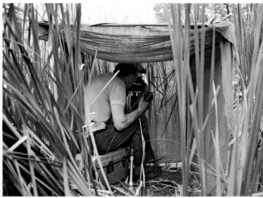

Cover the blind (including the roof) with appropriate foliage such as reeds or brush to make it blend in with its surroundings.

Inside the blind I patiently wait with my camera for the bird to return to the nest. The walkie-talkie (optional) in my right hand is for calling back my helper so he will distract the bird when I leave the blind. Normally the back of the blind would be covered with fabric and some foliage. For this picture these items have been removed to show the interior.

The completed blind—with additional touches of camouflage in place—should quietly blend into the landscape.

glass installed in three walls for easy viewing.

Photographing the gyrfalcon's nest was a major project that required an entire season to accomplish, so we spent considerable time in building a good blind. The wind at this site, 600 miles from the north pole, was always very strong, requiring the blind to be anchored by four heavy guy wires.

It is most important that the blind covering does not flap or blow in the wind. For this reason a very large cardboard carton (from a stove or re-frigerator) makes a good blind. All you need do is simply cut holes and a folding door as required. If you plan to use a carton blind for an extended period, you can prevent rain damage by covering the roof with a sheet of plastic and taping the edges down securely over the corners of the card-board carton.

You're going to be spending con-siderable time within the blind; so it would be a good idea to plan for suit-able seating. A large, strong carrying case that will double as a seat is very desirable. I have used a 4 x 5-inch Speed Graphic camera carrying case for years. To me it symbolized more than anything else the hundreds of happy hours I had spent peering out of a blind.

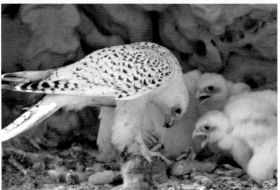

This series of pictures was taken at the location of a gyrfalcon's nest, 600 miles from the North Pole. Note that the plywood blind is held down by heavy guy wires. One-way glass windows were installed into the sides of the blind for easy viewing of the birds.

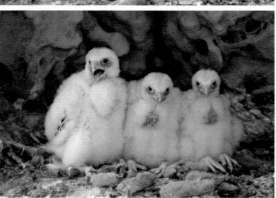

For a blind that does not flap or blow in the wind, use a large cardboard shipping carton. Cut a window for the camera and additional openings for peepholes. Camouflage the carton with foliage. Then use a piece of green or brown cloth to cover the remaining spaces around your equipment and to hide any distracting chrome trim on the camera. Hold the cloth in place with safety pins.

This stove-carton blind was set up and camouflaged in only a few minutes and now stands ready as a base for picture-taking operations.

Once I'm securely inside the blind, my partner finishes camouflaging the rear entrance and retreats, tricking the bird into thinking that everyone has left the vicinity.

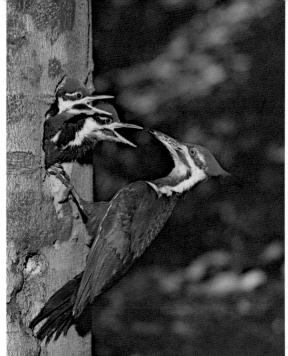

To get the picture of the pileated woodpecker feeding her young high in a tree, my partner and I rented a scaffold in Toronto and drove it 40 miles to the site. After assembling it in place we set a cardboard blind on top and, using a 5-foot pole, extended a flash reflector to position the light closer to the nest.

Don't overlook unusual lighting. This view was taken from a position on the ground using a long-focal-length lens.

TAKING THE PICTURE

Focusing the Camera

Normally you should focus on a point between the center of the nest and the back edge, at a height where the bird's head will be. To help you focus on this point in space put something such as a film carton into the nest momentarily. This will be particularly helpful in dim light, and I have found that its brief presence in the nest has no effect on the bird's return.

The Pose

Birds usually approach the nest from the side farthest from the camera, which often helps in obtaining good poses. Be patient and make your exposure only when the bird has reached your point of focus. Unless you are employing electronic flash, try to trip the shutter when there is a minimum of subject movement. It's a good idea to let a nervous bird return to the nest once or twice without subjecting it to the click and flash resulting from taking a picture, particularly if the pose is not good.

Your Helper

Successful use of a blind requires the cooperation of a companion called a "go-awayster." Once you're in the blind and ready to make a picture, your companion should leave so that the bird will think the blind is empty. Birds are unable to count, so if two people enter and only one departs, the bird believes the blind to be harmless. If the bird is out of sight, the go-awayster should depart noisily, singing or shouting for some distance to announce to the bird that the nesting area is now supposedly free from the intruders.

Of course, after taking your pictures, you should not come out of your blind in the bird's presence, or the

To make sure that the bird's head will be in focus, place a bright object such as a film carton in the nest exactly where you expect the bird will be. After you've carefully focused on the carton, remove it and retreat to the blind.

To photograph the series of a nesting great horned owl with her mate (pages 306, 307, and 308), my helper and I constructed an elevated blind next to the nest, leaving it in place for more than a month. Guy wires fastened to nearby trees supported the blind and protected it from destruction in case of heavy winds.

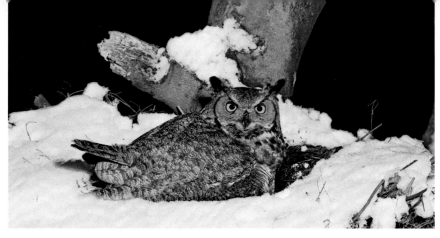
An Easter Sunday snowfall surrounded the mother-to-be keeping her eggs warm.

deception would not work again. So a signal system is necessary for the go-awayster to know when to return. My helper and I use a pair of walkie-talkie radios for this purpose, but a handkerchief poked out of the rear peephole of the blind will serve as an adequate signal. The go-awayster should return to within sight of the blind about every half hour to check on your photographic progress (binoculars can help in seeing the signal from a distance). When the handkerchief is spotted, your helper will know photography has been completed and it's safe to return to the blind, even though it may mean flushing the bird from the nest. This is one reason bird photography is best done by pairs of enthusiasts. Another advantage is in the help in carrying all the necessary gear.

BE FLEXIBLE

One feature that makes bird photography so fascinating is the need for an ever-changing technique. For example, on one field trip we were attempting to photograph terns at their nest on an islet so small that the blind was too close to the nest and frightened the birds. Also, the July sun made the blind unbearably hot, so we waded out into the lake with our release wires in our hands until the water reached our nostrils. The birds seemed to have no fear of our heads bobbing out of the water, and we took our pictures in comfort, submarine style!

Even separate birds of the same species are often as individualistic as humans, so they require different approaches to suit their temperament. One extremely fierce hawk attacked me several times while I was fastening my camera in the tree and alighted on the nest again before I could reach the blind. The next bird encountered of the same species was far too nervous to be photographed, even though every trick in my experience was called into play.

The entire subject of photographing birds in the wild—from gathering and checking equipment, studying a bird's habits, locating the nest, and building a blind to making the ultimate photograph—can be a challenging and satisfying hobby. The wait in the blind for a bird to return is often a rewarding experience as you quietly observe the constantly changing ecosystem around you. But the excitement of capturing on film a perfect image of a beautiful, free-spirited creature of the wild is fulfillment for me and the reason I believe that a bird in the bush is worth two in the hand!

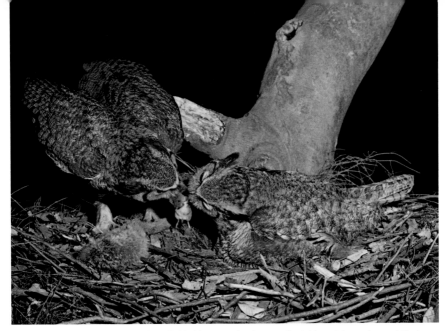

Remember that patience often yields big rewards when you're taking pictures from a blind.
Completely oblivious to my camouflaged presence close by, the male
brings a mouse to the nest and passes it over to his mate. The fur in the
lower left corner of the nest is the hind quarters of a rabbit from a previous meal.

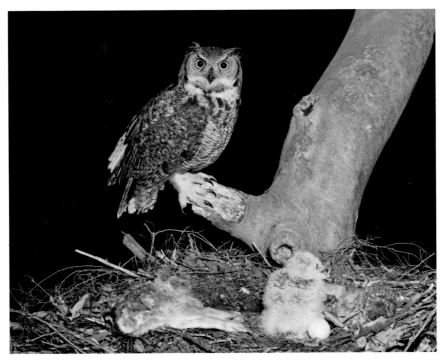

New life begins.

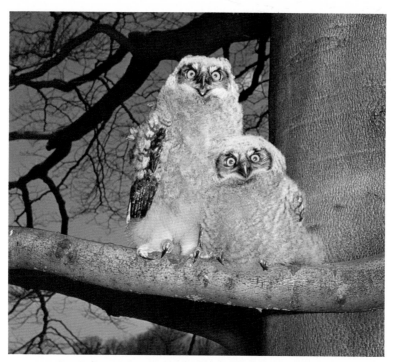

Now having left the nest, these young owls are about ready to fly.

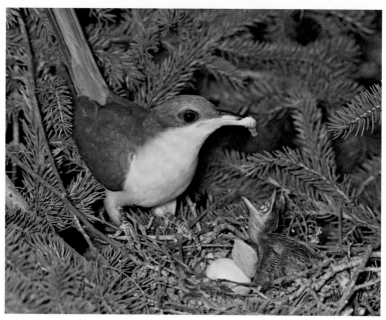

Yellow-billed cuckoo.

Your depth of field will usually be shallow at close range, so be sure to focus very carefully on that point where you've calculated the mother will be.

Don Duryeé is supervisor of Visual Aids Production in the Photographic Services area of Eastman Kodak Company. His professional background before joining Kodak in 1966 includes several years' experience as a news photographer and as a portrait photographer. Don is an active member of the Professional Photographers of America and the Photographic Society of America. In addition to being a top photo illustrator and salon exhibitor, he often serves as a judge and instructor of photography. A graduate of New York Institute of Photography, Don has also studied photography at Kent State University, Ithaca College, and Winona School of Professional Photography.

BUILDING AND USING A HOME STUDIO

By Don Duryeé

During the past several years in which photography has been both a hobby and a profession to me, I've become increasingly picture-oriented and less concerned with gadgets, equipment, and the general mechanics of photography. What is important to me is that final image—how well it communicates and how close to technical perfection it is.

To achieve these qualities in my pictures, I prefer using simple controls, lighting, and props. Savings in costs are impressive by following this procedure. But perhaps more important, I find that I can often produce a more effective result as well.

In this article you will see some of the simple, inexpensive, and easy-to-construct props and equipment that I use in my small home studio. You will also see what professional-looking photographs you can create by using just a single light, an occasional reflector, a little music, and a congenial smile from your favorite model.

To produce this high-key effect, I beamed an electronic flash through a translucent umbrella. The umbrella scattered the light for an almost shadowless illumination.

LIGHTING CHOICES

Most of my photographs are taken with soft illumination, either from electronic flash bounced off an umbrella, or with a floodlight through a diffuser. I also occasionally use special-effect lighting, such as theatrical-type spotlights. The light from a slide projector can also provide convenient illumination for situations where you want a colored spotlight effect. Simply insert a gelatin filter into the slide gate and throw the lens out of focus. You can then adjust the size of the spotlight by any of the following techniques:

• Change the degree of image blur by turning the focusing control.

• Move the projector closer or farther away from your subject.

• Use a zoom lens on the projector. KODAK CAROUSEL Projectors, for example, will accept a variety of special-purpose accessories including a 4 to 6-inch (102 to 152-mm) zoom lens.

This picture was illuminated with only one light—
an electronic flash bounced into an umbrella.

Umbrella lighting can produce a soft,
natural result such as this.

Umbrella Lighting

When you select your lighting, strive to achieve the most natural lighting result possible. Avoid hot spots, double shadows, and the uncomfortable look on your model's face caused by squinting into a bright light source.

Specially designed umbrellas with highly reflective surfaces are commercially available for photographic use. They are ideal for portraits and still-life photos in the home studio. When properly aligned with your light source, they reflect the soft, diffused light onto your subject. The result is a natural appearance that will flatter your model by either reducing or eliminating harsh shadows and those strained expressions so often recorded with harsh lighting. Bouncing a light off an umbrella and back toward the subject generally fulfills most of my lighting requirements.

Another umbrella-lighting method I often use when I want to achieve very soft results involves bouncing the light from the umbrella off a reflector and then to the model. This double bounce-light arrangement cuts down the light intensity, so your exposure times will be longer.

Still another umbrella-light modification is to make a spotlight reflector from a conventional studio umbrella. It's a simple way to concentrate light on a small area, and it works extremely well. You can narrow the beam for this hot-spot effect by closing the umbrella nearly all the way. The smaller you make the umbrella opening, the more concentrated will be the light bouncing from it. The umbrella spot is an excellent lighting technique for tabletop photography, especially where you want to control your light in a small, selective area.

I use several umbrellas in my home studio to meet my various lighting

A slide projector served as the light source for the picture above. To create the blotches of rich colors, I cut ¼-inch holes into a 2 x 2-inch piece of opaque cardboard, covered the holes with colored gels, and then projected the completed assembly onto the model and background.

Here's a simple one-light technique for producing extra soft shadows on your subject's face:

Using an electronic flash, an umbrella, and a reflector, bounce the flash from the umbrella—to the reflector—to the subject. You'll need a modeling light in the umbrella to achieve best positioning of both umbrella and reflector.

requirements. My umbrellas range from 12 inches to 5 feet in diameter, but I can fulfill most any of my lighting needs with any of them. I have several merely for convenience. For example, one is slightly translucent so that I can beam a strong light directly through the material for a diffused, soft result (see illustration on page 310).

For selective lighting of an indoor scene, try draping your umbrella light with some form of opaque covering. Such a covering, around all but the desired opening, reduces the chance of light scattering around the room—illuminating unwanted areas and pos-

sibly causing lens flare. You can drape your umbrella with fabrics such as a KODAK Professional Focusing Cloth, black felt material, or a camper's Space blanket (which I'll explain more about later).

The limits to which you can modify umbrella lights are, perhaps, restricted only by your imagination. One of my favorite umbrella-light modifications involves using barn doors, similar to those used on studio floodlights, to reduce the scattering of light. To make an inexpensive barn door, take a piece of cardboard about 16 x 20 inches and clamp it to a light stand. You can then move the rig next to your

One umbrella light, placed high to the right and slightly behind the model, created this Rembrandt lighting. A spotlight that was covered with a filter and a patterned grid illuminated the background.

A 150-watt spotlight makes a handy modeling light for umbrella units.

You can drape an umbrella light with an opaque material, such as a KODAK Professional Focusing Cloth or a Space blanket, to keep light from scattering and causing lens flare.

Use a piece of window screen or a commercially available cross screen in front of your lens to produce a star effect. Illumination here was a spotlight placed high and slightly to the left of the camera.

umbrella light at a height and position that will shield the model or camera from any unwanted illumination.

Outdoor Floodlights

With the flexibility of being able to easily change color balance with gelatin color-correction filters over a camera lens, it's possible to use many different types of artificial illumination for your studio lighting. I find that outdoor reflector floodlights (150 watts) last a long time in the studio and provide me with plenty of lighting flexibility. They are available in several colors as well as white. I often turn the floodlights on when I begin my shooting session and leave them on as long as 4 hours at a time. They will last more than a year when used in this way, making them the least expensive studio lights that you can buy.

ONE-LIGHT TECHNIQUES

Too much light can destroy the effect that you are trying to bring out in a picture. I want just enough light to make the picture and no more. The picture on page 317 is a very low-key study that appears to be lighted with studio spotlights. Actually, it was made in a normally bright room using very simple lighting. To control the mood and get the effect that I wanted, I used a 75-watt household lightbulb in a 12-inch studio reflector. Basing my exposure on the highlights, I was able to ignore the ambient light in the scene and create a picture that shows a girl surrounded by darkness.

Another benefit to this one-light method is that negatives produced in this manner require little or no dodging or burning-in when printed. I have found that black-and-white negatives will generally reproduce well on a normal paper grade, and color negatives produce excellent results.

Someone recently commented that

Rembrandt lighting—produced by a 75-watt lightbulb
in a 12-inch studio reflector.

he had seen a series of my pictures and thought that I must have the most elaborate lighting equipment in the world. My reply was that I nearly always work with just *one* light. I like the effects that one light can produce in photographing people— whether that light be from a window, an electronic flash unit, a floodlight, or a reflector.

I also like the old-fashioned style of lighting known as Rembrandt lighting because of its glamorizing effects. In Rembrandt lighting, the camera looks into the shadowed side of the face instead of the brightly lighted side as it would in a basic three-quarters view of the face.

A one-light technique really pays off when making figure studies. To highlight the form of your model, you can create a rim-light or backlight effect by placing the light source slightly behind the subject. Since most of your subject will be in deep shade, you can work with the figure only and don't have to be concerned with skin blemishes and other irregularities that might be a problem with conventional lighting techniques.

317

Rembrandt Lighting—¾ View of Face

Rembrandt Lighting—Profile View of Face

REFLECTORS

For special lighting situations, you can make your own reflectors that work well and are quite inexpensive to build. One of my favorites is the Space blanket (mentioned earlier), available through outdoor-sports (hunting and camping) stores. The blanket is silver on one side and either blue, green, or red on the other side. Use the silver side for normal lighting situations where you want the greatest amount of light possible to reflect into the scene. To really get your money's worth, you can also use the colored side on those

occasions when you want to reflect a colored highlight onto your subject. Use the colored side also as an out-of-focus background. Let me emphasize the term out-of-focus because the quilted pattern of the blanket is prominent and could produce a distracting background if reproduced in sharp focus. To make the blanket appear out of focus, reduce the depth of field of the camera lens by opening the lens aperture to its widest setting.

You can easily hang the blanket for a backdrop anywhere in your studio

One light—placed high and to the left of the girl—with a reflector on the right side to soften the shadows. The negative was printed in the darkroom through a texture screen.

Umbrella light only—no reflector.

Umbrella light with a reflector added to slightly fill in the shadows.

by using clothespins, thumbtacks, or tape. When you have no immediate plans for using the blanket, you can fold it into a small bundle for easy storage.

BACKGROUNDS

Whether you are making still lifes, portraits, or figure studies, your pictures will carry more impact if you have a strong center (or centers) of interest. One of the easiest ways to focus viewer attention onto your subject is to keep the background as simple as possible. Often even the line where the wall meets the floor can prove to be an unwanted background element. If for some reason you cannot eliminate this through a change in camera angle, you still have an effective alternative—a seamless background. Many photographers, including me, believe that a roll of seamless backdrop paper is one of the best investments you can make for your home studio. Available from photographic specialty stores, these rolls are supplied in many colors and are usually 9 feet wide x 36 feet long. Prices vary, but in general, you can figure on paying about the same as you would for a couple of meals in a good restaurant.

Once you have trucked your roll home and have it in the room of your choice (basement, attic, spare room, garage, etc), mount it at or near the ceiling either by suspending it from above or by resting it on high supports from the floor. Once it's in place, you can roll out as much as you need. Frequent walking on the paper will leave hard-to-remove footprints and shorten the life of the paper. When the end of the paper that is on the floor starts showing its age, simply cut it off and roll out a few more feet. You will discover that 36 feet of paper will last you quite a long time.

To help focus viewer attention on your model, use a background free from distracting elements. Plain or nearly plain walls or backdrops generally work best.

Here I used a roll of white, seamless backdrop paper for an uncluttered background. Seamless paper is available in rolls 9 feet wide x 36 feet long through some photographic specialty stores.

Although I have rolls of yellow, brown, red, blue, white, and black paper, I have found that I really need only two kinds of backgrounds for my photography—black and light blue. I generally prefer to work with a black background and throw a lot of light on it to lighten it rather than use a dimly lighted white paper to produce gray. White backgrounds tend to induce flare when shooting in small quarters because so much light bounces back toward the lens.

STUDIO SIZE

If you have not yet tried any studio photography in your home because you don't think you have enough space, then let me tell you about my situation. All of the pictures in this article were taken in an area of my basement 8 feet wide x 22 feet long which has been set aside for my photo hobby. The narrow width is a slight inconvenience since I must cut off better than 1 foot of width from my

You can lighten an area in a black background simply by throwing a lot of light onto it with a spotlight placed nearby.

If your camera has double-exposure capability, you can try this:

Take a full-face portrait of your model against a black background. Keep all light off the background. Next turn the model for a profile view and move in closer with your camera. Flood the background behind the model's head with plenty of light. Do not light the model. The result will be a black silhouette against a dark-gray background. Now make your second exposure on the same frame of film.

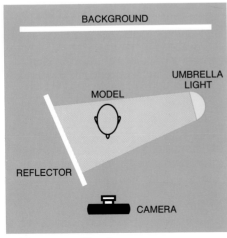

Exposure No. 1

Exposure No. 2

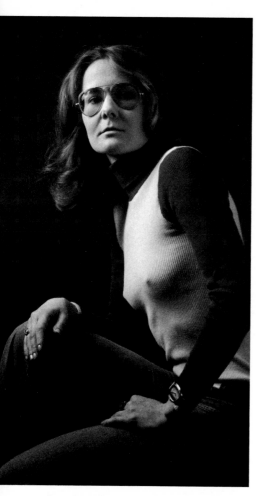

Even though my small studio has a ceiling height of only 6 feet, I can create the illusion of greater space by selecting a camera position very near the floor with my model posed on a low stool. A black background also helps suggest a more expansive setting.

seamless backdrop paper. You might also be interested in learning that my ceiling height is a sensational 6 feet! Believe it or not, though, I can take a great variety of pictures within these confines.

I have built many props and other equipment to function in my small studio. As you perfect your own style of photography in your home, apartment, or wherever you set up your lights and camera, you'll discover that size is not nearly as important as good background, subject, and lighting control.

SHARP IMAGES WITH INEXPENSIVE EQUIPMENT

Many people overemphasize the importance of highly sophisticated, expensive equipment. I have a series of 40 x 60-inch prints, made from 35-mm negatives, that have outstanding sharpness. The normal comment by viewers is "Well, the reason they are so sharp is that you were using very expensive lenses." Actually, the series was shot with a $39.95 lens. Whatever equipment you are using, it's important that you know your equipment well and use it to its full advantage. Find out what the optimum aperture of your lens is (whether it be camera or enlarger), mark it, and try to use that f-number all the time. Pick the shutter speed to fit the aperture.

When I check my lens for sharpness, I prefer taking pictures of a brick wall rather than a chart. I take a series of pictures at a distance where the wall is sharp with the lens focused at infinity. Each exposure is made at a different f-number. Be sure to keep a good record so you can tell later (after the film is processed) which exposure was made at which f-number. If you're working with negatives, make enlargements of each one so you can check corner-to-corner sharpness.

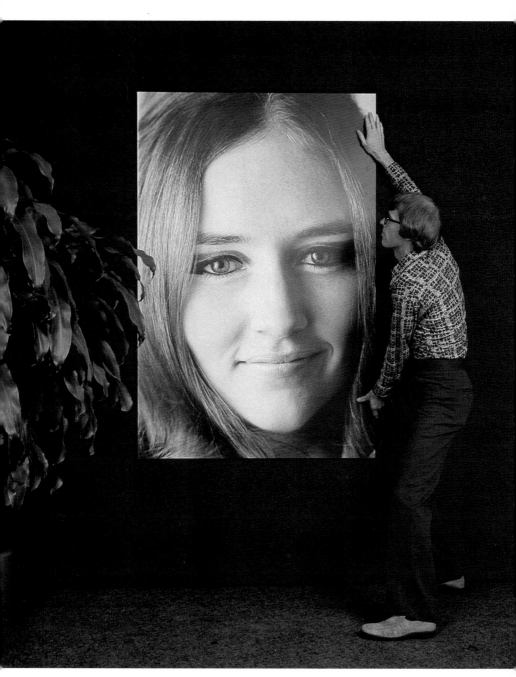

This 40 x 60-inch print was enlarged from a 35-mm negative
(KODAK TRI-X Pan Film).

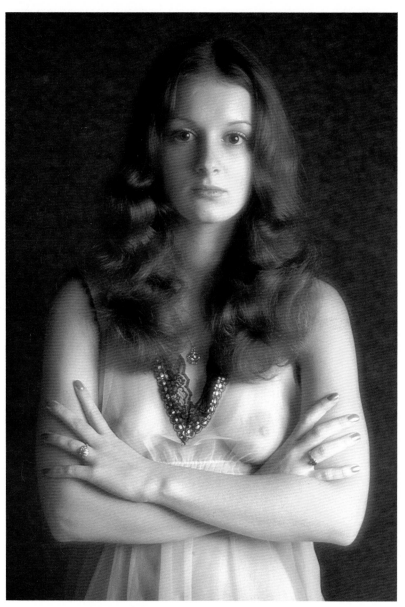

With a soft-focus attachment over your camera lens,
you can produce diffused, subdued images.

SOFT-FOCUS ATTACHMENTS

When you think of a soft-focus attachment, your mind probably turns toward one of the commercially available attachments that produce foggy or misty effects—some of which have center areas that are sharp. These attachments, available in series or millimeter-diameter sizes to fit most lenses, are both convenient and extremely capable of producing excellent results. There might be an occasional situation, though, when you would like to try some really offbeat soft-focus effects in your studio. I have come up with a few modifications of my own, one of which involves using household glue, such as Duco cement, on a 3-inch-square piece of glass or skylight filter. First spread some glue onto the glass. After it has had a chance to dry, you can then peel it off selectively. You can create a zoom effect in a picture by using layers of glue on a piece of glass placed in front of an extremely wide-angle lens.

Here's another technique for producing soft-focus pictures in your studio. Use a piece of 3 x 3-inch glass (or a skylight filter) and a small container of hair spray. Apply some of the spray directly onto the glass. It will easily wipe off later with a little water. After attaching the glass to the camera lens, look through the camera lens, and if you think it's necessary, apply more spray to the glass until you get the effect you want.

Lace curtains also work well as a soft-focus-producing tool. Place them between your model and the camera. You can apply different amounts of light to them to get special effects.

You can make your own soft-focus attachment by dabbing a few beads of clear household glue onto a piece of glass or a skylight filter. Here the center of the glass was kept fairly clear, allowing most of the face to remain sharp.

Here's a handy soft-focus attachment made by dabbing clear glue onto a skylight filter.

For this extremely soft-focus result, I used a homemade lens arrangement consisting of a +10 (approximate) close-up lens secured to a bellows.

CHOOSING YOUR MODEL

All of the preceding soft-focus techniques are particularly applicable to portraiture and glamour photography. My approach to photographing women is, perhaps, a little unusual. Most photographers look for beautiful subjects to be their models. I look for average-looking young ladies and enhance their good features through careful studio and darkroom controls. It's amazing what you can do.

How do you know when a person is photogenic? Well, I guess you probably learn this mostly from experience. While it may seem hard to believe, shyness in a girl helps you achieve a better picture.

Before actually taking any pictures, it's a good idea to review with your model a few picture samples of the type of photos you plan to take. By your doing this the model can get a better idea of the mood you're trying to achieve and you'll be getting the model's reactions regarding those poses she prefers.

Don't limit your soft-focus accessories to lens attachments. A lace curtain, placed between the camera and model, makes a good studio prop for producing an interesting soft-focus picture.

MUSIC IN THE AIR

I wouldn't think of photographing any-one without playing background music during the session. I'm generally too busy figuring f-numbers, shutter speeds, lighting ratios, etc, to make very much casual conversation. An FM stereo radio, tape deck, or record player with separate speakers can fill the room with relaxing music. The sound relaxes the model and general-ly breaks the ice between the two of us. Music can make a big difference in achieving the picture that you're after.

Use music for any kind of picture. It's no secret that most people are self-conscious in front of the camera. Happily, music is nearly always close at hand in one form or another and can be one of your best friends in the studio. The next time you invite some-one over to model for a picture-taking session, add a little music to the room and watch your pictures improve.

If you have not already done so, now's the time to clear the junk out of that spare room, corner of the base-ment, or what-have-you, and set up your own little studio at home. Put into practice some of the ideas and tech-niques I've suggested in this article, and you'll be surprised at the relative-ly low cost involved in building and using a home studio and at what a rewarding addition it can be to your hobby of photography.

This rainbow effect was created by exposing through a diffraction grating with a bare bulb just off to the right, out of sight of the lens.

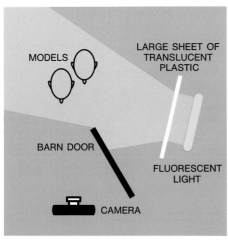

MODELS

LARGE SHEET OF
TRANSLUCENT
PLASTIC

BARN DOOR

FLUORESCENT
LIGHT

CAMERA

Soft music from my FM stereo radio filled the room during this picture-taking session. The lighting (see diagram) was somewhat dim, probably contributing to the relaxed atmosphere. My camera shutter speed was a full second.

The location and size of your studio area are not nearly as important as having a compatible background, a relaxed subject, and good control over your lighting.

Music helped set the mood for this happy picture. I consider music to be *my* best friend in the studio.

John Fish is director of Consumer Markets Publications at Eastman Kodak Company, where he is responsible for the production of books, pamphlets, manuals, folders, and guides on a variety of photographic subjects for amateur photographers. John has been taking pictures and teaching photography for more than 30 years. His pictures and articles have appeared in numerous photographic exhibitions, books, and magazines. Although he enjoys using a wide variety of photographic techniques, he has specialized in wildflower close-ups for many years and finds the subject especially rewarding.

PHOTOGRAPHING WILDFLOWERS

by John Fish, FPSA

Wildflowers grow almost everywhere— in deserts, swamps, and fields, on mountains, roadsides, and in vacant lots—offering the outdoor enthusiast a wealth of picture opportunities. These abundant flowers of uncultivated plants are in bloom every month of the year in some part of the country. Some, like the dandelion, are referred to as weeds when they flourish where they aren't wanted, while others are so rare that they are protected by law.

Familiarity with wildflowers can give an exciting purpose to a walk through fields or along a woodland trail. Those who learn to know the wildflowers are rewarded with rich returns of pleasure. Many of these attractive, showy flowers are true harbingers of spring as one of them is so aptly named. The early ones push up through the snow before spring is barely under way and blossom before their leaves are out.

For the wildflower photographer the rush of blooming starts early in the spring and continues through summer. The pattern varies depending on location—mountain and desert wildflowers have shorter, more brilliant seasons.

Wildflowers are one of our natural resources with their beauty offering a kind of enjoyment to all that is afforded by few other things in nature. Unfortunately, some of our wildflowers have

Strawberry bush, sometimes known as hearts a-bustin', is a species of slender, upright
or trailing shrub that occurs south of Pennsylvania in forests and lowlands.
This photo of the warty, red fruit, which measures about 1½ inches across, was taken
in the fall of the year on an overcast day under full skylight. A skylight filter was used over
the macrolens to eliminate the bluishness of the overcast lighting. I used selective
focus to soften the background, achieving the effect with a wide aperture and a fairly
fast shutter speed to offset any movement of the fruit.

been overpicked and are in danger of extinction—many have completely disappeared from places where they were once common.

Through photography, though, we have an excellent way to appreciate and preserve the natural delicacy of wildflowers. The photo tips you are about to read on the next few pages will help you—as camera-toting enthusiasts—capture the beauty of wildflowers on film to enjoy and share with others. Occasionally, I have included biographical information about some of the wildflowers to help you know them better as they lure you into the great out-of-doors.

SINGLE-LENS REFLEX CAMERAS

These cameras that allow you to view your subject directly through the lens are by far the most convenient to use for wildflower pictures. You see exactly what is in the picture area at the moment of exposure. In addition, you have an opportunity to preview your depth of field in advance with many cameras.

With all single-lens reflex (SLR) cameras, you will be able to see your depth of field when shooting at maximum aperture to overcome a low level of natural illumination or to focus selectively on a portion of the flower.

American water lily—
photographed with a normal
lens on a hazy-bright day.

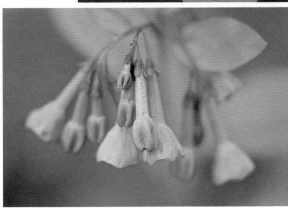

Virginia bluebell—illuminated
by natural light.

GETTING CLOSE TO WILDFLOWERS

Wildflower blooms come in a wide range of sizes, but most are quite small, so it is important to get close to make effective wildflower portraits. Pictures of wildflowers at a distance are rarely satisfying because they do not normally grow in large masses of color.

There are three common ways to obtain good close-up pictures. The method that once was most popular is to add accessory close-up lenses to the primary lens of the camera. Another accepted method is to use a bellows extension or tube(s) on cameras that have removable lenses. Today, the most common method involves an interchangeable macrofocusing lens.

I'll discuss the uses of each method

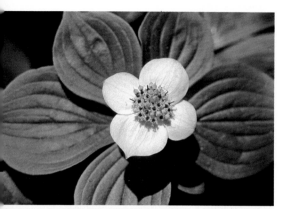

With photographing wildflowers as your hobby, you have the dual opportunity to obtain close-up pictures of blooming color early in the season and then to return later to photograph the berries or seeds of the plant. These two pictures, taken about 3 months apart, show the transition of a bunchberry dogwood from flower to fruit.

The flower, which appears white, is actually composed of several tiny, greenish-yellow flowers compactly clustered in the center and surrounded by four petal-like leaves (bracts) about ¾ inch long.

Unlike its tree-size relative, the flowering dogwood, bunchberry grows no more than 12 inches tall, often only 2 to 6 inches high. Originally coming from Asia as a stowaway, it now can be found in wooded areas of the northern United States and Canada.

Late in the summer, the bunchberry begins to form the compact clusters of scarlet berries from which it gets its name. Although inedible for humans, it is a glorious sight for birds (that will scatter the seeds)—and for wildflower photographers. Both photos were taken with a macrolens on an SLR 35-mm camera in bright sunlight.

and let you decide which is best for you. However, if the love of wildflower photography grips you as it has me, I think you'll eventually move to the easy-to-use macrolenses.

Close-Up Lenses

You can get as close as 4 to 5 feet with almost any camera and as close as 2 to 3 feet with most 35-mm cameras. But to take extreme close-ups you generally need the help of some additional close-up accessories. Close-up lenses, for example, fit over most camera lenses like filters, and they allow you to take pictures closer to wildflowers than the normal focusing distance.

Your photo dealer can help you select the close-up lens you need to fit your camera. You may also need an adapter ring and retaining ring to hold the close-up lens in place. Close-up lenses come in different sizes (called series) to fit different camera lenses. Consult your camera manual to learn what series of close-up lens and adapter ring (if any) your camera needs. Your photo dealer can also measure your camera lens to determine what series of lens attachments it accepts. Eastman Kodak Company

Marsh marigold, sometimes called cowslip, is no relation to the popular garden marigold. It is a member of the buttercup family, growing throughout the United States in swamps and at brooksides with its "feet" in water. When you search for marsh marigold in the spring, wear a pair of high boots or you'll be frustrated in your desire to get close.

Photographed from afar, the golden flowers make an interesting pattern. Moving closer brings more attention to the detail, and making the extra effort to focus for an extreme close-up pays dividends when suddenly an insect appears on the principal bloom.

does not manufacture close-up lenses, but they are supplied by other companies, including these:

Ponder & Best, Inc.
1630 Stewart Street
Santa Monica, California 90406

P.R.O.
159 West 33rd Street
New York, New York 10001

Spiratone, Inc.
135-06 Northern Boulevard
Flushing, New York 11354

Tiffen Optical Company
71 Jane Street
Roslyn Heights, New York 11577

UNIPHOT, Inc.
61-10 34th Avenue
Woodside, New York 11377

Close-up lenses are available in different strengths or powers, such as +1, +2, and +3. The higher the number, the stronger the lens and the closer you can get to your subject. You can use two close-up lenses together to work at even closer distances. For example, a +2 lens and a +3 lens equal a +5 lens. When you use two close-up lenses together, the stronger lens should be closer to the camera. More than two lenses used together can result in poor image quality and can cut off the corners of the image.

Extension Tubes or Bellows

If your camera will accept extension tubes or bellows, you can make close-up pictures without accessory lenses. Extension tubes and bellows are usually used on single-lens reflex cameras, because with these cameras you can see exactly what will be in the picture and check the focus by looking through the viewfinder. However, when you use tubes or a bellows, you'll need to increase the exposure

to compensate for the light loss that results from the lens extension. To determine what exposure compensation is necessary, see the instructions packaged with the equipment, or use the Lens-Extension Exposure Dial in the *KODAK Master Photoguide,* KODAK Publication No. AR-21, available from photo dealers.

Macrolenses

Macrolenses are available as interchangeable lenses for single-lens reflex cameras. Fitted with an extended focusing mount, a macrolens permits continuous focusing from infinity to relatively close distances for about same-size reproduction of many subjects. The ease of use and quick-focusing capability of macrolenses make them desirable for wildflower photography—especially for the smaller varieties of flowers.

Lens-to-Subject Distance Is Important

In close-up picture-taking, depth of field is very shallow. Since the range of sharp focus for a close-up lens may be only a fraction of an inch, the distance between the lens and the subject you are photographing is critical.

When you look through the viewfinder of a single-lens reflex camera, you can see whether the picture will be sharp and properly framed because you're looking directly through the lens that takes the picture.

When you use close-up lenses on a nonreflex camera, you can't check the focus by looking through the viewfinder, so it's important to measure the distance from the close-up lens to the subject.

The table on the right tells how much area (called field size) will be included in the picture when close-up lenses are used on 35-mm cameras.

It's easy to make a simple device

CLOSE-UP DATA FOR 35-MM CAMERAS

Close-Up Lens and Focus Setting (in feet)	Lens-to-Subject Distance (in inches)	Approximate Field Size (in inches) 50-mm Lens on a 35-mm Camera
Inf	39	18 x 26¾
+1 15	32¼	14¾ x 22
6	25½	11¾ x 17¼
3½	20⅜	9⅜ x 13¾
Inf	19½	9 x 13½
+2 15	17¾	8⅛ x 12
6	15½	7⅛ x 10½
3½	13⅜	6⅛ x 9⅛
Inf	13⅛	6 x 8⅞
+3 15	12¼	5⅝ x 8⅜
6	11⅛	5⅛ x 7½
3½	10	4⅝ x 6¾
Inf	9⅞	4½ x 6⅝
+3 plus +1 15	9⅜	4¼ x 6⅜
6	8⅝	4 x 5⅞
3½	8	3⅝ x 5⅜
Inf	7⅞	3⅝ x 5⅜
+3 plus +2 15	7½	3½ x 5⅛
6	7⅛	3¼ x 4⅞
3½	6⅝	3 x 4½
Inf	6⅝	3 x 4½
+3 plus +3 15	6⅜	2⅞ x 4¼
6	6	2¾ x 4⅛
3½	5⅝	2⅝ x 3⅞

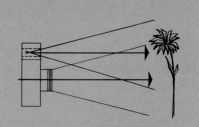

At close subject distances, the viewfinder of a nonreflex camera doesn't show exactly what you'll get in the picture.

338

that will help you measure the subject distance and show you the area that will be included in your picture. See the sections on String Rangefinder and Focal Frames.

I like to capitalize on the shallow depth of field inherent in the use of close-up lenses, extension tubes, bellows, and macrolenses to produce a photograph which, to me, is much like the visual image I obtain when I look closely at a flower. Even in bright light I often open up to maximum aperture on the camera lens to limit depth of field further and then use a correspondingly higher shutter speed to "freeze" any motion. The result shows the most important portion of the flower critically sharp, while the background and less important elements of the plant are fuzzy and unclear.

String Rangefinder. You can use a ruler to measure close-up lens-to-subject distance, but it's much easier to carry a piece of string that you have measured ahead of time. Tape or tie one end of the string to your adapter ring. Then tie a knot in the string at the correct focusing distance for each close-up lens you plan to use. For example, if you plan to use a +2 and a +3 lens on a fixed-focus camera, simply tie one knot at 17 inches for the +2 lens and another at 12 inches for the +3 lens. You can make knots for as many distances as you have lenses. With the string held out straight from the front of the camera toward the subject, move your camera until the string is taut when the knot is at the subject. Then drop the string and make your picture.

This method is simple and convenient for determining the proper focusing distance, but it doesn't show you what you'll get in the picture. At close focusing distances, the viewfinder doesn't show exactly what will be in

the picture, because the viewfinder on a nonreflex camera is located above or beside the camera lens. This phenomenon is called parallax. You can correct for parallax by tipping the camera slightly in the direction of the viewfinder after you have composed the picture. The closer you get to the subject, the more you need to tip the camera in order to get in the picture what you first saw through the viewfinder.

Focal Frames. Another simple but more effective measuring device for nonreflex cameras is a focal frame. The frame, made to accommodate your camera with a specific close-up lens, will define the area of view, maintain the correct camera-to-subject distance, and correct for parallax. Focal frames are available commercially. Check with your photo dealer.

If you would like complete information on constructing a focal frame and other close-up measuring devices, request the KODAK Customer Service Pamphlet *Close-Up Pictures with KODAK INSTAMATIC Cameras and 35 mm Cameras* (AB-20) from the address under ADDITIONAL PHOTO INFORMATION at the back of this book.

CHOOSING YOUR FILM

The film you use should depend on personal preference for the way it reproduces colors and your primary interest in obtaining slides or color prints. When I want to reproduce flesh tones in pictures of people, I prefer KODACHROME Film. However, I'm really pleased with the way KODAK EKTACHROME Film reproduces green foliage, so it is usually my choice as a slide film for wildflower photography.

Film speed also becomes a significant factor to consider if much of

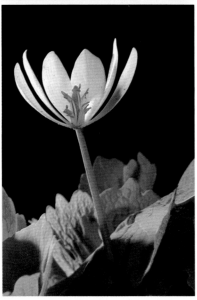

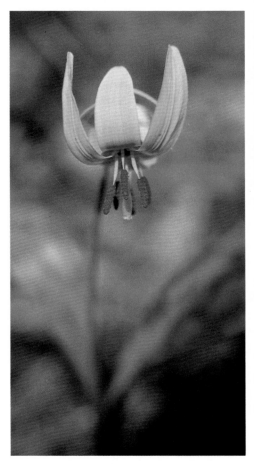

Dogtooth violet. A wide-open aperture and extremely close distance produced a shallow depth of field. This technique, known as selective focus, diminishes a distracting background.

A native of the eastern United States, bloodroot is another first sign of spring, blooming in open, mixed-deciduous forests. It has a beautiful but very fragile flower with delicate petals 1 to 2 inches long. The flower may last only one day.

The long shot on the top left establishes how clumps of bloodroot appear in the woods. Only the extreme close-up (bottom left) of a 2-inch bloom, made with a bellows focusing attachment, shows the fine detail of this delicate wildflower.

The poisonous rhizome of this low perennial has a bright, red-orange sap that is responsible for its name.

There is a treat in store for the wildflower photographer who searches in the low woods and moist meadows at varying times of the year. Many wildflower plants offer a variety of picture opportunities as they develop.

In this series of close-ups made with natural light, a macrolens was used on a 35-mm SLR camera. The first photo shows the bud of the mayapple as its leaves begin to unfold in the early spring. The time was early morning, and the droplets formed from the night dew provided a fresh springlike appearance.

In the next picture, the giant leaves have unfolded. The bud, protected beneath the leaves, can be photographed only from a worm's-eye view—by lying on the ground.

The single waxy-white mayapple flower, usually 1 to 2 inches across, hides so well beneath the leaves that a photo like the last in this series, illuminated with sunlight, is only possible by rearranging some of the leaves to let the sun shine in.

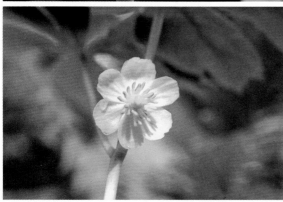

your wildflower photography will take place in wooded areas where the light is generally quite dim. While it is true that you can compensate for a slower film by using a tripod and slow shutter speeds, I much prefer the flexibility and convenience afforded by taking my pictures with the camera handheld. For this reason, KODAK EKTACHROME 200 Film (Daylight), with its high speed, is a good choice for me.

In the medium-speed range you have several choices of slide films. These include KODACHROME 64 Film (Daylight) and KODAK EKTACHROME 64 Film (Daylight). You might like to try both of these films on a variety of similar wildflower subjects and decide, on a comparison basis, which you like better.

If your picture-taking goal is color prints, choose a color-negative film such as KODACOLOR II Film, which has a speed of ASA 100 and good exposure latitude. You can either process and print KODACOLOR Film yourself or have it handled through a photo dealer.

When using KODACHROME or EKTACHROME Film, you should consider using a skylight filter (No. 1A or equivalent) to reduce bluishness in your slides of wildflowers photographed in the shade or on overcast days. The filter does not require any change in exposure.

Because color films "see" some colors at the end of the spectrum where the eye has little or no sensitivity, you may find that blue wildflowers, such as asters, bluebells, lupines, gentians, monkshood, and others, invariably photograph reddish or purplish—although they look blue to the eye. Most blue flowers reflect blue light in the region of the visible spectrum where the human eye is most sensitive to blue. They also reflect a good portion of red, but only in the region of the spectrum to which the eye is least sensitive. Coincidentally, that situation is reversed in respect to a color film; the blue reflectance falls at a region of minimum film sensitivity and the red reflectance at maximum film sensitivity.

While a strong bluish filtration will help (a No. 82C filter or equivalent), it won't entirely correct this phenomenon, called anomalous reflectance, and will alter the surrounding colors. Probably the best advice is to realize that this condition does exist and to make appropriate mental allowances.

LIGHTING FOR CLOSE-UPS
Natural Light

For most of your outdoor wildflower close-ups you will probably use natural lighting. If part of your subject is in sunlight and part in shadow, you can use a reflector, such as a white cardboard, to reflect the sunlight into the shadow areas.

Another material—often even more convenient than white cardboard—is aluminum foil. A square of heavy-duty aluminum foil (like that used for baking) that has been crumpled—then carefully smoothed—is excellent. You can support it with twigs or some other handy object such as the legs of your tripod.

Backlighting and sidelighting can be quite effective for making close-ups of flowers and foliage. These types of lighting bring out the texture and emphasize the translucency and delicate qualities of wildflowers.

Flash

Many serious photo hobbyists like to use flash for wildflower close-ups. When you use flash close to the subject, you can set your lens at a small opening to get good depth of field. I prefer using a small electronic flash

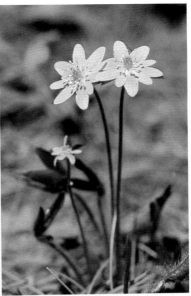

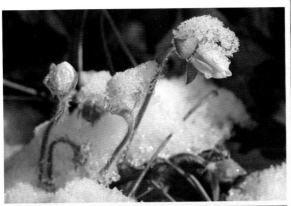

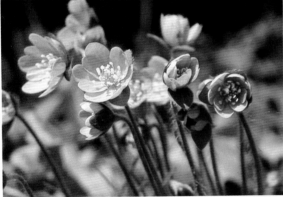

The furry heads of hepatica are among the first woodland harbingers of spring. The tiny flowers, which vary in color, are ½ to ¾-inch across and may be lilac, pale blue, white, or rose.

Hepatica (liverwort) grows in open woods and on forest slopes in the eastern United States. The new green leaves appear on these plants toward the end of the flowering period and persist through the summer and following winter.

Once you have found hepatica in bloom in the early spring, keep the location in mind and go back to visit the site while a remnant of late snow remains. These furry heads may be the start of your springtime wildflower photography after the long, forced abstinence brought on by winter.

All pictures in this series were photographed in natural light.

unit for wildflower close-ups. Flash units of this type have a flash duration of approximately 1/1000 second, which can capture most moving subjects (flowers on a breezy day) without recording a blur. Because I expose for the brightness of the flower, the background, being underexposed, becomes darker and is therefore not distracting. One flash held at a 45-degree angle in front of the flower will produce a pleasing effect similar to that of normal sunlight. But a second flash positioned above and behind the flower will add rim lighting and a greater feeling of depth.

When using flash to illuminate your wildflower close-ups, don't use regular guide numbers to calculate exposure. The inverse-square law, on which guide numbers are based, doesn't apply when the flash is used at extremely close distances. You should run your own tests to determine the best camera-to-subject distance for your film and flash combination using a given f-stop. I'd recommend f/22. Making careful records, take several color slides (all at f/22) using flash at varying distances from a medium-tone flower. Repeat this distance-changing series two more times with white and dark flowers. After the film is processed, select the slide that has the best exposure for each category of flower—light-, medium-, or dark-toned. Based on your records of camera-to-subject distance from the test, make a table that shows the optimum distance at which to photograph each category of flower. Then each time you take pictures of flowers, just set your camera at f/22 and the distance recommended in your table. For taking pictures by this method, you might find it convenient to use a string rangefinder (see page 339) with knots tied at the distances determined in your tests.

To simplify lighting for wildflower close-ups, many enthusiasts develop a standard setup with electronic flash. Once exposure information has been determined by test for specific distances, your subjects become "sitting ducks."

In the portrait of the large-flowered trillium, two synchronized flash units were used to bring out modeling and texture. I placed one extension flash to the left and rear of the flower, to produce translucence and brilliance through partial backlighting. The other (used as a fill light) was close to the lens axis but back considerably so that it would not eliminate the shadows completely. The interaction of highlights and shadows creates an almost 3-dimensional effect. The combination of a fast shutter speed and small lens opening with flash caused the background to go black because there was so little exposure from the daylight.

The picture of the mayapple, also known as mandrake, was taken with the combination of a +2 and a +3 close-up lens attached to the lens of a rangefinder camera, using a focal frame to define the picture area. The flash, attached to the camera, was reduced in brightness by several thicknesses of white handkerchief. Although the camera-to-subject distance with this type of setup is not flexible, it is very convenient to use. The flower and yellow fruit of the mayapple are difficult to photograph without flash because of the umbrella-like leaves.

Nine species of Solomon's seal cover the United States and bloom in the spring. The red berries appear in the fall on false Solomon's seal, also known as spikenard. I used a Spiratone Twinlight Macrodapter with two miniature electronic flash units for the flash picture. The Macrodapter mounts onto the front of the lens in the same manner as you would screw on a filter or adapter ring. It has two adjustable flash shoes to which twin electronic flash Minilights can be attached. Each light was aimed at about 45 degrees, and the picture was taken with the lens and flash about 9 inches away from the berries.

The comparison picture, made at the same time using only natural light, was exposed at 1/8 second at f/3.5. Note the lack of good depth of field and a lighter background when flash is not used.

Mayapple

Large-Flowered Trillium

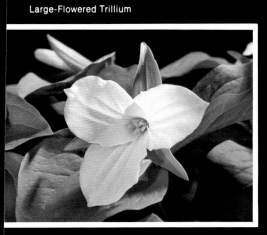

False Solomon's Seal

INDOORS

For greater subject control when photographing wildflowers, you might try moving them indoors. Using a spade, carefully dig up your fragile subject, taking as much soil with it as you can. Keep the soil together so you will not disturb the roots. Put the flower into a plastic bag so it will not dry out. The flower will remain fresh for a long time if you keep the roots moist. After you have completed photography, be sure to return the flower and soil clump to a location where the flower can continue to live and reproduce.

CAUTION: Do not remove wildflowers from private property without permission of the owner. Also, some species are protected by law. Check with your State Department of Conservation.

You can take fine indoor close-ups by using only two or three tungsten (3200 K) photolamps. When you want to emphasize the contours and shape of a flower, photograph the subject against a relatively dark background and rimlight it by placing lights slightly behind the subject. Make sure the camera lens is shielded from the direct light of the lamps. You can emphasize surface textures by skimming the light across the surface of the flower.

You can also use electronic flash units (as described on page 342) for photographing wildflowers indoors. I prefer using photolamps, though, because I can see the lighting effect in the viewfinder that I will eventually be recording on film.

EXPOSURE

Whether you're taking existing-light close-up pictures outdoors or close-ups with photolamps indoors, you'll want to use an exposure meter to carefully determine your camera settings. When you make a reflected-light ex-

posure-meter reading of a small subject, the reading will be influenced by a bright or dark background. For this reason, it's a good idea to make reflected-light readings from a surface having a standard, midtone (average brightness) reflectance, such as a KODAK Neutral Test Card. Or you can use an incident-light meter to make a reading from the subject position.

With an SLR camera that reads the exposure through the lens, you can obtain an accurate exposure for small flowers by moving the camera close enough to the flower to fill the frame. Even if the flower is out of focus, the reading that you get will be appropriate whether the subject is light or dark and will not be influenced by foliage or the background.

SOME HELPFUL EQUIPMENT

Besides clothing suited to the conditions and terrain that you expect to encounter in your search for prize-winning wildflower subjects, be sure to take along some insect repellent. In addition, you will find that sometimes you may wish to lie flat on the ground (which may be wet) to meet your subject at its level. A large sheet of plastic (plastic drop cloth, lawn bag, etc) will help keep you dry.

Include twist-ties in your gadget bag for staking long-stemmed flowers on breezy days. A pocketknife is helpful for making stakes from branches to hold swaying flowers steady.

A tripod can be a great help in shooting close-ups of flowers, especially under the dim-light conditions usually found in the forest. Tripods with a reversible center post are best because they can support a camera close to the ground. Small tripods designed for use on tabletops are also good as an aid to camera steadiness at near-ground level.

(continued on page 351)

Witch hazel is a bushy shrub or small tree found from Nova Scotia to the north of Mexico. The Indians and early settlers used the aromatic bark of the twigs for medicinal purposes and many kinds of extracts. For generations the branches were used as divining rods for the location of water and precious ores. The small flowers, which are about ½ inch long, appear on naked branches in the winter, usually after a brief thaw in December or January.

For this picture, I picked a branch on which the blooms had just started and brought it indoors. Once in the warm interior, the blooms soon opened fully. I chose a windowsill for the close-up to provide an out-of-focus background with an appropriate natural appearance.

Wake-Robin

A dark background can hide clutter that might compete with your wildflower portrait. With a dark background, free of distracting elements, your flower subject will stand out in sharp contrast. Here are three examples of how you can achieve a dark background:

• When I found the beautiful wake-robin (also known as purple trillium) in a shaft of sunlight in the woods, I asked my wife to stand in a position so as to throw a shadow on the ground behind the flower to darken the background.

With flower petals 1 to 2 inches long, the wake-robin inhabits moist woodlands east of the Mississippi River and flowers from April to June. The blooms of this native perennial are the color of raw meat and have a decaying odor that attracts flesh flies upon which it depends for pollination.

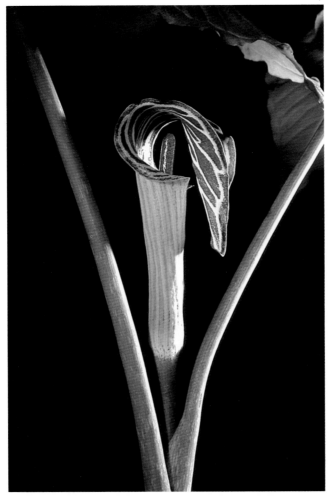

Jack-in-the-Pulpit

• In the spring, look for jack-in-the-pulpit in moist forests from Nova Scotia westward to Minnesota and southward to the Gulf of Mexico. The American Indians called this native plant Indian-turnip.

With the cap over the pulpit, it's rare to find sunlight illuminating the erect, cylindrical spadix (jack). Although the lighting and background appear similar to those of the wake-robin, I achieved this result by digging up the jack-in-the-pulpit and taking it inside. I placed the plant on a table just inside my garage door. A floodlight, placed high to the right, simulated a shaft of sunlight, while another, located to the left at camera level and farther away, added illumination to the shadows. At night I opened the garage door behind the jack and had a perfect black background. With no wind to cope with, it was possible to use a long exposure and a small lens opening for maximum sharpness.

Monkshood

• To get the dark background for the close-up of monkshood, I selected a flower stem and camera angle that included natural shade and dark vegetation.

Monkshood, which is a poisonous member of the buttercup family, has flowers that are more blue to the eye than in this photo. The change in color demonstrates the phenomenon referred to as *anomalous reflectance*.

For near-the-ground picture angles, remove the center post from the tripod, invert it, and replace it as shown here. This puts the tripod head (with camera attached) as low to the ground as desired. Wear rough-and-ready clothes so that you can sit or lie on the ground while you look through the viewfinder.

Tripods may not let you put your camera as close to the ground as you would like. For placing the camera firmly in position *very close* to the ground, make a unipod by obtaining a ¼ x 20 stove bolt (or threaded rod) about 6 to 12 inches long. This will fit the tripod hole in most cameras. Cut the head off the bolt and grind it to a point. Next fasten a nut and washer on the bolt so that when attaching the camera you will not turn the bolt too far into the tripod socket and risk damage to the camera. With the camera attached to this device, push the bolt into the ground in the proper location to photograph the flower at ground level.

You can eliminate troublesome backgrounds in your wildflower close-ups by placing a sheet of art paper, mounted on card stock, behind the subject. Be careful not to cast a shadow on the background. Blue is a good color to resemble the sky for a natural effect. One enthusiast I know uses an out-of-focus color print of the sky—with just the right number of clouds, in just the right places. You can carry this idea further and use color prints of out-of-focus vegetation.

A kit made up to carry the background cards could also include your reflector(s) and a spray bottle of water to simulate tiny droplets of dew for adding sparkle and highlights to your photo subject.

In your pursuit of wildflower subjects, chances are you'll encounter many flowers and berries in the woods and fields that might be unfamiliar at first. To help you identify those plants, carry along in your gadget bag a guidebook on the subject. One helpful publication is *A Field Guide to Wildflowers,* by Roger Tory Peterson and Margaret McKenny.

A low camera angle here enabled me to record the sky as a
background for these berries of common ninebark.

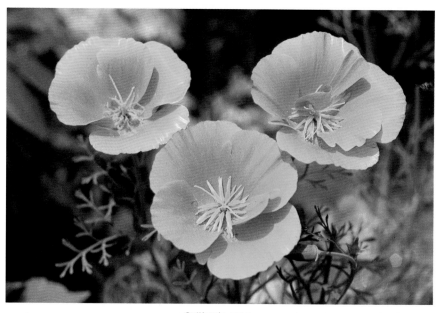

California poppy

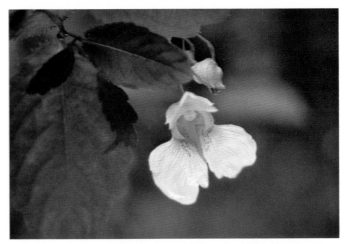

Jewelweed

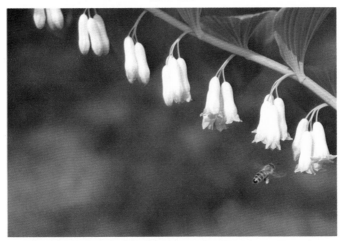

Solomon's seal

Dutchman's breeches

Bellwort

Baneberry—photographed by natural light
on KODACHROME 25 Film, 1/30 second at f/5.6.

Fireweed

Leaves of young Washington lupine—laden with morning dew.

A PICTORIAL GLANCE AT SPORTS

by Martin Taylor

The special allure of a dramatic sports picture is the vicarious thrill it communicates to its viewers. Sports events are human drama—pitting people against people or people against seemingly impossible records. The pleasure that a viewer gets from a good sports picture is partly the feeling that "I am there. I am part of the action. I could do this."

Pictorial interpretation of a sporting event conveys this feeling of involvement. It also displays the color, grace, and power of athletes at work. It does not record a time, place, and particular event—that is left to the photojournalist. In a philosophical sense, you're not trying to capture a specific instant but an impression of what is really happening. At an auto race, you're not photographically interested in who won but in the visual sensations that distinguish an auto race from any other activity.

How do you do it? How do you detach yourself from the results to define the essence of your subject? Start with the following: some background knowledge, great locations, carefully selected equipment, and the sensitivity to recognize scenes that express the essence of your chosen sport. Stamina, sturdy clothes, and comfortable shoes are also welcome.

This article can help you start taking successful sports photos. We've included ideas and techniques to get

Martin L. Taylor writes, edits, and often illustrates Kodak books and pamphlets for amateur photographers. He maintains a close connection with organized amateur photography through his periodical *KODAK Camera Club News* and membership in the Photographic Society of America. For his creative efforts as editor of *The Ninth Here's How,* he has received international recognition from the Society for Technical Communications.

Marty, who holds a bachelor of arts degree in journalism from Stanford University, has taught English in Mexico and Spain. He has also taught photography and served as a judge for photographic competitions. Marty is an experienced travel photographer and a writer of magazine articles on outdoor hobbies.

Marty rates sports activities high on his list of both photographic and athletic interests. When not at his typewriter or behind a camera, Marty enjoys actively participating in such sports as tennis, sailing, ice hockey, camping, and skiing.

Sport is grace. Before the competition begins, acquaint yourself with the roster. Know whom to watch for a spectacular performance. This photographer knew that he could count on Janet Lynn for some great moments on the ice.

NORM KERR

you going and to fine-tune your efforts. But this is only a beginning. The rest is up to you. You could take piano lessons for 50 years and never learn to play. You learn to play by practicing, and you master sports photography by practicing with your camera. More than to conquer some important techniques, you'll want to experiment to produce pictures that are truly your own.

Incidentally, make sure you read the picture captions for this article. These descriptions will help clarify ideas stated elsewhere in the text.

RESEARCH

If you already enjoy and understand a particular sport, you're well on your way to making successful pictures. It takes a certain mating of minds to produce spectacular action pictures. You have to feel the same challenge that the participant feels—know the critical points.

Unless you're an official, a bit of brushup on the rules and scoring might be in order. Investigate the players. Although you're not interested in individual names or reputations, know who's likely to outshine all others in a stunning performance—who's the most graceful, most powerful, most demonstrative, and so on. As pantomime players must exaggerate their actions for the audience to understand, you must find a player who is more visually exciting for your audience to perceive more clearly the character of the performance.

FREDERICK LUHMAN

Sport is a blur of color. Understand the game and learn when the
participants are at the peak of stress.

GARY WHELPLEY

Sport is tension. Involve the viewer by capturing the instant between start and
completion. Force your audience to build a mental image of the entire action. In this case,
Gary Whelpley caught a Norwegian ski jumper between the start of the
glide and the touchdown point on the slope.

LOCATION

Knowing the location is another must. You have to find the best picture-taking spots. Consider proximity to the field of play, background, lighting, mobility, and comfort. You want to be as close to the action as possible. This way you can cut down on the strength of your telephoto lens and, as a result, have more shutter-speed and *f*-stop flexibility. You want to pay special attention to the lighting conditions. Will the sun be right in your face? That is fine for a silhouetted athlete accented by a strong lens flare but terrible if you're trying to show a slow-shutter-speed blur. If you're taking pictures at night, are you close enough to the overhead light to obtain adequate exposure?

When you make your preliminary plans, ask authorities what you're allowed to do. Can you move around? Can you approach the field of play? Can you use flash in an indoor situation? Can you cross the track between races? How close to a sailing race can you operate your boat? Asking these questions and many more can help you get close to the action—close enough to feel the basics.

Some sports lovers encounter certain difficulties photographing big-league events where spectators are supposed to stay in their seats. That shouldn't stand in the way. Remember—you don't care who's playing, winning, or losing. You're after the game itself. Photograph your high school in action, and you'll probably be allowed to get closer, particularly when you offer to share your pictures. The same is true of amateur athletic clubs. The other solution is to find professional or semiprofessional sports at the grass-roots level which allow the spectators close to the fences.

Several types of motorcycle racing

Ask authorities for the best place to stand for good pictorial results. An inquiry about this cross-country ski race in Sweden helped the photographer find a spot atop a house from which to record the 10,000 skiers at the starting line.

Be on the lookout for motorcycle racing events that no doubt take place in your area several times a year. You can generally get quite close to the action and still be in a safe location.

are like this. Within range of every community in the United States is a motocross or scramble track. Local citizens and touring professionals compete nearly every weekend. Once you've paid the entrance fee, you can walk where you please, cross the track (between races), and set up your gear for great results. Sailing is similar, except that you'll probably want a boat. If you don't get into a racer's way, you're free to choose your vantage point.

EQUIPMENT
Equipment is important. It's more a question of what to leave home, rather than what to bring. Take as little as possible. Restrict yourself to what you're sure you will use. The more accessories you take, the more you'll have to carry, and the greater the time you'll spend poking through your gadget bag—time you could spend taking pictures. Use your ingenuity to make up for what you lack in hardware.

You'll be richly rewarded if you make a practice run on a particular sports location. Take your camera and spend one trip exploring the area and looking for the best camera positions and lighting angles; then try to determine exactly what hardware you'll need for the sports pictures you want.

A 35-mm camera is light enough to carry for a long day, and the accessories are reasonable in weight as well. Telephoto lenses up to 300-mm (6X image magnification) can be handheld during bright, sunny periods and the 20- and 36-exposure roll choices permit you to take lots of pictures before changing film. After becoming thoroughly familiar with a particular area, you should need no more gear than you can carry in one gadget bag, except a tripod if you must have one.

The closer you are to your subject,

DON MAGGIO

A normal or short telephoto lens is adequate for recording the full beauty of many scenes at a fox hunt. The country setting is as important in this picture as the rider, the horse, and the fence. To say "fox hunt" photographically requires more than a close-up of the participant.

GARY WHELPLEY

On the other hand, the perfect picture of a ski jumper demands a lens with strong magnification to bring the subject close and minimize the expanse of sky.

362

Add an electronic flash unit to your game plan for indoor sports. Make sure that your flash unit is strong enough to cover the action. Ask permission to take flash pictures during the game.

Dim illumination needs a fast film. To capture the arc of this tennis serve, a high-speed color film was used to allow a fast shutter speed.

the shorter the lens you'll need. If you happen to photograph a high-school wrestling match, chances are that you'll never need any more magnification than that which a 135-mm lens provides for your 35-mm camera. If you're following the Grand Prix circuit, you'll want a 200-mm lens or longer. An 80—200-mm zoom lens is a particularly convenient, all-around telephoto accessory. You have the choice of innumerable focal lengths within this 80—200-mm range, which you can increase by adding a teleconverter. (See "Photographing Wild Birds," page 290.)

If you're going to be inside in very dim light, fairly close to your subject, take a fully charged electronic flash for sharp, bright pictures. Flash-to-subject distance will depend on several factors including the power of the flash unit, speed of the film, and f-stop range of the lens.

FILM

With long telephoto lenses or any telephoto lens in dim light, you'll probably want some additional camera support and fast film. I use KODAK TRI-X Pan Film for black-and-white prints, KODACOLOR 400 Film for color prints, and one of the high-speed KODAK EKTACHROME Films for color slides. With medium telephoto, normal, or wide-angle lenses and moderate shutter speeds, I go with medium-speed films, such as

KODAK FILMS FOR SPORTS PHOTOGRAPHY

Situations	Black-and-White Prints	Color Prints	Color Slides
Long Telephoto Lens, Fast Shutter Speeds (1/500, 1/1000), Dim Light	KODAK TRI-X Pan Film	KODACOLOR 400 Film	KODAK EKTACHROME 200 Film (Daylight), KODAK EKTACHROME 160 Film (Tungsten)
Medium Telephoto, Normal, or Wide-Angle Lens; Moderate Shutter Speeds (1/60—1/250)	KODAK PLUS-X Pan Film (size 135) or KODAK VERICHROME Pan Film	KODACOLOR II Film	KODACHROME 64 Film or KODAK EKTACHROME 64 Film
Normal or Wide-Angle Lens, Slow Shutter Speeds (1/4—1/30)	KODAK PANATOMIC-X Film (size 135)		KODACHROME 25 Film

KODAK PLUS-X Pan Film for black-and-white prints, KODACOLOR II Film for color prints, and KODACHROME 64 or KODAK EKTACHROME 64 Film for color slides. On bright days with normal or wide-angle lenses and slow shutter speeds, I use slower films, such as KODAK PANATOMIC-X Film for black-and-white prints and KODACHROME 25 Film for color slides.

Although I'll be discussing film choices for specific techniques later in this article, see the table above for some general suggestions.

TECHNIQUES

You'll find some of the most successful sports-photography techniques demonstrated in the pictures that accompany this article. Few of them require special equipment—just a practiced eye and an active imagination. To simplify, I've divided the idea of technique into two parts. The first concerns camera handling, and the second describes action awareness.

Camera Handling

Fast shutter speeds stop motion. The direction of motion can help you determine a proper shutter speed, which might allow more depth of field or more light-gathering at twilight.

Look at it this way. If you're standing on the side of a racetrack and looking down the straightaway, cars 500 yards away will appear to be coming directly at you. If your camera is stationary on a tripod, those cars will not move quickly through the viewfinder until they get very close. It's only when they pass by that you notice the terrific speed. On going away from you, they appear to get slower.

Important: To stop all movement in the picture, remember that action crossing your field of vision requires a much higher shutter speed than action moving toward or away from you.

If freezing every detail in the picture isn't crucial, here are some other methods. Pan your camera with the action, keeping the subject in the same place in your viewfinder. You'll have to do this anyway for very fast action across your path. You can pan with a fast shutter speed and keep most of the picture sharp, or you can pan with a slow shutter speed to throw the whole scene into an interesting blur.

Any action with a reciprocal movement, like that of a diver (what goes up must come down), will allow you to photograph the action at its peak, when most of the movement stops.

Use a fast shutter speed to stop motion. Notice how every small detail in this action portrait is sharp. Also notice that the movement is almost toward the photographer.

When you're photographing something coming nearly toward you, the motion, which appears to be slow, is easier to capture with a slower shutter speed.

When fast action crosses your field of vision, it might cause a blurred image even with a very fast shutter speed. You can reduce or eliminate subject blur by panning your camera with the action.

The photographer held his camera steady on the halted racer, allowing the passing cars to record as blurs. (If the camera had been panned with the moving cars to keep them sharp, the stopped machine would have been blurred—a peculiar result.)

This comparison of techniques at a track meet shows the different effects gained with a high shutter speed (everything sharp in the picture) and with a slow shutter speed while panning (a reasonable degree of sharpness in a few elements of the picture). For more information on fast and slow shutter speeds, turn to pages 369 through 374.

365

Panning with a fast shutter speed. Most detail in the subject is sharp.

Another way to freeze action is to capture a motion at its peak. This diver had reached the fraction of a second when he had stopped rising but had not yet begun to fall.

Panning with a slow shutter speed—a show of flowing color.

Review: Basic Techniques for Action Pictures

1. Use a high shutter speed (to stop most or all movement).
2. Photograph motion toward or away from you (when you don't want or can't use a fast shutter speed).
3. Pan your camera with a fast or slow shutter speed (to blur the background).
4. Catch your subject at the peak of motion (to use a slower shutter speed).

Action Awareness. So much for basic camera handling. The most important part of your sports effort should be attention to the sport itself. Watch all the details that make up the game. Focus on a baseball pitcher and watch every movement. Where do you find the absolute statement of this art? True, there are many facets to the player's participation, but there will be some particular motion that spells to you the complete essence of baseball from the pitcher's mound. Perhaps it's a long windup or the release, or maybe it's the careful scrutiny of the catcher's signals over an upraised mitt. Whatever you find, concentrate on translating your impression to film. How big should your subject appear in the frame? Should there be motion or stillness? Do you want a silhouette or a fully lighted image? Do you want to center attention on those watchful eyes or on the clenched fist? It's all part of the game, and the variations are numberless. Keep asking yourself "What is there about this game that I find fascinating?" When you have the answer on film, you should have a first-rate picture.

GARY WILLSON

A fast turn on a slalom ski draws a curtain of water across the background and stretches the skier's body over the water at an angle that seems to defy the law of gravity. That face is taut and totally concentrated. It would be difficult to improve on this study of high-performance water-skiing.

DAVID HENRY

What is swimming? Many athletes might answer that water sports are at least 50 percent breathing—getting enough air into the lungs at the right time. This photo displays the importance of breathing with the swimmer's open mouth and closed eyes.

FINE-TUNING YOUR MECHANICAL APPROACH

Be Ready

Once you are comfortable with the fundamental camera-handling techniques and you feel sensitive to the flow of action, try these ideas. In most of your pictures, even the ones blurred by extremely slow shutter speeds, you may want to have one small area of the subject in sharp focus. Since most sporting events feature a fast pace, you won't be able to focus on each individual situation. You'll have to pre-focus on a place where you know there's going to be some action and wait for play to move into your area of sharp focus. Use the smallest possible lens opening to give you maximum depth of field so that precise focusing can be less critical. To compensate for the small lens opening you'll probably have to lower your shutter speed a bit.

Once you've prefocused, make sure your exposure is set for the subject. When you start taking pictures you won't want to take extra time bothering with camera adjustments. If you're using a zoom lens, keep your zooming to a minimum. Use the zoom to frame your picture and then leave it alone. If you want to zoom the lens at a slow shutter speed to concentrate attention on your subject, that's another story.

You want to be completely ready to take pictures. The speed of most sports will leave you behind if you're still fiddling with your camera when play begins.

MARTY TAYLOR

Be prepared, just as the competitors are prepared. Determine your exposure before the contest starts. Prefocus on a spot that will give you good composition. Plan your technique. When the action begins, you won't have time to make adjustments.

ALEXANDER CARTER

Use a fast shutter speed and a telephoto lens to expose the detail of an athlete under strain.

RICHARD RAHMLOW

LINDA WALLACE

For super-sharp action pictures of indoor sporting events, focus carefully and use an electronic flash unit.

A telephoto lens helps you concentrate viewer attention on detail by allowing you to crop out unwanted extras.

Frozen Drama with Fast Shutter Speeds

When you're dealing with a sport that requires human bodies to make incredible strains and contortions (gymnastics, wrestling, boxing, swimming, and track) and that affords observation of bulging muscles and straining, concentrating faces, you have great material for sharp close-ups.

There are two reasons why you'll want to use your fastest shutter speed. First you want that face or whatever to be as acutely defined as photographically possible. Second, you want to throw everything except your subject out of focus with a large lens opening (minimum depth of field).

Concentrate on your subject.

Outdoors use a lens with enough magnification to zero in on the essentials. Indoors, you'll want to make your lens choice with the same criteria, but you're likely to run into exposure difficulties with fast shutter speeds. If permitted—make sure you ask—use an electronic flash unit to supplement the light and freeze your subject. As I've said before, many schools and athletic clubs won't object to your making pictures, with or without flash, particularly when you offer to share your pictures. The flash can solve your exposure problem and will give you super-sharp action pictures you never thought possible.

Determine your camera position by the location of the sun. You can add to the excitement with judicious use of backlighting.

The Feeling of Action with Slow Shutter Speeds

As mentioned before, one of the most dramatic expressions of speed in a photograph is the use of extremely slow shutter speeds for a blur and mixture of colors. The word *color* is important here because the flowing effect works best with color film. To me, black-and-white renditions usually lack impact.

Depending on your sport, slow shutter speeds mean anything from 1/30 second to 1/4 second. For proper exposure you'll need to use a small lens opening, probably f/22, and a slow film. If your normal exposure on a bright day is 1/125 second at f/11 with KODACOLOR II Film, a change to a shutter speed of 1/8 second will require a lens opening of f/45. Chances are that you don't have that f-stop on your telephoto lens. Here's what you can do. First load your camera with a slow color film that has an exposure index of ASA 25 (KODACHROME 25 Film, for example). That brings your required lens opening down to about f/32 at 1/8 second. Your lens probably doesn't have that aperture either, so you can attach a polarizing screen to the front of your lens or use a neutral density filter for extra help. For details on using either of these accessories to reduce the amount of light entering your camera, see "Nature-Trail Photography," page 390.

Panning with slow shutter speeds.

For any action with a distinct lateral movement (that of a runner, a race car, a motorcycle, etc), panning with the action can produce a variety of results. Experiment to find out which effect pleases you most. While you pan the camera at 1/125 or 1/60 second, most (not the wheels) of a race car, speeding across your field of vision, will be sharp; and the background will be a streak of mixed hues. At 1/15 second, you'll combine many different types of motion, including possible vertical camera movement. Everything except some small part of the car that you catch just right will be blurred. (Most judges of salons and photo competitions prefer that *something* be sharp in your picture.) But the rest of the image will be a delightful sweep of brightness. Very effective. If you're photographing a strong vertical movement, you can pan vertically.

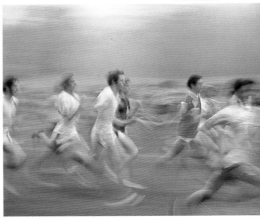

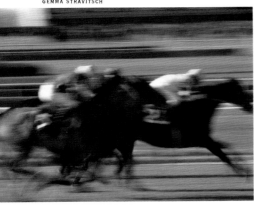

Panning the camera on a moving subject while using a slow shutter speed increases the feeling of motion and tends to mix the colors in the scene. This can be extremely effective if you want to get rid of an unattractive background. Exposure for the horses was 1/60 second at f/11. The motorcycle photo exposure was 1/30 second at f/22. Although a slower shutter speed, 1/15 second, captured the runners, their heads recorded moderately sharp.

Notice the different effects obtained by holding the camera steady and
exposing with a slow shutter speed. The water-skier is poised,
though obviously moving, on a patchwork of dancing light reflections.
The bicyclists present a different scene. Racers near the camera
are blurred almost out of recognition, while competitors in the back
of the pack aimed at the photographer are nearly sharp.
(Exposure: f/11 at 1/30 second.)

Slow shutter speeds holding the camera in one place. For ghostly pictures that show action occurring over a length of time (a player is shown in a continuum, rather than frozen in place) try a slow shutter speed, such as 1/15 second. A good subject would be a basketball player going up for a toss or making a shot. A baseball pitcher delivering the pitch would also be effective. For this effect you do not have to move the camera. In fact, it is preferable to have the camera pretty well anchored, although you can try it handheld. With the camera anchored, the background ought to be fairly sharp. A handheld camera, on the other hand, will probably produce a background image that shows signs of camera movement.

Zooming at slow shutter speeds. If you're photographing a sport such as baseball, football, or basketball, where the players often maintain their positions for several seconds, try some slow shutter-speed zooms. You'll get the effect of dramatic motion without having the subject move at all. You'll need a zoom lens that can be easily zoomed while you simultaneously operate the shutter release. Try a variety of slow shutter speeds, from 1/4 second to 1/30 second, and experiment for the best effect. When your subject is nearly motionless, the center of your image should be fairly sharp, particularly when you use a tripod or other steady support.

Some zoom lenses have a twisting ring that changes focal length; some merely slide back and forth. With the kind that twist, you'll need longer shutter speeds (1/4, 1/8, 1/15 second), because it takes extra time to twist the ring. With the sliding type, you can get the same effect with faster shutter speeds, from 1/15 to 1/60 second. Although the twisting type almost

PETER CULROSS

DON MAGGIO

There are many ways to approach your subject. One way is straightforward, which is perfectly fine for the photojournalist. The pictorialist might enjoy the challenge of zooming in on the action to concentrate all interest on a single important element. In the latter case, that element *is* the shot. (Zoomed exposure: f/11 at 1/8 second.)

WILLIAM HEIDEN

always requires a tripod, you can usually get away without using a support for the sliding type with faster shutter speeds.

Experiment with your zoom lens. The variations are endless. Zoom out from the least magnification to the greatest, zoom in (from greatest to least), and try pictures holding the subject at one focal length for a split second before you zoom. This last technique will give you a fairly strong image of the subject but also some of the zooming motion.

The Final Touch

Some photographers combine an uncanny sports sensitivity with their darkroom skills to produce derivations, posterizations, and other zappy expressions of sports. Printmakers find that they can crop and manipulate straightforward pictures to bring forth masterpieces. If you're into darkroom work, these avenues are also open to you.

Now It's Up to You

Whatever your technique, remember that it is only a mechanical function to be subordinated to your final visual statement. You want viewers to say "That's it—that says all about playing basketball that I ever remember. Why, I can feel the ball, the court, the heat, the fatigue, and hear the crowd, as though I'm in there playing." What you don't want to hear is "My, what a pretty zoomed interpretation of a basketball game."

For impressionistic results like these, consult *Creative Darkroom Techniques,* KODAK Publication No. AG-18, and use your imagination!

After picturing a collection of bicycle racers on an indoor track, the photographer made a high-contrast print in the darkroom. The result was a big prizewinning image that looks rather like a sheet of music, with the wheels becoming notes on the staff of the track.

Two outstretched hands and a ball—you've come close to defining the sport of basketball in a single photograph.

Edwin A. Austin is a supervising photographic specialist in the Photo Information department of the Consumer Markets Division at Eastman Kodak Company. A native of Colorado, Ed earned his degree in Business Administration from the University of Colorado.

His career with Kodak has taken him throughout the country—first as a sales representative in Massachusetts and later as a sales trainer, creating and presenting workshop programs to photographic salespeople in many major cities.

Currently, Ed works on several phases of audiovisual program creation—planning, photographing, and presenting—for National Parks, educational TV productions, and general audiences. He draws from his experience also in personal correspondence, answering questions from photo dealers and customers.

Ed is also actively involved in environmental conservation work as a member of his town conservation board. Other photographic interests include nature/conservation photography and participation in the Kodak Camera Club and the Photographic Society of America, which has brought him major awards in several international competitions. Ed's article "Top-Quality Slide Projection" appears starting on page 9 of this book.

NATURE-TRAIL PHOTOGRAPHY

by Edwin A. Austin

WHY TAKE NATURE PICTURES?

Through photography I have discovered that there is more beauty and drama in nature than man could hope to create. By recording these wonders of nature on film I hope to inspire in those who see my pictures the same feelings that I have—feelings of awe, wonder, peace, respect, and the desire to preserve and protect the natural world from exploitation and "over-living." Before *Care* must come *Aware*. I believe that nothing can create this awareness as thoroughly as photography.

Picture-taking along a nature trail can be as simple as an hour's stroll in an undeveloped area of a park with a lightweight, easy-to-use pocket camera—or as challenging as a backpack deep into a wilderness area with 25 pounds of camera, lenses, and tripod. Of course, there are also many in-between situations into which most nature-trail photography falls. It's this middle area of challenge that carries the greatest amount of interest for me.

Reveal an exciting photographic world in sunsets and sunrises. With any camera, take sunset pictures from half an hour before sunset until the color fades. Take sunrise pictures from the moment the colors appear until they disappear into the light of day. Include something interesting in the foreground for a strong silhouette.

When taking a picture to show an overall view of an expansive scene, look for an appropriate foreground frame to help add a feeling of depth and reality.

General scenic pictures taken early or late in the day can show the effect of the sun (low in the sky) as it produces strong shadows and provides a feeling of your being there.

Sunrise—Rocky Mountain National Park.

Late afternoon at the same location.

WHAT TO PHOTOGRAPH

The variety of picture possibilities is almost without limit for people who have broad interest in their total environment. Typically, the pictures taken most are scenic snapshots. Yet this type of picture can be one of the most challenging to take if you want to capture the mood and expansive feeling of nature's vastness.

The basic technique of including appropriate foreground or framing will do much to add a feeling of depth and reality to scenics. The time of day can likewise do much to enhance the feeling of being there. Early or late in the day the low angle of the sun creates important shadows that say "distance and depth."

A picture sequence can also sensitize a person to the ever-changing character of nature. Through sequencing it's possible to illustrate the dramatic change that occurs within an entire day, the variety of interpretations possible of a single scene, or a comparison of that scene through the seasons.

Spectacular color is often present early or late in the day. The early color often begins during the hour prior to sunrise, while sunsets last beyond the setting of the sun. For such pictures, *persistence* to get up early if necessary, *patience* to wait for the right moment, and *planning* to locate good foreground can pay off with exciting pictures. With cameras that can be set manually, read the brightest part of the sky with the exposure meter. Then use ½ to 1 full f-stop *less* exposure than the reading to enhance the richness of the colors. This way, too, foreground subjects become dramatic silhouettes, adding depth and interest.

Early morning hours also offer the possibility for lovely, tranquil views of ponds and lakes. Before the sun

This picture, taken more than one-half hour after sunset, required a tripod and an exposure of several seconds. For good color in pictures of the sky very early or late in the day, measure the brightest part of the sky with an exposure meter. Exposure at 1/2 to 1 *f*-stop less than the measured reading may enhance the richness of the colors in some instances.

warms the air, the day is still and the water is glass-smooth to provide a surface for perfect reflections.

You don't always need sunny days for outstanding pictures. Though some people retreat from the outdoors when it is foggy or raining, such days can offer a wealth of picture-taking opportunities. Take exposure-meter readings of the important subjects within the scene. Otherwise, the meter can be easily influenced by an unwanted white sky or distant fog, resulting in underexposure for most nearby subjects. If you are unable to make a selective reading of a subject within the scene, make an overall reading and then give about 1 *f*-stop more exposure than recommended by the meter. Needless to say, there are no hard-and-fast rules about correct exposure under these conditions, and the safest procedure is to bracket your exposure by about half a stop on each side of the estimated exposure.

One of the best times to photograph people is on overcast days, when the lighting is soft and diffused. If the moisture is heavy, close-ups of flowers, cobwebs, and other delicate subjects become "diamond-studded." If there is moisture in the air, it's a good idea to protect your camera with an umbrella, poncho, or plastic bag. Check the surface of the lens often for moisture buildup and remove it with a soft, lintless cloth or lens-cleaning paper before taking any pictures.

To get pictures showing smooth-as-glass water like this, get up early before the sun warms the air and creates breezes.

Bad weather can provide great picture opportunities. Notice how the fog in this picture adds to the mood of the lonely, wind-bent trees at timberline.

The red jackets of these hikers added a touch of eye-catching color to this nearly monochromatic scene along the trail.

Keep your camera clean and dry. A plastic bag can keep both trail dust and moisture off your camera during non-picturetaking periods.

YOUR PHOTO HARDWARE

Extra equipment that can be useful as your interest and skill advance includes automatic or adjustable cameras for less-than-good weather conditions, and wide-angle, telephoto, or zoom lenses to vary the perspective.

Although wide-angle lenses produce images that include more subject matter than normal or than telephoto lenses do at the same distance from the scene, they do have the effect of making distant scenes appear smaller. This image-size reduction can cause a loss of the dramatic effect you have been seeking unless you take advantage of strong foreground subjects to create a feeling of depth. If you don't have an interesting, appropriate foreground to include in your composition, it's often better to take more than one picture of a broad scene with a normal lens rather than squeezing it all into one picture with a wide-angle lens. An exception to this

might be when you find yourself in a narrow valley or canyon and want to include as many of the trees and/or mountains surrounding the scene as possible.

For enhancing the dramatic effect of rugged mountains, consider using a telephoto lens. As you would expect, it gives the opposite effect from that of a wide-angle lens: the mountains appear larger in relationship to foreground subjects.

Using a polarizing screen with an adjustable camera in good weather increases color saturation by reducing reflections. When used under the proper light conditions, the screen can also darken blue skies and partially penetrate atmospheric haze. For information on how a polarizing screen affects polarized light, refer to *Filters and Lens Attachments for Black-and-White and Color Pictures,* KODAK Publication No. AB-1.

28-mm lens

50-mm lens

135-mm lens

200-mm lens

A wide-angle lens gives you the benefit of being able to include large expanses of scenery (including foreground) in a single picture.

A telephoto lens was used for this sunrise picture to make the mountain appear much closer.

This picture was taken without a polarizing screen.

A polarizing screen was used here to darken the blue sky.

A special strap called a Kuban hitch prevents my camera from bouncing against my body as I hike.

Bags, Straps, and Packs

As you move farther from your car and time stretches into hours and distances into miles, you'll find that how you carry your equipment is very important. Here are some factors for you to consider:

1. Safety from a slip or fall
2. Protection from the elements (rain, snow, sun, sand, etc)
3. Convenience
4. Comfort

While an over-the-shoulder gadget bag and a narrow, around-the-neck camera strap are fine for a short stroll, they leave much to be desired for a longer walk or hike. Wide neck straps that spread the weight of the camera over a wider neck area are well worth the added small expense. A further refinement that keeps your camera from bouncing and hitting against rocks while you're climbing is a special strap called a Kuban hitch. You'll find it or similar harness arrangements available at many outdoor-outfitting stores.

A small pack for photographic equipment frees your hands and balances the weight of your equipment on your shoulders, back, or hips. Many styles are available; however, one

with a leather bottom offers additional protection to equipment. Although most packs require removal before you can get at their contents, I have recently discovered one pack that is always accessible—the "fanny" pack. It has additional advantages of placing the weight on your hips (less tiring than shoulders) and holding sufficient supplies for most day trips. My particular pack holds three extra lenses, filters, film, reflector, lunch, and a windbreaker.

Tripod on the Trail

Does a nature photographer need a tripod? No doubt about it, I admit to being prejudiced in favor of a tripod—to the point of carrying my 5-pounder on 20-mile backpacks! I think that some type of independent support for the camera is helpful in a number of picture situations:

For pictorial picture-taking, I prefer using a tripod because it allows me to take more time to study the composition and background. With your camera on a tripod you can also work with slower shutter speeds, giving you small f-stops for maximum depth of field.

1. Use a tripod with telephoto lenses to minimize camera motion and provide sharper pictures. Telephoto lenses amplify camera movement. For example, a 135-mm lens on a 35-mm camera amplifies any camera movement at the instant of exposure by almost 3 times normal.

2. When taking close-ups with a tripod you have a free hand for holding a reflector or flash unit or for shading the background.

3. A tripod is helpful for taking all scenic pictures and close-ups because it aids you in choosing a pleasing composition. With the camera securely mounted on a tripod you can take more time to carefully study your framing in the viewfinder and pay close attention to the background.

A lightweight, easy-to-use camera gives you more time to concentrate your attention on the activity around you, increasing your chances of getting more and better pictures.

Whenever I use a tripod, I also use a cable release to avoid inadvertent camera motion. If I forget my cable release, I let the camera self-timer release the shutter for no-hands and no-shake operation.

After my picture-taking is over, I carry my tripod on my back. However, when actively taking pictures, I hand-carry it (sometimes with camera attached), shifting hands frequently to avoid fatigue. With the equipment so convenient, I can set up for a picture quickly and find that I am actually seeing more to photograph as a result.

If you don't want to carry a tripod, look for well-placed natural supports that can help you steady your camera. Tree stumps, rocks, or other available objects can support either your camera directly—or your arms while you carefully squeeze the shutter release.

What About a Camera?

Is there an ideal camera, film size, or format for nature pictures? It's a question best answered by determining first the ultimate use of your pictures. For good snapshots of nature, family, and travel, pick a lightweight, convenient-to-carry pocket camera, such as a KODAK TRIMLITE INSTAMATIC® Camera. With several models from which to choose, you'll find a variety of features including normal and telephoto lenses, automatic operation, focusing capability, and built-in flash. In addition to any other camera that I may be using, I always carry a pocket camera for casual family snapshots.

Color slides provide the easiest means to share still pictures with groups of people. For taking slides I usually prefer the 35-mm format camera because it offers a great variety of accessories and film choices.

On the other hand, there are other photographers who prefer larger format roll-film cameras for the large images they produce. Aside from the weight disadvantage, many cameras in this class offer the same features, flexibility, and choice of accessories as do 35-mm cameras.

To capture action on film, nothing does it better than motion pictures. Super 8 cameras (silent or sound) are available with a wide variety of fea-

An ice pattern photographed close up with
a macrofocusing lens.

Be sure to focus very carefully
when taking extreme close-ups as
depth of field will usually be quite
shallow.

For extreme close-ups you have several
lens-accessory choices, including extension
tubes, bellows, and close-up lens attachments.

The soft lighting of an
overcast day helped
record shadow detail in
this close-up study of
alpine timber.

A shaded, subdued background emphasizes the bright pattern on the wings of this cecropia moth. When taking close-ups, control or select backgrounds which will not distract the viewer's eye from your center of interest.

tures to match your moviemaking needs in the field. For recommendations on moviemaking equipment and techniques, see your photo dealer or write to Eastman Kodak Company, Photo Information, Department 841, Rochester, New York 14650.

SPECIAL TECHNIQUES

Taking Close-Ups

Many 35-mm single-lens reflex cameras can be purchased or later equipped with special macrofocusing lenses that let you focus so close that an object 1 inch high will actually be 1 inch high on the film. If you really enjoy making extreme close-up nature pictures, you may find that the extra convenience and quality these lenses offer may be worth the additional investment.

Even without such exotic lens equipment, a single-lens reflex camera of good quality makes a fine close-up camera because what you see in the viewfinder is what you get on the film. To move closer than the minimum focusing distance of any lens, use accessories such as extension tubes, bellows, or close-up lenses.

(For more information on equipment for taking close-up pictures in nature, see "Photographing Wildflowers," pages 336 through 339.)

The background is usually the last thing you think about when taking a close-up, but it can spell success or failure to the artistic acceptance of the picture. An object in the background of a nature close-up that is brighter than the main subject can easily become a distraction in your picture. A carefully positioned shadow will remove or diminish this distraction. It's generally quite easy to create a localized shadow exactly where you need it simply by properly positioning a hat

or jacket or by having a friend stand in a certain spot between the sun and the background. Of course, it also may be possible for you to perform some housecleaning to improve the background by moving or camouflaging unwanted elements. It took me some time to train myself to *see* the background in the viewfinder while composing for a nature close-up. But careful background control is worth the effort because a distracting light-colored rock, leaf, or twig can spoil an otherwise award-winning photograph.

A slight breeze can try the patience of the most patient photographer when taking close-up pictures of vegetation. Subject movement caused by a breeze will show as a blur in close-up pictures unless you use a very fast shutter speed. On the other hand, it's generally to your advantage to use a slow shutter speed (perhaps 1/30 second or slower) so that you can select a small f-number for greater depth of field.

If you want to achieve a sharp, motion-free image and good depth of field, consider the following:

- Take pictures early in the day, when there is usually little, if any, breeze.

- Use a high-speed film such as KODAK EKTACHROME 200 Film so that you can use a fast shutter speed and small f-number. In bright sun it's possible to stop down your aperture to f/11 and still use a shutter speed of about 1/250 second—fast enough to freeze the movement of most vegetation.

- Hold a large piece of clear plastic sheeting next to the subject to shield it from the breeze but let sunlight pass through.

- Use electronic flash. (See "Photographing Wildflowers," page 342.)

Handling Water

Water in its many forms is an intriguing nature subject—from the smooth-as-glass look of water in early morning that we've already mentioned, to the thunderous tumbling of a waterfall. You can change the mood of a waterfall simply by your choice of shutter speed. A very fast shutter speed portrays an excited and dynamic feeling, while a speed of 1/15 second or slower produces a quiet, soothing feeling sometimes referred to as the cotton-candy effect. As you change the shutter speed, you must compensate with your lens opening to maintain a constant exposure. If your camera doesn't have a lens opening as small as f/32 or f/45, which is often needed with slow shutter speeds on sunny days, use one or more of the following techniques to take cotton-candy water pictures:

- Take pictures on an overcast day.

- Use a slower-speed film.

- Use a polarizing screen—it reduces light entering the lens by 1⅓ stops.

- Use a neutral-density filter.

Neutral-density filters absorb some of the light, and therefore, reduce the exposure when placed in front of your lens. They're supplied in several densities, and if necessary, you can use two filters together to build up the density you want. The following table shows the density values of the most popular neutral-density filters and tells how much each filter reduces exposure.

Density	Reduces Exposure by (f-stops)
0.30	1
0.60	2
0.90	3

Water—an icy stream, a tumbling waterfall, or a tranquil lake—can be a thrilling photo subject. If you have a camera with adjustable shutter speeds, you can simulate the cotton-candy appearance of rushing water by using a slow (1/15 second or slower) shutter speed.

Fast shutter speed.

Slow shutter speed.

For an artistic interpretation of close-up nature subjects, use a technique known as selective focus. Here a large lens opening was used to limit the depth of field so that only part of the insect would be in sharp focus. This technique can also be used to de-emphasize a distracting background.

Depth of Field

If you're striving for a habitat picture that will accurately show all details of a scene in sharp focus, you may prefer the extra depth of field (area of sharpness) that comes from using small (f/16 or f/22) lens openings. For other types of pictures where you may prefer a more artistic interpretation, you can choose a technique known as *selective focus*. A large lens opening such as f/2 or f/2.8 limits the depth of field, especially at close distances.

Capturing Wildlife—on Film

Wildlife is perhaps the most challenging of subjects to be photographed in nature, offering us a picture-taking hobby in which luck sometimes plays an important role. However, with plenty of patience and preparation, you can increase your chances of being lucky. You can easily lure some subjects into your picture area, such as humming-

birds to feeders and squirrels to peanuts. For your own protection when photographing wildlife, it's a good idea never to get between a mother and her young.

Since most wild animals will not readily let you move close enough to them for frame-filling pictures, you'll need some extra lens equipment. When photographing many larger animals and birds, you'll find a telephoto lens to be almost a necessity for recording large, attention-getting images on your film. How powerful a telephoto lens you use depends somewhat upon your interest and your wallet, as well as upon how much lens and tripod weight you are willing to carry on the trail.

A 2½-power lens (nominally a 135-mm lens for a 35-mm camera) will bring you close enough to many of the less easily frightened animals you may encounter. If your plans call for some really serious wildlife photogra-

A telephoto lens came in handy for taking these two wildlife photos. In each case a tripod was used for camera steadiness.

Most wild animals are unpredictable. To be safe and to avoid startling interesting subjects, photograph from a distance, and never separate a mother from her young.

A high-power telephoto lens is a must for photographing some species of wildlife.

phy, you'll probably prefer to use a lens in the 300- to 500-mm range. In addition to increasing the size of the image by 6 to 10 times, these lenses also increase the chance of recording any camera motion by the same amount. As a result, a tripod becomes a necessity.

For occasional picture-taking use, I find a 2X teleconverter lens acceptable, and it costs much less than another telephoto lens. Although it reduces the maximum lens opening by 2 *f*-stops (as from *f*/4 to *f*/8), it does *double* the focal length of a lens and can convert a 135-mm lens to a 270-mm lens in seconds.

Whenever I'm using a long telephoto lens or teleconverter lens combination for wildlife pictures, I choose a high-speed film so that I can use relatively fast (action-stopping) shutter speeds. In fact, if I'm using an extremely long focal-length lens (300- to 500-mm), the subject is very active, and the lighting is dim, I rate KODAK EKTACHROME 200 Film (Daylight) at an exposure index of ASA 400 and have it put through a special-processing procedure available from Kodak. I use a KODAK Special Processing Envelope, ESP-1 (available from most dealers), to get the special processing. The cost of the ESP-1 Envelope is in addition to the charge for regular processing by Kodak. After you've exposed the film at the increased film speed, put the roll into the envelope and take it to your photo dealer for special processing by Kodak, or mail it directly to a U.S. Kodak Processing Laboratory in the appropriate KODAK Mailer (for Prepaid Processing). Other laboratories may also process the film to the higher speed.

You'll find some wild creatures a little less shy in winter, when they feed nearer roadsides. Your car can be an excellent photographic blind.

Look for unusual nature subjects to photograph. A wide-angle lens was used here to emphasize the expanse of this windswept snow field.

RELIVING YOUR DISCOVERIES

Pictures made by you along your favorite nature trail provide a marvelous way to relive your discoveries and share them with your friends. But before you have a room full of guests, weed out any visuals that you're not entirely pleased with so that your audience will see only your best pictures. They'll like your presentation even more and will think of you as a master craftsman on the subject of nature photography.

If you enjoy making either black-and-white or color prints, you can assemble them into handy albums for easy reference and display at a later time. Consider having enlargements of your favorite pictures made for permanent display on the wall of your home or work location. Remember, too, that a photograph—taken by you—can make a very personal greeting card for a special occasion.

To present your pictures in ways that will awaken and inspire others to your awareness of nature, you can also refer to the suggestions offered in the articles "Producing Successful Slide Shows" and "Give Your Home Personality with Photographs" in this book. Other articles in this book that contain information that can be helpful are "Top-Quality Slide Projection," "Focus on Moods," "Photographing Wildflowers," and "Photographing Wild Birds." Articles of possible interest in other *Here's How* books include the following:

"How to Photograph Wildflowers" and "How to Produce a Slide-Tape Talk" in *The Third and Fourth Here's How*, KODAK Publication No. AE-104.

"Pictorial Lighting Outdoors," "Photography of Insects," and "The Art of Seeing" in *The Fifth and Sixth Here's How*, KODAK Publication No. AE-105.

Select your favorite nature pictures for home or office wall
decoration or possibly even to enhance a greeting card.

Teacher, writer, and photographer, Allan Horvath holds a Ph.D. in geology from Ohio State University. During the 1940s he served as a military photographer in World War II and later as a civilian photographer in the wind-tunnel branch of Wright-Patterson Air Force Base. Sharing his love for photography with an equal devotion to the field of geology, Allan has also worked in oil exploration in the Southwest and spent ten years teaching geology to university students.

With his nearly four decades of interest in photography, Allan has won dozens of awards in photo contests, with several hundred acceptances in international salons. A longtime member of the Photographic Society of America, he has written approximately 25 articles for the *PSA Journal*. Currently he is teaching photography at Sinclair Community College in Dayton, Ohio.

COLORFUL CRYSTAL PATTERNS USING POLARIZED LIGHT

by Dr. Allan L. Horvath

In recent years amateur photographers have become increasingly excited by the prospect of homemade crystal patterns. Simple items such as dextrose or citric acid yield crystal masterpieces which are often the envy of talented artists. The thrill of discovery is ever fresh since you never know what kind of pattern will form next—the same as in a kaleidoscope, the same design never repeats itself. Many photographers get a special satisfaction from recording the most exquisite of these patterns on color film and showing them to their friends.

Nature, of course, is the master artist in the creation of colorful abstractions. For billions of years natural processes have operated to produce the incredible variety of interlocking crystals which form the bedrock of our planet. By utilizing these same laws of crystallization, you can create a dazzling array of compositions in glowing color.

When polarized light passes through various crystalline substances, it produces a variety of pulsating colors by a process known as *birefringence*.* Both experienced photographers and beginners are astonished when shown how easy it is to create these variegated patterns and record them on film. Just a few simple chemicals are needed to construct a masterpiece of abstract art.

*Not all crystalline substances produce this phenomenon; e.g. sodium chloride (table salt) is unsuitable.

Benzoic acid spears formed by the melt process. Magnification: 4½X.
(All magnifications in the captions refer to image size on the film.)

Hydroquinone crystals—the evaporation process.
4X on KODACHROME 25 Film (Daylight).
(Chemical not entirely dissolved.)

CREATING CRYSTALS

Begin by purchasing some inexpensive compounds from a local source such as a well-stocked drugstore. Then obtain two small squares of polarizing film or filters and some 2 x 2-inch slide cover glass. KODAK Slide Cover Glass, 2 x 2-inch (thin)—for binding 35-mm and other small transparencies—will do nicely. You can get polarizing film from Bausch & Lomb, Inc., Scientific Optical Products Division, 1400 North Goodman Street, Rochester, New York 14602. Other sources are scientific supply houses such as Edmund Scientific Company and Sargent Welch Company—both of which have branches in larger cities.

Melting Easy-To-Melt Compounds

The easiest way for you to get successful patterns is to select compounds that melt easily. I recommend dextrose, benzoic acid, urea, or citric acid.

Sprinkle one or two ⅛- to ¼-inch grains or the equivalent in smaller grains onto the center of a glass slide and heat the underside of the glass with a hot iron. You can use a tacking iron such as is used for dry-mounting photos, a clothes iron, or even a warming tray that has an imbedded metallic heating element. Keep the glass moving on top of the heat source for even heating, or you could crack the glass. Moderate heat is best for most substances. Although this slow melting operation may take a while, it avoids boiling of low-melting-point chemicals that can produce excessive noxious vapor and numerous bubbles in the finished pattern. (Some bubbles are unavoidable.)

When you've completed melting, place another piece of glass on top, squeezing the solution between the glass plates. Align the edges of the

Citric acid crystals—the melt process. 4X.

two glasses and fasten the resultant sandwich into a fixed position with spring paper clips (Boston type) or some spring clothespins while the liquid cools to room temperature and crystallizes. Squeezing the sandwich during cooling tends to keep the crystals thin, which is essential to success and adds a directional flow to the forming pattern. Clips can be placed onto two, three, or all four sides for different stresses.

The crystal image should have a waxy, translucent appearance. If it appears whitish, the crystals are probably too thick for satisfactory color. Use less chemical or remelt the compound in the glass sandwich with the clips in place. Some patterns are artistically poor, requiring patience and repeated efforts. Variables which affect the final result are the amount of chemical used, rate of melting and

cooling, type of stress placed on the sandwich, and even slight irregularities in the glass. It will soon become apparent that you can never duplicate your results exactly, a characteristic that crystals share with the snowflake phenomenon.

The cooling and crystallization which return the chemical to a solid or semisolid state may take seconds or minutes, depending on the nature of the substance and the room temperature. Place one of the polarizing films, commonly called polarizers, on top of the sandwich and one underneath, and you'll be able to watch the crystals grow during cooling.

For best viewing and greatest color saturation, orient the polarizers so that the direction of polarization in the upper film is perpendicular to the direction of polarization in the lower one. You can easily determine this direc-

tion even though the polarizers are not marked with arrows. Take the two polarizers and hold them together in front of a light. Rotate one polarizer until the light is blocked out. Now slip the crystal sandwich between the polarizers. You'll note that, where crystals have formed, there occurs a dazzling array of colors varying with the compound and its properties. Portions of the sandwich will be black where the chemical is absent or still liquid.

When all the solution has crystallized, some small black spots may remain where the chemical is absent or because of trapped air bubbles or irregularities in the glass. If there are only a few bubbles, you may still be able to locate a portion of the crystal pattern containing a suitable composition unmarred by these spots. Heating the slide slowly with one or two grains, as suggested, seems to keep the bubbles to a minimum. When you obtain an interesting pattern, bind the edges of the crystal sandwich with slide-binding tape to preserve the pattern for days or weeks, but don't wait too long to record your best patterns on color film since some substances deteriorate more rapidly than others.

If it's difficult to purchase chemicals in your area, write to the following source: Student Science Service, 622 West Colorado Street, Glendale, California 91204. In addition to a variety of chemicals, they offer a crystallography kit with polarizers and other equipment necessary to make crystals. Chemicals vary in their toxicity, so be venturesome but cautious. Treat all chemicals with care, and as a safety precaution, *keep the hot melt away from your eyes and nose.*

Summary of Procedure

1. Assemble necessary materials: 2 x 2-inch cover glass, vial of chemical, tweezers or chemical spoon, and a tacking iron or suitable heat source for melting.

2. In well-ventilated area deposit a very small amount of chemical onto the center of a cover glass and heat evenly, holding the glass with clips or clothespins.

3. Do not boil—slow heating is best. As soon as liquid forms, place a second glass on top and squeeze the liquid into a thin film by attaching clothespins.

 WARNING: Avoid breathing fumes by keeping your face away from the hot melt.

4. You can now insert the crystal sandwich, which appears colorless, between the two polarizers to watch the crystals form. Crystallization is almost instantaneous with most substances.

5. If you don't plan to photograph the crystals immediately, bind the edges of the sandwich with tape for semipermanence. Some substances evaporate or absorb water from the air with time, requiring a seal of clear nail polish (lacquer) around the edges of the sandwich. Even this precaution does not always prevent deterioration of the crystal pattern.

Handling Chemicals

Many of the chemical compounds suitable for crystal patterns are used as food additives in small amounts. These include benzoic acid, dextrose, citric acid, and vanillin. Since even quite common chemicals can be harmful in overdoses, make it a rule to handle all chemicals carefully and store them out of the reach of children.

In addition to the hazard of ingestion some chemicals can irritate the skin

and eyes. Others will decompose from excessive heat into harmful vapors.

If you prefer not to risk these vapors, I suggest the evaporation process for making crystals.

Crystals by Evaporation

Evaporation is not as popular as the melt process because it requires more time and patience. Some compounds, such as urea, give consistent results, while others require persistent effort and trial and error. My experience indicates there is great potential in this field for those who like to experiment and keep records.

In addition to urea—ascorbic acid, tartaric acid, Epsom salts, salicylic acid, and Bromo Seltzer are water-soluble substances suitable for making crystals. The list of workable substances includes photographic chemical compounds such as hydroquinone and some black-and-white developers (e.g., KODAK DEKTOL Developer and KODAK Developer D-76).

Preliminary application of KODAK PHOTO-FLO 200 Solution or a similar wetting agent permits water solutions to spread more evenly for evaporation. Wipe a glass slide with the wetting agent or even add a drop to the chemical solution if it seems to help. Some people sprinkle a few drops of water onto a cover glass, dissolve a small spatula of chemicals into the drops, and evaporate the

(continued on page 407)

SOME CHEMICALS USABLE FOR MAKING CRYSTAL PATTERNS

Chemical	Melting Process	Evaporation Process	Comments
Ascorbic acid (vitamin C)		X	Soluble in water; partly soluble in alcohol. Recommend: rubbing alcohol (70% ethyl).
Benzoic acid	X		Melting point: 121.7°C.
Bromo Seltzer		X	Soluble in water.
Citric acid	X	NR*	Melting point: 153°C; evaporation difficult.
KODAK DEKTOL Developer		X	Tricky; sometimes helpful to make sandwich by adding second glass after partial evaporation. WARNING†
Dextrose (glucose)	X	NR*	Melting point: 146°C.
KODAK Developer D-76		X	WARNING†
Epsomite (epsom salts)		X	Crystals tend to be thick, so experiment with concentration; also try sandwich.
Hydroquinone		X	Variable results; helpful not to dissolve entirely. WARNING†
Tartaric acid		X	WARNING: Causes eye irritation on contact.
Urea	X	X	Melting point: 132.7°C. Both processes excellent.
Vanillin		X	Soluble in 12 parts H_2O, 2 parts glycerol, and 2 parts 95% alcohol.

*NR—not recommended (less effective)

†**WARNING**: Repeated contact may cause skin irritation and allergic skin reaction. Avoid breathing dust. May be harmful if swallowed. If swallowed, induce vomiting. Call a physician at once. Keep out of the reach of children.

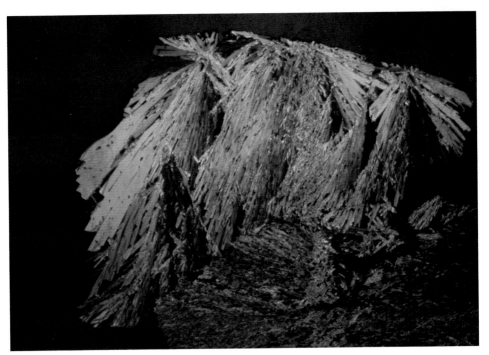

Dextrose crystals—the melt process.

Ascorbic acid (vitamin C) crystals formed by evaporation from a
rubbing alcohol (70% ethyl) solution. 4X.

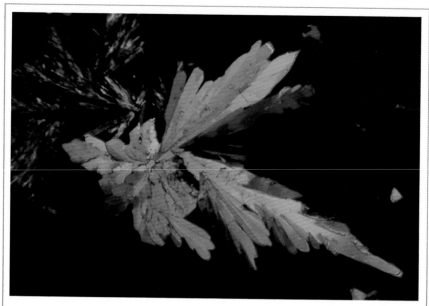

Epsomite (Epsom salts) crystals formed by evaporation of a water solution. 4X. .

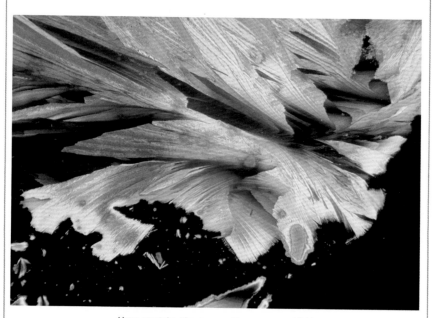

Urea crystals—the evaporation process. 1½ X.

Urea crystals—water-solution evaporation process. About 1X magnification.

Tartaric acid crystals—evaporation process. 4X.

Epsomite crystals—formed by evaporation. 4X.

The top picture was taken with polarizing filters rotated for maximum effect. In photographing the same crystals (below), I did not turn the polarizers at a 90-degree angle to each other. Notice the absence of rich colors in the crystals and the dramatic change in background density.

solution. This works sometimes, but many compounds require a more exact concentration to obtain the crystal thickness which gives optimum color.

It's better to be methodical. A chemical balance is not necessary; merely measure enough chemical to cover an object such as a quarter or a half-dollar, and stir it into a half ounce of water. If crystals are too thin, increase the amount the next time. Since evaporation may take several hours or more, place the glass slide, coated with solution, onto a shelf or in some other out-of-the-way place.

Your goal is to get relatively thin crystals which tend to do most of their growing parallel to the glass surface.

With some chemicals you can place a cover glass on top (as in the melt process) with or without clips after partial evaporation has produced a few crystals. This procedure may delay the completion of the crystallization process a week or more.

BIREFRINGENT COLOR

Once you've seen the beautiful patterns, you'll probably ask how these brilliant colors originate. When light rays strike the first polarizer, only those rays pass which are vibrating parallel to the favored direction of the polarizer. When the second polarizer is oriented in its favored direction at right angles to the first polarizer, no

You can produce a light overall effect such as this one by not turning the polarizers entirely 90 degrees to each other.

light rays can penetrate the pair. When the crystal sandwich is inserted between the two polarizers, the light traveling through the first polarizer is intercepted by individual crystals in the pattern and split into separate components (birefringence). One of the components now vibrates in a new direction that differs 90 degrees from the original rays and therefore possesses the ability to pass through the second polarizer.

The color we see (actually the wavelength of the rays beaming through the second polarizer) depends on the unique structure of the crystalline material and the alignment of the crystal axes with respect to the vibrating rays. This is partly verified by rotating the glass sandwich while keeping the polarizers on each side fixed relative to each other. You can watch the colors change and move along various directions corresponding to crystal alignment.

A rather imperfect example of polarized light, in which portions of both ray components are mixed, becomes apparent when you hold the sandwich and one polarizer in a fixed position while rotating the other polarizer. Continuous rotation of the polarizer produces an almost pyschedelic effect.

PHOTOGRAPHING THE CRYSTAL PATTERN

You can copy the crystal pattern immediately with camera and color film, or set it aside until several fine patterns have developed. Although other color films are adequate, I prefer either KODAK EKTACHROME 64 Film or KODACHROME 25 Film (Daylight) because both have given excellent rendition.

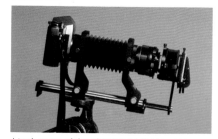

I took some of the pictures on these pages with a 35-mm camera that held a bellows attachment, 50-mm lens on a reverse adapter, and a slide copy attachment (all on a tripod).

The most popular way to record the crystals on film is to use a 35-mm single-lens reflex (SLR) camera and (1) a macrolens, one especially designed for close-ups, (2) the normal 50-mm camera lens or a wide-angle lens with extension tubes, or (3) the camera with a bellows attachment plus the normal or wide-angle lens.

Most macrolenses give sharp images but are limited to a maximum of 1X magnification—whereas extension tubes permit 2X or better magnification. A bellows attachment allows a film image that is 5X that of the original crystal with a 35-mm lens or 7X with a 28-mm lens.

To provide a diffused light source for copying with color film, try a handy slide sorter. Place a blue bulb or an electronic flash behind the plastic viewing panel to get a color compatible with daylight-type color film. Position the crystal sandwich, with properly oriented polarizers on each side, on the slide sorter in front of your tripod-mounted camera. Rather than focus or move the camera with a macrolens or extension tubes, it's easier to move the slide sorter back and forth along the edge of the table until the crystal image is sharp in the camera viewfinder. Always use a cable release to avoid camera movement.

If the crystals are extremely small or you desire to photograph only a small portion of the total crystal pattern (perhaps a ½-inch segment), you'll need to work with a bellows attachment. If you have a bellows with a slide-copying attachment, simply slip the crystal sandwich into the slot provided for the color transparency that you would normally copy with this attachment. A plastic diffusing screen behind the slot allows you to aim the camera and bellows/copier setup directly at a bare light source such as the sun, a photoflood, or an electronic flash unit.

If your camera has through-the-lens metering, you can make your nonflash exposure calculations easily—right in the viewfinder. When using electronic flash or an adjustable camera having no built-in meter, you'll have to do some experimenting for correct exposure. Whatever your light source

and method of determining exposure, bracket your settings by taking at least three pictures at three different f-stops, and keep records to be sure of getting optimum results over the long haul.

Advice for Close-Ups

Taking successful close-ups involves some factors which are not present in ordinary picture-taking. Camera lenses—except the macrolenses—are not normally designed for flatness of field at the extremely close distances involved in crystal photography. Using a smaller aperture helps remedy the decrease in edge sharpness but, at the same time, reduces the overall resolving power of the lens. With some SLR cameras you can reverse the camera lens for improved sharpness so that the rear element faces the object to be copied. Reverse adapters are available for many popular lenses and can be used with extension tubes and bellows attachments.

After careful focusing, close down the aperture at least 2 f-stops to get better depth of field. Avoid the smallest apertures (f/16 or higher), where lens resolution often decreases, even though depth of field increases. The longer exposures required at the smaller lens openings may also involve a corrective filter and exposure compensation because of reciprocity failure. The *KODAK Master Photoguide* (AR-21) provides a convenient calculator dial for determining effective f-number quickly and easily. You can also calculate the effective f-number by using the formula below:

$$\text{Effective } f\text{-number} = \frac{\text{Indicated } f\text{-number x lens-to-film distance}}{\text{Focal length}}$$

The lens-to-film distance is approximately equal to the focal length

This formation, made by the melt process, shows the need for careful focusing when working with the problem of shallow depth of field in close-up photography. Note that the subdued background is sharper than the brilliant triangular crystal. A better compromise focus would show the triangle sharper than the background.

of your camera lens plus the distance the lens is extended beyond its position at infinity focus.

To shield both the camera lens and the glass sandwich from reflections or stray light, simply use a makeshift lens shade. A curved sheet of black paper or a dark cloth will do. Reflections and lens flare have ruined many copying attempts.

Here are a couple of other possibilities to explore for those of you who might not have any of the close-up equipment described above. You might care to try a supplementary lens of high power with a long-focal-length lens. A +10 supplementary lens used on a 90-mm or 135-mm lens should give acceptable results.

Another procedure involves using a slide projector, such as a KODAK CAROUSEL Projector, to project the crystal image for copying. The lower-wattage, cool-running projectors are best. Compounds must have melting points equal to or higher than urea, or heat from the lamp will decompose the crystal. Place a sandwich of urea crystals (or a comparable substance) with polarizers on each side into the slide gate of the projector. Copy the image on the screen or a white wall with almost any camera having adjustable shutter and aperture controls. For details about how to copy a projected image, see "Slide-Duplicating Techniques," by Jerome T. McGarry in *The Third and Fourth Here's How,* KODAK Publication No. AE-104.

SLICES OF MINERALS AND ROCKS

I've found many satisfying hours in examining thin slices of rocks and minerals by polarized light. In addition to their natural beauty, these thin sections of ancient crystals provide important geological information to trained observers.

A vesicular basalt might supply data about a previously unrecorded period of volcanism; a garnet gneiss may yield facts about an epoch of mountain-building; and a third rock thin section could show evidence indicating a time of meteorite impact. In the case of sedimentary rocks, many limestones reveal mysteries from ancient seafloors where the soft sediment once trapped the remains of creatures that are now extinct.

The technique of cutting and grinding thin slabs of rock to 1/1000-inch thickness is routine for rock technicians but presents a problem for most photographers. Fortunately, prepared thin sections are available from various suppliers, including Ward's Natural Science Establishment, Inc., P.O. Box 1712, Rochester, New York 14603. You can send for a list of their available thin sections and current prices. Glass-mounted mineral and rock sections measure 1 x 1¾ inches but the rock slides cemented to the glass with epoxy are somewhat smaller. You'll need the higher magnification of a bellows attachment to get suitable image size of the mineral crystals, although I've recorded thin sections featuring large mineral fragments satisfactorily using extension tubes.

I suggest you order thin sections composed of the larger mineral grains (hornblende, pyroxene, mica cleavage pieces) or the coarse-grained rocks (granite, dunite, schist). Coarse limestones and marble are also suitable, but avoid clastic rocks such as silt-

This thin section of limestone rock shows a small brachiopod shell. 5X.

Hornblende mineral cleavage fragments. 5X.

Marble thin section with a bright mica flake. 5X.

A thin section of Manhattan schist. 5X.

Thin section of tourmaline crystals. 15X (approximately).

stone, sandstone, and shale. Basalt and rhyolite are fine-grained rocks which need a microscope capable of 20X magnification or better.

As you've probably noted, microscopes are unnecessary for some types of minerals and rocks, but they do have the advantage of enlarging small portions of thin sections to allow better control of the composition. The petrographic microscope has built-in polarizers for convenience and top-quality optics, but you can improvise ordinary microscopes with polarizers above and below the stage with fine results. Secondhand microscopes are available from scientific supply houses for as little as $75, although the petrographic type may cost three or four times that amount.

COMBINING PATTERNS WITH OTHER PHOTOS

Combining colorful crystal patterns with pictures of people is a challenge to the imagination. One method is to pose a person in front of a crystal pattern displayed on a rear projection screen, a regular screen, or a white wall. Aim your light(s) carefully to prevent light from spilling onto the projected image.

Another method is to bind two trans-parencies together. Normally this requires a slightly overexposed head or figure on one transparency and a crystal pattern with pastel shades or light areas on the other. If an appropriate pair is selected, the two, bound emulsion-to-emulsion for sharpness, should produce a combination that's not too dense for projection. Striking effects result from crystal patterns combined with human profiles outlined by a colored light.

Whether you decide to photograph the homemade variety of crystals as covered in this article or nature's age-old crystals, you'll discover a satisfying blend of science and art that will enthrall you and your friends. The endless variety of patterns allows your imagination to run wild as you select those portions of the crystals you want to photograph. Once you've gone through the process and seen how variable and satisfying the results can be, you can experiment with different combinations to achieve even greater variety.

When you're experimenting, I strongly suggest that you establish a good recording and identification method to help increase your chances for success in your future creative image-making.

ADDITIONAL PHOTO INFORMATION

If you have any specific questions not answered by the authors of the articles in this book, write to Eastman Kodak Company, Photo Information, Department 841, Rochester, New York 14650. This department has a staff of photo experts available to answer your questions on photography.

Single copies of KODAK Customer Service Pamphlets mentioned in this book are available free from the address above. Enclose a self-addressed business-size envelope with your request. On the back of the envelope, print the title *and* code number of the pamphlet(s) you would like. *No postage is required.*

Consumer Markets Division Rochester, New York 14650

The Here's How Book of Photography, Volume II
KODAK Publication No. **AE-101**

New Publication 12-77-EX
Printed in U.S.A.

KODAK, EKTACHROME, CAROUSEL, EKTANAR, EKTALITE, WRATTEN, KODACOLOR, VERICOLOR,
KODACHROME, ANALYST, INSTAMATIC, TRI-X, KODALITH, ESTAR, KODABROMIDE, PLUS-X,
EKTAGRAPHIC, PAGEANT, EKTACOLOR, PANATOMIC-X, DK-50, PHOTO-FLO, INSTATECH,
BROWNIE, TRIMLITE, VERICHROME, DEKTOL, and D-76 are trademarks.

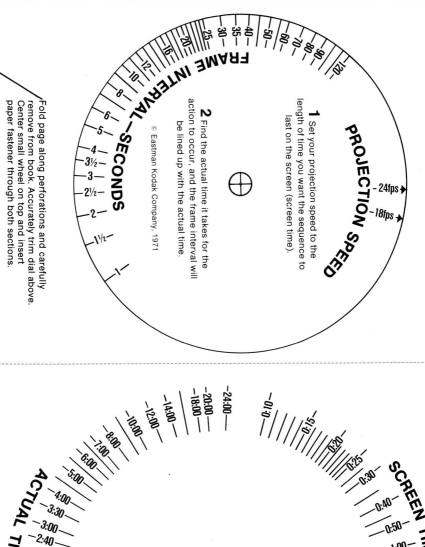

PROJECTION SPEED

1 Set your projection speed to the length of time you want the sequence to last on the screen (screen time).

→ 24fps →
→ 18fps →

2 Find the actual time it takes for the action to occur, and the frame interval will be lined up with the actual time.

© Eastman Kodak Company, 1971

FRAME INTERVAL—SECONDS

120 · 90 · 80 · 70 · 60 · 50 · 40 · 35 · 30 · 25 · 20 · 16 · 12 · 10 · 8 · 6 · 5 · 4 · 3½ · 3 · 2½ · 2 · 1½ · 1

Fold page along perforations and carefully remove from book. Accurately trim dial above. Center small wheel on top and insert paper fastener through both sections.

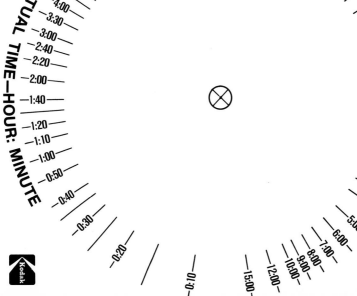

TIME-LAPSE CALCULATOR

SCREEN TIME—MINUTES: SECONDS

0:10 · 0:15 · 0:20 · 0:25 · 0:30 · 0:40 · 0:50 · 1:00 · 1:30 · 2:00 · 2:30 · 3:00 · 3:30 · 4:00 · 5:00 · 6:00 · 7:00 · 8:00 · 9:00 · 10:00 · 12:00 · 15:00 · 0:10 · 0:20 · 0:30 · 0:40 · 0:50 · 1:00 · 1:10 · 1:20 · 1:40 · 2:00 · 2:20 · 2:40 · 3:00 · 3:30 · 4:00 · 5:00 · 6:00 · 7:00 · 8:00 · 10:00 · 12:00 · 14:00 · 18:00 · 20:00 · 24:00

ACTUAL TIME—HOUR: MINUTE

Kodak